James Christen Steward

The New Child

British Art and the Origins of Modern Childhood, 1730–1830

University Art Museum and Pacific Film Archive
University of California, Berkeley

In association with the University of Washington Press

Published on the occasion of the exhibition
*The New Child: British Art and the Origins of Modern Childhood,
1730–1830* organized by the University Art Museum and Pacific
Film Archive, Berkeley

Exhibition itinerary:

University Art Museum and Pacific Film Archive, Berkeley
August 23–November 19, 1995

Dixon Gallery and Gardens, Memphis
December 10, 1995–February 4, 1996

Joslyn Art Museum, Omaha
March 9–May 5, 1996

Published 1995 by University Art Museum and Pacific Film Archive,
University of California, Berkeley

Distributed by the University of Washington Press, P.O. Box 50096,
Seattle, WA 98145.
Major funding for this exhibition was provided by the National Endow-
ment for the Humanities and the National Endowment for the Arts, fed-
eral agencies.

Works in the exhibition can be found in the Checklist of the Exhibition.

The photographs in this publication have been provided by the owners
or custodians of the works and are reproduced with their permission.
Additional photographic credits are noted on page 240.

Library of Congress Cataloging-in-Publication Data

Steward, James Christen
 The new child : British art and the origins of modern childhood,
1730–1830 / James Christen Steward. — 1st ed.
 p. cm.
 Published on the occasion of an exhibition of the same name orga-
nized by the University Art Museum and Pacific Film Archive, Berke-
ley; held at the University Art Museum and Pacific Film Archive,
Berkeley, Aug. 23–Nov. 19, 1995, Dixon Gallery and Gardens, Mem-
phis, Dec. 10, 1995–Feb. 4, 1996, and the Joslyn Art Museum,
Omaha, Mar. 9–May 5, 1996.
 Includes bibliographical references and index.
 ISBN 0-295-97481-8
 1. Art, British—Exhibitions. 2. Art, Modern—Great Britain—18th
century—Exhibitions. 3. Art, Modern—Great Britain—19th century
—Exhibitions. 4. Children in art—Exhibitions. I. University Art
Museum and Pacific Film Archive. II. Dixon Gallery and Gardens.
III. Joslyn Art Museum. IV. Title.
N6766.S78 1995
760´.044930523´094107473—dc20 95-16800

First edition

Front cover: Sir Thomas Lawrence, *Charles William Lambton* (plate 18)
Back cover: Sir Joshua Reynolds, *Cupid as Link Boy* (plate 8)
Frontispiece: Sir Joshua Reynolds, *Master Hare* (plate 2)

Edited by Paula Thurman
Designed by Bret Granato with assistance by Tomarra LeRoy
Produced by Marquand Books, Inc., Seattle

Printed in Hong Kong

The New Child

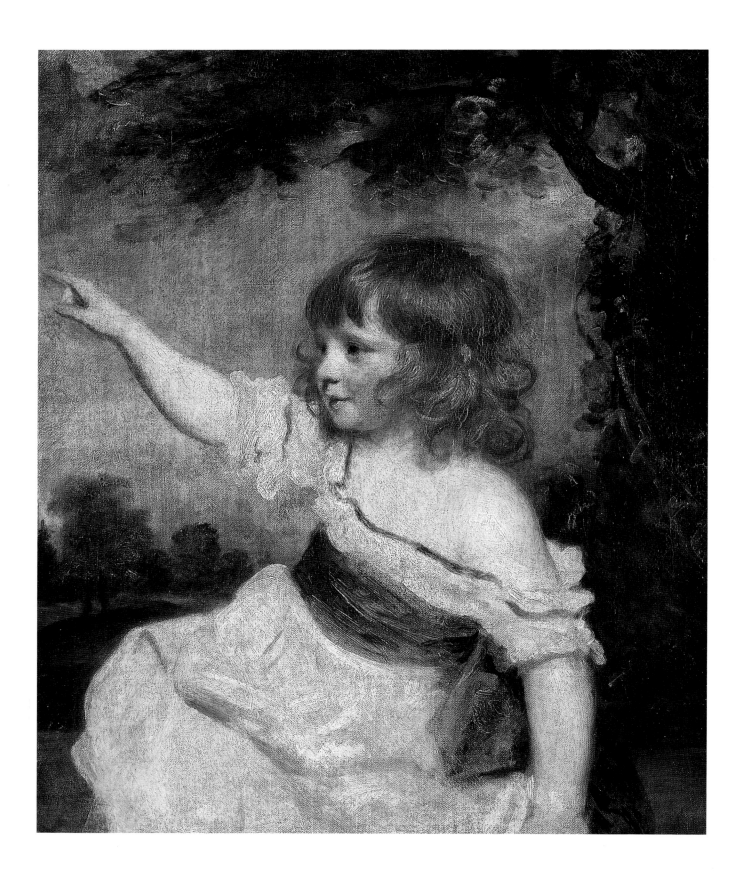

Contents

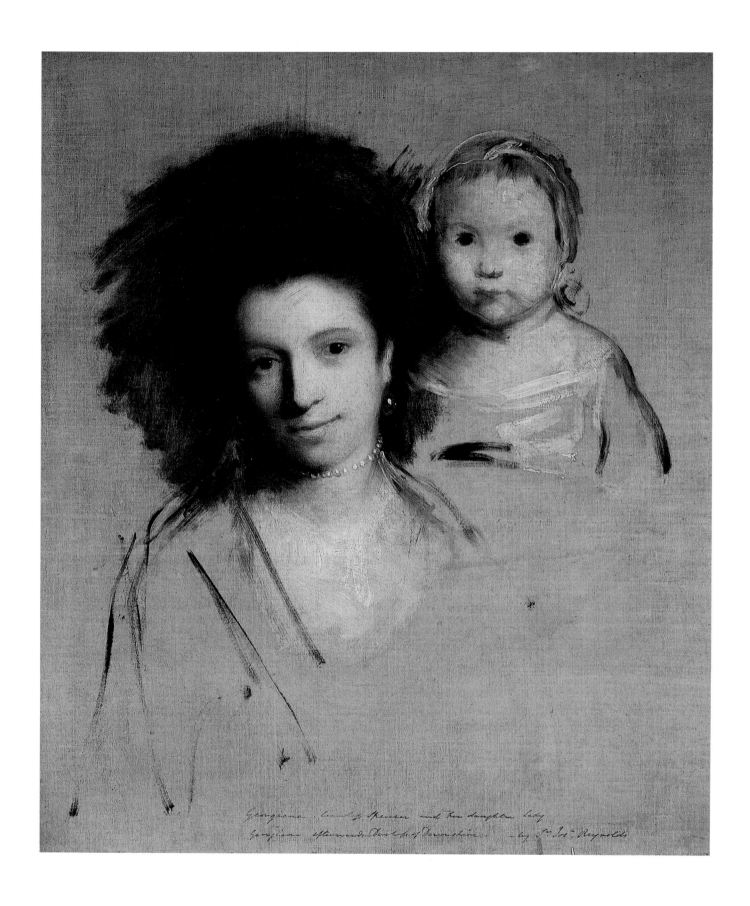

Georgiana Countess of Spencer and her daughter Lady
Georgiana afterwards Duchess of Devonshire. by Sr Jos. Reynolds

Childhood continues to be a subject of profound importance to modern society. The all too frequent occurence of child abduction or abuse striking a resonant national chord reminds us how much we as a society hold children to our hearts. At the same time, the nation's ongoing dialogue concerning child welfare, education, and problems of abuse reminds us of the continuing difficulty we have in defining the place of children in society, in caring for and educating them.

This book and the exhibition it accompanies explore the historical roots of the modern construct we call childhood in one time and place: Britain in the eighteenth and nineteenth centuries. Like our own, the period was one of dynamic change, both anticipated in and reflected by the visual arts. *The New Child,* in both book and exhibition, sets forth the evolving place of children in society and the arts. The links between art and culture emerge as indelible, while the visual material itself, from the sumptuous grand manner portrait to the diminutive children's book, is explored in terms of style and content.

The New Child sets up a paradigm for looking at visual material in a broader historical and cultural context. It continues the University Art Museum's strong tradition of presenting distinguished exhibitions that examine the role of art in the larger context of cultural analysis. *The New Child* helps celebrate the twenty-fifth anniversary of the University Art Museum as a vital presence on the Berkeley campus.

This exhibition is, however, the brainchild of one person, museum curator James Steward. Since joining the staff of the University Art Museum in 1992, Mr. Steward has created and organized a number of fine exhibitions, often combining an interest in aesthetics and social history. The New Child has grown out of his doctoral work at Oxford University and thus represents many years of research and analysis. We are delighted to share the fruits of his scholarship with our broader community in the form of this exhibition.

We are honored to have the patronage of Her Majesty Queen Elizabeth II's ambassador to the United States, Sir Robin Renwick. In addition, we wish to thank all of the lenders to the exhibition, especially those in Europe who have kindly allowed their works to travel so far and for so long. The participation of the tour venues has also been critical to the success of this project; I want to express my personal appreciation to Katherine Lawrence, acting director of the Dixon Gallery and Gardens, and Graham Beal, director of the Joslyn Art Museum, for their cooperation.

The exhibition could not have occurred without the important support of the National Endowment for the Humanities and the National Endowment for the Arts, federal agencies. We are grateful, too, for the support of the British Consulate-General for San Francisco, the British Council, Coopers & Lybrand, and Sotheby's New York as well as for the support of individual donors Phoebe Cowles, Kaalri and Douglas Grigg, Jane Restaino, Stephanie and Robert Rand, and Sharon and Barclay Simpson.

Sir Joshua Reynolds, 1723–1792, *Mrs. John Spencer and her daughter,* 1759, oil on canvas (unfinished), 30 × 25 in. (76.2 × 63.5 cm), Devonshire Collection, Chatsworth, reproduced by permission of the Chatsworth Settlement Trustees (plate 26).

Finally, I wish to thank the museum's board of trustees, whose ongoing support and heartfelt commitment to the goals of the museum continue to make projects of this kind possible.

Jacquelynn Baas
Director
University Art Museum and Pacific Film Archive
University of California, Berkeley

Acknowledgments

As I write, *The New Child* has now had a lifespan of over six years in one form or another, so there are inevitably many individuals and institutions to thank.

I owe special thanks to all the lenders to this project, many of whom shared with me their own knowledge of the works explored here. Research for this book and exhibition has been conducted with the generous financial support of Oxford University, Trinity College, Oxford; the Virginia Museum Foundation; and the Henry E. Huntington Museum and Library, which provided a much-needed residency during which the project came more fully into focus. Research was carried out in a number of places, and I would like to thank the staffs at each of the following: the Bodleian Library, Oxford; the London Library; the British Library; the Library of Congress, Washington, D.C.; the Huntington Library; the Yale Center for British Art; the Morgan Library; and the Doe Library at the University of California, Berkeley. A number of individuals have greatly strengthened my understanding of a rather unwieldy subject, most notably Francis Haskell, professor of the History of Art at Oxford University, and Brian Allen, director of the Paul Mellon Center for Studies in British Art. Others who have advised include Ann Bermingham, Susan Casteras, Patricia Crown, Carol Duncan, David Kunzle, Louise Lippincott, Mitzi Myers, Ronald Paulson, Aileen Ribiero, Allen Staley, Lawrence Stone, and Richard Wendorf.

At the University Art Museum, a number of staff members have been inextricably involved in bringing this project to fruition: Education Curator Sherry Goodman for her work on interpretive programs and for her enthusiasm for the project; Assistant Curators Kathy Geritz and Steve Seid at the Pacific Film Archive for designing an inspired series of film and video programs to accompany the gallery exhibition; Exhibition Coordinator Lisa Calden for undertaking the arduous task of physically bringing everything to Berkeley and for providing moral support; Designer Nina Zurier for designing a welcoming and appropriate gallery installation; Curatorial Assistant Eve Vanderstoel for devoting many months in support of every component of this project; and former Grants Writer Susan Avila, for her commitment to securing federal funding for this project. I have also benefited from the assistance of a number of talented research interns here at Berkeley, notably Jane Hyun and Elizabeth Schott. I owe a special thanks to museum trustees Jane Restaino and Barclay Simpson for believing in the project from the outset.

For the production of this volume I am most appreciative of the work of Ed Marquand and his staff at Marquand Books for designing a handsome volume; and of Paula Thurman's insightful and expert editing.

My thanks are also due to friends whose moral, emotional, and practical support has carried me through the years of working on this project, and whose friendship can never be adequately repaid: Gloria Eng, Jonathan Keates, Lewis Schrock, and most importantly Gerry Wiener. Finally, I dedicate this book to my mother, Carolee Steward, for helping me learn to look.

James Christen Steward
Curator
University Art Museum, Berkeley

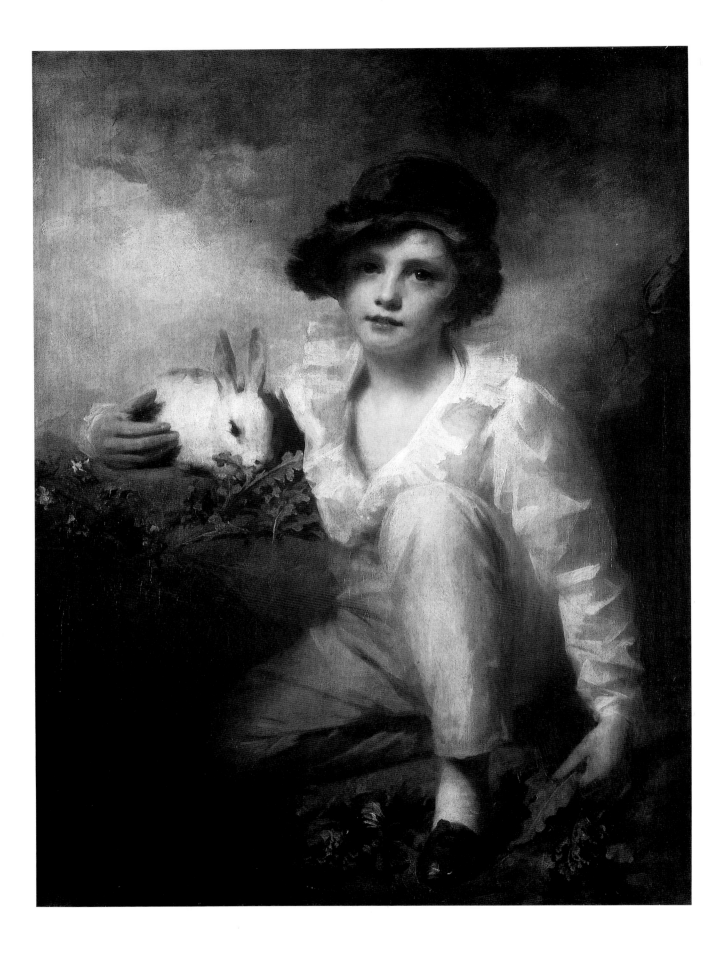

The goal of this study is to place the evolving representation of children and their families in Georgian Britain (strictly speaking, 1714 to 1837) in the context of their time—a context of remarkable change in Britain as government and society reorganized themselves in ways that we have come to accept as markers of the modern age. No less a participant and keen observer of this period than the diarist Joseph Farington described what he called "a change in the manners and habits of the people of this country,"[1] a watershed moment for Britain and its art which he situated around the year 1780. In our time, Ronald Paulson has described the eighteenth century in Europe as a period that marked the true end of the Renaissance,[2] with its idea of painting as moral philosophy, and the birth of the modern age, which began by narrowing its focus to humanly knowable "truths" (such as familial love, courage, or patriotism) and eventually created an idea of painting as primarily (or exclusively) a matter of paint on canvas.

Fundamentally, Georgian depictions of childhood and family life, far from being merely dextrous jottings of paint on canvas, seem to possess two descriptive purposes largely overlooked since Victoria's accession in 1837: to tell us about the character and relationships of the sitters and to tell us unsentimentally about the nature of childhood itself. This, first, suggests a certain complicity on the part of the Georgian viewer, a readiness to participate in the dialogue about the nature of the child, as a universal, and the child as an individual. Second, this demands that a distinction be made between the narrative and the descriptive, the former attending to action, the latter attending to the description of the observable surface of the world. In discussing Dutch art of the seventeenth century, Svetlana Alpers has argued that descriptive images that *appear* to dispense with a narrative mode still "were central to the society's active comprehension of the world."[3] With its move toward smaller-scale scenes that are domestic both in subject matter and in purpose, British art of the 1730s and then again from the 1760s is pleasureful and absorbed, like the subject of Alpers's study, with the *heimlich,* or the "home-like." Such images can be both narrative and descriptive, containing elements of storytelling about a particular sitter or sitters and about evolving societal values concerning children and families, while at the same time carrying descriptive bearers of meaning that tell us much about how Georgian society engaged the world. It is this idea, that Georgian images of childhood and the family can convey meaning, that has been largely devalued by past examinations.

The discovery of the narrative and descriptive in Georgian images of childhood raises a number of questions vital to our understanding of British art of the period. Were new artistic structures introduced? Were new private languages of meaning developed, and by whom were they understood? What happened to the role of moral, allegory, and allusion in the art of these years? Did artists of the time employ, subvert, or even ridicule traditional iconography? Were these bearers of meaning merely substitutions of new meanings for old ones? Who were the audiences for these works, and how knowledgeable were they? How much of the community possessed enlightened attitudes toward children and their representation at any given time? What was the

Sir Henry Raeburn, 1756–1823, *Boy and Rabbit,* 1786, oil on canvas, 40 × 31 in. (101.6 × 78.7 cm), Royal Academy of Arts, London (plate 44).

connection between works of art and social and political change? To these questions we can add Ernst Gombrich's desire to know the "programme" of the specific work of art which allows us to see what was possible within a given period and milieu: the details of the commission, the demands made by the patron, the attitudes of the artist, and the purpose the work was to serve.[4]

Questions such as these must be borne in mind when examining Georgian depictions of children and childhood for the social values and realities they describe. Previous studies of the representation of childhood have tended to fall into one of several traps: the superficial picture book examining only the decorative qualities of individual pictures without regard to context; the social history in which images are used as illustration without examination and without a fundamental understanding of how visual evidence differs from other documentary material;[5] and most recently social histories of art, and more specifically of portraiture, that have failed to understand how works depicting children differ from those of adults.[6] Similarly, traditional art history has denied Georgian portraiture and genre scenes their descriptive function, summarized in Randall Davies's observation that "if there is not very much of Sir Joshua's work that illustrates the manners and actions of people, there is still less of Gainsborough's."[7]

There is still the basic question of whether the meaning of child portraits and genre studies from two hundred years ago is accessible to us as viewers and critics working at the close of the twentieth century. Is the past retrievable? There are, of course, numerous natural limitations. Details of commissions can be lost, as can information concerning the original installation of paintings; the thoughts of individual artists or their patrons about childhood may have gone unrecorded. Happily, the eighteenth century was a time absorbed with the writing of letters and memoirs, no matter how publicly or privately the individual life may have been lived. Perhaps the greatest limitation is the lack of explicit linkages between specific images of childhood and larger social issues or discussions, the absence of recorded intentions for individual works of art. As the reader will discover, most of the images of children and their families explored in this study have left few written documents concerning their commissioning, intent, or early critical reception. Instead we must rely on a looser yet carefully constructed context, a tapestry woven of letters, diaries, statistical information, and the evidence of other works of art. Only by building this larger framework can we hope to understand whether an individual work of art or text was representative of a general attitude or merely an individual practice.

As Michael Baxandall has suggested in his incisive study *Patterns of Intention: On the Historical Explanation of Pictures,*[8] meaning for works of art from the past is on some level recoverable, although we must find a way to limit the *number* of possible meanings located in any single work of art. This can be done by understanding how significance changes with the age, how constructs of childhood are as context-specific as are the lives of individual sitters, how attitude can differ from practice. When placed in front of a child portrait by Sir Joshua Reynolds, for example, the generally sensitive viewer of today will almost certainly attach different meanings to it than would a visitor to the Royal Academy in 1770. Reynolds's *Cupid as Link Boy,* once its content is revealed to today's viewer, is likely to arouse ideas that would have been altogether

alien to habitues of Georgian London. It is here that the context of various eighteenth-century individuals—the artist, the patron, the viewer—becomes central in ascribing meaning and attempting to understand artistic transitions of the past.

Clearly the other questions concerning the representation of children and childhood in Georgian art cannot be treated so summarily. This study will use these questions as a guide in exploring views of the child in British art from about 1730 to 1830 and the new departures represented by some of these images. Throughout, it will be grounded in the distinction between a social history of *children* and a cultural history of *childhood,* cognizant of the difficulty if not impossibility of deducing a social history of childhood from documents left largely by adults. It will seek to place the visual material in historical, social, and literary contexts in order to understand what factors provoked these images to look as they do, the role the images in turn played in developing new constructs of childhood, and the powerful movements that compelled Georgian society to rethink the position of children in its world. It will thus combine an analysis of humane values with an analysis of the aesthetic values embodied in the works themselves to explain how it is that representations of children can be seen as a microcosm for Georgian artistic transformation.

Notes

1. Joseph Farington, R.A., *Memoirs of the Life of Sir Joshua Reynolds; with some observations on his talents and character* (London: T. Cadell and W. Davies, 1819), 65.

2. Ronald Paulson, *Emblem and Expression: Meaning in English Art of the Eighteenth Century* (London: Thames & Hudson, 1975), 8.

3. Svetlana Alpers, *The Art of Describing: Dutch Art in the Seventeenth Century* (London: John Murray, 1983), 236. She also suggests that most analytic tools in art history were developed for the study of Italian art, giving primacy to iconography and underlying verbal texts, whereas much art is less "narrational" than Italian art.

4. See Ernst Gombrich, *Symbolic Images: Studies in the Art of the Renaissance* (London: Phaidon, 1972), 6–7 and passim.

5. The social historian Linda Pollock (*Forgotten Children: Parent-Child Relations from 1500 to 1900* [Cambridge: Cambridge University Press, 1983]) accepts that visual evidence is different from other textual material, but then states her mistrust of it: "There is no reason why there should be any connection between the representation and that which is repre-

sented" (46–47). Instead of reflecting changing attitudes, changing images of children might be due merely to what she calls "technical improvements," such as learning to paint in three dimensions.

6. Typical of these problematic studies are, to cite only a few from the vast literature, Margaret Boyd Carpenter, *The Child in Art* (London: Methuen, 1906); Louis Hautecoeur, *Les Peintres de la vie familiale; évolution d'un thème* (Paris: Editions de la Galerie Charpentier, 1945); and Anita Schorsch, *Images of Childhood: An Illustrated Social History* (New York: Mayflower Books, 1979). Robert Rosenblum's *The Romantic Child: From Runge to Sendak* (London: Thames & Hudson, 1988) is a brief sketch that draws, to my mind, a number of unconvincing conclusions.

7. Randall Davies, *English Society of the Eighteenth Century in Contemporary Art* (London: Seeley and Co., Ltd., 1907), 46.

8. See Michael Baxandall, *Patterns of Intention: On the Historical Explanation of Pictures* (New Haven and London: Yale University Press, 1985).

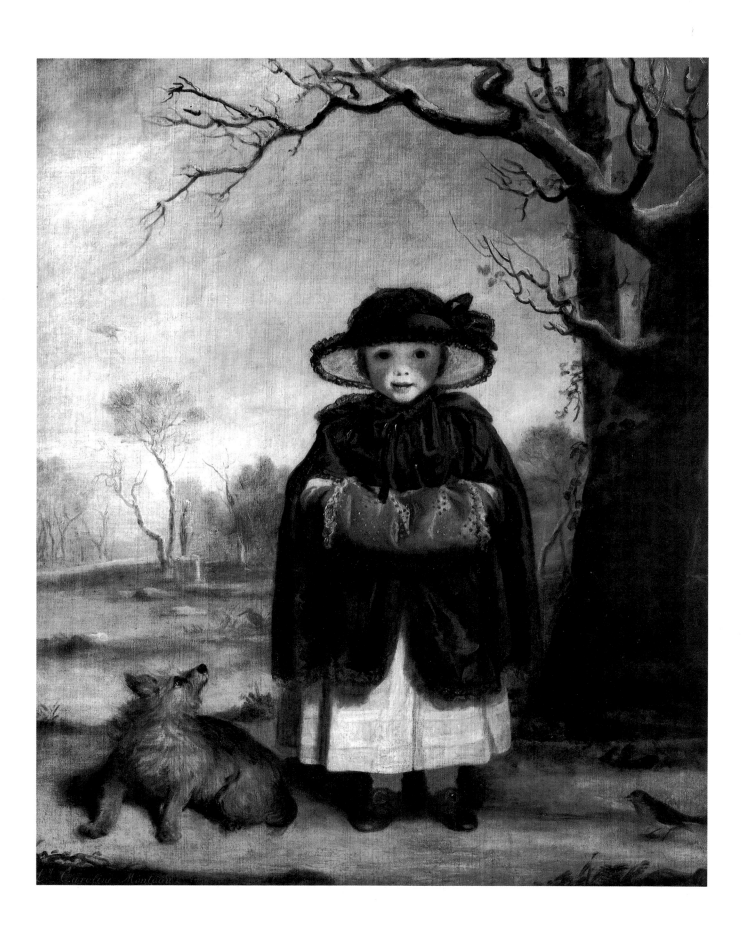

During the final two years of his life, from 1776 to 1778, the French philosopher Jean-Jacques Rousseau was occupied with writing *Les Rêveries du promeneur solitaire* as part of a long-term attempt to defend himself against his critics and justify the manner in which he had lived his life. In the ninth of the ten *Rêveries,* Rousseau, hoping to explain why he had placed his own children in a home for "found children" and to convince the reader of his love for them, describes his feelings for children in general. He states that he found the recompense for sacrificing his own children

> in the insights which these observations [of other children] helped me acquire about the first and the truest movements of nature, about which all our most learned men know nothing.[1]

When Rousseau wrote this in the winter of 1777 to 1778, he felt himself to be an old man, one so ugly as to be naturally repugnant to children. He had therefore, he says, given up spending time with children. He exclaims, with a grave feeling of regret:

> Oh! if I still had but for a few moments the pure caresses of the heart which come from a child still in his infant's coat, if I could still see in a few eyes the joy and contentment of being with me that I used to see so often—or for which I was at least responsible—of how much discomfort and unhappiness these short but soft tremblings of the heart would rid me! Ah, then I would not be obligated to search amongst the animals for the kindness which is now denied me amongst humans.[2]

If we doubt that by this Rousseau meant he actually preferred the "pure caresses" of children, or he found them more worthy, more "pure," we find that he attributed his progress in knowledge—or knowledge of human emotion—to watching them.

> If I made any progress in the knowledge of the human heart, it is the pleasure that I received in seeing and observing children which brought me that knowledge.[3]

For Rousseau, time spent with children, at least in his imaginings, was a kind of lost paradise, comparable in terms of his personal happiness with time spent with the first woman he loved or his stay on an idyllic Swiss island, although even more enlightening. But what of the divide, seemingly unproblematic for Rousseau, between what he wrote about children and his actual conduct toward his own children? This passes without comment.

 A similar rhapsody of children is found in the work of a number of prominent British writers. James Boswell, the great chronicler of Georgian London and biographer of Dr. Johnson, wrote in 1763:

Figure 1. Sir Joshua Reynolds, 1723–1792, *Lady Caroline Scott as Winter,* ca. 1777, oil on canvas, 55½ × 44 in. (141 × 112 cm), Duke of Buccleuch and Queensbury, courtesy of the Scottish National Portrait Gallery.

What Mr. Churchill calls *the grave triflers* are neither so wise nor so happy as he who can give his time and attention now and then to the rising sprouts of humanity and derive simplicity of feeling and gaiety of heart from children.[4]

William Wordsworth praised children in *The Prelude*, begun in 1798, and in the 1802 to 1806 "Intimations of Immortality from Recollections of Early Childhood," where he wrote of children as blessed—"The heavens laugh with you in your jubilee," "Heaven lies about us in our infancy." Wordsworth continues that in remembering childhood,

> Our Souls have sight of that immortal sea
> Which brought us hither,
> Can in a moment travel hither,
> And see the Children sport upon the shore,
> And hear the mighty waters rolling evermore.[5]

For Rousseau and Wordsworth, children and childhood at least philosophically hold specific virtues or characteristics not to be found in adults. By its nature childhood is regarded as distinct from the adult world and as offering unique insights to the adult onlooker—although, as his own practice showed, Rousseau did not necessarily wish to be with children for great lengths of time.

This view of the joys to be found in the companionship of children, written with an emotional appreciation for childhood knowledge, is remarkable enough for the late eighteenth century. Although many writers wrote of children from firsthand observation, few before Rousseau saw them as possessing insights beyond those of adults. Most saw them, if not as miniature adults, then at least as future adults, to be viewed through adult eyes. Differences between the child's world and that of the adult either most often passed without comment or were not seen as suggestive of any inherent superiority on the part of childhood. Yet what comes through most strongly in the work of Rousseau is a regretful melancholy concerning lost opportunity; in the work of Wordsworth, a romantic paean to the child at play in nature. What are we to make of the conflict between practice and theory, between the aged Rousseau's projection of certain feelings onto children and his actual conduct? How do we reconcile the disparity of Rousseau's or Wordsworth's constructs of childhood and the reality of the lived experience of children?

Rousseau's voice was not, of course, the only one to be heard concerning children in the 1760s and 1770s, nor did Wordsworth exist in isolation some twenty years later. Many of their literary and artistic compatriots in Britain in the generations before Wordsworth's also had much to say about the nature of childhood, the proper adult attitude toward the child, and the growing conception of childhood as a special period of life. As seen with Rousseau, the written word may be suggestive of a position that was taken but perhaps not so taken to heart as to be put into practice. This divide within the character of Rousseau, who is so often credited with the establishment of a cult of childhood and the natural child, hints at a much larger and ongoing debate about the very history of childhood itself. But is evidence for the history and discovery of children and childhood only to come from written sources, or can useful application also be made of the work of visual artists of the Georgian period? Did these artists perceive the child to hold characteristics specific to childhood in ways that distinguish their work from that of earlier—and indeed later—generations of artists? If so, how widely held does such a change in artistic attitude seem to have been? In what ways were traditional manners of representing children maintained? Do the visual images of children tell us something about the reality of children's lives other than what we can learn from the writings of authors such as Rousseau or Wordsworth? And most fundamentally, how does the visual record left to us convey changed and changing ideas? Were such artists actively engaged in transforming popular attitudes toward childhood? Or, to put the question another way, what is the relationship between the visual material and other sources of evidence for developing notions of childhood?

Questions such as these arise with even a cursory examination of the work of such well-known and oft-examined artists as William Hogarth, Sir Joshua Reynolds, Thomas Gainsborough, or Sir Thomas Lawrence. A glance at the visual material suggests, first, that a tremendous body of works concerned with children—alone, with other children, with animals, and in family groups—survives from the eighteenth century, and, second, that this number only grew as the Georgian period advanced into the age of Victoria. The mere evidence of a great number of such works need not arouse our interest in and of itself, for we can easily find large numbers of paintings with children in prominent roles at any time after the Renaissance. Further, painting of all kinds proliferated throughout the Georgian era, with the growth of the British art market, opportunities for public display of art, and so on.[6] A more thorough inspection of

the material will show that the number of works focused on children grew enormously in the late eighteenth century and that a large number of these works differ in nature from the paintings of children carried out both before and after. Examining these works and others in a more traditional mode will illustrate the extent to which they answered the same needs as the new philosophy, literature, and journalism of the period and the extent to which they played similarly didactic roles.

Like those used in many historical investigations, the dates used as endpoints in this study are both suggestive and defining. Artistically the British eighteenth century truly begins with the work of William Hogarth around 1730 and continues through the artistic watershed of the 1760s. This latter decade is marked by a number of events with far-reaching implications for British art and childhood, and indeed for the course of the arts in Britain for the next seventy years: George III, who was to play an important role as patron and, perhaps inadvertently, as trendsetter in the visual arts, ascended the British throne in 1760; Laurence Sterne began to write *A Sentimental Journey* and the German-born painter Johann Zoffany arrived in England in the same year; Rousseau's *Emile, ou de l'éducation* was first published in English in 1762; William Hogarth died in 1764; and the Royal Academy of Art was founded in 1768. The year 1830 marks not only political change in Britain and the European continent but also the rise of new questions concerned less with the dual issues of constructs and reality of childhood and more with the evocation of pure sentiment. Within the confines of this one-hundred-year period, no attempt will be made to force works of art into a deliberate pattern. Evidence of artists working before 1730 who held progressive views of the role and nature of the child will be presented as well as that of artists working throughout the eighteenth century who painted the child in traditional ways for traditional patrons.

The Child in Art: A Glance Back

Children have long played an important role in European painting, although this tradition generally lacked both a sophisticated sense of the individuality of the child and any real interest in the child's psychology or even experience as distinct from that of the adult.[7] At best the artist might strive to achieve a good likeness of a child sitter, but more often than not this was neither the case nor the goal. Precursors for many of the themes and issues to be

examined in this study can be found well before the eighteenth century, but for the most part these "anticipations" are the exception rather than the rule: a Renaissance painting in which a child is observed to behave in a truly childlike manner is the exception to the rule of the formal family portrait. Further, when rare precedent for an eighteenth-century scene of childhood can be found, the narrative interest is usually of a different nature; indeed, such narrative was not ordinarily for its own sake. Often, what is "new" about the "new child" in Georgian art is his prominence, his centrality, his emotive quality.

Before the eighteenth century the child's most frequent appearance in Western art is as the Holy Child in religious painting or as a putto in a variety of secular and religious works. Although the Madonna and Child afforded a way of representing the child in a family context, and the putti were an avenue to express delight in the behavior of infants, such representations usually carried symbolic meaning and consequently were of a different narrative quality and purpose, and were to be read differently, from works of portraiture or genre in Georgian Britain. Paintings of the Holy Family can scarcely be considered family portraits because they were understood to operate on another level, with a devotional purpose that transcended the presence or absence of interaction between the figures. In the cases in which a strong familial bond between the figures exists[8]—such as Leonardo's *Madonna and Saint Anne* (Louvre, Paris)—we must bear in mind that the multiple symbolic allusions carry greater weight than the simple narrative of a mother with her child. Similarly, the putto has allegorical allusions to antiquity as well as more purely decorative purposes, to which any reference to narrative or to an observed interest in children is subservient. Yet at the same time, the very fact that putti were not intended to be "real" allowed artists to express an astonishing variety of real aspects of children's lives through them. Both of these important traditions have different aims and ambitions than the works currently under discussion and fall outside the scope of this investigation. Where examples can be found of the child in art outside these two categories—Giorgione's *The Tempest,* for example, or certain paintings of great anecdotal interest by Bronzino—these are again exceptional cases rather than forming part of a larger artistic change.

Specific examples of true genre painting in which children play a central role[9] before the seventeenth century are scarce. In seventeenth-century France, we begin

to find a number of painted works in which the artists, such as Georges de La Tour or the Le Nain brothers, evince a legitimate interest in children per se, although it is still lacking in psychological individuation and centrality. Many works by the Le Nain brothers, such as Louis Le Nain's *Peasant Family* of about 1640 (Louvre, Paris), suggest an interest in the child within a family setting divorced from religious allusion. Scenes such as this depict the peasant family with monumental dignity and compassion, evolving from a tradition dating back to Pieter Brueghel the Elder. The children are observed naturalistically, but while they are highly "natural," they are largely anecdotal and are observed superficially, if sympathetically. The purpose of works such as this remains vague but probably does not imply any true compassion in a modern sense for the plight of the poor, for the painting does not truly reveal the world of the peasant child and certainly does not present this world from a child's perspective. More likely, it is a *divertissement,* a colorful diversion designed to appeal to the picturesque tastes of a privileged nobility. Interesting works by the seventeenth-century Spanish painter Bartolomé Murillo, such as *Two Peasant Boys* and *Two Peasant Boys with a Negro Boy* (both at the Dulwich Picture Gallery, London), also fall into the area of genre painting and were important to the eighteenth-century development of the so-called fancy picture, to be discussed in later chapters.

Of more immediate concern for this study are seventeenth-century Dutch representations of children, a subject explored in depth by scholars such as Simon Schama and Mary Frances Durantini.[10] This extraordinarily rich period witnessed a wide diversity of representations of children—in interior genre scenes, portraits, and works of a didactic nature. Perhaps the great Dutch innovation in depicting children was to present their earthiness. As Simon Schama states, "Dutch art did not invent the image of the mortal child, but it was the first culture to make it impolite."[11] As Schama and others have convincingly established, this development was made possible by the early growth in Holland of a mercantile middle class with the freedom, taste, and resources to patronize art forms produced especially for middle-class homes. A few works indicative of formats and issues of interest to eighteenth-century British artists illustrate this point.

In the important area of interior genre scenes with children, Pieter de Hooch's *A Boy Bringing Pomegranates* (Wallace Collection, London) is representative: the child is well observed, interacts naturalistically with an adult figure, and narratively and structurally bears as much weight as the adult in a scene elegantly composed of light and shadow. It is, unlike most works involving children painted outside Holland, believable as a slice of life, and the prominence of such scenes says much about the value placed by Dutch culture of this time on the domestic and the commonplace, on the presence of children within the daily routine.[12] Similarly, de Hooch's *Courtyard of a House in Delft* of 1658 (National Gallery, London) depicts a scene that includes a child whose presence is naturally observed—not the focus of the work but part of the life of the house. Although Sir Joshua Reynolds, writing in his 1781 *Journey to Flanders and Holland* was disturbed by what he saw as the "vulgar" nature of most Dutch art, the extent to which he and other British artists later borrowed from the tradition of Dutch genre painting will become clear.

One area of thematic importance in Dutch seventeenth-century genre painting is that of children depicted at play, with a full array of toys and games. Such works often carry uncertain moral messages and make unclear commentary on the prankish and willful nature of children; whether the artist intends complicity or judgment is not always evident. For example, Jan Steen's *The Eve of Saint Nicholas* (Rijksmuseum, Amsterdam) of 1660 to 1665 displays a typically wide range of narrative incident for an interior scene, focusing principally on the reactions of children to the gifts of toys, candy, and cake left for them, and even more especially on the reaction of one "bad" boy at the left of the canvas who has been given only a birch rod. The story is told with great relish as well as with great humanity. Other commonly portrayed subjects include scenes of women nursing children or rocking them in their cradles, a type of scene that previously had been restricted to images of the Virgin nursing the infant Jesus. These can be illustrated respectively by Pieter de Hooch's *Woman Nursing an Infant, with a Child* (De Young Memorial Museum, San Francisco) of 1658 to 1660 and *A Woman Lacing Her Bodice Beside a Cradle* (Gemäldegalerie, Berlin) of 1661 to 1663, in both of which the woman's nurturing role has a grandeur and secular beauty not seen before. In neither case, however, does the image have anything approaching a didactic quality.

We also find numerous Dutch family portraits in which children are prominently featured, such as Frans Hals's *Van Bereslyn Family* (Louvre, Paris), where the

children seem unaware that they are having their portraits painted. More remarkable are the portraits of children alone, such as Jacob Cuyp's *Portrait of a Child* (Collection of Sir John Plumb, Cambridge, England), an emblematic type of the "good" child as then perceived by the Dutch merchant class. An emblematic work in which the children hover between good and bad can be found in Judith Leyster's *Two Children with a Kitten and an Eel* (National Gallery, London), a comic painting suggesting with a certain degree of complicity the teasing and spiteful nature of children and a picture that can be seen as either portraiture or genre painting. Finally, there is the tradition of the child pastoral portrait, symbolizing ancestral ties to the land and securing the social status of the family through its connection with land ownership. In all of these works, Dutch artists have firmly rooted the child in the here and now, in a world in which death, particularly of the young and the old, played an extraordinarily powerful role. It is thus not unusual to find images (including portraits) referring to the death of children—a reality, it has often been suggested, whose widespread intrusion into family life may have encouraged parents of the seventeenth century to develop or maintain an emotional distance from their children lest they become too attached to such physically fragile creatures.[13]

The tradition of portraiture in which children are depicted is, of course, a broadly European one as well. From the early Renaissance we have examples of children in portraiture, although these are almost exclusively dynastic portraits in which the children represented are heirs to wealth and power, and in which the children are usually seen with one or both parents. The children serve as reminders of the parents', particularly the father's, successful insurance of the family line and title, especially in countries such as England, where laws of primogeniture dominated. Further, the figures of children in these portraits generally lack psychological and narrative interest, a narrative that is possible in multi-figure groups but denied in this format by the lack of interaction between figures. The artists choose, if anything, to capture the appearance of the sitters, the richness of clothing, accoutrement, and setting, rather than their character.[14] The children are rigid and immobile, scarcely individuated in their physiognomies from each other or from their parents. Of one such work, *Eleanora de Toledo and Her Son* by Agnolo Bronzino (Uffizi, Florence), H. W. Janson has written:

The sitter here appears as the member of an exalted social caste, not as an individual personality; [she is] congealed with immobility behind the barrier of her lavishly ornate costume. . . .[15]

Nothing is said of the children, or of the mother's relationship to them. Such a comment seems descriptive of most dynastic portraits: any familial affection between the sitters or narrative incident relating to the child is of decidedly secondary interest. There are, as before, exceptions—such as Giovanni Battista Moroni's *Portrait of a Man with Two Children,* or *The Widower,* of around 1563 to 1565 (National Gallery, Washington, D.C.), in which the artist is as concerned with portraying the sitters' inner spirituality as with rendering their simple costumes or physical appearances. This focus on spirituality once again denies the issue of individuality. François Clouet's so-called *Diane de Poitiers* (National Gallery, Washington, D.C.)[16] alludes to the sitter's role as a mother figure, but this work also stands out as exceptional within formal portraiture.[17]

The Eighteenth Century

For the eighteenth century in Britain, a basic cross section of painted works reveals some of the new questions faced by artists concerning children, the family, and constructs of childhood as well as their coexistence with traditional manners of representation. It will also enable us to begin to identify those issues in depicting children that are culturally specific to the Georgian period, and therefore socially driven, and to see with what diversity artists addressed these issues. Examples drawn from two-dimensional media, especially painting, will help formulate further questions to be addressed throughout this study and, by drawing on a number of artists, will circumvent for the moment questions of individual artistic personality and ability.

Portraiture

Especially when divorced from the family setting, many eighteenth-century representations of children exhibit an interest in candor and the observed "childlike" nature of children. These qualities are evident when the works of art are contrasted with those from earlier British artists. One such early work that may be taken as representative of its kind is Jonathan Richardson's *Garton Orme at the Spinet* (Holburne Museum, Bath) of about 1705 to 1708.[18] Working, like many of his contemporaries, in the tradition of Sir Godfrey Kneller, Richardson is somewhat

more expressive than his colleagues in at least attempting to convey a general feeling of childhood about his sitter, although he is severely hampered by portrait constraints of the time. The boy of about ten is dressed (in the demands of the convention) like a miniature adult and sits without movement, yet with a sense of childlike softness that is unusual for this date. In the next generation, William Hogarth's study *Horace Walpole* (private collection) of about 1727 to 1728 shows a boy of about the same age standing on a terrace pointing to a sundial that reveals his age and comments on the transitory nature of youth and life. The young Horace, approached by a disproportionately small dog, which he ignores, adopts the pose, costume, and body type of an adult. He stands on the terrace against a landscape background but almost seems to float; he is barely in the setting, let alone *of* it. Little other than the youthfulness of the face betrays the sitter as a child.

In the work of artists of the generation after Hogarth, images with a new spontaneity and freedom seem almost unrelated to those earlier works from Britain and abroad. One of the most remarkable of these is an early work by Thomas Gainsborough showing a far more marked interest in the personalities of the two sitters, *The Artist's Daughters Chasing a Butterfly* (plate 1) of about 1756. The painting exhibits a great sense of spontaneity, of being truly of the moment, as the two girls clasp hands and chase a butterfly, which inevitably eludes them. Here, Gainsborough, painting for himself without the restrictions of a patron, was entirely free to paint as he chose, to indulge his feelings for his own children, and to emphasize their fragility. Even the subject matter refers to the fleeting nature of life and, more particularly, of childhood—the butterfly that will escape their grasp, the flower on which it has landed that will fade. It is an interrupted scene, for the action that will follow will reinforce the idea of change and mortality. Yet the emblematic content, while still present, is subdued (the butterfly is indeed physically marginalized) to the sense of these two girls as vulnerable children to be loved, cared for, and protected. The composition itself is novel, pushing the two girls to one side, with only a small area of light color surrounding the butterfly to balance them. Mary's outstretched arm, the simplicity of dress, the bravura painting in the folds of their aprons, the hands clinging together, their more convincing insertion in nature—all of these elements combine to capture the true feeling of these two girls as genuine, fragile children caught in a single moment in time. Gainsborough seems to suggest that this childlike innocence and wonder will depart, never to return, and it is this impending loss coupled with the girls' vulnerability that reminds the viewer that this is the world of childhood as projected through the eyes of an experienced, even world-weary, adult.

Although this marvelous painting has little precedent (it was carried out a full six years before the appearance of Rousseau's influential tract *Emile, ou de l'éducation*), there are a number of striking parallels both in Britain and in France that are instructive about the importance of Gainsborough's achievement. The standard French child-portrait type of the eighteenth century, as seen in a work by François-Hubert Drouais such as the *Comte d'Artois and His Sister, Madame Clotilde* of 1763 (Louvre, Paris), shows the extent to which French child portraits were constrained by the lagging development of a mercantile middle class. Instead, French artists were more exclusively reliant on aristocratic and royal patronage than was the case for their British counterparts. Even when an artist like Jean Honoré Fragonard painted a work such as *The Two Sisters* of 1770 (Metropolitan Museum of Art, New York) showing two unidentified young girls, the children remain relatively undifferentiated. The hobbyhorse, as rigid as the two girls, is the sole concession to the world of childhood, for Fragonard's real subject still seems to be the surface movement of light on clothing and hair, the chiaroscuro effects of light and shadow on the girls, and the richness of texture and drapery.

These French types were certainly known to the more successful British painters of the day and formed a basis for comparison for the nascent British School still insecure about its own merits. Nowhere was this more true than in the case of Sir Joshua Reynolds, first president of the Royal Academy and the leading advocate for historical and international content to elevate portraiture to the Grand Style. Yet Reynolds was also capable of remarkable sensitivity to his numerous juvenile sitters, a fact that especially struck contemporaries because of the artist's childlessness. Reynolds's *Lady Caroline Scott as Winter* (figure 1) of about 1777 reveals the artist's ability to enter into the world of the child. Reynolds places the little girl near the center of the canvas, standing alone as an icon of vulnerability in a wintry landscape in order to arouse the sympathy of the viewer.[19] Framed by an overhanging tree and passing bird, Lady Caroline is accompanied only by a small terrier, which turns to look at her

and helps focus the viewer's attention, and a robin hopping about in the snow at the far right. Such creatures reinforce the idea that this is a child's innocent world, a world of nature, albeit one with allegorical meanings. These specific animals ally with Lady Caroline's femininity, just as the owl, a symbol of learning, and the spaniel, a sporting dog, do in Reynolds's portrait of Lady Caroline's brother Charles (figure 2). The power of *Lady Caroline Scott as Winter* for contemporaries is well described by Horace Walpole's reaction upon seeing the portrait in Reynolds's studio in 1776:

> But of all delicious is a picture of a little girl of the Duke of Buccleuch, who is overlaid with a long cloak, bonnet and muff, in the midst of the snow, and is perishing blue and red with cold, but looks so smiling and good-humoured, that one longs to catch her up in one's arms and kiss her till she is in a sweat and squalls.[20]

Again the artist has caught his child sitter at a single moment in her life, one in which she, like Gainsborough's daughters, is both fragile and vibrant, forthright and in need of protection. Clearly it is an image intended to appeal to adult sentiment, and Walpole has fallen into the artist's trap.

Reynolds further developed this kind of child portrait as a prototype of immense popularity. In works such as his *Master Hare* (plate 2) of 1788, the child now dominates the canvas and the natural setting. No longer vulnerable, the child is a symbol of confidence for the future —a confidence evident in Reynolds's pictures of girls as well as boys. It is to the artist's credit that here we forget that this is a child seen through adult eyes, for he is presented in his world without filters, without emblems. This shift in focus—to the child, to animals, to the natural setting—becomes characteristic of the most innovative painters of the late eighteenth century. Both Reynolds and Gainsborough underline the validity of this child's world, giving it descriptive elements appropriate to childhood, enlarging the child against the background setting, and excluding adult scale while still intending the painting for the appreciation of an adult audience.

In paintings of children with their families, a similar shift in attitude toward the family and the child's place within it is evident, with the child moving from a peripheral to a central position and inheriting greater narrative importance. Again, it is difficult to locate substantial works containing other than dynastic interest prior to the eighteenth century. Le Nain's *Portraits in an Interior* of 1649 (Louvre, Paris) provides an exception, depicting

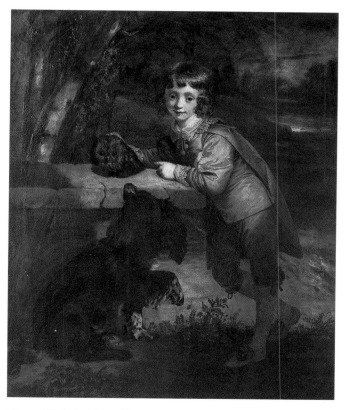

Figure 2. Sir Joshua Reynolds, 1723–1792, *Charles, Earl of Dalkeith*, ca. 1777, oil on canvas, 55½ × 44⅛ in. (141 × 112 cm), Duke of Buccleuch and Queensbury, courtesy of the Scottish National Portrait Gallery.

a French family group from a less privileged class than might be expected. Even so, the painting as a family portrait is about hierarchy. Seated on the right is the first of the three generations, an elderly man who looks placidly at his wife, behind whom stands a younger woman, perhaps an unmarried daughter. On the left is the next generation, the man who will take over as head of the household, with his wife and two children. These two girls stand stiffly, emotionally at a distance from the other members of their family. Although they do, as portraits, resemble children, they have none of the attributes we, as modern viewers, associate with childhood. Seated at the far left is a young boy in tattered clothing playing a pipe, probably a servant or apprentice, and thus a part of this middle-class (or, more strictly speaking, merchant-class) family. The hierarchy is clear: the painting's voice is that of the old man, whose wife is treated with respect and dignity as befits her age and the position of her husband. The following generation is placed only slightly farther down the scale. For the seventeenth century, this structuring of the generations, with no sense of individualized personalities, family interaction, or familial or conjugal love, may yet have been the representation of a merchant ideal in that it admits the concept of family society at all.

Family portraits of members of the wealthy and landed classes were important in Britain throughout the eighteenth century, underlining property ownership and family inheritance at the same time that they suggest a restructuring within the family. Many of these works, often in the newly developed genre of the "conversation piece" (see Chapter Three), have a stylistic connection with the tradition of royal portraiture, the outcome in part of the upper class's desire to affiliate itself with the monarchy (or its trappings) and to acquire superficially the gloss of familial permanence. In this genre, the aristocratic mode is adapted to the smaller "cabinet" rooms of great country houses as well as to the smaller rooms of lesser country houses and increasingly to the modesty of middle-class homes. One such painting is William Hogarth's 1732 portrait, *The Cholmondeley Family* (plate 3). Here, the adult members of an aristocratic family are seated or stand at the left of the painting behind a curtain drawn back by airborne putti—a common enough device —to reveal that the mother is already deceased (she died of consumption in France in 1731) and has been painted from memory. The father, Lord Malpas, is seated in a formal pose used in the seventeenth century for nobles and church dignitaries, imposing a hierarchical meaning on the painting. He looks sternly at his wife, who holds her right hand in front of a young child seated on the table between them. A second adult male stands behind the father. A severe mood prevails: there is no sense of movement or interaction among these figures, due in part to the solemnity appropriate to the wife's death. And yet, at the right of the canvas is a remarkable and altogether surprising scene of two boys playing. One boy stands on the seat of a chair and is about to step onto a precariously high stack of books, while a second boy rushes toward him, perhaps to prevent this false step. This arrangement of children seems to be without precedent, and the very independence of these two young figures, beyond the control of their parents or tutors, suggests a new meaning for the canvas.[21] The traditional hierarchy in which children are subjected to the father's will is being broken down, perhaps not unlike Hogarth's own troubled relationship as an artist to the aristocracy. Yet these children remain fixed and have no emotional or spatial relationship with the other figures in the painting. The only adult who observes their play is the standing male figure, but his face registers no expression. Even the dog, asleep at the bottom right, perilously close to the boy's prank, is unmoved by the activity above him. Although all the figures are rather doll-like, disproportions in scale between the children and the adults (even the child seated on the table has no baby fat and is depicted as a miniature adult) make it difficult for the viewer to accept these children as observed *real* children. What conditions or attitudes in society would have led the aristocratic Lord Malpas to accept a family portrait emphasizing childish play at the expense of his own authority? Could it be that the British aristocracy (or even British society in general) was already conditioned in 1732 to accept the concept of a separate world of childhood? Had patriarchal hierarchy ceded the field of the family to other concerns?

Sir Joshua Reynolds's monumental portrait *The Family of the 4th Duke of Marlborough* (plate 4) at Blenheim provides a number of interesting comparisons with *The Cholmondeley Family,* despite the tremendous difference of scale between the two works. Painted between 1777 and 1779, this enormous painting is an example of Reynolds's historical portraiture in the Grand Style, with quite conscious allusions to royal portraiture. The fourth Duke of Marlborough here assumes the same pose as Lord Malpas in Hogarth's painting, emphasizing the father's traditional role of authority within the family, while in reality the figure of the duchess dominates the canvas. Reynolds employs a number of other devices to undermine the duke, in more effective, albeit more static, ways than those used by Hogarth in his attempt to inject a moment of playfulness into an otherwise serious work and somehow unsettle the status quo. Reynolds subdivides the Marlborough family into three groups. The first is that of the fourth Duke and his eldest son, described by David Mannings as united "in the masculine world of classical collecting and connoisseurship,"[22] a highly prized vocation of eighteenth-century male nobility depicted in many of Reynolds's paintings, such as the *Society of the Dilettanti* (Society of Dilettanti, London). The duke emphasizes his bond with his son both by looking at him and by resting his right arm on his son's shoulder. The second group consists of the eldest daughter at the far right and the duchess in the center, with her commanding height, who serves as a link between these male and female worlds. She looks tenderly at her daughter while lightly touching her husband's sleeve with her right hand. The third group is made up of the three younger children playing with a mask in the foreground of the painting, an incident evidently based on something Reynolds saw the children doing in the family sitting-room at Blenheim.[23]

Unlike Hogarth, Reynolds successfully integrates the playful children into the life of the family through a complex series of gestures. He also distinguishes each child from the others, not just by painting their portraits but, more significantly, by emphasizing differences in personality: one child grins impishly at the viewer, delighting in frightening the second child who recoils against her eldest sister. One of the three dogs in the painting reacts to the mask, while the other two, balanced at left and right, also seem aware (perhaps through the first dog) of what is going on. A third small child, standing behind the mask, is only marginally involved in this playfulness and aligns himself with his father and brother by gesturing at them.

The tremendous change of scale has afforded Reynolds the possibilities of subtle differentiation between figures and a rich vocabulary with which to narrate family life denied in Hogarth's *Cholmondeley Family*. Allowing also for the vital distinction between public and private installation (the work by Reynolds was destined to hang in a public space at Blenheim) and for differences in painterly skill (Reynolds was primarily a portraitist while Hogarth was not), we can see that Hogarth and Reynolds shared a similar concern for questions of family structure and relationships, for the coexistence of the world of children within the adult power structure. Again, we must ask why the artists chose to and were allowed to portray these important families in these ways, subtly undermining the role of the fathers and working against an established hierarchy. How did the artists come to have this interpretive freedom in depicting children, and why did they choose to use this freedom in this way? How much did they participate in expanding the possibilities of representation?

The grandeur of the Marlborough group leads quite naturally to a consideration of the tradition of royal family portraiture and the special constraints that tended to exert a conservative influence on this area, such as the large-scale ceremonial portraits executed by Benjamin West in the 1780s. However, it is more revealing of attitudes toward the family and the new domestic taste at court to look instead at King George and Queen Charlotte's adoption of the conversation piece for many portraits of their family.[24] In its second wave of popularity, the genre's most talented practitioner was the German-born Johann Zoffany, whose conversation piece *Queen Charlotte with her Two Eldest Sons* (plate 5) of 1764 picks up many characteristics of painting from the 1740s and

then imbues them with extraordinary documentary interest. The queen sits rigidly at her dressing-room table,[25] her left hand placed on the head of a royal dog. Her eldest son, dressed in a Telemachus costume and carrying a spear, stands to her left in front of a clock, which tells us this is the time when members of the royal family received visitors, including their own children. The eldest son grasps the dog by its collar but, instead of directing his gaze at his mother, looks at his younger brother, who wears a Turk's dress. The dress of the boys is evidence both of the taste for the exotic common to the period, referring to the increasingly international role played by the British state and, by extension, of Britain's future monarchs, and at the same time of their status as children. The toy drum abandoned on a chair reinforces this status. The two boys are involved in playing dress-up —we even have documentary evidence of the arrival and first wearing of these costumes on 8 September 1764[26]— imitating the world of their elders and the enjoyment of fancy dress. Although the younger son leans on Queen Charlotte's knee, she does nothing to acknowledge his closeness, instead looking dispassionately toward her elder son. The queen is the largest, most central figure here, yet the focus is diffused throughout the scene, falling on the children's costumes, the vanity set on the table before the queen, the furniture, and the decor of the room, including the play of two mirrors reflecting each other. This diffuseness, in which the presence of the children is one component, has the effect of minimizing family relationships, in adherence with earlier traditions of the conversation piece (as seen in the work by Hogarth) and with their status as royals. It is significant that the king, the actual source of power, is not depicted, allowing the viewer to focus on the family unit without reference to the monarch's authority as is appropriate to a fundamentally private form of painting. It is a lush, formal portrait, rich in detail but without psychological depth, representing the lavish but withdrawn world of the royal mother and her children.

It is enlightening to contrast Zoffany's painting with the work of Anthony Van Dyck, since he was considered the greatest painter of royalty to that time in Britain and early viewers of Zoffany's works would have had Van Dyck in mind (in some cases literally, with canvases hanging next to those by Zoffany, Reynolds, and Gainsborough). The *Five Eldest Children of Charles I* of 1637 (The Royal Collection, Windsor), known to eighteenth-century artists including Hogarth, who seems to have

derived *The Graham Children* (plate 13) from it compositionally, is a more public portrait than the Zoffany and betrays a legitimate interest in the position (i.e., rank) of these children. Yet it omits the parents, focusing exclusively on the children and specifically on the eldest son and heir, thus emphasizing the painting's importance as a dynastic portrait. It is this son, the future Charles II, who will one day rule. Expression is almost negligible, for the artist is interested in the opulence of the setting, in likeness rather than character (the faces are rather generic), and gesture is largely ignored except for the two young children interacting with each other in the right background. The essentially rigid poses of the bodies, the detailed costumes, and the aloofness of the figures set a highly admired standard for portraits of royal children, influencing artists such as Zoffany more than a century later even as they sought a more informal solution to the portrait question.

Genre Painting and Fancy Pictures

Putting portraiture aside, it is not difficult to find examples of the child in art with emblematic value well before Gainsborough in 1756 or Reynolds in 1777.[27] In a typical work by the Antwerp-born painter Joseph Francis Nollekens (active in England after 1733), *Two Children of the Nollekens Family Playing with a Top and Playing Cards* (plate 6), the two children are part of a theme developed in the seventeenth century that was common to the Age of Enlightenment: the commingling of *vanitas,* or references to the fleeting nature of life, with the simple representation of children's diversions. In this painting of 1745, one child sits at the left in a low chair, her right arm raised in the air after pulling the string of a top to set it spinning. Her companion kneels behind a small table or footstool and reaches out her right hand to her friend, knocking down a house of cards. Both activities have clearly defined allusions to the passage of time, the fragility of life, and the transience of youth. Nollekens is thus working within a valued tradition, a tradition explored with great beauty and tenderness in France by his near-contemporary Jean-Baptiste Siméon Chardin. Meaning in this work, however, seems to be confined to emblem: the children's expressions are flat and distracted, the two do not truly interact with each other, and their games are purely symbolic rather than descriptive as the actual games of two young girls. Against this, Gainsborough's portrait of his daughters seems all the more touching and unusual.

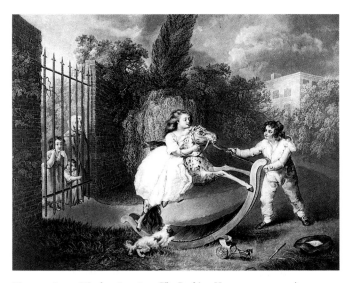

Figure 3. James Ward, 1769–1859, *The Rocking Horse,* 1793, engraving, 18 × 21⅞ in. (45.7 × 55.6 cm), Trustees of the British Museum.

A second genre study of children at play, James Ward's engraving of 1793, *The Rocking Horse* (figure 3), has utterly different interests. Two well-dressed children play with a rocking horse in a pleasant garden. Other toys, such as a small horse and carriage, are scattered around them, abandoned as their attentions have moved on to new games. A small dog joins in the gaiety. To the left, however, seen through the grille of a gate, two children and their mother watch these privileged children at play. The smaller of the two children at the gate looks at his sister with an expression of sadness and yearning, gesturing with one arm at the more fortunate children on the other side of the gate. The engraving is an uncharacteristic combination of children from different classes, an only slightly veiled critique of class disparity warning the viewer against the selfish frivolity and irresponsibility of the privileged, a theme with far greater social concern (and sentimental value) than the portrayal of *vanitas* in Nollekens. Children are the appropriate focus for they are impressionable, and their ideas and behavior may yet change to better accommodate the poor. Nollekens's painting may be emblematic but it is not didactic; Ward's engraving forgoes the emblematic quality and aims only to instruct, not to distract or to make a universal point about time that might be applied to rich and poor. It is not surprising that the earlier theme, so popular with artists such as Chardin, should have worn itself out by the 1790s. This move toward didacticism and sentiment will be examined in later chapters.

Turning to a second subject of genre painting devoted to children, that of children learning their lessons,

we find didactic elements in the work of numerous British artists of the Georgian period. At the same time, such elements are present—and have been well studied—in the works of French artists such as Chardin, who may have inspired the work of the French-born Philip Mercier, or the native-born Englishman Joshua Reynolds. At the Salon of 1740, Chardin, whose work was widely known in eighteenth-century Britain, exhibited *La Maîtresse d'école* ("The Schoolmistress," National Gallery, London), in which a child is depicted working at a small table with a young woman, probably a governess or, as suggested by Pierre Rosenberg, the child's older sister.[28] Our attention is drawn to the large pin with which the young woman points out the letters of the alphabet to her pupil. There is no background ornamentation, the only detail in addition to the two figures being the occasional table on which they lean. The figures are placed at a right angle to each other, ranged across the canvas in the friezelike way typical of Chardin's figure studies, a design that abstracts and universalizes the subject. Chardin sets up a contrast, even a gentle opposition between the child and the adult, emphasizing the child's attempt to concentrate while giving the young woman an expression blending concern with distraction. Even so, he makes little attempt to individualize the child, who exhibits no real behavioral traits that might be thought of as childlike. Only the young woman, with her round chin, the terse set of her lips, the condescension in her eye, receives this kind of attention. It is the interaction between the two figures, rather than a scrupulous rendering of detail or of portrait, that attracts the artist and the viewer. Still, like other works by Chardin, it is an outstanding document for its time.

When Sir Joshua Reynolds takes up the theme of the child learning, as he does with the *Boy Reading* (private collection) of 1747, he paints the child without an accompanying adult figure. Like the work by Chardin, which Reynolds may have known from trips to Paris in 1768 and 1772 or from contemporary engravings, *Boy Reading* depicts a child's absorption in and distraction from a book at a time when more and more children from more varied economic backgrounds were learning to read. Reynolds's boy, seated at a table with several books before him, seems lost in thought, looking beyond the book he meant to be reading. It is a shadowy study, derived from works by Rembrandt van Rijn, more evocative than detailed. At the same time, it moves beyond the emblematic quality of the Chardin and possesses more psy-

chological insight, more involvement in the sitter's identity as a child. While both the Chardin and the Reynolds seek to amuse and divert the viewer, the two artists betray different degrees of interest in the individual child and in the value of direct observation. In this way, *Boy Reading* clearly looks forward to some of Reynolds's most original work, his so-called fancy pictures.

The fancy picture gave free rein to the artist's imagination (or fancy) and allowed him to depict *types* of children who would never have been the subject of traditional portrait commissions. Such works are exceedingly rare before the middle of the eighteenth century, and their emergence in Britain can be traced to the work of the French immigrant artist Philip Mercier. Nevertheless, related protoypes can be found in the work of artists such as Chardin, as we have seen, or the Swiss-born painter Alexis Grimou, as in his *Young Pilgrim Girl* of 1726 (Uffizi, Florence). Grimou was largely self-taught by looking at the work of Rembrandt and Van Dyck, and the influences are evident in this small painting of a girl in simple dress holding a staff in her right hand. The artist's primary concern is the Rembrandtesque use of chiaroscuro—the pale glow of the girl's skin set off against the somber background shadows—but he does nothing to exploit the imaginative possibilities of the fancy picture. Instead, the inclusion of the iconic scallop shell and staff suggests an identification of the girl with Saint James da Compostella (Saint James the Greater), the patron saint of pilgrims, which gives the work religious or emblematic reference points. Although narrative detail can be found in late eighteenth-century fancy pictures, it is rarely of a religious nature. In this work Grimou has allied himself with the more traditional confines of Christian art, choosing not to explore the position of this girl—is she happy or sad?—or to individualize her, so she can only distract us but do nothing to move us.

Thomas Gainsborough's *Cottage Girl with Dog and Pitcher* (plate 7) of 1785 is, by contrast, the epitome of the artist's sentiment. One of his finest fancy pictures, it portrays a young barefoot girl in ragged clothing standing framed by a clump of trees to the left and a bright cloud to the right, thus enveloped by nature. She carries a small dog on one arm and a broken pitcher in her hand. Her wistful, downcast expression implies that she knows the misery of her condition. The pitcher, the dog, the tattered clothing, and the girl's posture are descriptive as well as narrative, suggesting a story for this poor country

girl while raising many questions. How was the pitcher broken? Where is she headed down this lane? Subjects such as this, like Jean-Baptiste Greuze's contemporary paintings of young girls in France, often refer to the girl's path in life, the broken pitcher a symbol of the impending (or actual) loss of her virginity. The painting thus offers the potential for titillation to the viewer, a second narrative level that speaks both to the girl's situation as sexual victim and to the adult viewer's construct of child sexuality. Whether or not we read this as moralizing is a question of positioning. In the absence of Gainsborough's stated intent, can we discover whether contemporary viewers favored the sentiment or the titillation? Certainly Gainsborough has focused on the girl's bearing and expression to achieve a mood of pathetic sadness, an emotional intensity that contrasts markedly with many of his commissioned portraits.

The purpose of such a work, particularly when compared with a fancy picture from the 1720s, is difficult to determine. It is often suggested that paintings such as Gainsborough's *Cottage Girl* were intended merely to amuse the upper classes by reinforcing their own sense of happy superiority and showed a complete failing of moral commitment on the artist's part. Yet there is surely more here than a fashionably picturesque presentation of a country child, for Gainsborough has carefully rendered the tattered state of her clothing, her skin is dirty rather than clean. Is she perhaps a hesitant precursor to the evocation of class disparity seen in the James Ward engraving, creating the contrast between well-to-do viewer/patron and indigent child sitter? Does this not raise the issue of the relationship of power while (or perhaps *by*) safely distancing the child from the adult viewer? The nature of sexual attraction or titillation is made altogether different by separating the girl's economic position from the viewer's. Clearly a number of complex issues, suggesting the divide between constructs of childhood and the reality of a child's life, have motivated this sensitive portrayal of a poor rural waif.

Equally complex are the fancy pictures of Sir Joshua Reynolds, most notably his *Cupid as Link Boy* (plate 8) of 1774. Here a young boy in worn clothing has been given wings—wings that ally him with classical antiquity and thus with the long tradition of classically derived paintings in Western art and the safe, if suggestively romantic or erotic, depiction of the child Cupid. This boy looms monumentally against a background of buildings low on the horizon in a strikingly original composi-

tion. Even more so than in the portrait of Lady Caroline Scott, the child is almost unnervingly close to the viewer, giving him greater immediacy and intensity than the typical adult figures of contemporary paintings. There is a clear shift in scale here toward that of a child's world, underlined by a dichotomy between near and far, between enclosure and freedom—dichotomies to be taken up by the Romantic movement.

Visual structure aside, it is the subject of Reynolds's *Cupid as Link Boy* that is most provocative. The link boy of the title refers to the role of this boy as a torch-carrying guide for pedestrians making their way through the dark city streets of eighteenth-century England. Notorious both as thieves and for sexual exploitation, link boys were often affiliated with the plying of the prostitute's trade.[29] Reynolds intends on one level to elevate the subject by the association of the link boy with the classical god of love, yet the allusions are also reasonable descriptions of an actual link boy—he carries a phallic-shaped torch, he makes a lewd gesture with his arm, and a pair of cats mate on the rooftop at the far left. Such narrative elements make a strong commentary (intended or not) on the degradation of love since the time of classical and Renaissance cupids, or the frolicking cupids of the Rococo period. At the same time, they are evidence of Reynolds's fascination with the complex nature of the child—his capacity for evil and satisfying the carnal—even in a child seemingly aged no more than five or six. Again the adult viewer is confronted with the sexual subject matter. The link boy is a kind of urban counterpart to Gainsborough's cottage girl. Surely this is the first time the sexual nature of a very young child is examined in mainstream British art. In this light, *Cupid as Link Boy* makes an important contribution to complex depictions of children and childhood, and to understand this contribution we must ask what societal conditions and attitudes made such an image possible, who its intended audience was, and how this view could have coexisted with Rousseau's construct of the innocent child of nature —questions that will be addressed later in this study.

In the variety of works drawn from portraiture, genre painting, and fancy pictures discussed thus far, most have precedents, however distant, in the European tradition. Some of these works show striking changes in attitude toward children and methods of representing them in the years after 1730, while others follow quite naturally on earlier portrait traditions. Although these earlier traditions and their adherents in Georgian Britain

were perhaps most concerned with an often oppressive patriarchal authority, in the years after 1730 we find children everywhere—making music, sketching, riding, playing cricket, touring, picnicking with their parents— sharing with their parents, in J. H. Plumb's words, "the pleasures of the mind, the body and the heart."[30] Indeed, many of these activities were themselves new, made possible by the growing affluence of the middle class and its indulgence in pleasure. This diversity of imagery suggests not only a nascent artistic interest in the lived experience of children, in how real children spent their time playing, learning, and even working, but also a complex relationship of complicity, projection, and domination between adult painter/viewer and child subject.

In examining the corpus of child imagery from Georgian Britain, a number of subjects exist for which there is *no* adequate precedent in British or Continental art. These fall largely in the area of moralizing genre painting, works intended to teach their viewers specific values and attitudes and which show the artist to be truly engaged in the ongoing dialogue about children and childhood. One of the most significant of these images is George Morland's *A Visit to the Child at Nurse* (plate 9) of about 1788, which reveals the moralizing concerns of this artist some twenty-five years after the publication of Rousseau's *Emile*. Morland shows a mother visiting her child. The infant clings to its wet nurse, afraid of its unknown natural mother, as two other small children look on. The setting is of documentary interest, revealing the wet nurse as having other charges or possibly her own children, yet she is still able to establish an emotional bond with the privileged baby she holds.[31] Placed in the context of Morland's other works on social themes and the challenges to wet nursing and traditional education being raised by Rousseau and others, we see that Morland is here describing and indeed criticizing the social pretensions of the mother and the hollowness of her values which have allowed her the luxury of emotion without the responsibility. Accepting, then, that Morland's painting and popular engravings after it were designed to change the viewer's attitudes, how prevalent were these attitudes in the first place? Did Morland and others succeed in bringing about change, or were they merely reflecting changes already in progress?

Although there is no precedent for this painted subject in Britain, Morland and other painters of moralizing child subjects were scarcely operating in a vacuum. Its lesson, and the concept of advocacy painting, is closely related to an emerging movement in France, seen in works such as Greuze's famous *La Mère bien-aimée* ("The Well-Loved Mother," Laborde Collection, Madrid). Here a mother is inundated by the love of her six children while her husband and mother look on the scene with affection. The compositional movement is entirely toward the mother in what Anita Brookner has called "a tidal wave of family happiness."[32] It is beyond question that Greuze intended the contemporary viewer to derive a lesson from this work, one that prophesied the rewards to be obtained by being a "naturally" devoted mother. Is this what the remarkable Frenchwoman Elisabeth Vigée-Lebrun and numerous English artists had in mind when they painted not just genre scenes but family portraits? Another French contemporary, Etienne Aubry, gives us the paternal equivalent in his *L'Amour paternel* ("Fatherly Love," Barber Institute of Fine Arts, Birmingham), of 1775. In this convivial family scene in a lower- or middle-class setting, the subject is the reward to be reaped by the devotion of a good man to his children. The central device is a small grinning child reaching up to embrace his father while two other small children, their mother, and grandfather look on happily. From the cat sleeping on the chimneypiece to the colors used by Aubry, all in this scene is harmonious and calm. Both the Greuze and the Aubry were engraved and widely sold, in Britain presumably as well as in France. All three works reflected a sudden and unprecedented upsurge of appreciation in late-eighteenth-century Britain for works devoted to the subjects of the happy family, the education of the child, nursing, the instilling of moral values, and similar themes of childhood. The reasons behind this appreciation and the relationship between the visual evocations of Georgian childhood and social change form the focus of this study.

Plates

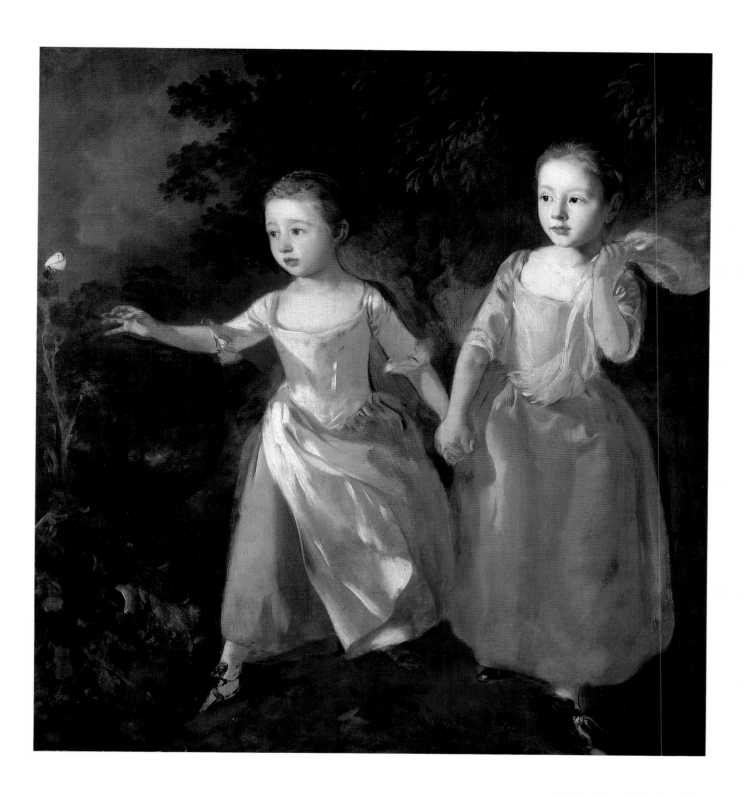

Plate 1. Thomas Gainsborough, 1727–1788, *The Artist's Daughters Chasing a Butterfly,* ca. 1756, oil on canvas, 49¾ × 41¼ in. (126.4 × 104.8 cm), The Trustees of The National Gallery, London.

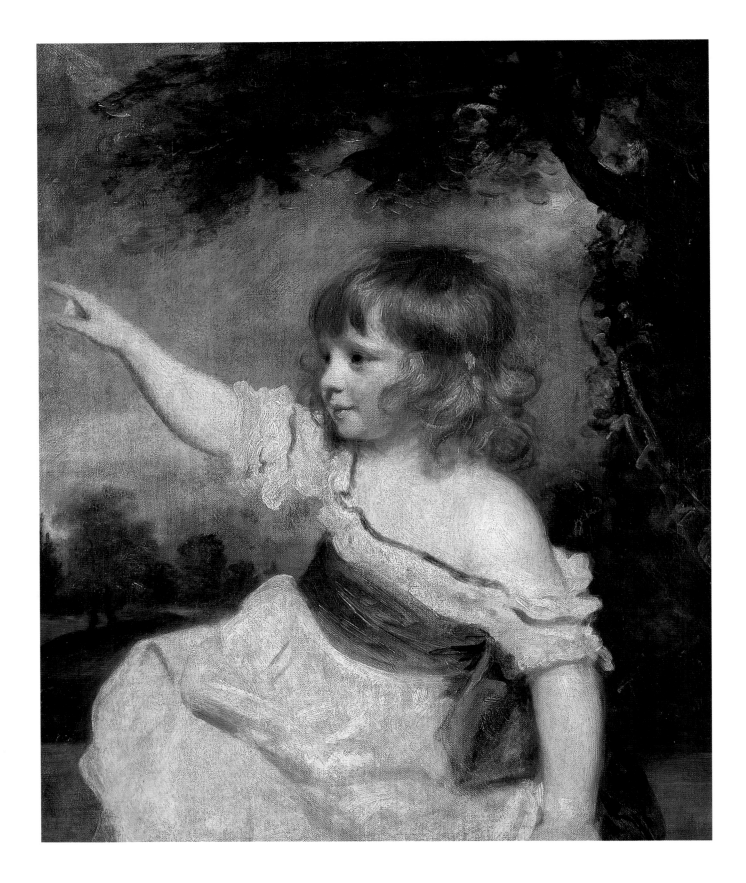

Plate 2. Sir Joshua Reynolds,
1723–1792, *Master Hare,* 1788, oil on
canvas, 30⅜ × 25 in. (77.2 × 63.5 cm),
Musée du Louvre, département des
Peintures.

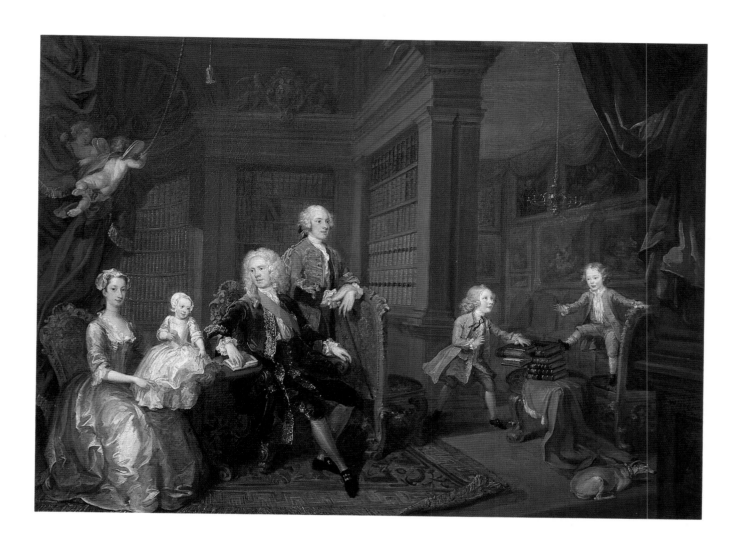

Plate 3. William Hogarth, 1697–1764, *The Cholmondeley Family*, 1732, oil on canvas, 26½ × 35½ in. (67.3 × 90.1 cm), Private collection.

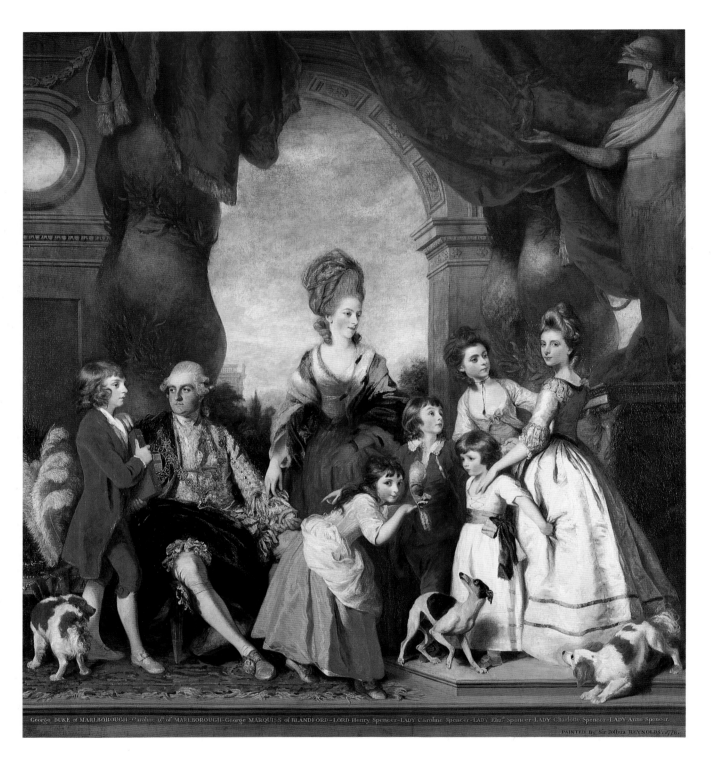

George DUKE of MARLBOROUGH-Caroline D.ss of MARLBOROUGH-George MARQUISS of BLANDFORD-LORD Henry Spencer-LADY Caroline Spencer-LADY Eliz.th Spencer-LADY Charlotte Spencer-LADY Anne Spencer.

PAINTED By Sir Joshua REYNOLDS 1778.

Plate 4. Sir Joshua Reynolds, 1723–1792, *The Family of the 4th Duke of Marlborough* (Red Drawing Room, Blenheim Palace, Oxfordshire), 1777–79, oil on canvas, 125 × 113¾ in. (318 × 289 cm), reproduced by kind permission of His Grace The Duke of Marlborough.

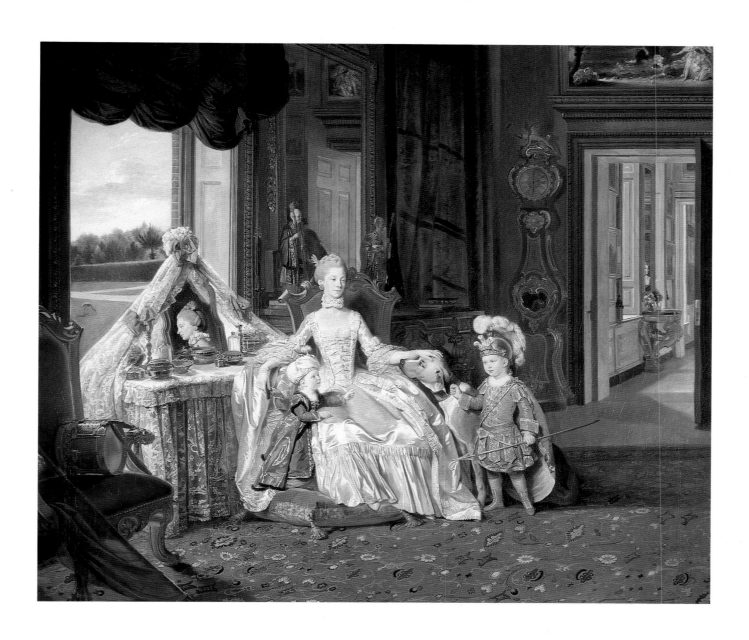

Plate 5. Johann Zoffany, 1733–1810, *Queen Charlotte with her Two Eldest Sons*, 1764, oil on canvas, 44¼ × 50⅞ in. (112.4 × 129.2 cm), The Royal Collection, © 1994 Her Majesty Queen Elizabeth II.

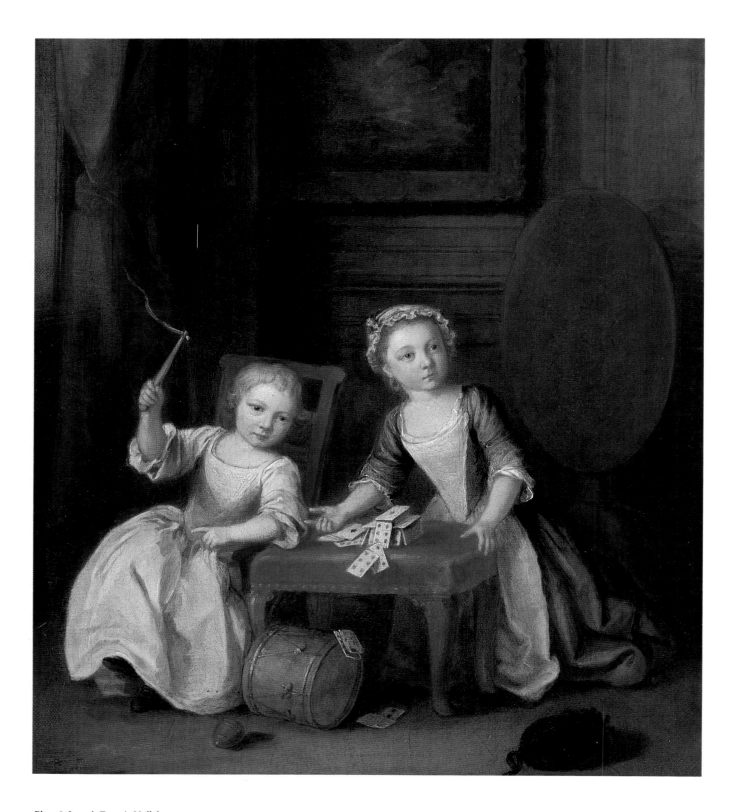

Plate 6. Joseph Francis Nollekens,
1702–1747/48, *Two Children of the
Nollekens Family Playing with a Top
and Playing Cards,* 1745, oil on
canvas, 14⅛ × 12¼ in. (36 × 31 cm),
Yale Center for British Art, Paul
Mellon Collection.

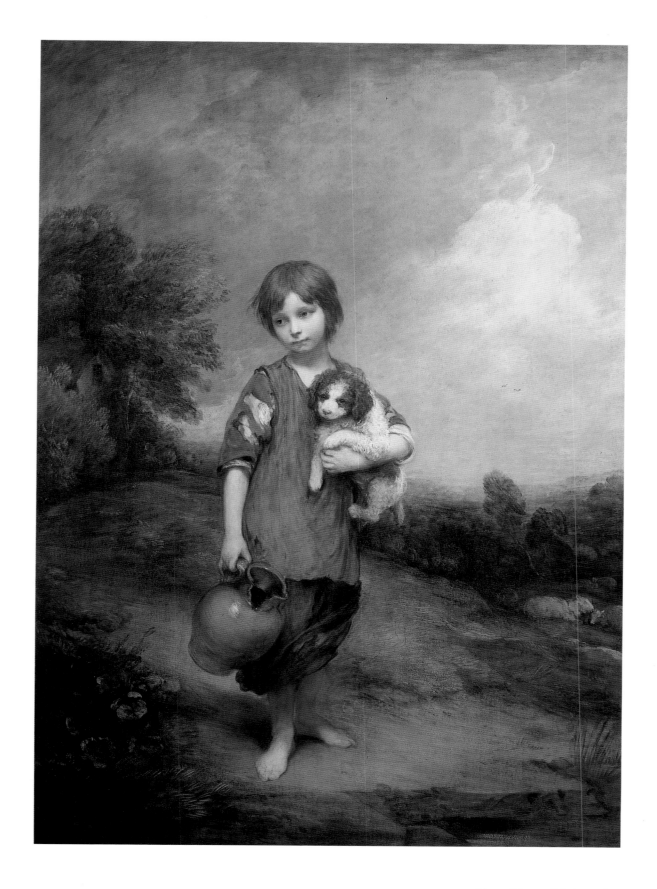

Plate 7. Thomas Gainsborough, 1727–1788, *Cottage Girl with Dog and Pitcher,* 1785, oil on canvas, 68½ × 49 in. (174 × 124.5 cm), National Gallery of Ireland.

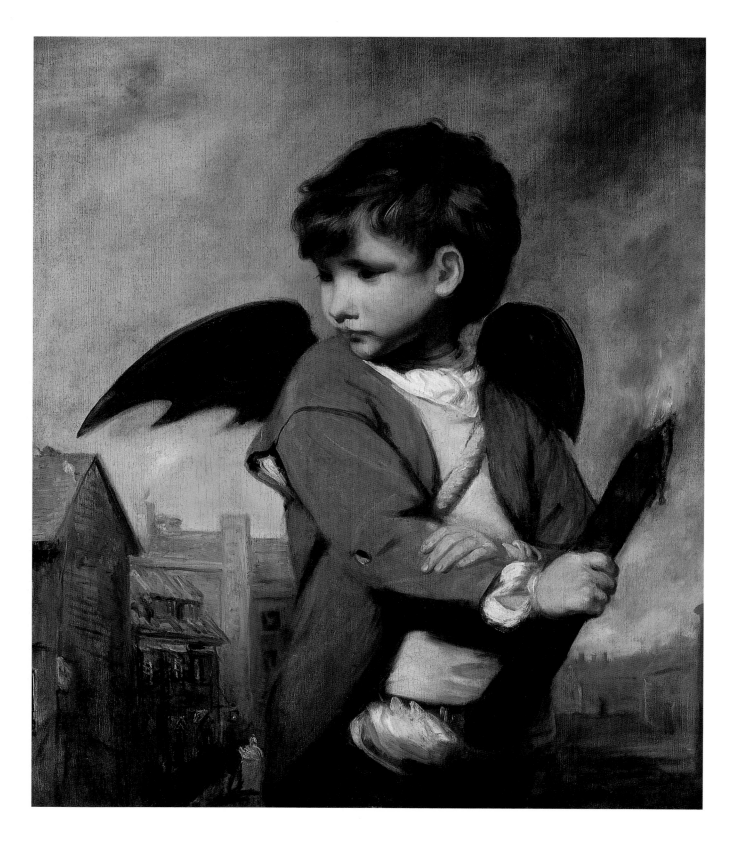

Plate 8. Sir Joshua Reynolds,
1723–1792, *Cupid as Link Boy,*
1774, oil on canvas, 30 × 25 in.
(76.2 × 63.5 cm), Albright-Knox
Art Gallery, Buffalo, New York,
Seymour H. Knox Fund.

Plate 9. George Morland, 1763–
1804, *A Visit to the Child at Nurse,*
ca. 1788, oil on canvas, 24¼ × 29½
in. (61.6 × 74.9 cm), Syndics of the
Fitzwilliam Museum, Cambridge.

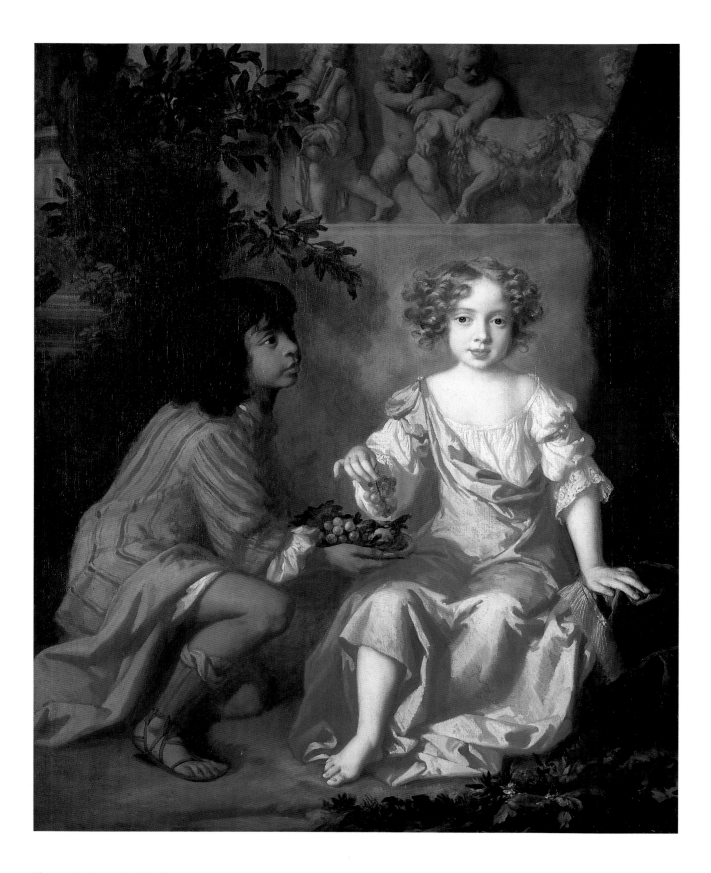

Plate 10. Sir Peter Lely, 1618–1680,
Lady Charlotte Fitzroy, ca. 1674,
oil on canvas, 50 × 40 in. (127 ×
101.5 cm), York City Art Gallery
(presented by the National Art-
Collections Fund).

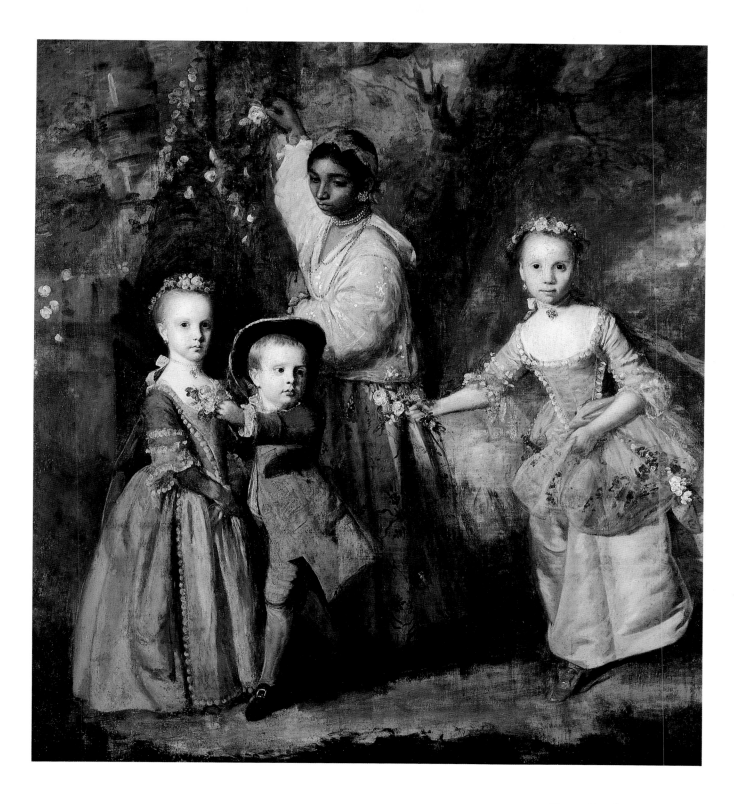

Plate 11. Sir Joshua Reynolds, 1723–1792, *The Children of Edward Holden Cruttenden with an Indian Ayah,* 1759–62, oil on canvas, 70⅞ × 67¾ in. (180 × 172 cm), Museu de Arte de São Paulo.

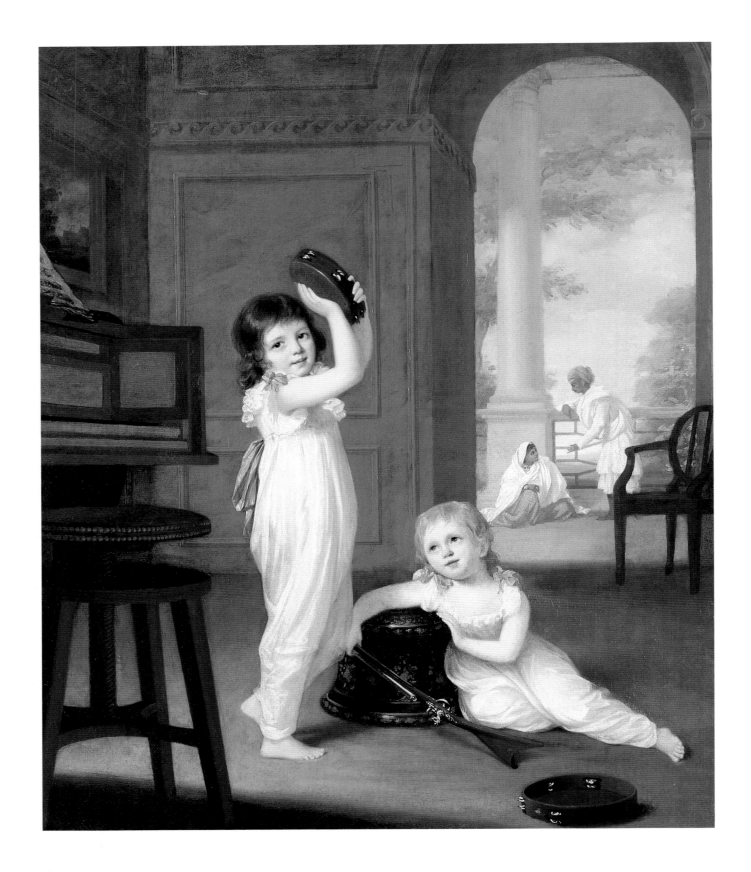

Plate 12. Arthur W. Devis,
1762–1822, *Emily and George Mason
with their Ayahs,* ca. 1794–95, oil on
canvas, 39 × 42½ in. (99 × 108 cm),
Yale Center for British Art, Paul
Mellon Collection.

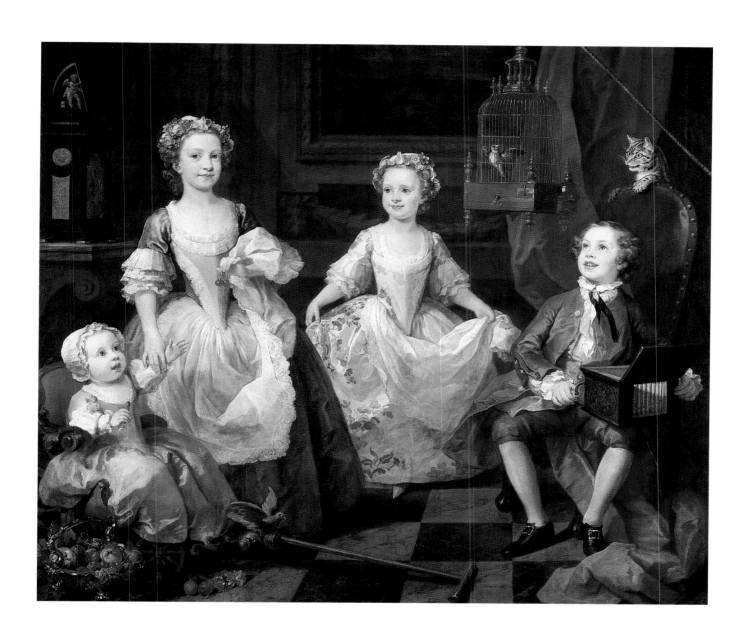

Plate 13. William Hogarth, 1697–1764, *The Graham Children*, 1742, oil on canvas, 63⅛ × 71¼ in. (160.3 × 181 cm), The Trustees of The National Gallery, London.

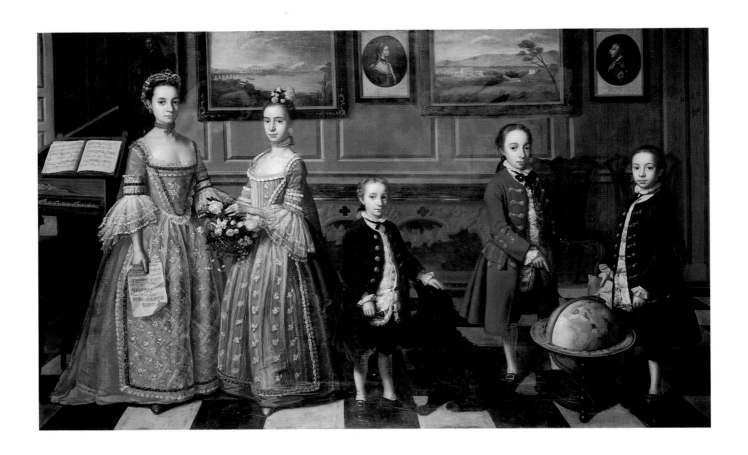

Plate 14. Strickland Lowry,
1737?–ca. 1785, *The Bateson Family,*
1762, oil on canvas, 64⁷⁄₁₆ × 104 in.
(163.7 × 264 cm), Ulster Museum,
Belfast.

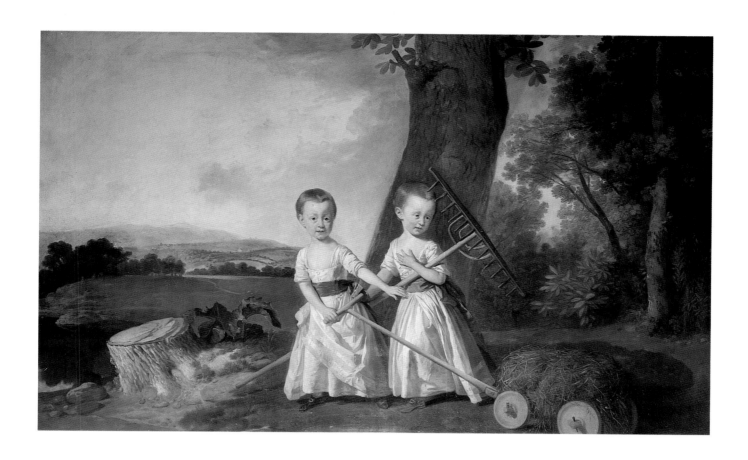

Plate 15. Johann Zoffany, 1733–1810, *The Blunt Children*, 1768–70, oil on canvas, 30¼ × 48¾ in. (76.8 × 123.8 cm), Birmingham Museums and Art Gallery.

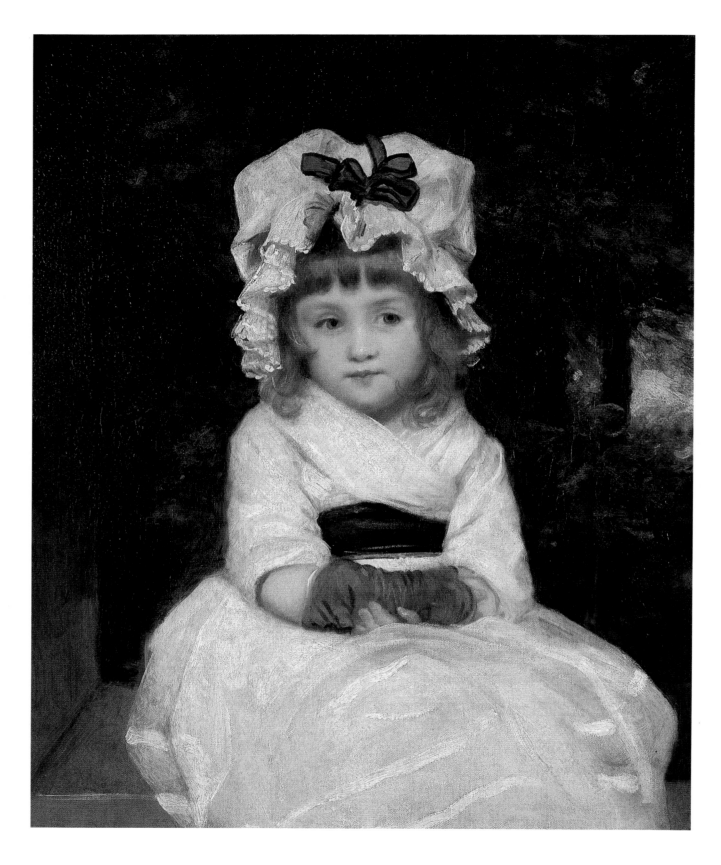

Plate 16. Sir Joshua Reynolds,
1723–1792, *Penelope Boothby*, 1788,
oil on canvas, 29½ × 24⅜ in. (74.9 ×
61.9 cm), Private collection,
courtesy of the Visitors of the
Ashmolean Museum.

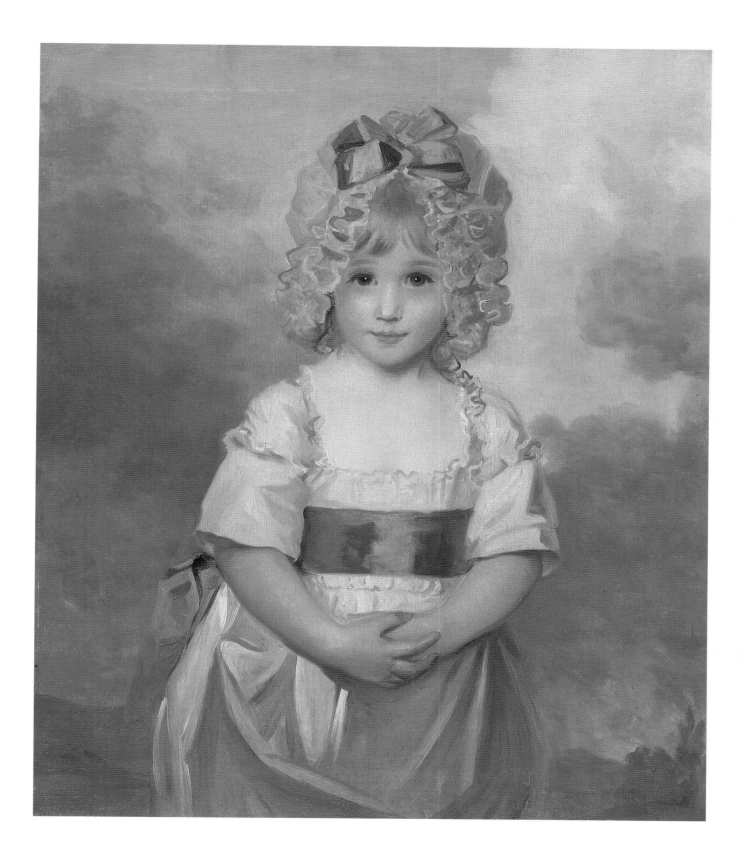

Plate 17. John Hoppner, 1758–1810,
Miss Charlotte Papendiek as a Child,
1788, oil on canvas, 30 × 25 in.
(76.2 × 63.5 cm), Los Angeles
County Museum of Art, William
Randolph Hearst Collection.

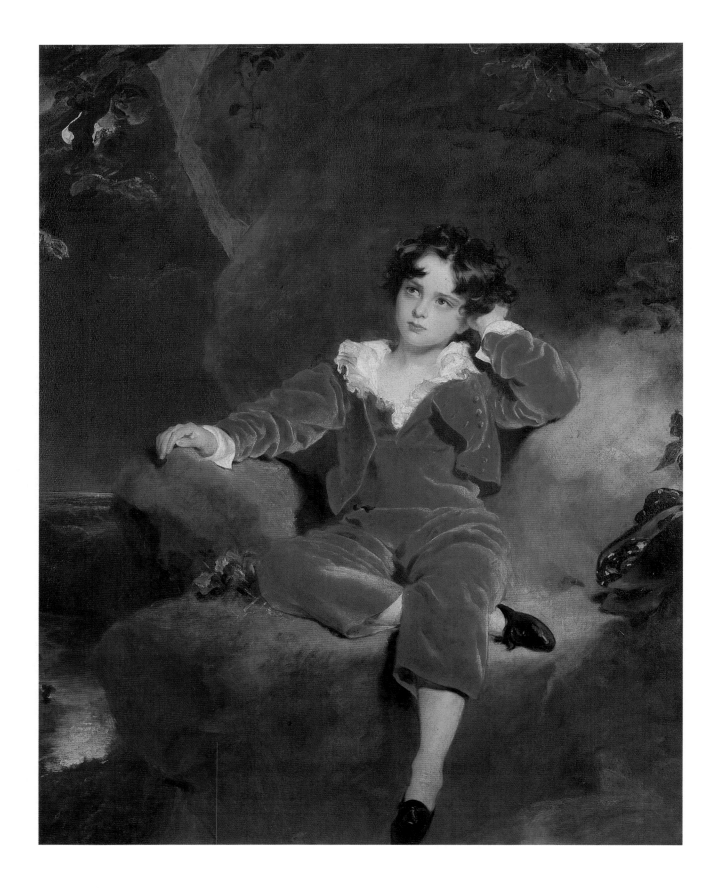

Plate 18. Sir Thomas Lawrence,
1769–1830, *Charles William
Lambton*, R.A. 1825, oil on canvas,
55½ × 43⅜ in. (140.9 × 110.2 cm),
Trustees of the Lambton Estate.

Plate 19. Allan Ramsay, 1713–1784, *Sketch of a Dead Child,* 1743, oil on canvas, 12⅝ × 10¾ in. (32 × 27.3 cm), National Galleries of Scotland, Edinburgh.

Plate 20. William Hogarth,
1697–1764, *A Fishing Party (The
Fair Angler)*, ca. 1730, oil on canvas,
21½ × 18⅞ in. (54.9 × 48.1 cm), The
Trustees of Dulwich Picture Gallery.

Plate 21. Arthur Devis, 1712–1787, *The John Bacon Family*, ca. 1742–43, oil on canvas, 30 × 51⅛ in. (76.6 × 131.1 cm), Yale Center for British Art, Paul Mellon Collection.

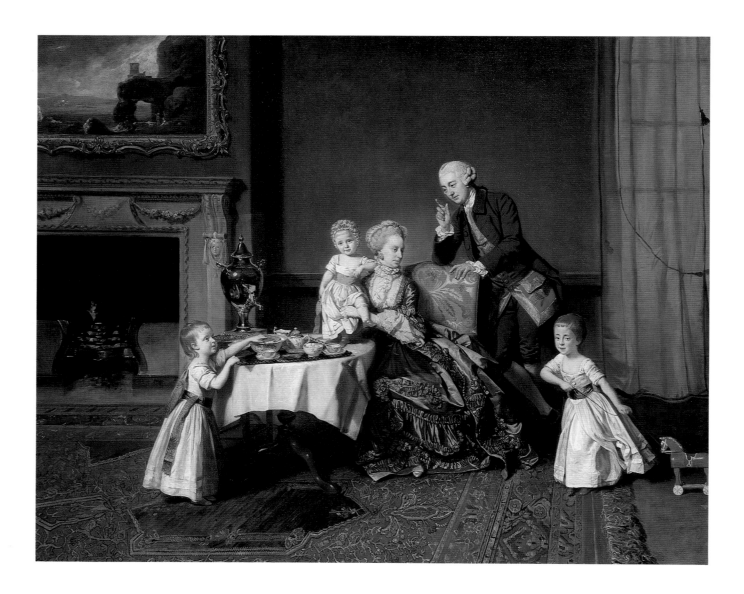

Plate 22. Johann Zoffany, 1733–1810,
*Lord Willoughby de Broke and His
Family*, 1766, oil on canvas, 39½ ×
49½ in. (100.3 × 125.7 cm), The
Leger Galleries Ltd. and Thomas
Agnew & Son Ltd.

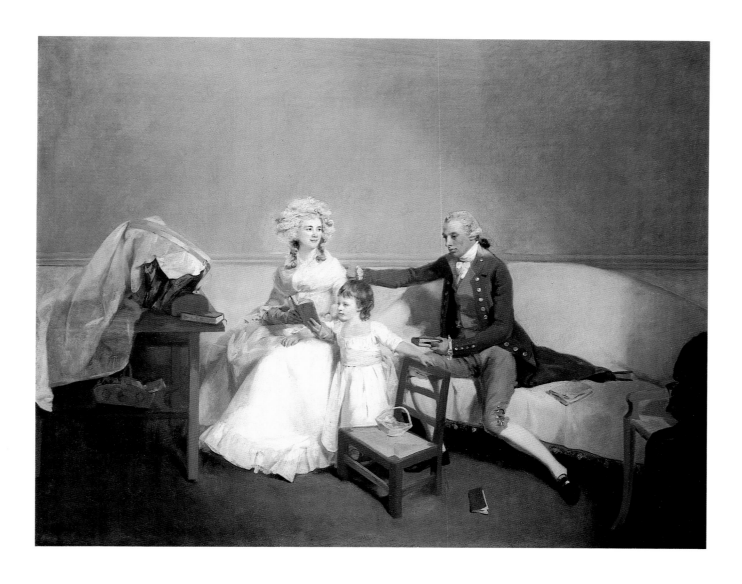

Plate 23. Henry Walton, 1746–1813, *Sir Robert and Lady Buxton and their daughter Anne,* ca. 1786, oil on canvas, 29 × 36½ in. (73.7 × 92.7 cm), Norfolk Museums Service (Norwich Castle Museum).

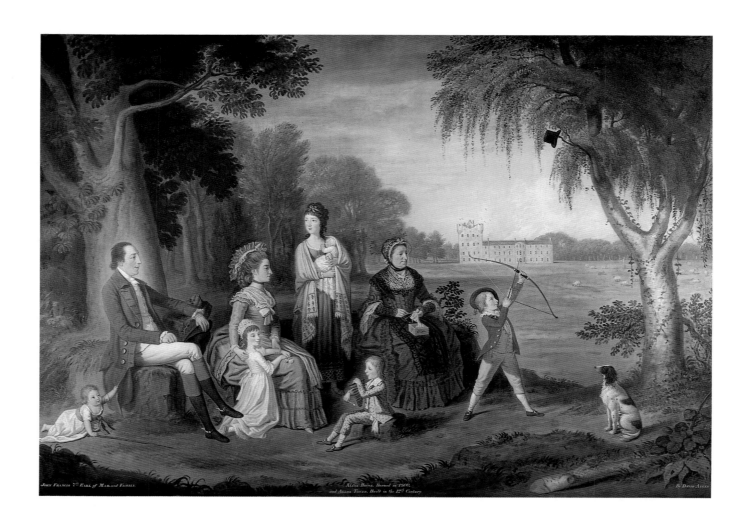

Plate 24. David Allan, 1744–1796,
*The Family of the 7th Earl of Mar
at Alloa House,* 1783, oil on canvas,
60⅜ × 85¼ in. (153.4 × 216.5 cm),
Trustees of the late Lord Mar and
Kellie, courtesy of the Scottish
National Portrait Gallery.

Plate 25. Sir Joshua Reynolds, 1723–1792, *Jane Hamilton, wife of the 9th Lord Cathcart, and her daughter Jane,* 1755, oil on canvas, 48¾ × 39 in. (123.8 × 99.1 cm), Manchester City Art Galleries.

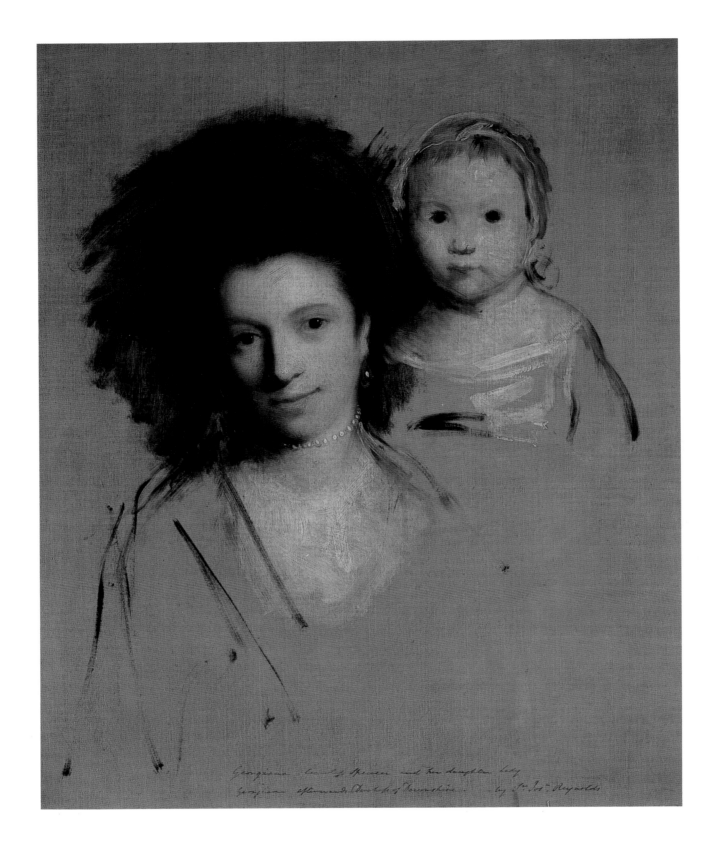

Plate 26. Sir Joshua Reynolds,
1723–1792, *Mrs. John Spencer and
her daughter,* 1759, oil on canvas
(unfinished), 30 × 25 in. (76.2 ×
63.5 cm), Devonshire Collection,
Chatsworth, reproduced by
permission of the Chatsworth
Settlement Trustees.

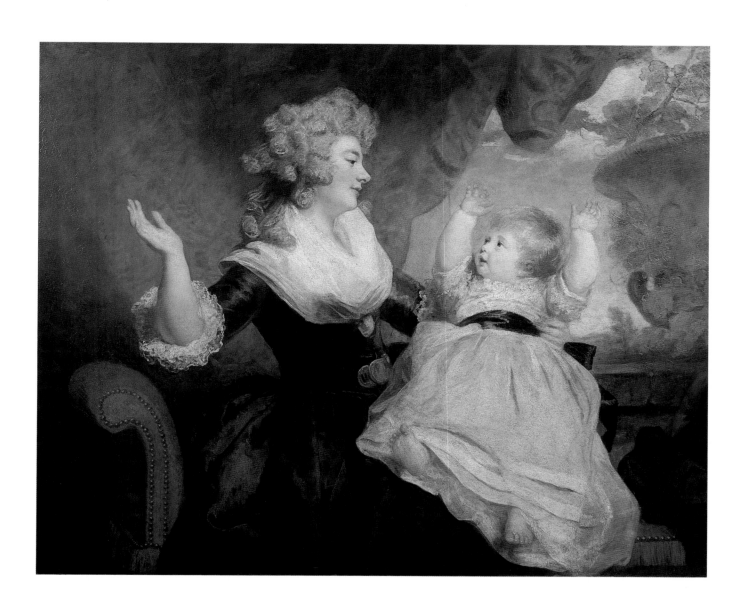

Plate 27. Sir Joshua Reynolds, 1723–1792, *Georgiana, Duchess of Devonshire, with her Daughter,* ca. 1784–86, oil on canvas, 44½ × 55⅛ in. (113 × 140 cm), Devonshire Collection, Chatsworth, reproduced by permission of the Chatsworth Settlement Trustees.

Plate 28. John Hamilton Mortimer,
1740–1779, *Gentleman and Boy
Looking at Prints,* ca. 1765–70,
oil on canvas, 30 × 25 in. (76.2 ×
63.5 cm), Yale Center for British
Art, Paul Mellon Collection.

Plate 29. Johann Zoffany, 1733–1810,
*The Reverend Randall Burroughs
and his son Ellis,* 1769, oil on canvas,
28 × 35¾ in. (71.1 × 91 cm), Musée
du Louvre, département des
Peintures.

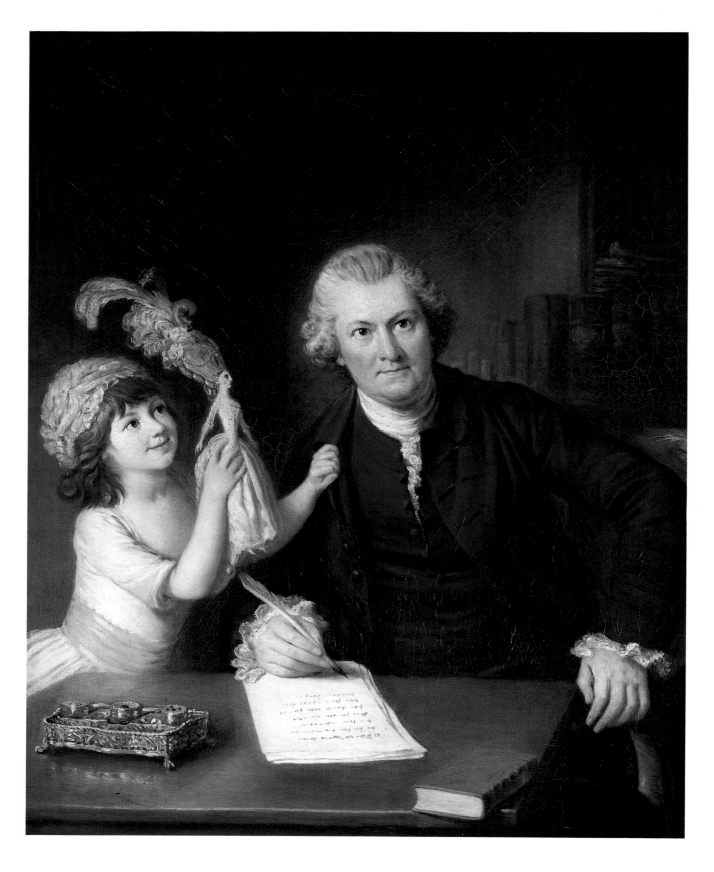

Plate 30. William Hoare, 1707–1792,
*Christopher Anstey with his daughter
Mary*, ca. 1779, oil on canvas, 49⅝ ×
39¼ in. (126 × 99.7 cm), National
Portrait Gallery, London.

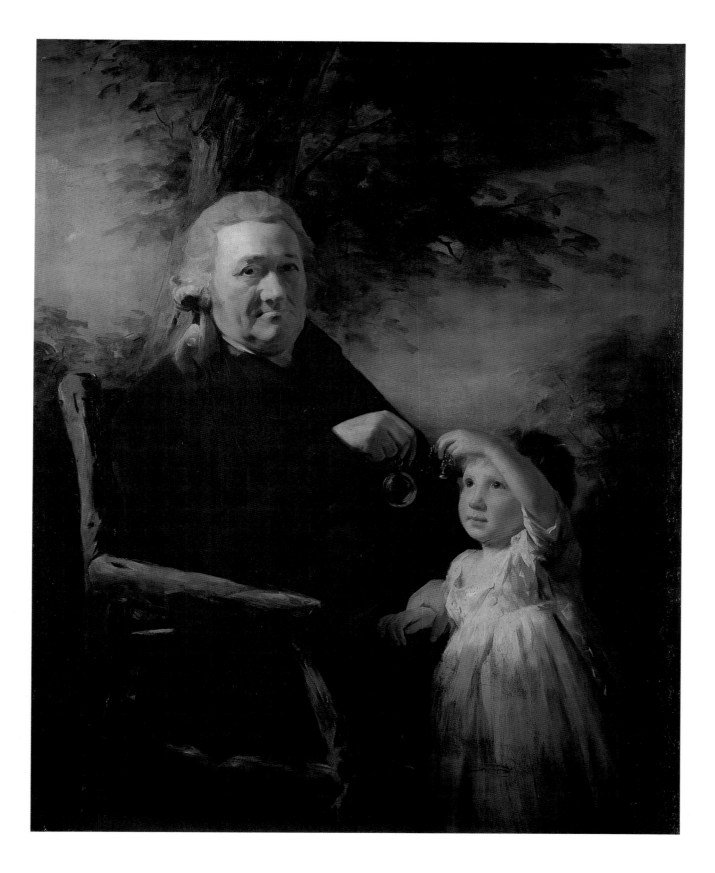

Plate 31. Sir Henry Raeburn, 1756–1823, *John Tait and his Grandson*, ca. 1793, oil on canvas, 49⅝ × 39⅜ in. (126 × 100 cm), National Gallery of Art, Washington, Andrew W. Mellon Collection.

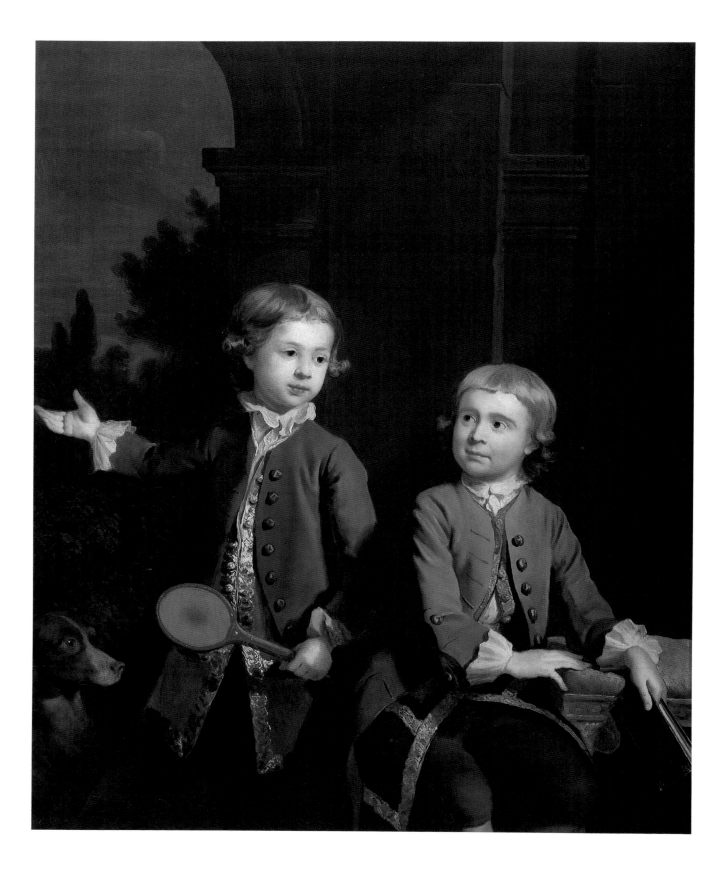

Plate 32. Joseph Highmore,
1692–1780, *Henry Penruddocke
Wyndham and his brother Wadham*,
1743, oil on canvas, 50 × 40 in. (127 ×
101.6 cm), Private collection, cour-
tesy of Lane Fine Art Ltd., London.

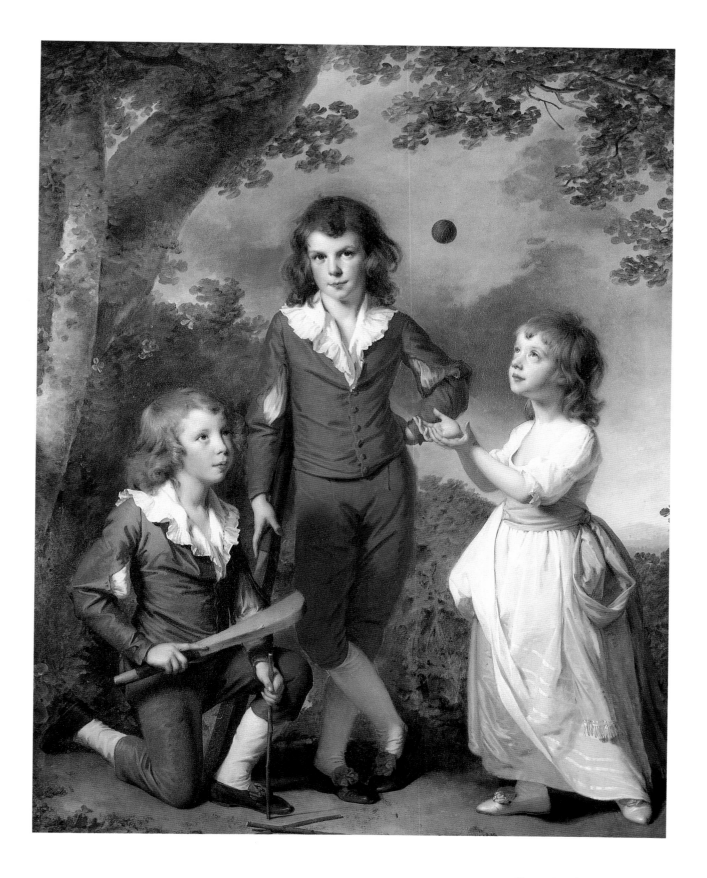

Plate 33. Joseph Wright of Derby,
1734–1797, *The Wood Children*,
1789, oil on canvas, 66 × 53 in.
(167.6 × 134.6 cm), Derby Museums
and Art Gallery.

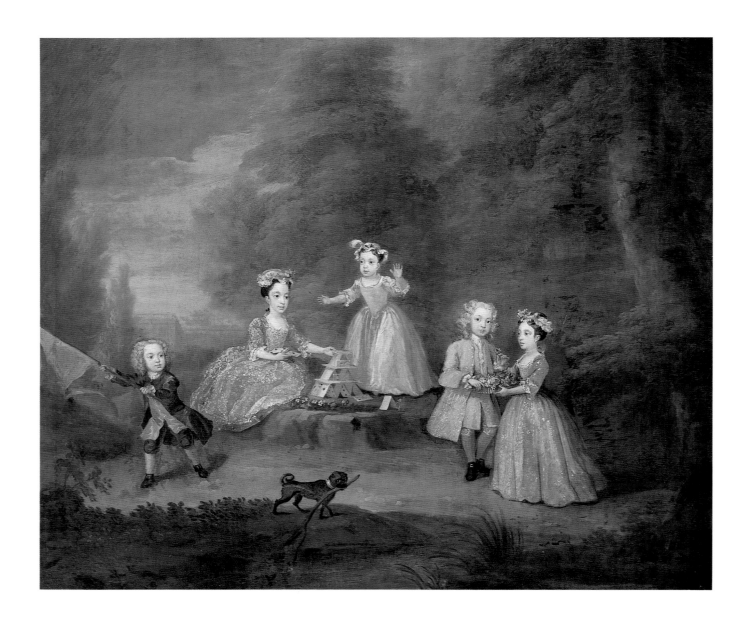

Plate 34. William Hogarth,
1697–1764, *The House of Cards,*
1730, oil on canvas, 25 × 29⅞ in.
(63.5 × 75.9 cm), National Museum
of Wales.

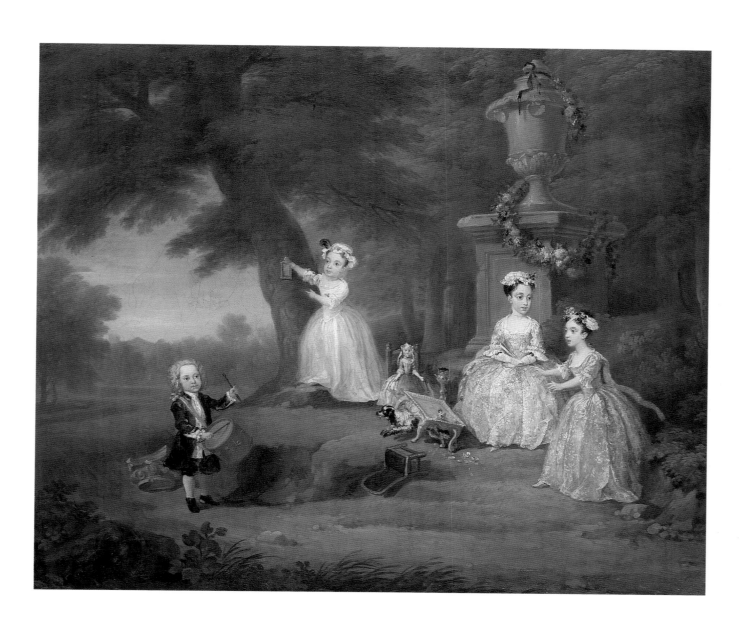

Plate 35. William Hogarth,
1697–1764, *The Children's Party*,
1730, oil on canvas, 25 × 28⅞ in.
(63.5 × 73.3 cm), National Museum
of Wales.

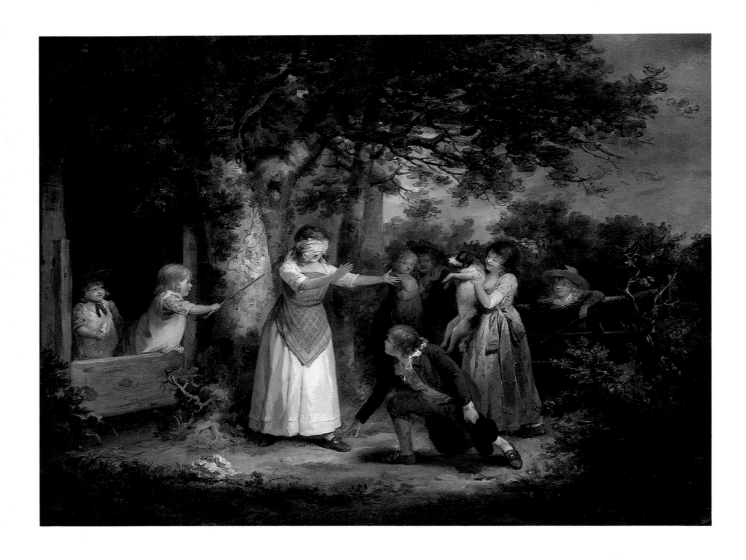

Plate 36. George Morland,
1763–1804, *Blind Man's Buff,*
1787–88, oil on canvas, 27½ ×
35½ in. (69.9 × 89.8 cm),
The Detroit Institute of Arts,
gift of Elizabeth K. McMillan.

Plate 37. Francis Danby, 1793–1861,
Boys Sailing a Little Boat, ca. 1822,
oil on panel, 9¾ × 13¼ in. (24.8 ×
33.7 cm), Bristol Museums & Art
Gallery.

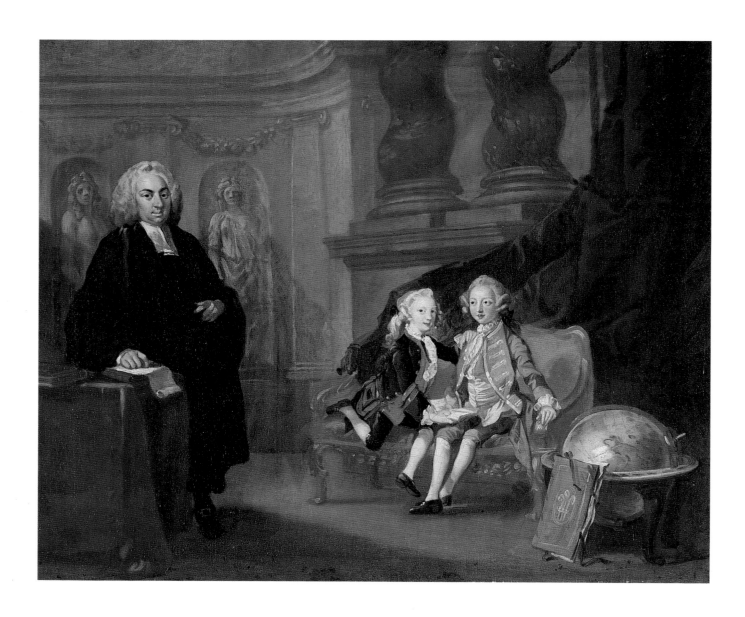

Plate 38. Richard Wilson, 1713–
1782, *Prince George and Prince
Edward Augustus with their Tutor,*
ca. 1748–49, oil on canvas, 25 ×
30⅛ in. (63.5 × 76.5 cm), Yale
Center for British Art, Paul Mellon
Collection.

Plate 39. John Hoppner, 1758–1810,
*John James Waldegrave, 6th Earl
of Waldegrave,* 1800, oil on canvas,
30 × 26 in. (76.2 × 66 cm), The
Provost & Fellows of Eton College.

Plate 40. William Mulready, 1786–
1863, *Train Up a Child in the Way
He Should Go; and When He Is Old
He Will Not Depart From It*, 1841,
oil on canvas, 25½ × 31 in. (64.8 ×
78.7 cm), The FORBES Magazine
Collection, New York.

Plate 41. Joseph Francis Nollekens, 1702–1747/48, *Children Playing with a Hobby Horse,* ca. 1741–48, oil on canvas, 18 × 22 in. (45.7 × 55.9 cm), Yale Center for British Art, Paul Mellon Collection.

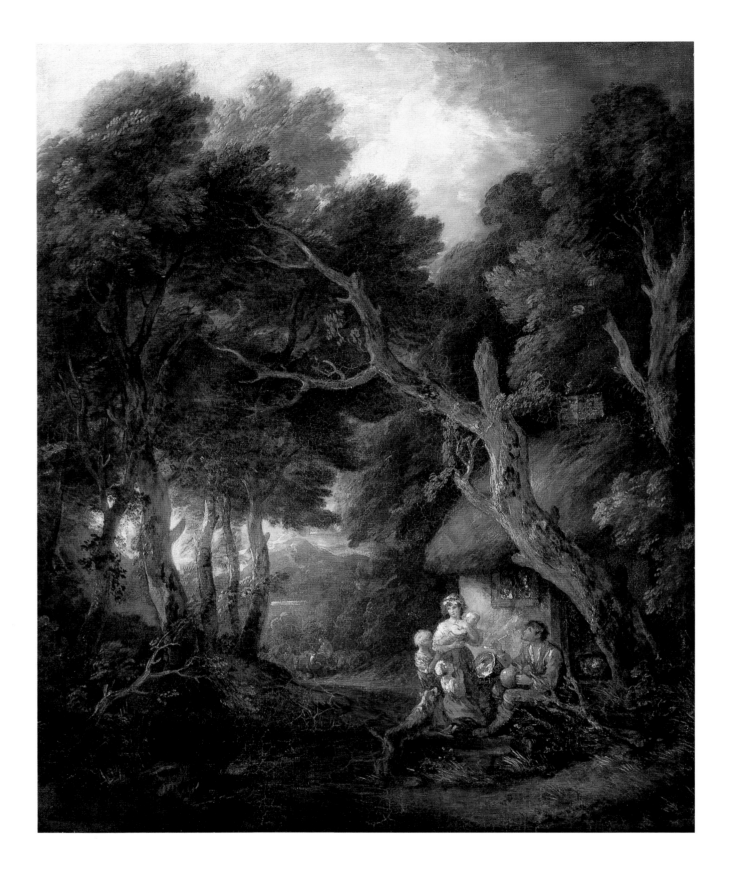

Plate 42. Thomas Gainsborough,
1727–1788, *Peasant Smoking at
Cottage Door,* 1788, oil on canvas,
77 × 62 in. (195.6 × 157.5 cm),
Collection Wight Art Gallery,
UCLA, gift of Mrs. James Kennedy.

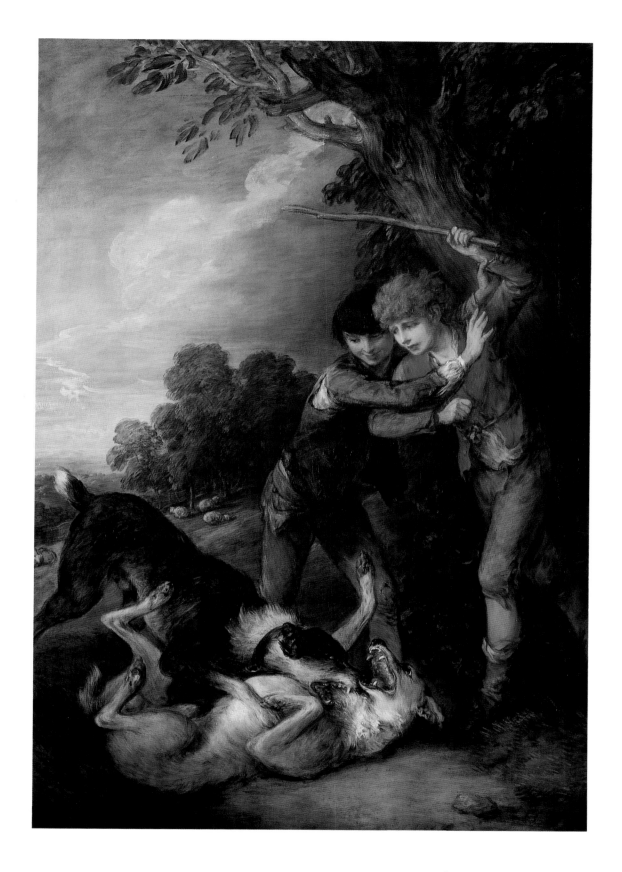

Plate 43. Thomas Gainsborough, 1727–1788, *Two Shepherd Boys with Dogs Fighting*, 1783, oil on canvas, 88 × 62 in. (223.5 × 157.5 cm), The Iveagh Bequest, Kenwood–English Heritage.

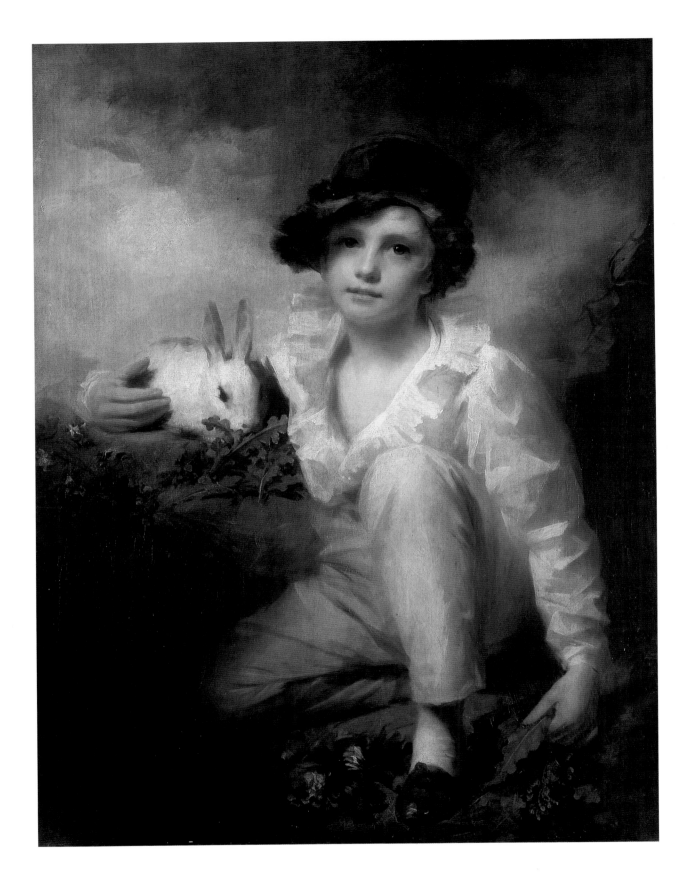

Plate 44. Sir Henry Raeburn,
1756–1823, *Boy and Rabbit*, 1786,
oil on canvas, 40 × 31 in. (101.6 ×
78.7 cm), Royal Academy of Arts,
London.

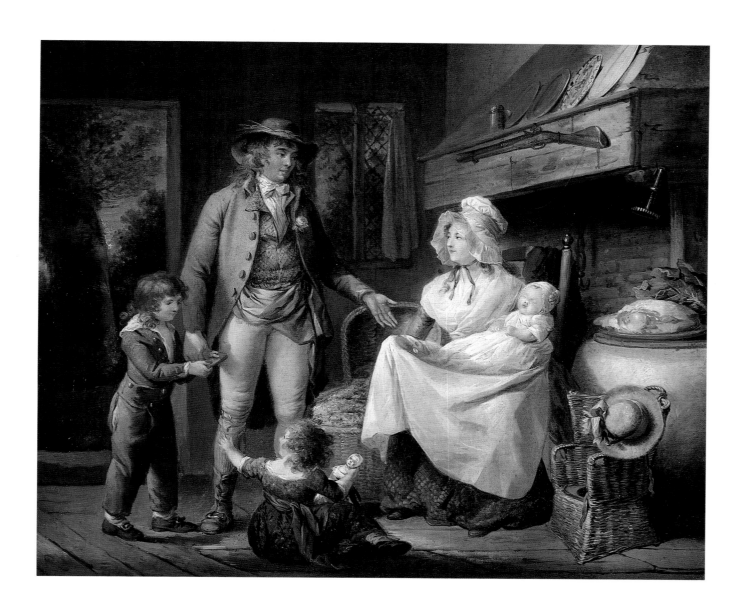

Plate 45. George Morland, 1763–
1804, *The Comforts of Industry*,
1790, oil on canvas, 12¼ × 14½ in.
(31.1 × 36.8 cm), National Galleries
of Scotland, Edinburgh.

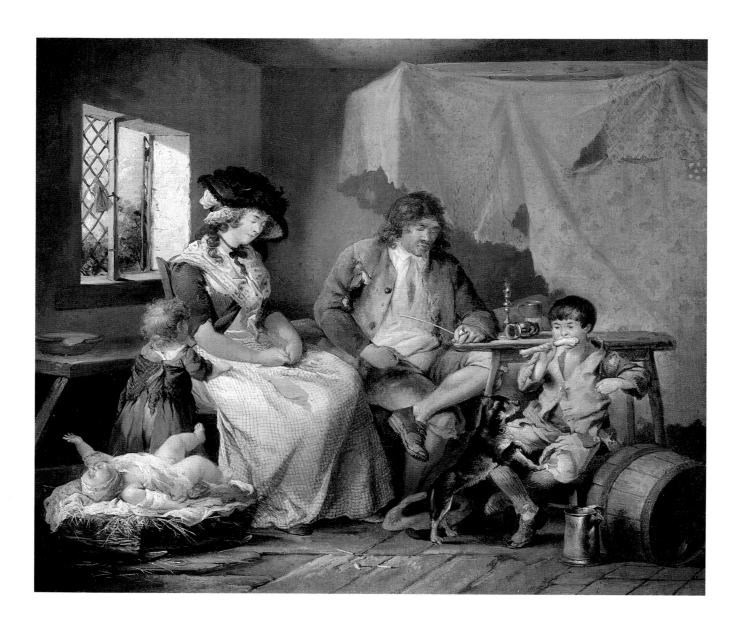

Plate 46. George Morland,
1763–1804, *The Miseries of Idleness,*
1790, oil on canvas, 12¼ × 14½ in.
(31.2 × 36.9 cm), National Galleries
of Scotland, Edinburgh.

Plate 47. Francis Wheatley,
1747–1801, *The Happy Fireside—
Married Life,* 1791, oil on canvas,
31½ × 26½ in. (80 × 67.3 cm),
Private collection.

Plate 48. John Constable, 1776–
1837, *A Suffolk Child,* 1835, water-
color, 7¼ × 5⅜ in. (18.5 × 13.7 cm),
The Board of Trustees of the
Victoria and Albert Museum,
London.

Plate 49. Philip Mercier, 1689–
1760, *Playing Soldier (The Dog's
Education),* ca. 1744, oil on canvas,
50 × 39⅜ in. (127 × 100 cm), The
Detroit Institute of Arts, gift of
Mr. and Mrs. Edgar B. Whitcomb.

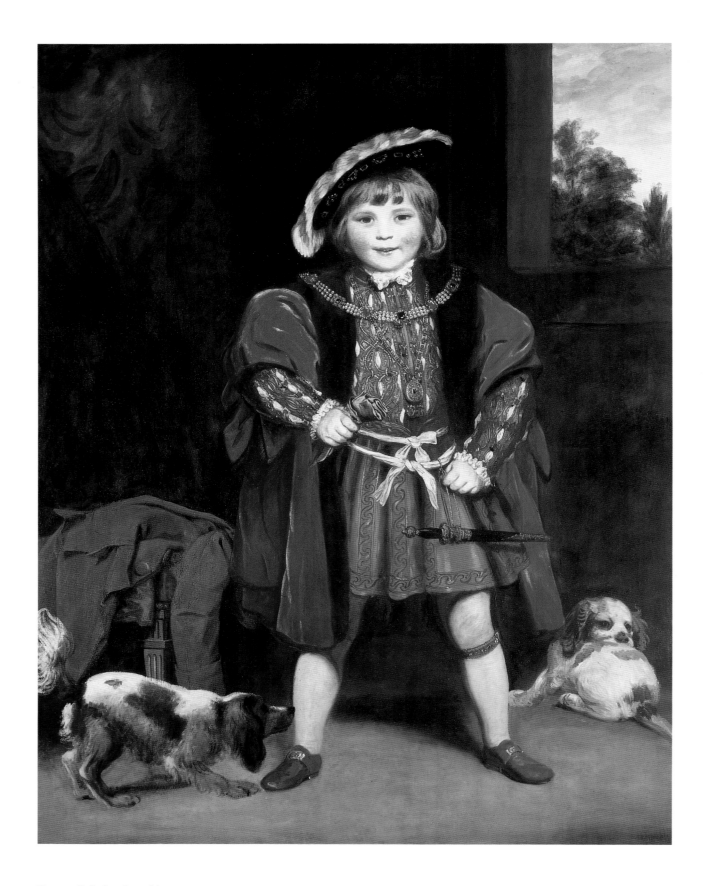

Plate 50. Sir Joshua Reynolds, 1723–
1792, *Master Crewe as Henry VIII,*
1775–76, oil on canvas, 55 × 43½ in.
(139.7 × 110.5 cm), The Rt. Hon.
The Lord O'Neill TD DL.

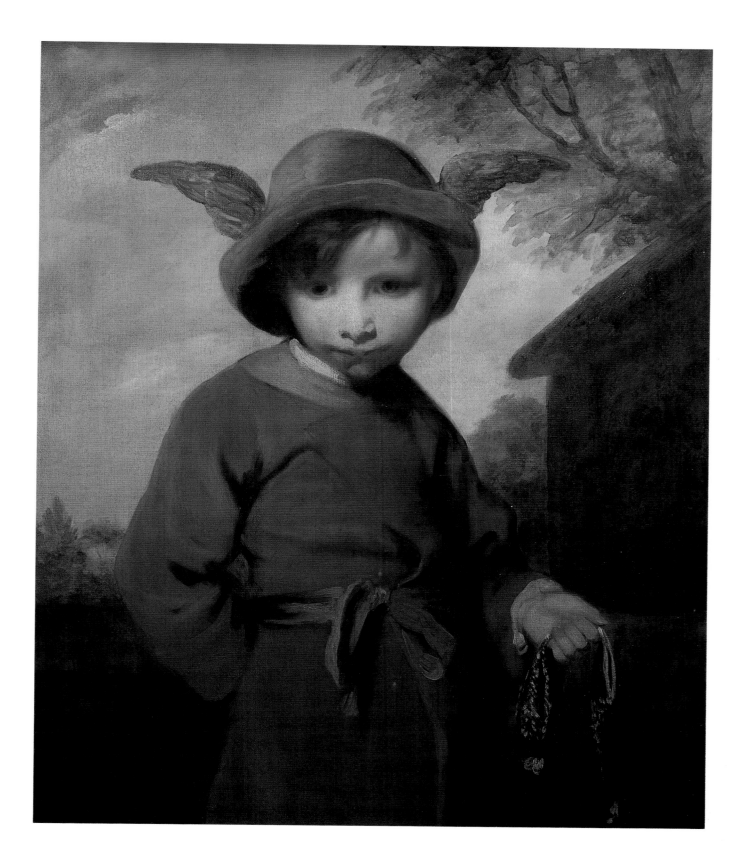

Plate 51. Sir Joshua Reynolds, 1723–1792, *Mercury as Cut Purse*, 1771, oil on canvas, 30 × 25 in. (76.2 × 63.5 cm) framed, The Faringdon Collection Trust.

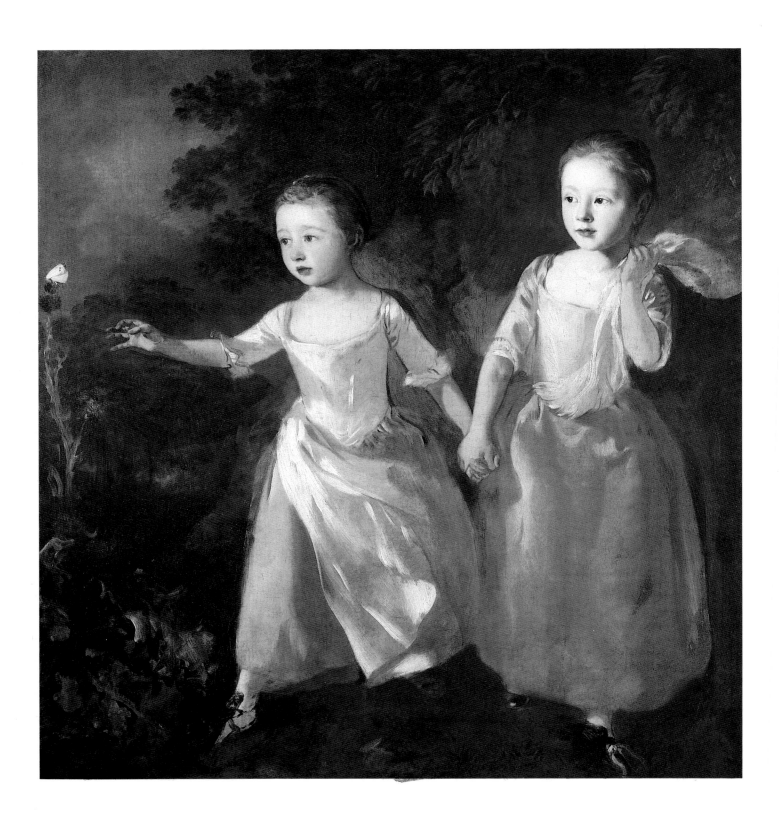

The history of childhood in Georgian art is intimately connected with the history of childhood as a field of study, one that is not much more than twenty years old. Since the modern-day origins of the field began with the publication in 1973 of Philippe Ariès's groundbreaking *L'Enfant et la vie familiale sous l'ancien régime*, published in English as *Centuries of Childhood*, what might have seemed a relatively straightforward matter has become a hotly debated subject with adherents of two primary points of view. The first, comprising Ariès, Lawrence Stone, and others,[1] has put forward the notion that children were seen as miniature adults until the advent of the modern period, and as such were subject to severe discipline, distance, neglect, and even cruelty. Childhood was at best an inconvenient and uncertain investment in the family succession, a view that has tended to suggest, erroneously, an equal concern for this succession among all classes. Further, Ariès has promoted the view that children occupied a position basically no different than that of other members of a large family unit—a unit that existed for economic reasons without the bonds of affection that we see today as one of the markers of the nuclear family. Ariès wrote that the burden of socializing children was not even seen as part of the family's function:

> The transmission of values and knowledge, and more generally the child's socialization, were neither guaranteed nor controlled by the family.[2]

Ariès and his adherents have situated a profound change in the position of children in the late seventeenth and early eighteenth centuries, arguing that this period first witnessed the development of societal attitudes that remain current: the acceptance of childhood as a distinct period of human existence, the position of children as the cornerstone of the family, and the need to base the parent-child relationship on reciprocal love and affection. Ariès based much of his interpretation on the apparent lack of documentary evidence suggesting bonds of affection in the premodern family, and argued that, in addition to pure economic necessity, this situation had evolved out of the fragility of infant life, high infant mortality rates, and the resultant hazards for parents who might become too fond of children likely to be taken by death before their maturity. Ariès pointed to visual evidence in support of his argument, but relied primarily on evidence from France, both documentary and otherwise, to support claims that he then applied to Western Europe generally.

 A second and more recent view of the history of childhood has been advanced by Linda Pollock and others, who argue that there is a history of continuity in attitudes toward children and that bonds of affection dominated society's view of children even in the poorly documented medieval period.[3] The Pollock position, which is based on

Figure 12. Thomas Gainsborough, 1727–1788, *The Artist's Daughters Chasing a Butterfly*, ca. 1756, oil on canvas, 49¾ × 41¼ in. (126.4 × 104.8 cm), The Trustees of The National Gallery, London (see plate 1).

substantial documentary evidence in the form of diaries, memoirs, and other manuscript materials, overlooks periods of dramatic change—such as the eighteenth century—in favor of emphasizing continuity of affection, parental involvement in the rearing of children, and the emotional importance of children to the family unit.

How to reconcile these two points of view? Although other areas are disputed, there is some consensus among historians that child rearing has progressively improved over the centuries.[4] But for Pollock, the failure of Ariès's argument was his overreliance on statistical information, which could be uneven due to the vagaries of surviving records and to differences along regional and national lines, and in discounting first-person evidence. Yet Pollock, too, fails to acknowledge the enormous social change experienced in Britain in the wake of events such as the Glorious Revolution of 1688 and the following rise of an English middle class. Both Ariès and Pollock have created flawed contexts against which to evaluate attitudes toward children. Yet what is most striking about the conflict is the failure of all parties to recognize the divide between the history of childhood and the history of children, of their lived experience. The history of childhood is a history of attitudes, of constructs progressively put forward in different historical periods as well as by different groups and individuals within the same historical moment. How such constructs were carried over to the actual treatment of children is another question. Understanding the divide between historical construct and reality, and examining the roots of each, can do much to make sense of the compelling evidence cited by Ariès, Stone, and Pollock in reconciling change and continuity.

While it is not appropriate here to provide a complete reappraisal of the two opposing schools of thought, or an in-depth contrast of eighteenth-century attitudes against those of the previous century, change and continuity seem best explored simultaneously, and, where possible, through the voices of the eighteenth century.[5] First, two assumptions of the Ariès school can be quickly discarded: arguments that the child had little place in the family because of the enormous size of extended families,[6] and that, prior to the late eighteenth century, the child was unloved because of the dangers of emotional attachment at a time of high infant mortality—for Ariès "the child did not emerge from a kind of anonymity."[7] On the first point, Pollock has convincingly shown that the traditional English family consisted only of parents, children, and servants,[8] and remained remarkably constant throughout the early modern period. The average household size in the seventeenth century was 4.18 members, peaking in the eighteenth century with 4.57 members, and then retreating slightly in the nineteenth century to 4.21 members.[9] The reorganization that is significant to eighteenth-century Britain is not one of size but of centrality. The family increasingly began to cut itself off from society, raising a wall of privacy between family and society[10] and organizing itself around the child in order to control the child's development and aspirations.

The second argument from Ariès has also been undermined statistically. Although childhood mortality (defined as deaths before age nine) was high in the medieval period, rather than declining it actually rose between the years 1650 and 1750 to 265 deaths per thousand, and peaked in the nineteenth century at 288 deaths per thousand,[11] a time when Ariès and Stone argue it was becoming safe to become emotionally attached to the young.[12] The peak in child mortality rates thus actually coincides with the work of Charles Dickens or the Victorian sentimental painters, more than one hundred years after Georgian artists fully discovered the complexities of children in their work. Maternal mortality rates in childbirth certainly improved during the Georgian period: sixteen mothers per thousand died in the late seventeenth century, and this was halved to eight per thousand in the later eighteenth century.[13] This, however, would suggest less physical risk to the mother, which we might expect to translate into a reduced fear of becoming pregnant, rather than perforce greater ease in loving a child once born. Combining statistics of infant and maternal mortality, we see that some 94 percent of all births were normal and healthy for both mother and child early in the eighteenth century.

In examining the lives of eighteenth-century artists, it appears that many were quite familiar with the death of children. All of the Scottish artist Allan Ramsay's children by his first wife died young,[14] and she died in childbirth in 1743, the same year he painted his moving and tender *Sketch of a Dead Child* (plate 19). When Ramsay remarried, his first two children by his second wife lived only a few hours.[15] Sir Joshua Reynolds was the seventh of eleven children, five of whom died in their infancy.[16] Sir Thomas Lawrence was one of sixteen children, only five of whom outlived their parents, who died in 1797.[17]

Ariès and those sharing his views suggest that further evidence of disregard for children can be found in

parental hostility toward female offspring in centuries, including the eighteenth, when male heirs were favored. However, in Britain in 1750, 52 percent of landed families produced no male heirs,[18] so in the majority of cases there were no male heirs to be favored and Ariès's point does not seem to be supported by the statistical evidence. What is it then that allowed eighteenth-century parents and artists to love their children? Mortality rates and personal experience are often at variance in the individual case, so some other factors must be at work.

Looking at Georgian Children

Perhaps the fundamental question facing adults about children, at least into the nineteenth century, involved the child's basic nature and his capacity for good and evil. Throughout the first half of the eighteenth century, childhood was seen as a malleable period, profoundly important in the formation of character, intellectual skills, and religious faith. It was a period in which, according to Calvinism and the Puritans, the child's inherently sinful nature could be overcome by training.[19] With the 1762 publication of Rousseau's *Emile* and his temporary exile in Britain from 1765 to 1767, this dialogue began to shift. As society reexamined the question of original sin in children, many accepted Rousseau's argument, which derived from the idea of the noble savage and posited that children were by nature innocent and were only corrupted by an already corrupt society.[20] For Rousseau, the principle vehicle for this corruption was education, which took the innocent child and perverted him at the hands of incompetent taskmasters. Sir Joshua Reynolds evidently agreed, for his early biographer Edmund Malone tells us that he too believed in the innate natural charm of children until destroyed by society. Malone writes:

> It was one of his favourite maxims, that all the gestures of children are graceful, and that the reign of distortion and unnatural attitude, commences with the introduction of the dancing-master.[21]

Despite the controversies that grew up between revisionists, such as Rousseau, and conservatives, such as John Wesley, the founder of Methodism, or the newly respectable political conservatism of the Puritans, memoirs and correspondence from the eighteenth-century provide ample evidence that upper- and middle-class parents watched over and commented upon the progress of their infants and children—evidence denied by writers such as Ivy Pinchbeck and Margaret Hewitt.[22] For both

conservatives and revisionists, for those who saw the child as inherently evil and for those who saw him as innocent, childhood already occupied a special platform and was seen as a unique period of life during which the fate of the child, and that of the future adult, hung in the balance. As a period of profound significance to both Calvinists and the Rousseau circle in the formation of the future adult, childhood merited close attention, and in many cases this attention extended not just to the future adult but to the child as a child.

Particularly from the mid-eighteenth century, many letters and works of art attest to the daily observations made by parents as well as their feelings of affection, pride, and sincere interest in their children as individuals with distinct personalities predictive of their future adult character. For example, Frances Boscawen writes to her husband, a navy admiral away at sea in 1747, about their first child, then aged two and a half:

> I must have one observation in it that savours of vanity, but upon so true a foundation that it ought to excite your gratitude. The comparison of our children with your brother George's. I went directly from our boy to his girl. What a difference! In every circumstance, and in nothing more than behaviour. She would not come near me, and is as far from an agreeable child as she is from a pretty one. Ours is both, in the highest degree, and so everybody thinks. I wish you had seen him at his grandfather's yesterday and riding in the chair with mama. He stood you may imagine, and was so delighted 'twould have entertained you.[23]

Mrs. Boscawen is absorbed by the idea that her children are naturally superior to others; that they are a source of pride to her is clear. Similarly, Emily Kildare, Duchess of Leinster, a mother of almost fanatical devotion who later became a slavish disciple of Rousseau in raising her younger children, wrote in 1750 of her children, Caroline aged eleven days, George aged two, and William aged one:

> You desire I will tell you something about my little girl . . . she is in the first place small, but fat and plump, has very fine dark *long* eyes, which I think a great beauty, don't you? and her nose and mouth like my mother's, with a peeked chin like me. As for her complexion, she is so full of the red gum that there is no judging of it, but what is best of all is that she is in perfect health and has been so ever since she was born. . . .
> [George] is in the first place much improved as to his beauty, but the most entertaining, comical, arch little rogue that ever was, chatters incessantly, is immensely fond of me and coaxes me not a little, for he is cunning enough, very sweet-tempered and easily

Figure 4. William Hogarth, 1697–1764, *Gerard Anne Edwards as a Child*, 1732, oil on canvas, 12½ × 15⅝ in. (31.7 × 39.7 cm), Upton House, Oxfordshire, The Bearsted Collection (The National Trust).

governed by gentle means; in short, if I was to set down and wish for a child, it would be just such a sort of boy as he is now. William is a sweet little child, too, in a different way. He is not so lively or active as George is by a good deal, but is forward enough both as to his walking and talking. . . . He is the best-natured little creature that can be and excessively passionate already, but puts up his little mouth to kiss and be friends the very next minute.[24]

The mother here stresses not only the bonds of affection between herself and her children—including the one being wet-nursed—but also the individual nature of each child. A visual equivalent of these descriptions is perhaps evidenced in Hogarth's portrait *Gerard Anne Edwards as a Child* (figure 4) of 1732, certainly one of the earliest British painted representations of a child in infancy. Gerard Anne, son of one of Hogarth's more important patrons, Mary Edwards, is no more than a year old here in his dress and skull cap but sits up in his woven crib, ornamented with rich linens. He holds a children's toy in his hand and looks at the dog in the corner, already at this very young age establishing the relationship between child and animal.

This interest in describing the attributes of the individual child and, when that child is the writer's own,

of taking pride in his or her virtues, is the compulsion that increasingly drew the Georgian parent into commissioning a painted portrait of his child. An early expression of this motivation, from before the Georgian period, is found in Sir Peter Lely's *Lady Charlotte Fitzroy* (plate 10). Although still partaking of seventeenth-century portraiture conventions—the stiff, stylized pose of the body, the importance of drapery, the relatively unindividuated face conforming to current standards of beauty—*Lady Charlotte Fitzroy* emerges as a more complex study of a child. She is seen as an independent figure without overt reference to her family. But instead of posing her alone, Lely has painted young Charlotte with her Indian servant boy, who kneels in homage to the fair white female and proffers a tray of fruit. The inclusion of the Indian boy refers to the girl's class position and to the quality of her upbringing, at a time when Indians occupied the same lowly place in society as Africans, and both could be sold publicly through newspaper advertisements.[25] In a not-so-subtle commentary on class and race relationships, the inclusion of the servant child also has the effect of referring to the Fitzroy family *in absentia,* the servant standing in for the missing parents. The child is thus cared for while remaining within the world of

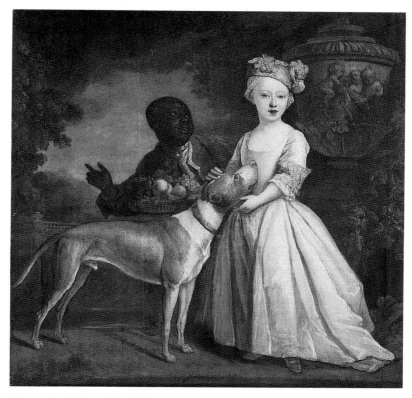

Figure 5. Bartholomew Dandridge, 1691–ca. 1755, *Young Girl with Dog and Page,* ca. 1720–30, oil on canvas, 48 × 48 in. (122 × 122 cm), Yale Center for British Art, Paul Mellon Collection.

children—surely it is no accident that the servant, too, is a child.

This theme continues throughout eighteenth-century portraits of children. Bartholomew Dandridge takes it up in the 1720s with his *Young Girl with Dog and Page* (figure 5), with subtle changes from the work by Lely. The child, although younger, is now seen standing full-length and has, if anything, a more monumental quality. The race and sex of the servant are changed, so that Dandridge's child is accompanied by an African girl of about her own age. The addition of the dog is notable, too, a motif that assumes great importance in Georgian portraiture, especially in this work where the dog is a sporting breed more than half the child's size. Reynolds took up the racial theme in *The Children of Edward Holden Cruttenden with an Indian Ayah* (plate 11) of 1759 to 1762, where the ayah was said to have saved the children's lives during an Indian uprising. Compositionally the ayah, while in the flowery shadows, pushes the children forward and establishes a relationship of power and servitude with children who might themselves otherwise be seen as lacking power. Finally, Arthur W. Devis explores the theme again at century's end in his lively *Emily and George Mason with their Ayahs* (plate 12),

painted 1794 to 1795. Like the painting by Reynolds, the setting specifically refers to the children's upbringing in India and once again their status is asserted—the children are cared for, and they command authority. The commentary is made more pointed by painting the children indoors and in large scale, with a monumentality much like that of the Dandridge child. The ayahs are much smaller figures on a distant verandah. Still, they are linked by similarities of pose, with young George Mason reclining on the floor like his female ayah. Perhaps the most remarkable feature of Devis's canvas is the liveliness of the group: Emily performs on a tambourine while her brother leans against his toy regalia on the floor.

The developments of a realistic sense of liveliness and of direct observation of actual children are two of the clearest indications in Georgian art of changing attitudes toward children. Both are brought together in one of the greatest depictions of children from the period, William Hogarth's *The Graham Children* of 1742 (plate 13). The four children of the Chelsea Hospital apothecary, Daniel Graham, are carefully differentiated in age and character, and yet the painting is reminiscent of an adult conversation piece in the way the figures are disposed across the canvas.[26] This disposition seems to derive from two

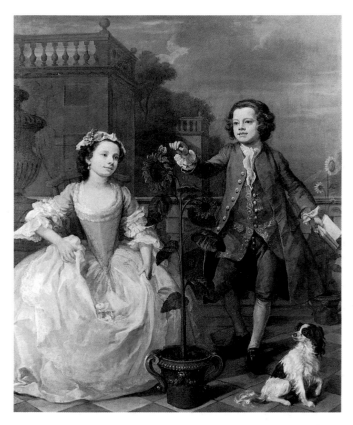

Figure 6. William Hogarth, 1697–1764, *The Mackinen Children,* 1747, oil on canvas, 70⅞ × 56¼ in. (180 × 143 cm), National Gallery of Ireland.

sources: the first, the Rococo serpentine line of Jean Antoine Watteau, whose works Hogarth could certainly have known;[27] the second, Van Dyck's painting of the Stuart children at Windsor. Hogarth, however, animates *The Graham Children* in a way that would have been impossible in a royal portrait of Van Dyck's time. Indeed, Graham's commission of the painting from Hogarth, who had limited success in receiving commissions from the royal family and the nobility, may have been a reflection of Graham's *nouvelle richesse.*[28] On the left, an infant boy sitting in a cart reaches out with his pudgy fingers toward his sister, who holds a bunch of cherries, emblematic of future passion and a warning against lust. She restrains her younger brother in the adopted pose of the absent mother figure, staring not at the boy but gazing blankly at the viewer. A second girl occupies the center of the painting and holds her dress in a pose resembling a curtsy. At the right, a seated boy turns the crank of his music box and looks at a bird suspended in a cage over his head, perhaps believing that it is his music that makes the bird sing when in fact it may be the cat stalking the bird over the back of the boy's chair. The threatening motif of the stalking cat injects an element of instability, an awareness

that the equilibrium of the painting and of childhood itself is about to change. Equally, there are suggestions, however subtle, that Hogarth is using these charming children to mock adults. Is the boy's relationship to the bird not unlike the adult's relationship to the child?

The Graham Children is an image of transience and of the fragility of childhood, incorporating emblematic qualities at the same time that it delights in the observed behavior of children. In addition to the motif of the predatory cat, there is a clock topped by a scythe-bearing cupid above the infant on the left. While we can easily see this cupid as a warning against the natural course of life and a symbol of death, it is also a sad reminder that the infant, Thomas, died between the time of the work's commission and its completion. Further, it has recently been shown[29] that a related drawing, the *Head of a Sleeping Child* (British Museum, London), is a preparatory drawing for the infant Thomas, raising the possibility that Hogarth drew from the dead child and that the painted baby was based on the posthumous study. Thus, as Elizabeth Einberg states,

> the most vital and vivacious detail of the picture might actually be a posthumous portrait of the baby, poignantly posed below a clock decorated with the symbols of the transience of life.[30]

Accepting this identification reveals the extent of Hogarth's interest in observing children directly and in recording the life of a lost infant for a presumably grieving father.

Hogarth's inclusion of emblematic devices in a painting of children carried out from direct observation allowed him to be quite explicit with his own con-

Figure 7. Benjamin West, 1738–1820, *Sketch for A Group of Five Children,* undated, chalk on paper, 9⅞ × 13¼ in. (25.1 × 33.6 cm), The Board of Trustees of the Victoria and Albert Museum, London.

Figure 8. John Singleton Copley, 1738–1815, *The Children of Francis Sitwell, Esq.,* 1787, oil on canvas, 71 × 81 in. (180.3 × 205.7 cm) framed, Sir Reresby Sitwell, Bt DL, Renishaw Hall, Derbyshire.

struct of childhood. A second work of 1742 again shows Hogarth working with emblematic devices to evoke the character of children. *The Mackinen Children* (figure 6) contains obvious *vanitas* references in the girl gathering fallen petals in her apron and the boy reaching out for a butterfly on a sunflower. The sunflower also has an emblematic value, for it was an image of devotion,[31] and Hogarth uses it to suggest the affection of these siblings for each other and, perhaps, in absentia, for their parents who commissioned the painting. The butterfly, too, holds an emblematic function, with a history including John Bunyan's frequently reprinted *Book for Boys and Girls* of 1686 containing the following lines in the poem "Of the Boy and Butterfly":

> Behold how eager this our little boy
> Is for this Butter-fly, as if all joy
> All profits, honour, yea, and lasting pleasures
> Were wrapt up in her . . .[32]

The butterfly is the visual manifestation of Hogarth's purpose (and the parents' in commissioning a portrait of their children)—the attempt to capture a moment before it disappears forever. Still, other emblematic readings are also possible: the sunflower may also symbolize

fleeting beauty; the butterfly may suggest learning, toward which the boy reaches out. One must, however, be wary of any such readings in the work of an artist as original as Hogarth. Richard Wendorf has suggested that he may have been using these elements as *impresa,* or personal and arcane allegory.[33] We have at least Hogarth's own word that he sought through "deportment, words, and actions"[34] to inject iconic motifs into the drama of private life.

Two portraits of children from the 1760s underline the variety of artistic options available in representing children. Strickland Lowry's portrait *The Bateson Family* (plate 14) of 1762 shows the five Bateson children in the hall of Orangefield, the family home in County Down (seen in a landscape on the back wall). It is a highly documentary canvas, both with reference to the children's clothing and to elements of popular taste, such as the harpsichord and the music sheets on it, legible as "If Love's A Sweet Song," first published in 1750.[35] Johann Zoffany's *Blunt Children* (plate 15) of 1768 to 1770 is by contrast largely devoid of this kind of documentary interest. Instead, the artist is concerned with showing the children in a kind of playacting. One boy carries a large

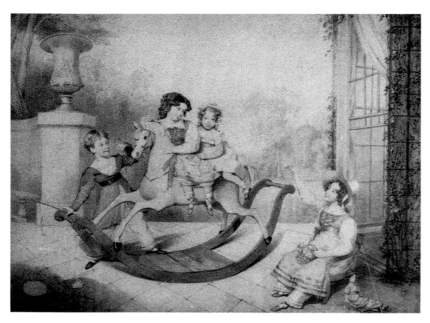

Figure 9. Octavius Oakley, 1800–1867, *Sir Reresby Sitwell with his Brother and Sister,* ca. 1828, watercolor, 32½ × 27 in. (82.6 × 68.6 cm) framed, Sir Reresby Sitwell, Bt DL, Renishaw Hall, Derbyshire.

rake, the other pulls a wheelbarrow laden with hay; both garden tools seem outsized in contrast to the diminutive children. The children's activities allude both to their future roles as landowners, their future property seen in the background, and to the fashionable taste for rural life. Beyond the reference to rural life, however, the boys are innocently playing at being laborers, a posture frequently imposed by Reynolds, who often chose to paint aristocratic girls as farmhands. This kind of playacting at being of a lower class was a complex commentary on class and social relationships, as we will see in Chapter Seven.

The inherent drama of private life is picked up by later portraitists looking at children *without* including the emblematic or iconic. This is most commonly the case in group portraits of children, which late in the eighteenth century combined close observation with an attempt to individuate the sitters through pose, costume, and attributes, as in Benjamin West's undated *Sketch for A Group of Five Children* (figure 7). One of the best of these group portraits is John Singleton Copley's *The Children of Francis Sitwell, Esq.* (figure 8) of 1787. Against the extraordinary framing of a great open window, we see one of the Sitwell sons rush toward his older brother, Sir Sitwell Sitwell, then eighteen, obliterating the game of cards being played by another brother on the floor. It seems likely that the two boys have been fighting over a house of cards. Behind them stands a sister who has been interrupted in her reading of a musical manu-

script and looks up with some consternation. She serves as a kind of surrogate parent figure. The scene is one of tremendous movement within a stately setting, where the notion of childlike behavior is given visual expression —seen in contrast to Octavius Oakley's watercolor of the Sitwell children a generation later (figure 9). The emblematic—the house of cards on the rumpled carpet— is decidedly secondary.

Throughout much eighteenth-century writing run concerns of a quotidian nature for the practical welfare of children. Typical of this worry is a diary entry for 1789 by the Reverend William Jones, in which he states his fear that his income is insufficient to support his family and he worries about the fragility of life in general:

As to myself, when I reflect on my present numerous family, and the large addition to it which I may in all probability expect, and think of the uncertainty of my employment, or the uncertainty of my own life, should I be ever so successful in my school, I seem oppressed with an insupportable load of cares and anxieties.[36]

Jones is evidently more concerned with the likelihood of his own mortality and the need to care for his children rather than with the possibility of *their* mortality. Even with a large family of a size to contradict Ariès, nowhere does Jones seem to regret his children[37] or express a desire to take up the newly popular practice of contraception. Even here, we see the implicit devotion of the father to his children, whose worries would not exist

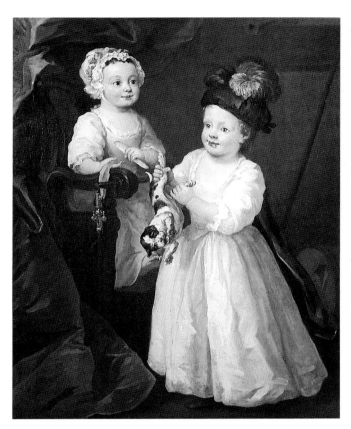

Figure 10. William Hogarth, 1697–1764, *Lord Grey and Lady Mary West as Children*, 1740s, oil on canvas, 42 × 35⅜ in. (106.7 × 89.8 cm), Washington University Gallery of Art, St. Louis.

torture. In the right background, a broken tin drum lies discarded on the floor, a further comment on the passing interests of children as well as the transience of childhood. Fragility united with malevolence (or as Hogarth might have thought it, honesty) marks the artist's work and allies it with the straightforward writing of many of his contemporary diarists. When Hogarth paints a child alone, as in his charming portrait *Boy in a Green Coat* (Art Gallery of Ontario, Toronto) of about 1756, fragility and honesty are strongly present. The frankness and seriousness of the boy's gaze suggest an awareness of the difficult future awaiting all children, a kind of Puritanical sadness, and a subtle mimicking of adulthood. Both remind us, as the Hogarth scholar David Bindman has put it, "that childhood is a transient state, that children seek instinctively to imitate adults."[38]

The close observation of the individual child is a practice that grows through the following years and finds its strongest expression in the Romantic movement of the early nineteenth century. Writing to a friend in 1803, the poet Samuel Taylor Coleridge describes his two children, Hartley, aged seven, and Sara, less than a year:

> Hartley is . . . a strange, strange boy, "exquisitely wild," an utter visionary, like the moon among thin clouds he moves in a circle of light of his own making. He alone is a light of his own. Of all human beings I never saw one so utterly naked of self. He has no vanity, no pride, no resentments . . . his thoughts are so truly his own. . . . If God preserves his life for me, it will be interesting to know what he will become. . . .
>
> My meek little Sara is a remarkably interesting baby . . . she smiles as if she were basking in a sunshine, as mild as moonlight, of her own quiet happiness.[39]

Coleridge describes his children in language typical of the Romantic movement, emphasizing their individuality and their relationship with the elements of nature, such as sunshine and moonlight. Writing of children in general, the childless writer and artist William Blake takes a similar view, crediting children with the same kind of special insight expressed by Rousseau in the *Rêveries*. In a letter of 23 August 1799 to Dr. Trusler, Blake writes:

> I am happy to find a Great Majority of Fellow Mortals who can Elucidate My Visions, and Particularly they have been Elucidated by Children, who have taken a greater delight in contemplating my Pictures than I even hoped. Neither Youth nor Childhood is Folly or Incapacity. Some Children are Fools and so are some Old Men. But There is a vast Majority on the side of Imagination or Spiritual Sensation.[40]

were he capable of the neglect posited by Ariès and others. In none of these writers do we sense that their feelings per se are especially revolutionary, for, in the case of the letter writers, expressions of pride and care pass without special interpretation, understood if not expected by the recipients of their prose.

The matter-of-fact reporting about one's children is an attribute especially prevalent in the painted works of the first half of the century. This straightforward quality, combined with direct observation, characterizes William Hogarth's paintings of children. His *Lord Grey and Lady Mary West as Children* (figure 10) of early 1740 pretends to direct observation and finds itself somewhere on the divide between Calvin and Rousseau by showing children to be both sweet and evil. Here, Lord Grey, the three-year-old son of the fourth Earl of Stamford, who commissioned the work, maliciously if playfully holds a struggling small dog in the air by its hind legs. He wears a black plumed hat and ribbon which would seem to allude to the father's judicial or ministerial function. The boy's one-year-old sister, the future Lady Mary West, sits barefoot in a barred high chair with a placid expression on her face, quietly acquiescing in Lord Grey's game of

Figure 11. Thomas Gainsborough, 1727–1788, *Heneage Lloyd and His Sister,* ca. 1750–55, oil on canvas, 25¼ × 31⅞ in. (64.1 × 81 cm), Fitzwilliam Museum, University of Cambridge.

For Blake, the imagination of childhood is wedded to childhood's distinct capacity for pleasure, and he writes in the *Four Zoas* (1797 to 1804) that happiness for children is found "in pleasure which unsought falls round [their] path."[41]

As suggested by Coleridge's letter, one attitude toward children that was distinctly novel for those who came to believe in the child's innate goodness was the equation of their innocence with nature, and particularly with the animals with whom they shared that world. In the early Romantic period, emotions were projected onto inanimate objects and animals, causing them to become more than mere symbols. Already we have seen Dandridge's child sitter in allegiance with an animal as early as the 1720s. Over the century, the revolutionary belief in a natural world of equality and freedom led to a new painterly fluency of child sitters and setting, with literary parallels late in the century in Coleridge and Wordsworth's *Lyrical Ballads* of 1798, Wordsworth's "Lucy" poems of 1798 to 1799, and Wordsworth's "Intimations of Immortality from Recollections of Early Childhood" of 1802 to 1806.[42] This last is perhaps the most direct application of Wordsworth's thoughts on nature to childhood, exploring the meaning of the intensity of the child's experience of the natural world, a fundamentally sensory experience destined to fade into the "light of common day," or adulthood.

Perhaps the greatest artistic expression of thinking about the child of nature came in the development of the pastoral portrait, with roots well in advance of the eighteenth century. Rich and varied works allying children with animals in a natural setting were carried out in the seventeenth century by artists such as Paulus Moreelse and Dirck Santvoort, with painters such as Peter Lely taking the tradition with them to Britain. Placing the sitter out of doors could serve a variety of purposes. In works from the seventeenth century, the pastoral portrait often functioned allegorically, equating the child sitter with, for example, John the Baptist as a shepherd of men.

When Thomas Gainsborough first took up the pastoral portrait in the mid-eighteenth century, the inclusion of relatively doll-like children in a landscape setting had more to say about land ownership, pride of possession, and family status than it did about a *relationship* with nature. His portrait of *Heneage Lloyd and His Sister* (figure 11), for example, poses two children in a panoramic landscape, betraying Gainsborough's then not-uncommon practice of actually using dolls in his studio to resolve compositional issues. The children stand in for their absent parents, assuming much of the *gravitas* of adult poses while still suggesting the bond of affection between siblings. Gainsborough moved beyond this stagelike pastoral in an extraordinary way in painting his own daughters, notably in the unfinished portrait of

Figure 13. Thomas Gainsborough, 1727–1788, *The Artist's Daughters,* ca. 1758–59, oil on canvas,
16 × 24½ in. (40.6 × 62.2 cm), The Board of Trustees of the Victoria and Albert Museum, London.

about 1756, *The Artist's Daughters Chasing a Butterfly* (plate 1 and figure 12, page 80). Fully immersed in nature in a moment of wistful spontaneity, the two girls are compelling yet fragile individuals. The elder daughter is more cautious, perhaps wiser, restraining her younger sister from chasing the butterfly that will inevitably evade her grasp. The moment retains a coded message: the butterfly symbolizes the transience of childhood just as it did in Hogarth's *Mackinen Children.* The landscape is dark enough to be threatening yet seems warmly enveloping. Gainsborough's liberation from the need to justify his stylistic innovation to any patron enables him to indulge his affection for his children and create a deeply personal narrative for his own consumption. Gainsborough painted his daughters again in the late 1750s (figure 13) and then for a third time in 1763 to 1764 (figure 14) when he shows them with the artist's tools with which he was teaching them to draw landscape. The vulnerability of his children was still at the front of Gainsborough's mind in this picture and when he wrote about his efforts to tutor them:

> I think I had better do this than make fine trumpery of them, and let them be led away with vanity, and ever be subject to disappointments in the wild goose chase.[43]

This complex description of the artist's feelings for his children combines a desire to protect them in the world with a clear lack of faith in their abilities, a nearly misogynistic view of their likelihood as women to be taken in by fashion, vanity, and the false promises of men.

The relationship of children to the natural world was perhaps best brought out by Sir Joshua Reynolds in the years after *Emile.* When Reynolds exhibited a portrait of Miss Sarah Price with sheep at the Royal Academy in 1770, the arbiter and collector Horace Walpole noted in his catalogue:

> Never was there more grace and character than in this incomparable picture, which expresses at once simplicity, propriety, and fear of her clothes being dirtied, with all the gravity of a poor little innocent.[44]

For Walpole, the pastoral portrait of a child is well suited to bringing out the gravity and innocence he situated in the child's nature. Yet how much can Miss Price be *of* nature if she fears sullying her clothing?

In later pastoral portraits, such as *Master Hare* (plate 2) of 1788, Reynolds modifies the format and eliminates the farm animals. He places the child in a landscape setting but brings him close to the viewer at the front of the picture plane to suggest the child's dominance of the landscape, his ease in the outdoor world, and his oneness with nature. Freely painted and well observed in the details of the boy's uncut locks and the ungendered frock that falls off one shoulder, *Master Hare* emphasizes the child's innocence and vulnerability (for

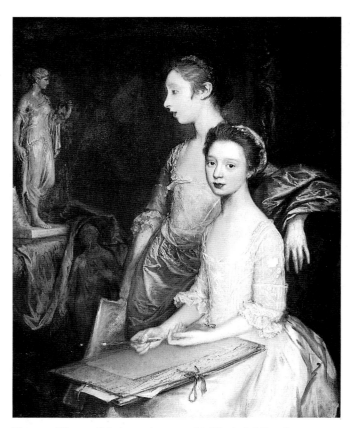

Figure 14. Thomas Gainsborough, 1727–1788, *The Artist's Daughters,* 1763–64, oil on canvas, 50 × 40 in. (127.2 × 101.7 cm), Worcester Art Museum.

the child is clearly very young) at the same time that it develops his power and monumentality. Paintings such as this one, engraved in 1790 by R. Thew and entitled *Infancy,* quickly became something of a prototype for the child of nature.

At the same time, *Master Hare* says more about its child sitter than this equation and comfort with nature. The outstretched arm is a gendered gesture of power, of possession of the landscape, and is thus an allusion to the child's future authority. It is a gesture absent from Reynolds's portrait *Penelope Boothby* (plate 16) of the same year. Penelope was the daughter of Sir Brooke Boothby, a student and friend of Rousseau's who played a major role in introducing Rousseau's philosophy to English literary circles, including that of Reynolds's patron the Duke of Dorset. *Penelope Boothby* is one of Reynolds's most successful child portraits, original in pose (framing the girl in a doorstep against a dark background) and skillful in its painterly execution. Yet, just as Master Hare is, in eighteenth-century terms, masculine and aggressive, Penelope Boothby is feminine and passive: her eyes are averted from the viewer in a sensitive downward glance while her oversized mobcap allies

her with her mother and emphasizes her diminutive stature. While Master Hare reaches outward, Penelope seems to look inward. The unfortunate Penelope, who died in 1791 at the age of seven, proved to be an important inspiration for neo-Romantic images of childhood, including the 1793 funerary monument by Thomas Banks in Ashbourne, Derbyshire, and Henry Fuseli's 1796 illustrations to Sir Brooke Boothby's book of verse entitled *Sorrows Sacred to the Memory of Penelope.* The sight of the Banks monument, where Penelope appears to be alive but sleeping, reportedly moved both the child's father and Queen Charlotte, very much the "new" royal mother herself, to tears.

Reynolds's portraits of Penelope Boothby and Lady Caroline Scott relate visually to the genre work of his French contemporary Greuze, as in the latter's *Young Boy Playing with a Dog,* shown at the Salon of 1769, or his *Boy with a Dog* (Wallace Collection, London). Reynolds may well have known both of these through engravings or through his 1771 visit to Paris and may have borrowed Greuze's habit of bringing the child to the fore of the picture plane. Reynolds's young girls are seen with sympathy, as are most of his child sitters of the 1770s and 1780s, but also with a characteristic sharpness and delineation of personality (rather than detailed physiognomy) that is absent in the work of Greuze. This discernment of character in very young children—Master Hare was only three years old when painted by Reynolds—placed Reynolds at the forefront of contemporary thinking about childhood.

Reynolds was greatly admired by contemporaries for his pastoral portraits of children.[45] For James Northcote, Reynolds's most notable student as well as his biographer, it was the naturalness and cohesion of child and setting that made such portraits memorable. Northcote recalled an encounter with such a portrait in conversation with William Hazlitt:

> I remember once going through a suite of rooms where they were showing me several fine Vandykes; and we came to one where there were some children, by Sir Joshua, seen through a door—it was like looking at the reality, they were so full of life—the branches of the trees waved over their heads, and the fresh air seemed to play on their cheeks—I soon forgot Vandyke![46]

Also in 1788, at the same time Reynolds was painting *Penelope Boothby,* John Hoppner produced the charming child portrait *Miss Charlotte Papendiek as a Child* (plate 17). Like Reynolds, Hoppner has brought

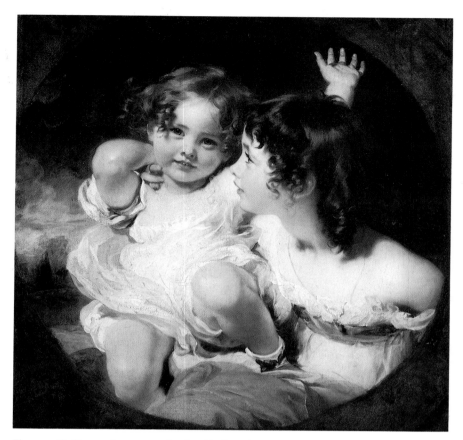

Figure 15. Sir Thomas Lawrence, 1769–1830, *Emily and Laura Calmady,* 1824, oil on canvas, 30⅞ × 30¼ in. (78.4 × 76.8 cm), The Metropolitan Museum of Art, Bequest of Collis P. Huntington, 1925.

his sitter close to the viewer, dropping the horizon line to very near the bottom of the canvas so that most of the backdrop is a tempestuous sky. Charlotte, the daughter of one of Queen Charlotte's attendants who was a prominent diarist of her time, is a remarkably self-possessed child. She stands primly, her hands folded gently against her apron, her head enveloped in a frilly mobcap. Her large, dark eyes engage the viewer directly, suggesting the presence of an individual personality.

Sir Thomas Lawrence inherited the mantle of the pastoral child portrait, like much else, from Reynolds. When he painted *Charles William Lambton* (plate 18) in 1825 he chose the by-then standard landscape setting. The landscape is less a backdrop than a tailored envelope to the boy's elegant, red velvet suit. It is a portrait of the contemplative child, derived from Martin Archer Shee's *Portrait of the Artist's Son,* which in turn derived from Reynolds's *Honorable Richard Edcumbe,* shown at the Royal Academy in 1774 and engraved by William Dickinson in the same year.[47] Young Charles sits in a chair seemingly carved out of a tree, as though it is now nature's role to accommodate this confident, even arro-

gant, sitter. Like the child himself, the landscape has become so exquisitely rendered as to be made decoratively harmless. Lawrence has pushed the child away, literally pushing him further into the canvas and figuratively pushing him away from the immediacy with which Reynolds depicted Master Hare. A critic writing for the *Morning Herald* thought the boy's air of "lofty contemplation" did not accord with his youth.[48] Another contemporary critic described *Charles William Lambton* as depicting a boy "enjoying a waking dream of childhood . . . for the moment, unconscious of external objects. His attitude is simple and natural—just as a child might throw himself down on a green bank, after being fatigued with sport, when the flow of his animal spirits subsides, without being exhausted."[49] The early nineteenth-century biographer of Lawrence, D. E. Williams, saw him as "simple nature, pure, artless, and unsophisticated . . . without any of the emblems used by painters to describe rank or wealth."[50] Surely the boy's crimson velvet suit must suggest wealth, and point out the artifice of his "attitude" in nature, but these are denied by early critics. Has the more immediate, probing innocence of Reyn-

olds's children by now become uncomfortable, even threatening, to be rendered harmless by the decorative and, elsewhere, the sentimental?

Lawrence's vivacious portrait *Emily and Laura Calmady* (figure 15) from 1824 suggests that this may indeed have been the case, for the girls are all flying limbs and curls and rose-tinted cheeks. They are convincingly childlike in the energy Lawrence injects into the canvas —where the girls are brought forward to the very edge of the frame, almost ready to burst out upon the viewer. Their beauty moves in the direction of a different kind of immediacy, one that is entirely emotional and lacks Reynolds's academic groundwork. D. E. Williams described the girls' beauty as "scarcely delicate enough for the child of a lady. It is rather the beauty & health of the rustic child who has played at the cottage door, or wandered in the sun to the meadows with the village children, gathering butter-cups and daisies."[51] This rusticity, while charming, held an inappropriate element of threat for an aristocratic sitter, or for a privileged viewer, as we shall see in Chapter Seven.

Works of art and literature such as these suggest a sense of intimacy between children and the natural world and are thus part of the rise of humanitarianism. While this may sound simple enough to the modern reader, it would have been impossible without the post-1762 promulgation in Britain of Rousseau's ideas on the child of nature. A letter by the influential poet and philosopher James Beattie about his 1771 *The Minstrel,* tracing the story of a shepherd boy who finds his education in nature, suggests the still-revolutionary quality of these ideas a decade after *Emile:*

> That a boy should take pleasure in darkness or a storm—in the noise of thunder or the glare of lightning; should be more gratified with listening to music at a distance than with mixing in the merriment occasioned by it; should like better to see every bird and beast happy and free, than to exert his ingenuity in destroying or ensnaring them—these and such like sentiments, which, I think, would be natural to persons of a certain cast, will, I know, be condemned as unnatural by others![52]

A decade later, Thomas Day's didactic children's book the *History of Sandford and Merton* (1783)[53] preached kindness to animals both as an expression of a child's goodness and as a way to learn the practice of charity before applying this skill to humans later in life. Day was close to the painter Joseph Wright of Derby, whose representations of children, such as his portrait of Frances

Warren of 1762 to 1764 (Collection of Mrs. Gerard Sweetman), seems to return to the seventeenth-century pastoral tradition, although with a different didactic purpose, one more behavioral than spiritual.

Beyond his interest in Rousseau's theories and contemporary philosophy, the childless bachelor Reynolds may have developed much of his thinking about children through his attachment to his niece Theophila Palmer, whose portrait at age fourteen he exhibited at the Royal Academy in 1771. Miss Palmer lived with Reynolds from 1770 to 1773[54] and often sat to him for portraits and fancy pieces, as, later, did her own daughter Theophila. The 1771 portrait naturally evolves from the sort of domestic observation made possible in a household environment. The details—the title *Clarissa Harlowe,* legible on the book's spine; the pages flaring open on the girl's lap; the lean of Theophila's head upon her hand—possess a domestic naturalism reminiscent of the work of Chardin (his *Young Governess* of about 1739, National Gallery of Art, Washington, D.C.). Still, placed within his oeuvre of child portraits, *Theophila Palmer Reading* is more than a response to Chardin. Reynolds is describing his affection for a particular child, an affection that is clear in a letter to Theophila of 12 August 1777:

> I never was a great friend to the efficacy of precept, nor a great professor of love and affection, and therefore I never told you how much I loved you, for fear you should grow saucy upon it.[55]

One senses that Reynolds must have been a difficult taskmaster for a young girl, withholding his affection in order to help develop character. Yet at the same time we learn that Reynolds could successfully paint children by entering into their world. His student James Northcote recalled how Reynolds would fix a child's attention during sittings by telling fairy stories,[56] remembering fondly:

> Grand rackets there used to be at Sir Joshua's when the children were with him! He used to romp and play with them, and talk to them in their own way; and, whilst all this was going on, he actually snatched those exquisite touches of expression which make his portraits of children so captivating.[57]

Perhaps it is not surprising to see that those artists who most convincingly depicted the world of children themselves often possessed childlike qualities or a childlike vision. Reynolds, for example, evidently wished to cultivate a childlike innocence in looking at art, saying of himself and his initial failure to respond to Raphael on his trip to Rome in 1749 to 1752 that "it was necessary . . .

that I should become as *a little child.*"[58] Northcote later said of him that he used "an innocent, childlike simplicity" to attract sitters.[59] Gainsborough wrote of himself when dying, "'Tis odd how all the childish passions hang about me . . . I am so childish that I could make a kite, catch gold finches, or build little ships."[60] When dealing with adults, he seems to have preferred the company and patronage of rather childlike people. George Morland was famous for avoiding polite society, yet according to his early biographers, he was always popular with children and "delighted to take part in their games, was lavish in his expenditure for them, and never happier than when making them happy."[61] For all these artists, the affinity with childhood was a source of inspiration. For William Blake, as we shall see, adopting a pictorial style with childlike qualities allowed him to subtly undermine the conventional themes of children's books and teach the adult reader to approach the world as a child would.

To those like Blake who believed in the inherent goodness of children, the negative view of children expressed by many was incomprehensible. One explanation was put forward in 1788 by the philosopher Bleken, who suggested that those who find the innocent behavior of children offensive must do so "because it reproaches them with the errors of acquired folly."[62] This neatly summarizes the dominant opposing viewpoints of the day: seeing children either as the Rousseauians' innocents corrupted by society or as the Calvinists' embodiment of original sin.

Parents also tell us much about the importance they placed on their children and why. For Frances Boscawen, children were not just a present good but also an assurance of her own future security, as she described in a letter of 1756 to her husband:

> I presume sometimes to look forward to future years, when you will be wrinkled and I shall be grey. Place each by the other's side in our warm, well-built mansion, surrounded with these your old friends; each will have his neat cabin to the rising sun; a large room and a good fire for all to assemble. We shall talk of old stories, admire the young plants, our sons and daughters. Set them to dance, or laugh round about a commerce table, with good cheer, good hours, good humour and good wine.[63]

George Romney, the temperamental artist likened by his early biographer and friend William Hayley to Rousseau, also found increasing attachment to children as he grew older, in this case the children of his landlord. He wrote in a letter of 18 July 1793:

The CHILD.

Man that is born of a Woman, is of few Days, and full of Trouble. He cometh forth like a Flower, and is cut down: He fleeth also as a Shadow, and continueth not.

JOB xiv. 1.

Man, who conceiv'd in the dark Womb,
 Into the World is brought,
Is born to Times with Misery,
 And various Evil fraught.

And as the Flow'r soon fades and dies,
 However fair it be,
So sinks he also to the Grave,
 And like a Shade does flee.
 E 2

Figure 16. Hans Holbein, 1497–1543, "Death seizing a child," from T. Hodgson, *Emblems of Mortality* (London, 1789), woodcut engraving, 3⅛ × 2⅛ in. (8 × 5.4 cm), The Pierpont Morgan Library, New York.

I have eight children to wait on me, and fine ones. I begin to feel the necessity of having these innocent little spirits about one, they give more soft delight to the mind than I can describe to soften the steps down declining life.[64]

Such attachment was not without risk, of course, despite improvements in the infant mortality rate. For Margaret Woods, writing to a friend in 1777, her children connected her to life but this was also a source of anxiety, for she was fearful of investing too much in the fate of precarious beings:

> My dear little cares . . . attach us strongly to life; and without a guard over ourselves, we are in danger of centring too much of our happiness in them. They may, indeed, in various ways, be deemed uncertain blessings, their lives are very precarious, and their

Figure 17. Benjamin West, 1738–1820, *Study for The Apotheosis of Princes Alfred and Octavius,* undated, pen, brown ink, and brown wash on cream paper, 17⁷⁄₁₆ × 11¹⁵⁄₁₆ in. (44.3 × 30.3 cm), Museum of Fine Arts, Boston.

future conduct proving as one could wish, not less doubtful. I already often look forward with anxiety, and the most ardent wishes for their welfare, in a state of permanent felicity. They are now pretty playthings, and pleasing calls of attention, and should be received with grateful hearts, as additions to our present comfort; but we should consider, that they may be blessings only lent for a time.[65]

Clearly, parents still worried about their children's futures, even if the actual dangers to them were diminishing in the years after 1750. Artists did not shy away from this reality, however, as in Allan Ramsay's immensely touching portrait of a dead child (plate 19), presumably the child whose birth also brought about the death of his first wife.[66] At the same time as this basically private picture was made—or one by Hogarth where it is difficult to determine if the child is dead or merely sleeping[67]—artists and public were still confronted with emblematic images of dead children, such as one after Hans Holbein published in 1789 as "Death seizing a child" (figure 16) in a volume entitled *Emblems of Mortality*.[68] Equally,

more public memorials to the death of young children were carried out, such as Benjamin West's *Apotheosis of Princes Alfred and Octavius,*[69] painted following their respective deaths in 1782 at age two and 1783 at age four. Preceded by numerous preparatory studies (figure 17), West's work was a commission from the king and incorporated traditionally emblematic elements such as the two cherubs at the top and the identifying backdrop of Windsor Park. The change we must situate is not just that it was becoming safe to love one's children, but that changes in values—the rising influence of Rousseau's theories of the child of nature, of the cult of Sensibility and its belief in the virtues of the emotions, of early Romanticism—altering the construct of childhood made it increasingly likely that parents would take this risk regardless of the dangers.

"Character" and the Painting of Portraits

Eighteenth-century beliefs about the nature of individuality and what was called "character" further fostered the diversity of Georgian images of the child, for these encouraged in parents a belief in the distinctive nature of the individual child and in childhood as a special time in life. Although many eighteenth-century writers questioned whether human nature could be understood at all, the philosophical debate, encompassing figures such as John Locke and Rousseau and biographers such as Dr. Johnson, James Boswell, and Mrs. Piozzi, focused on the integrity and permanence of the self[70] and was part of an increasing emphasis on the importance and distinctiveness of the individual. This included an expansion of the historian's and the painter's interests from the "great" men to the everyday—although the historian James Granger admitted that he had perhaps "extended the sphere of it [his writing] too far: I began with monarchs, and have ended with ballad singers, chimney sweepers and beggars."[71] So how did this extend to children and their representation?

As Richard Wendorf has remarked, "The art of presence is inextricably tied to the reality of absence,"[72] and it is perhaps the fundamental role of portraiture to evoke the presence of the absent sitter, often not merely absent but deceased. The theoretician Jonathan Richardson argued that the function of a portrait was to

keep up those sentiments which frequently languish by absence, and may be instrumental to maintain, and sometimes to augment friendship, and paternal, filial, and conjugal love and duty.[73]

The portrait could thus play a central role in developing the newly important attributes of familial love. And such a view must have found a ready audience—Reynolds claimed that he had been formed as an artist by reading his father's copy of Richardson's *Essay on the Theory of Painting*.

Richardson's view of the power of the portrait was repeated through the century. An anonymous critic writing in the *St James Chronicle* for 28 April–1 May 1781 commented that portrait painting "awakens, it fosters those tender Feelings which make life agreeable, and softens the Pangs of Absence." Dr. Johnson wrote of his friend Sir Joshua Reynolds's portraits that their great achievement was in "diffusing friendship, in reviving tenderness, in quickening the affections of the absent, and confirming the presence of the dead."[74] A viewer of the 1783 exhibition of the Royal Academy wrote of Gainsborough's portrait study of four-year-old Prince Octavius, who had died a week after the exhibition opened, that this child, "blooming in the natural health of Gainsborough's pencil, seemed to say, 'I yet live! Look at me!'"[75] Such thoughts both encouraged the artist to look into the sitter's personality and to appeal to the emotions of the viewer. Portraiture could then have a beneficial, even cathartic impact on the viewer that might, in Gainsborough's words, "regulate the judgment of others."[76] This emotional appeal was increasingly exploited after 1760 as part of the rising cult of Sensibility and the Age of Enlightenment's sense that self could be continually improved, even if Lord Chesterfield, in educating his bastard son to the most exacting standards, maintained that sentiment was distinctly middle class. Sculptural portraits on or alongside tombs figured prominently in Romantic thinking and shared with painting contemplative qualities of moodiness and melancholia at the century's end.

Ancestral portraits might also play a practical role, reminding the owner of family tradition, either real or invented in the case of new industrial wealth. Jane Austen, for example, satirized the upper classes for remaking their houses and forgetting their heritage. In *Persuasion* she describes the Musgrove family, found, "like their houses," in a state of alteration, perhaps of improvement:

> Oh! could the originals of the portraits against the wainscot, could the gentlemen in brown velvet and the ladies in blue satin have seen what was going on. . . . The portraits themselves seemed to be staring in astonishment.[77]

Austen underlines not the personalities of the sitters, nor their place in the affections of the living, but their emblematic value as living reminders of tradition and stability, which "family" has come to represent.

The visual arts were recognized, then as now, to contain certain limitations not faced by literary forms. In its narrative aspects and the time demanded of the reader to comprehend a text, literature was seen as fundamentally temporal, while painting and sculpture remained primarily spatial (with the exception of certain narrative friezes). Thomas Gainsborough was, for one, aware of these limitations when he wrote of the nonformal means available to enrich his pictures:

> Had a picture Voice, Action, &c to make itself known . . . , but on a face, confined to one view, and not a muscle to move to say here I am, falls very hard upon the poor Painter who perhaps is not within a mile of the truth in painting the Face only.[78]

Here the face alone, the portrait, holds the potential for failure to capture a "truth" seemingly more available to those working with the nonvisual. Still, we have seen that extra-narrative elements could be included which required more extended "reading" in order to reach the true meaning of a work, as in the emblematic and symbolic features in portraits such as Hogarth's *Mackinen Children* (figure 6). Other devices are also available to the artist to transcend the single moment: the narrative series, such as those by Hogarth, linked to the contemporary rise of the novel; multiple portraits of a single sitter over time, such as Reynolds's portraits of Johnson; allusion to the Old Masters or to history painting, as advocated by Reynolds in his *Discourses on Art* presented to the Royal Academy; and the personification of the sitter by association with various accompanying objects, such as those referring to the sitter's hobbies or career. In child portraits this might take the form of including a cricket bat in a formal portrait, as Joseph Wright of Derby does in his painting *The Wood Children* (plate 33), or the addition of children's toys in works by Hogarth such as *Lord Grey and Lady Mary West as Children* (figure 10). Once again this raises the question, which was introduced with Hogarth's *Graham Children* (plate 13), of when the emblematic detail becomes an element of narrative. Is the action of a child playing a music box or, as in Copley's portrait of the Sitwell children, rushing across a room merely symbolic, or does it also become a narrative of childhood? Can the emblematic be seen as revealing the artist's—or perhaps the sitter's—

constructs of childhood and thus the revelation of a kind of *internal* narrative?

Late in the eighteenth century, inventive use was also made of informal poses to suggest personality or the emotional state of the sitter. That this informality might first appear in the representation of children should not, then, be entirely surprising. We have already seen Hogarth using informal poses to portray children in *The Cholmondeley Family* (plate 3) in order to counteract the stiff formality of the adult world. At the same time, this informality seems to be inherently child*like,* a representation of how children actually behave as well as a comment on their growing independence and the separateness of childhood. Copley has taken up a similar motif in *The Children of Francis Sitwell, Esq.* (figure 8) only without such strong reference to the adult world. The children's realm seems removed from true adulthood yet available to the opportunities of the world through the use of the powerful symbol of the open window.

Personification and pose must both be seen as playing a special role in the representation of children, and indeed allegorical motifs are especially important in determining meaning in the portraits of children. In nonportrait areas, Reynolds suggests that the lower the art form—and the fancy picture and the landscape with figures both fall lower on the scale than portraiture— the more the embellishments of detail, color, light, and shadow are necessary.[79] Through such elements incorporating allusion and its iconographical possibilities, time can be, in Richard Wendorf's phrase, "either abolished or infinitely extended."[80]

In discussing the power of good portraiture, numerous eighteenth-century artists have argued that, in Reynolds's words, "Nature herself is not to be too closely copied," for to do so would be to deny the role of the imagination.[81] Instead, Reynolds argues that perfect form is to be found by "leaving out particularities, and retaining only general ideas." In painting the human form, this might include enlarging the proportion of the figure to the background field to create a sense of claustrophobia, intimacy,[82] or brooding intensity, as in Reynolds's almost monstrous infants. Especially in the madonna-like images of mothers holding their children, proportions could be exaggerated in a Mannerist vein, or the composition could be spatially eccentric, incorporating close-ups or foreshortening to emphasize individual character. Gestures, even ones of long-standing artistic use, could be

imbued with new, individual meaning for each sitter. With these options available to him, it is then, according to Reynolds, a question of the artist's skill in deciding which "circumstances of minuteness and particularity" to include to "give an air of truth to a piece"[83] and to appeal to the mind or the imagination—a skill demanding subtlety in selecting the secondary elements. Northcote goes even further to suggest that through these choices the "character, the degree of mental power, and peculiarity of disposition" are almost entirely the results of the painter's work.[84] The portrait then becomes a portrait not just of the sitter but of the portraitist as well—again a kind of internal narrative made visible.

Reynolds was scarcely alone in adopting new portrait devices. One of the more general transitions we can locate in the eighteenth century is the move beyond likeness,[85] away from the idealized representations of Lely and others and toward the expression of personality and emotion in portraiture. Northcote summarized this change by saying that "the great point is to catch the prevailing look *and* character."[86] Yet the move away from idealization involved fine distinctions, as is obvious to any modern viewer of late-eighteenth-century portraiture. Much of it, like Reynolds's *Master Hare* (plate 2), still appears greatly idealized. Certainly this is because of the need to capture character while still flattering the sitter, a challenge Reynolds acknowledged. He was critical of other artists for straying too far from flattery and is quoted by Northcote as criticizing his fellow painter John Opie for being

> too severe upon his sitters. Portraits are wanted by relations and friends, who see with the eyes of affection; a portrait-painter must be able to accommodate himself to these feelings, or he will not succeed.[87]

Although some artists may have regarded the child's face as a blank slate on which their own values could be inscribed, it was clearly felt that the issue of capturing character included portraits of children. When Lady Grantham writes her father in 1784 that "Sir Joshua is undoubtedly the best at discovering children's characters,"[88] she explicitly tells us that this interest in character and personality extended to representations of children, both in individual portraits and fancy pictures of known "types."

For many artists, this transition from likeness to "character" was insufficient to win their affection for the art of portraiture. As the most social form of art, with obligations to the sitter as well as his friends and family,

portraiture was bound by both social *and* artistic conventions. Thomas Gainsborough's opinion of portraiture is a contradictory one, for in his letters he continually railed against portrait painting (as did academician James Barry) yet at the same time wrote—to a patron—that mere likeness, rather than any more profound investigation, was "the principal beauty and intention of a Portrait."[89] Gainsborough's very impatience with "face painting" may have delayed his own discovery of the imaginative possibilities of the genre. His ultimate move from the doll-like figures populating landscape scenes to the elegant and intimate portraits of his London years is one of the great breakthroughs of his career. John Opie, too, as professor of painting at the Royal Academy, lashed out against portraiture, although he blamed its defects on the realities of patronage to which he felt enslaved:

> [the British artist] is condemned for ever to study and copy the wretched defects, and conform to the still more wretched prejudices of every tasteless and ignorant individual, however in form, features and mind utterly hostile to all ideas of character, expression and sentiment.[90]

James Northcote was at pains to explain the relatively low opinion in which portraiture was held in the eighteenth century and speculated that one reason for this was "the ignorant interference and dictates" of the patron, although he felt that Reynolds had escaped this failing by his own good judgment—and, presumably, his stature, which allowed him to persuade his patrons round to his own perspective.[91]

Some modern critics have argued that the chief merit of eighteenth-century child portraits is the complete freedom they afforded artists, unhampered by "the dictates of pride or vanity of adult sitters,"[92] as if patronage somehow became irrelevant. It would seem surprising if Hogarth, in painting *The Cholmondeley Family* (plate 3), or Reynolds, in painting *Georgiana, Duchess of Devonshire, with her Daughter,* entirely escaped the demands of their patrons, no matter how free the resulting canvases may appear by comparison with much contemporary work. The question of whether patrons did, in fact, hold back stylistic developments in the eighteenth century is an important one. With child portraits, the question becomes more complicated since the patron was most often a parent, and the resulting product could blend not only an artist's ambitions and a parent's feelings for his child but their respective constructs of childhood. As few patrons have left us their thinking as pa-

trons, it will be especially important, in Chapter Three, to look at their writings on parenthood.

When, characteristically of the period, the goals of portraiture began to merge with those of other genres, such as landscape or history painting, some critics saw this departure from the goals of likeness as a good thing. William Gilpin, one of the great theoreticians of the Picturesque, saw this departure from capturing likeness as a pleasing and a natural development. He wrote before 1776 that even Reynolds, left to himself in his portrait practice, would forsake the detailed likeness for something more picturesque: "He will throw the hair dishevelled about your shoulders,"[93] without regard to actual appearance. Edmund Malone, Reynolds's early biographer, wrote in 1797 that he particularly admired Reynolds's family groups for diving, as it were, "into the minds, and habits, and manners, of those who sat to him,"[94] perhaps because the family group allowed the artist to bring together multiple characteristics and the suggestion of narrative. Gainsborough's champion, Philip Thicknesse, wrote for his part in 1770 that Gainsborough "has exceeded all the modern Portrait Painters, being the only one who paints the mind (if we may be allowed the expression) equally as strong as the countenance."[95] The satirical critic Anthony Pasquin was, however, highly critical of what he saw as "a disposition in our modern Artists to make the portraiture independent of the person represented,"[96] a tendency for which he blamed Reynolds. While complimenting Reynolds's "genius in respect to composition and effect," he could not accept his lack of "Truth" through which "he has erected a silken standard of fallacy."[97] Similarly, Pasquin attacks Angelica Kauffman for her lack of Truth, particularly in painting children:

> Though Mrs Kauffman has convinced the world that she possesses much grace, she has not convinced them that she possesses much truth. Her children are not rotund, fubby, and dimply, but slender and juvenile. *Fiamingo* and *Guercino* have given us the true character of infants, which Mrs KAUFFMAN never understood.[98]

Elsewhere, he writes that all she can do is "design pretty faces and graceful attitudes, without any authority from nature to warrant the transaction"[99]—a sentiment concerning her child portraits shared by John Hoppner and Henry Fuseli from the late 1770s. Much of the difficulty for Pasquin and others on both sides surrounded the issue of "Truth," which might, at least in part, be equated

with "Character." Does it reside internally or externally, and of what does it consist? This was particularly problematic for the child portrait for there was no consensus on the "true character" of children, in Pasquin's phrase. Artists attempting to capture new elements—naturalism, the attributes of Romanticism—were not necessarily able to convince Pasquin and others of the validity of their departure from visible truth in search of something less tangible, more suggestive.

The physiognomy of children attracted interest throughout the eighteenth century, both in applied studies by artists and in more theoretical studies by philosophers. In the latter, Johann Lavater's *Essays on Physiognomy,* first translated into English in 1787 with plates by Henry Fuseli and reissued in 1789,[100] became the bible for the cult of Sensibility in portraiture, promoting the idea that sensibility and its openness to the emotions directly affects a person's appearance. Lavater cited George Romney's *The Warren Family* (exhibited at the Free Society of Artists in 1769) in this regard for clearly showing three varieties and attitudes of sensibility among the members of the family. Lavater wrote:

> Each perfect portrait is an important painting since it displays the human mind with the peculiarities of personal character. In such we contemplate a being whose understanding, inclinations, sensations, passions, good and bad qualities of mind and heart are mingled in a manner peculiar to itself.[101]

Of course, it was not the sitter alone who was to be affected by sensibility but the viewer who was to be sensitive *to* portraiture. Again, this dialogue with the viewer, who is now made privy to the true character of the sitter, establishes a kind of narrative in which virtue is extolled and through which constructs are developed.

William Hogarth also felt that the face was "the index of the mind." Surprisingly, for an artist who painted children with such frequency and originality, he argued in *The Analysis of Beauty* that children's faces possessed little interest. Hogarth wrote that "There is little to be seen by children's faces, more than that they are heavy or lively; and scarcely that unless they are in motion."[102] Is this because of a lack of character on the part of the child? A lack of distinctively individual personality? A few pages later Hogarth continues:

> From infancy till the body has done growing, the contents both of the body and the face, and every part of their surface, are daily changing into more variety, till they obtain a certain medium.[103]

From this one suspects that the "little to be seen" is for Hogarth a product of the constant change that a child's appearance undergoes, changes to which the adult artist is insufficiently sensitive or which may simply seem untrustworthy for being still unformed. The "variety" of the body may stand for the progressive development of individual character.

For Sir Joshua Reynolds, writing in his Third Discourse, outward change even in the developing child is superficial and immaterial. The artist's goal must be to find and understand the underlying "Truth" of the human body, which remains constant from childhood to old age. This truth in all sitters must include "that expression which men of his rank generally exhibit" in addition to "those expressions . . . which their respective situations generally produce,"[104] so that truth of character arises both from rank and role.

For some, like Reynolds, the presence of character combined with the "naturalness" of the child to form the perfect subject for art. Northcote reports:

> When Sir Joshua Reynolds wanted to learn what real grace was he studied it in the attitudes of children, not in the school of the dancing master, or in the empty strut or mawkish languor of fashion.[105]

Speaking for himself, Northcote continues:

> It seems to me that it is the absence of all affectation or even of *consciousness* that constitutes the perfection of nature or art . . . in the most ordinary actions of children, what an ease, what a playfulness, what flames of beauty they do throw out without being in the smallest degree aware of it.[106]

The child could thus provide something of a window into the untutored soul, prior to the corruption Rousseau equates with traditional education (Reynolds's dancing master). Henry Fuseli probes the physiognomy of childhood further, looking at links between grace and beauty, between the natural, the spontaneous, and the beautiful. Writing in a review of Uvedale Price's *Essay on the Picturesque* in 1794, Fuseli ponders:

> If the picturesque be founded on ideas of age and decay, in contradistinction to those of youth and freshness, it may be asked what are the principles from which the forms and actions of children derive their power of pleasing. It cannot be simply from beauty, if proportion and symmetry be as essential to that quality as softness and a smooth surface. Their parts melt not into each other by imperceptible undulation, but, when exerted, are marked by indents, folds and cuts, smooth indeed, but sudden. . . . The head, belly, and

knees of children preponderate over the neck, hips and legs. . . . Their action, sudden in its onset, rapid in its transitions, and unrestrained in reflection, surprises whilst it delights. Their expression, "naive," arch and equally contrasted by imbecility and appetite, now mimics the man, now shrinks back into the child, but never admits of languor. . . .

Perhaps the same reason which makes sketches more picturesque than finished pictures may be given for the superior picturesqueness of children and the young of all the creation: the elements of motion, form and growth exist, but the transitions from part to part are either not delineated, or abruptly marked.[107]

The transitions seen by Hogarth here become positive virtues, sources of delight. The awkwardness of the unformed child is to be admired and valued, even preferred to the grace of the adult of the species. By the end of the eighteenth century, the painter's attraction to the child, to his "picturesqueness," is a given. Only the reasons are still unresolved. Fuseli summarized his view of children elsewhere by writing:

All actions and attitudes of children are graceful, because they are the luxuriant and immediate offspring of the moment—divested of affectation and free from all pretence.[108]

Fuseli is thus very much in the camp of Rousseau's followers, claiming special virtues for childhood and capping a century that reclaimed the innocence of children.

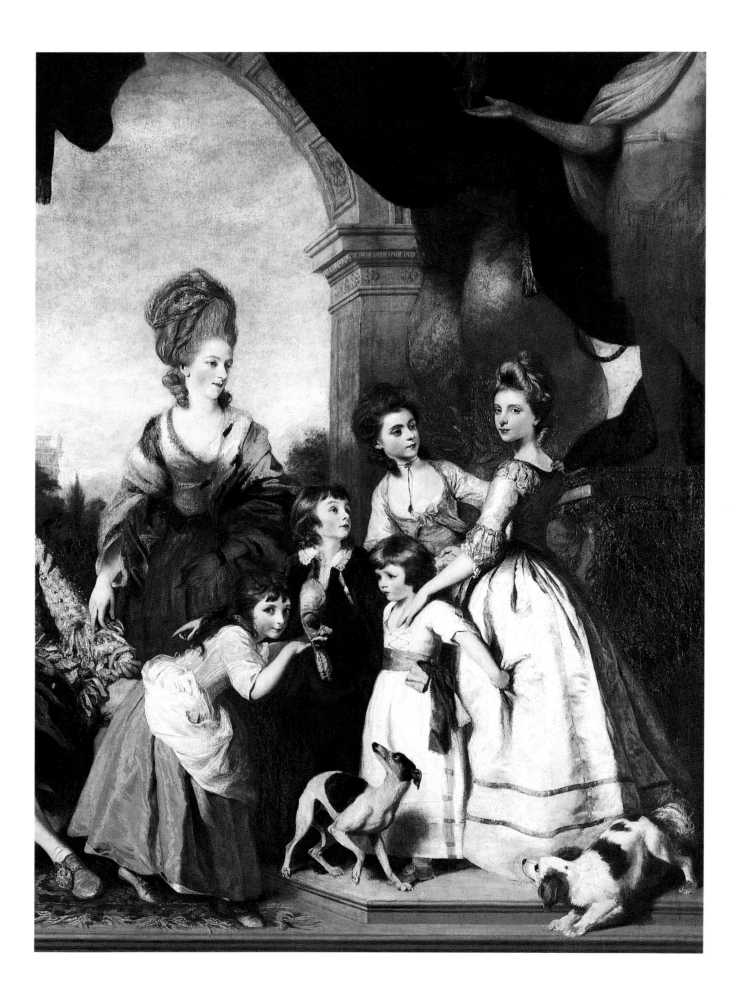

Chapter Three / *The Georgian Family and the Parental Role*

Parents, artists, and other writers of the Georgian period have left ample evidence that the company and presence of children was to be enjoyed—in practice as well as theory. It is clear from their own words, however, that the parents' paramount concern was for the child's future well-being, for his future role as a useful member of society, rather than for the child's present happiness. This often carried with it a conflict for the individual parent that does not pass without notice—how to reconcile the love and affection felt for an individual child or for children in general with the need to engender lifelong values. Even when servants did much of the practical child-rearing, as was true of much of the middle and upper classes, primary responsibility for raising the child resided with the mother, and general direction was to come from her, although increasingly education became the responsibility of the father. With this basic structure in mind, we must ask from what sources came this division of parental responsibility. Does the visual record of the Georgian period carry the same values and morality inherent in literary texts? Perhaps a few examples of family portraiture will help frame the question.

As suggested in Chapter One, the development of the conversation piece, the formal portrait of a group of figures interacting, or in "conversation," lent itself well to the domestic family portrait. William Hogarth used it brilliantly in *The Cholmondeley Family* (plate 3) to illustrate the distinct worlds of adulthood and childhood, with few linkages between the two. The symbolic inclusion of the deceased mother in the portrait group allies this type to a more aristocratic form of portraiture, while the playfulness of the boys brings into question the notion of paternal, indeed parental, hierarchy. Yet it is telling that in the history of Hogarth criticism this element is either overlooked or denied.[1] This denial is in itself interesting, revealing a critical tendency to affirm rather than question the hierarchy that is fundamentally at odds with Hogarth's own purpose, simultaneously appealing to aristocratic tastes and getting in his own attack as a socially engaged artist. Instead, the children inject a bit of life and nature into what Ronald Paulson has called "stuffy systems of social order,"[2] systems in which Hogarth himself did not truly belong. Here the stuffy system is the oppressive family Hogarth is cleverly undermining, and the weapon is the children who are part of the family but who have not yet grown to adult responsibility and seriousness. The children undermine hierarchy in a variety of ways: direct disobedience or disregard of an adult figure, inattention and an insistence on childish behavior (and thus a rejection of the adult model), and a general impending dissolution of order (the precarious climb). All the while that Hogarth seems interested in the realistic gaiety of children, his true subject seems to be the question of aristocratic, patriarchal authority. Hogarth's subtle rebellion—and indeed the rebellious exploits and ambiguous parentage of a *Tom Jones* or a *Joseph*

Figure 18. Sir Joshua Reynolds, 1723–1792, *The Family of the 4th Duke of Marlborough* (Red Drawing Room, Blenheim Palace, Oxfordshire), 1778, oil on canvas (detail, see plate 4), reproduced by kind permission of His Grace The Duke of Marlborough.

Andrews in contemporary English prose fiction—seems to be against not only a specific patron but against the increasingly dominant family unit in early Georgian Britain.

Sir Joshua Reynolds incorporated elements of childish play in an early family portrait, *The Eliot Family* (Collection of the Eliot Family) of 1746. Despite its inspiration from Van Dyck's grand-scale *Pembroke Family* at Wilton House, *The Eliot Family* retains the small scale of the conversation piece and, perhaps owing to the relative informality of the genre, some of Hogarth's playfulness. Focused on an adult son and heir, *The Eliot Family* nevertheless is one of few works in Reynolds's oeuvre in which children are allowed to romp freely. One of the Eliot boys runs in from the left, while one of the smaller children is carried on the back of Captain the Hon. John Hamilton, who in 1749 married the by-then widowed Mrs. Eliot and became stepfather to her children.[3] As in the Hogarth and Reynolds's *Family of the 4th Duke of Marlborough* (plate 4 and figure 18), examined in Chapter One, playfulness is allowed to exist within the sphere of adult supervision.

That Reynolds has injected a grand manner portrait with elements of playfulness does not undermine the fact that *The Family of the 4th Duke of Marlborough* is ultimately a hierarchical portrait that does not question the respect due the august figure of the duke. He adopts the pose used in the seventeenth century to depict nobles and high church officials—the same pose used by Hogarth for Lord Malpas in *The Cholmondeley Family*. The child's play with the mask invites complicity on the part of the viewer, yet at the same time ultimately derives from the activity of the father. The motif of the grotesque mask probably comes from similar scenes on classical gems and sculpture—from the very world of connoisseurship the duke epitomizes. This motif, engraved on its own right in 1790 by Schiavonetti and, later, by Turner as "The Ghost," suggests a link between the world of children and the masculine world of the father.

When Horace Walpole saw this work at the Royal Academy in 1778 he noted in his catalogue that he disliked its formal elements, such as the duke's pose and "flat and bad" coloring, "killed by a red velvet curtain,"[4] but he enjoyed the children and the dogs. The tremendous social importance of the Marlboroughs, as well as the scale of the painting, insured a barrage of critical responses in the press. The *Morning Post* singled out the "ingeniously appropriate" employments of the figures, including the children, for admiration,[5] all the while criti-

cizing the parents' faces for lacking "that benign satisfaction consequent on such a situation," having such a noble family so nobly depicted. The *General Evening Post* admired the "beautiful simplicity" of the eldest son's head "which it is impossible to describe."[6] A critic for the *Public Advertiser* wrote that "there is great Truth and Nature in the Action and Expression of the Child's Countenance,"[7] referring to the child recoiling from the mask. Throughout this criticism, the vocabulary used—simplicity, truth, nature, appropriateness—suggests an awareness of the theories of Rousseau and an acknowledgment of the construct of childhood.

Ultimately, Reynolds's ability to speak of the world of children and of adults in the same painting suggests a kind of entente between the two, itself inspired, according to Reynolds, by the Venetian school. In a draft of the Thirteenth Discourse, Reynolds wrote:

> The Venetians like the wild imaginations of Tasso and Ariosto—the same mixture of serious and ludicrous. If Paul Veronese introduces boys playing with monkeys, dogs and cats fighting for a bone; so Ariosto treats you with a ludicrous episode in the midst of a grave narrative.[8]

Reynolds's "grave narrative" is the dynastic family portrait with childhood play as its "ludicrous" counterpoint.

Hogarth returns to the painted commentary on family hierarchy in *A Fishing Party* (plate 20) of about 1730. Here, a child, either restrained or held upright by an anxious nursemaid, holds a fishing rod with the help of his mother. This threesome—the child, the helping mother, and the controlling servant—is closely linked by their gazes, their arm gestures, and the warm surrounding light. Meanwhile, the father has been banished to the lower left of the canvas.[9] Seen in shadow with his back to the viewer, he baits the child's hook. This father is irrelevant despite the mother's rather feeble gesture toward him which succeeds only in heightening his peripheral relationship to the mother-child unit. Is this unidentified family participating in a shift of the family structure? Hogarth again seems to undermine a patriarchal structure through compositional means, here to the advantage of the domestically based, mother-child (-servant) relationship.

Similarly, Hogarth's portrait of 1733 of Mary Edwards with her husband, Lord Anne Hamilton, and her son, Gerard Anne (Tate Gallery, London), is not only a portrait of a child with his parents but is part of a larger comment on domesticity. Mary Edwards holds a copy of

Figure 19. Benjamin West, 1738–1820, *The Artist's Family,* 1772, oil on canvas, 20½ × 26¼ in. (52 × 66.5 cm), Yale Center for British Art, Paul Mellon Collection.

the *Spectator*—a publication espousing many of the domestic virtues of the Georgian middle class—open to a passage on the virtuous rearing of children as she gestures to her child with her other hand. Clearly she intends to remind her husband of his fatherly duties, a heavily ironic statement to early viewers of the canvas as the infamous Lord Hamilton was an irresponsible spendthrift, and the marriage was widely known to be an unhappy one.[10] Here, Hogarth, speaking for the mother (a close friend to the artist, and here his patron), upbraids the bad father for neglecting his proper role.

Hogarth was not alone in his use of the conversation piece as a commentary on the family. Provincial artist Arthur Devis was the most prolific English artist to work in the genre at this time and came closest to defining the essentials of the genre. Drawing on disparate influences such as the French Rococo, the work of Gabriel Metsu and Pieter de Hooch in Holland (Devis had been a pupil of the Antwerp artist Pieter Tillemans), the English country house portrait, and the social aspirations of a rising middle class, Devis worked primarily with country gentlemen and their families. His patrons could not afford, or had no contact with, the more cosmopolitan Hogarth. Devis's style is marked by its linearity and its

lack of visual connection between figures, whose doll-like appearance is partially accounted for by Devis's use of small mannequins (complete with their own wardrobes) in composing his scenes. In Devis's family portraits, such as *The John Bacon Family* (plate 21) of 1742 to 1743, the overall tone is one of formality—a transference of aristocratic aims to bourgeois clients. It is an image of familial contentment, again deriving from Samuel Richardson's domestic ideal as expressed in *Pamela, or Virtue Rewarded.* The sitters' possessions and collections dominate the diminutive figures conveying a pseudo-past of Roman and English heroes—a past invented to suit the sitters' newly achieved position and lay their claim to the shared history of the nation. We learn about the figures not through pose or movement or expression but from the objects that surround them, and yet, even so, relationships emerge. One son, standing with his father, holds a flute and sheet music as a sign of his musical accomplishment. Another child leans affectionately toward her mother, while to the side, in relative independence, two children build a house of cards. The setting tells us the most about the father. The Palladian drawing room with medallion portraits of Milton, Pope, and Newton, along with a number of

Figure 20. George Stubbs, 1724–1806, *The Wedgwood Family*, ca. 1780, oil on canvas, 48 × 60 in. (121.9 × 152.4 cm), Trustees of the Wedgwood Museum, Barlaston, Staffordshire, England.

scientific instruments, describes the senior Bacon's taste and intellectual milieu as a Fellow of the Royal Society. The children are largely projections of their father, blank slates onto which the requisite talents can be written. The painting is an image of restraint and refinement along Whig lines, into which, like most of Devis's work, only the quietest of moralizing comments is allowed to intrude.

Johann Zoffany carried on the family conversation piece in a more sophisticated context in works such as the marvelous *Lord Willoughby de Broke and His Family* (plate 22).[11] Seen in the breakfast room at their home at Compton Verney, the family is presented in a scene of domestic tranquility. The seated Lady Willoughby supports her youngest daughter on the breakfast table, holding up the girl's skirt to keep it out of their tea dishes. A boy standing to the left of the table reaches up to take a sandwich from a teaplate. As he does so he looks up, across the mother-sister pair, to meet his father's glance and reprimanding finger. A second son pulls a toy horse along the floor at the right under the affectionate gaze of his mother. Motifs such as this were admired, albeit humorously, by some eighteenth-century critics, including the pseudonymous Roger Shanhagan who wrote of a similar motif in a Copley family portrait of 1779:

He is also acquainted with the business of Toy-makers and Milliners, for who but them could have invented and decorated that useful and ornamental play-thing, with which the child upon the floor seems to divert itself?[12]

Shanhagan then retitles the Copley work "A Gentleman's Family and Furniture." In the Zoffany, all is warmth—the tones of a Turkish carpet, the fire in the hearth, the landscape painting above the mantelpiece—to stress further the familial interaction and the parents' gentle instruction (rather than harsh discipline). Although this painting seems to have escaped contemporary critical notice, Benjamin West's conversation piece of his own family of 1772 (figure 19), in which he played on the myth of his Quaker background, was reviewed by a contemporary as "a neat little scene of domestic happiness, and does the artist credit on the score of his feelings."[13] West paints an aura of light around his wife and her newborn child, Benjamin West Junior, underscoring the atmosphere of contentment and tranquility in the haven of the artist's home. West saw the picture as one representing the ages of man, but the critic for the *General Advertiser* saw it far more personally, and questioned West's taste in exhibiting such a personal subject.[14]

A number of artists created portraits of domestic happiness, from Henry Walton's *Sir Robert and Lady Buxton and their Daughter, Anne* (plate 23) to George Stubbs's portrait of the Wedgwood family of about 1780 (figure 20) to David Allan's *Family of the 7th Earl of Mar at Alloa House* of 1783 (plate 24). Walton was a student of Zoffany's who largely painted genre scenes in the late 1770s and came closer than any of the other artists we have seen to the work of Greuze and the *genre sérieux*. Walton's portrait of the Buxtons is tonally restrained, a muted palette of gray, pink, and olive green, relying on a rather arid composition to focus the viewer's attention on the sitters. Young Anne, about age four, links her parents together as part of a ladder effect created by her father's arms and the back of a small chair. Anne looks at the book her mother holds, so that the scene is not just one of family harmony but of education. Like Stubbs in his somewhat plain but intelligent portrait of the Wedgwoods, the Scotsman David Allan takes the Earl of Mar's family outdoors, depicting four generations of the earl's family in the landscape park at Alloa. The composition takes a number of features developed by artists such as Devis—the park setting, the family home in the background, the figures ranged horizontally across the canvas —and uses them almost formulaically. Yet Allan's clear interest in children, especially the young boy who takes aim with his bow and arrow at his hat suspended high in a tree, elevates the painting to a higher standard. The level of incident is high—another child plays the pipes,

an infant crawls on the ground at the left—and suggests the peaceable kingdom of the aristocratic family at its ease. It is scenes such as these that J. H. Plumb had in mind when he accurately wrote:

> The implied happiness of the husband and wife with their children [marks] a vital social change in eighteenth-century life. In the seventeenth century, upperclass children had spent little time with their parents, who were concerned to maintain an oppressive patriarchal authority, but in the art of the late eighteenth century, we find children everywhere—making music, sketching, riding, visiting ruins, picnicking with their parents—sharing with them the pleasures of the mind, the body, and the heart.[15]

This art was so widespread by the 1780s that it became the subject of satire, as in Henry Bunbury's *A Family Piece* of 1781 (figure 21). This stipple engraving shows a family group posing on a dais, as they would have done in Reynolds's studio, with the "ennobling" attributes of the parents' two doves and the emblems of Cupid the child holds in his hands. Rather than seeking to mock Reynolds or other portrait painters, *A Family Piece* ridicules the "Cits," the rich city merchants who had the money but not the taste to appreciate the new portrait style and who aped the tastes of the aristocracy. The coarseness of the sitters is, nevertheless, mediated by the painter in his work-in-progress, summarizing the struggle over character and likeness in a genre as patron-driven as portraiture.

A FAMILY PIECE.

Figure 21. William Dickinson, 1746–1823, *A Family Piece,* 1781, stipple engraving after the drawing by Henry William Bunbury, 9⅞ × 14½ in. (25.1 × 36.8 cm), Print Collection, The Lewis Walpole Library, Yale University.

Childbirth and Nursing

Historians of childhood have differed in their interpretations of parental response to the birth of a child. Elisabeth Badinter has argued, for example, in *L'Amour en plus,* that the average eighteenth-century parents remained unconcerned about the survival of their babies and that it took one hundred years after the publication of *Emile* for most parents to cherish their children.[16] Others, such as Lloyd de Mause, believe that the change to a more "intrusive" mode of child care, which gave rise to the field of pediatrics, was the result of new thinking that children were no longer "full of dangerous projections," and thus much less threatening. De Mause further suggests that this change was well under way late in the eighteenth century.[17] Lawrence Stone strikes a position between the two, stating that De Mause is right only for the landed and professional classes,[18] whereas the poor remained indifferent to the birth and survival of offspring until much later.

Linda Pollock suggests that one of the reasons for the discrepancy in these interpretations has been an overreliance on child advice literature, which may have had relatively little impact on and was not necessarily the same thing as actual parental practice.[19] A wise approach then would be to study a variety of texts in order to discover parental attitudes as well as practice. When we do this, we find ample evidence that parents, both mothers and fathers, rejoiced in and agonized over the birth of a child. In 1775, the biographer and man of letters James Boswell reacted with anxiety to the birth of his first son:

> When I had seen the little man I said that I should now be so anxious that probably I should never again have an easy hour. I said to Dr Young with great seriousness, "Doctor, Doctor, Let no man set his heart upon any thing in this world but land or heritable bonds; for he has no security that anything else will last as long as himself." My anxiety subdued a flutter of joy which was in my breast. I wrote several letters to announce my son's birth. I indulged some imaginations that he might perhaps be a Great Man.[20]

Boswell's mixture of apprehension over the fragility of the newborn child and his anticipation of future pride is touching, yet it emphasizes the extent to which the child's birth is a foretaste of future joy. Superficially, Boswell seems to hold his emotions in check because of the fear that his son may not endure, but at the same time there is a sense that the boy, his "little man," is valued for what he will accomplish one day, rather than cherished for his own sake. For other writers, the birth of a child could be emblematic of something other than future promise, most notably the concept of "family" itself. Melesina Trench in her memoirs recalls her delight at the birth of her first child in 1787, when she was just nineteen, where she describes not only the birth of a child but that child's role in cementing the bonds of the family:

> The delight of that moment would counterbalance the miseries of years. When I looked in my boy's face, when I heard him breathe, when I felt the pressure of his little fingers, I understood the full force of Voltaire's declaration "Le chef-d'oeuvre d'amour est le coeur d'une mère" [The masterpiece of love is a mother's heart] . . . My husband's delight in the birth of his son nearly equalled mine. My love for *him,* the father of my child, grew in strength, and I looked upon myself as the happiest of women.[21]

The child again holds the promise of future happiness, a form of protection against the encroachment of age. At the same time, the mother's feelings for this child are the embodiment of the most perfect love—a concept the writer has, tellingly, borrowed from the great Enlightenment philosopher and one that contradicts the primacy of divine love. Yet this love for her child, expressed directly, is to some degree contradicted by the emblematic value the child holds, speaking to the future and to bonds between spouses.

The birth of a son was to be preferred to that of a daughter throughout the Georgian period, at least among the aristocracy, which needed to produce male heirs. On the delivery of a son in May 1790, the Duke of Devonshire paid 13,000 pounds into his wife's bank account to pay off her debt—it was understood even at the time that this was payment for services rendered.[22] The actual practice of delivering a child went through one profound change away from male domination in the Georgian period that speaks to the larger question of domesticity. Most childbirths still occurred under the paternal roof until the early nineteenth century. By 1830, this had changed and childbirth most frequently took place in the presence of the maternal family.[23] Even here, paternal ties were loosening, at the same time that domesticity was becoming fully normative. The demise of absolute paternal authority was not to be institutionalized, however, until the Infant Custody Act of 1839 gave women the right, in the event of legal separation from their husbands, to the custody of their children under the age of seven, officially recognizing the importance of the "maternal instinct" for both mother and child.

It is important to remember that not all women treated childbirth as a blessing. The agony of childbirth was a bonding experience among women who shared as battle stories "the horrors, miseries, terrors" of childbirth.[24] Frances Boscawen admits to having a terror of childbirth—not an irrational fear for an age when women frequently died in childbirth. Yet this implies no lack of love on her part for the children she bore, for she later wrote her husband at sea:

> Have no anxious thoughts for the children. Assure yourself they shall be my sole care and study and that my chief purpose and the business of my life shall be to take care of them and to procure for them a sound mind in a healthful body.[25]

Eventually, with the rise of affective individualism, pregnancy became the cause of some despair for maternal parents, fearing the risk to the pregnant woman who could in fact become apologetic about her condition. Even the occasional husband might feel this anxiety at the threat of childbirth, the need for heirs at odds with the well-being of their wives. One such husband, Lord Morley, wrote his sister in 1809 that his bride of two months, already pregnant, "suffers a great deal. . . . It requires a great deal of logick indeed to persuade me that it is a good thing."[26] At least until the use of anesthesia began in the nineteenth century, childbirth became the critical rite of passage in a woman's life.

After the trauma and joy of childbirth, the most pressing question for women who could afford the choice was whether or not to breast-feed. The alternative was the practice of wet-nursing, of sending the child to a woman of the lower class to be breast-fed, a choice that was commonly made by women of the upper classes.[27] The upper classes widely believed, at least until late in the century, that women who were nursing needed to abstain from sexual intercourse to avoid spoiling their milk. For parents in this group, it is probable that the impulse to send children out to nurse came equally from the fathers' wishes to resume their conjugal relationship and had little to do with intended neglect of the child. Georgiana, Duchess of Devonshire, wrote in this regard in 1783 that she resented the "abuse" she received from her husband's relatives for nursing her daughter because of "their impatience for a son and their fancying I shan't so soon if I suckle."[28]

Yet wet-nursing came to be seen as the very embodiment of willful neglect on the part of parents who were privileged enough to know better and to have alternatives. The practice came under attack by Rousseau and others, arguing that mothers of all classes should nurse their own children. For Rousseau, nursing was an important act that would indirectly promote the view of the family as an intimate social unit, based on specific, often physically rooted, bonds of affection. Although pleas in favor of maternal breast-feeding had been made as early as the sixteenth century,[29] this is one area in which eighteenth-century parenting underwent a true revolution. Upper-class parents who had used wet nurses—and the percentage is difficult to determine—came under pressure to give up the practice after the publication of *Emile* and many other tracts, notably with Dr. William Cadogan's influential 1748 *Essay upon nursing and the management of children*, which went through twenty editions by the end of the century. Cadogan argued that all children should suck their own mothers with very few exceptions, as this is healthier for both mother and child. He wrote, "I could wish, that every Woman that is able, whose Fountains are not greatly disturbed or tainted, would give suck to her child,"[30] at least until the age of three months after which meat broth could be added to the child's diet. Throughout Cadogan's advice, it is significant that he does not allow for a single stage in development when wet-nursing is appropriate, and he assumes that parents *naturally* have affection for their children. Breast-feeding is ultimately to the father's good as well, and Cadogan gives him responsibility for supervising the management of his child's feeding rather than suffering it "to be made one of the Mysteries of the *Bona Dea* from which the Men are to be excluded."[31] Even so, Cadogan argues that the child should be dressed by, and allowed to sleep with, an able servant. William Buchan, writing in 1772, largely agrees with Cadogan but argues that mothers, including those who cannot give suck, should supervise the nursery directly. Christian August Struve, writing in 1801, continues this line of argument, suggesting that women who entrust the care of their children to servants are guilty of "a criminal species of indulgence and are unworthy of the sacred name of mother."[32] Neither Cadogan, Buchan, nor Struve explicity cites as justification for this direct parental intervention the widespread concern that, as William Darrell wrote, peasantry was a disease, like the plague, that was easily caught. It was therefore best to protect the child within its own social class.

Diaries attest to a combination of breast-feeding and wet-nursing.[33] The most common complaint in breast-

Figure 22. Anonymous [Thomas Rowlandson], 1756–1827, *Political Affection*, 22 April 1784, engraving, 8¾ × 12⅞ in. (22.3 × 32.7 cm), Trustees of the British Museum.

feeding was insufficient milk,[34] which might lead even the best-intentioned parent to seek out a wet nurse. Mrs. Thrale breast-fed her first child for a time but stopped because she (Thrale) lost too much weight. James Boswell and his wife chose to have a wet nurse but had trouble with the first they engaged and had to find a second. She, happily, was "an excellent one," and their son "was visibly fuller in flesh and healthier in looks."[35]

The late eighteenth-century movement against wet-nursing on the part of reformers had a practical foundation, however, for the mortality rate for wet-nursed children was substantially higher than the average. This is possibly due to the fact that wet nurses took in many children at the same time, and they could then end up being nutritionally deprived. The result was the severe irony of wealthy and privileged babies suffering malnutrition—and therefore greater susceptibility to disease—merely because of an accepted social practice, at a time when malnutrition among the poor was widespread. Cadogan saw this as one of the great risks of wet-nursing, arguing somewhat erroneously that poor children were healthier than wealthy children because, in part, they were breast-fed by their mothers. Neglect could come in other areas as well, as in Elizabeth Holland's letter where she wrote, "I was brought to bed of a lovely boy in October, but owing to the neglect of the nurses he fell into convulsions and died."[36] John Stedman wrote at the

outset of his published diary of having been sent to a series of four wet nurses:

> The first of these bitches was turn'd off for having near suffocated me in bed; she having sleep'd upon me till I was smother'd, and with skill and difficulty restored to life. The second had let me fall from her arms on the stones till my head was almost fractured, & I lay several hours in convulsions. The third carried me under a moulder'd old brick wall, which fell in a heap of rubbish just the moment we had passed by it, while the fourth proved to be a thief, and deprived me even of my very baby clothes.[37]

After this, his beleaguered parents gave up and had the boy weaned, albeit earlier than planned, at age ten months.

Lower-class children could also be sent out to nurses, as in the practice that arose around 1760 of boarding out London's pauper children to nurses in the country. The parish of St. James, home to William Blake and many other artists, began to send its pauper children to nurses at Wimbledon Common from 1762. This practice grew in response to the extraordinarily high death rates of urban pauper infants: of one hundred London pauper children under the age of twelve months in 1763, only seven were alive two years later.[38] The success of this program is clear some twenty years later when poor children sent to nurse in the country had a much greater chance of survival than did their urban counterparts: in

1783, impoverished London mothers lost twenty-four of fifty infants while rural nurses lost only two of the seventy-seven infants consigned to their care.[39] Such success must attest to an unusual degree of care in the selection and supervision of the wet nurses and should not be taken as a sign of the health, in the abstract, of the practice.

The popularization of breast-feeding among the middle and upper classes is substantiated by numerous letters and diary entries, most frequently by mothers themselves. One mother, Sarah Pennington, writing in a private letter of about 1760 that later found its way into an instructional volume on parenting, gives directions on child care:

> Let us begin with food and raiment, the two first things necessary. The former I know you will, if possible, administer yourself in the manner nature has intended; where this happens, by some accident, to be impracticable, which is very rarely the case, cow's milk . . . is by far the best substitute. . . .
>
> All Children will discover their desire of food by motions that plainly show them to be searching for something; these motions will be continued a considerable time without any cry, which is only the consequence of repeated disappointments in this search; such signs from them should always be waited for, carefully observed, and immediately answered.[40]

Much is suggested here that is indicative both of the mother's constant attentiveness to the infant's needs—dominant over the mother's other obligations—and of contemporary attitudes toward nursing. She is certain that the reader of her letter will naturally choose to breast-feed if at all possible, citing the new and irrefutable authority of "Nature." The cessation of breast-feeding is described by the Quaker Betty Bishop's diary entry for 1787 as painful for both mother and child; she describes weaning her two-month-old daughter:

> Little dear Betsy brave and very quiet considering she has no breast. I began weaning of her yesterday morning on account of my nipples being so bad but very little milk.[41]

Bishop's entry suggests her own regret at the need to wean her child, mandated by the need to properly nourish the child.

As we have seen in Chapter One, George Morland's *A Visit to the Child at Nurse* (plate 9) was a powerful visualization of the dangers of wet-nursing. Few artists seem to have taken up this theme—propriety seems to have demanded that nursing remain largely unillustrated. One exception, however, is Thomas Rowlandson's "anony-

Figure 23. James Gillray, 1757–1815, *The Fashionable Mamma,—or— The Convenience of Modern Dress,* 15 February 1796, hand-colored etching, 12⅜ × 8 11/16 in. (31.4 × 22.1 cm), Print Collection, The Lewis Walpole Library, Yale University.

mous" satirical etching *Political Affection* of 1784 (figure 22), attacking the Duchess of Devonshire for her political campaigning in the Westminster elections. The duchess is seen suckling an oversized fox, standing in for Charles James Fox, the candidate, while her own child, the nine-month-old Georgiana, cries unnoticed in the corner. The contrast of beauty and bestiality was something of a trademark of Rowlandson's, playing against the popular knowledge of "Roman Charity" images. *Political Affection* suggests that the Duchess Georgiana's advocacy of breast-feeding was well known in 1784 (see below), while putting her in her place for stepping too much outside the home and creating a public role for herself. Equally satirical but now focused on the suckling of a real child is James Gillray's *The Fashionable Mamma, —or—The Convenience of Modern Dress* (figure 23), published in 1796. Gillray comments cynically on the new-found popularity of breast-feeding among the upper classes, apparently intended as a "public admonition"

for a specific viscountess.[42] Gillray's noblewoman is shown nursing her child through breast-high slits in her gown, yet she cannot even hold her own child. For this, a sweetly smiling maid is employed, contrasting sharply with the icy rigidity of the mother. The painting on the wall behind her, labeled "Maternal Love," provides the lesson for our noblewoman, impatient to be off in the waiting coach, as well as an ironic counterpart to her failed maternal instincts.

Like wet-nursing, the practice of swaddling infants to the age of ten or twelve weeks was common until the mid-eighteenth century, out of a belief that this would insure the correct development of the limbs. Leading strings, described by Charlotte Papendiek, lady-in-waiting to Queen Charlotte, as "a band round the waist, with a loop on each side, of a length to hold, so as to support the child in case she should tumble,"[43] and recommended to her by the queen, had a similar restrictive role in somewhat older children[44] in preventing their movement and equally came under attack.[45] Both were about the safety, immobility, and, symbolically, the control of the child. The move against the use of swaddling and leading strings came from various quarters, the first of which may have been John Locke. In Richardson's novel, Pamela reads Locke's *Thoughts Concerning Education* and agrees that children are clothed too tightly.[46] In Pamela's words:

> How has my heart ached many and many a time when I have seen poor babies rolled and swathed, ten or a dozen times round; then blanket upon blanket, mantle upon that; its little neck pinned down to one posture; its head more than it frequently needs, triple-crowned like a young pope, with covering upon covering; its legs and arms as if to prevent that kindly stretching which we rather ought to promote . . . the former bundled up, the latter pinned down; and how the poor thing lies on the nurses lap, a miserable little pinioned captive.[47]

Significantly, Dr. William Cadogan, physician to the Foundling Hospital from 1754, forbade the practice of swaddling there. He argued as early as 1748 in favor of freedom for children, writing:

> The Mother who has only a few Rags to cover her Child loosely, and little more than her own Breast to feed it, sees it healthy and strong, and very soon able to shift for itself; while the puny Insect, the Heir and Hope of a rich Family, lies languishing under a Load of Finery, that overpowers his Limbs, abhorring and rejecting the Dainties he is cramm'd with, 'till he dies

a Victim to the mistaken Care and Tenderness of his fond Mother.[48]

Cadogan was influenced by Locke's thinking concerning the advantage of few intermediaries in the rearing of children, taking this a step further to argue that children did not need these "idle Aids" to improve on what nature had given them. Rousseau advocated freedom of movement for the child from birth, principally in *Emile* of 1762, and the German tractarian Christian August Struve in *Rearing and Treatment of Children . . . ,*[49] published in English in 1802, wrote against swaddling as part of an emphasis on the child's health and convenience and the extent to which these were ignored in adult life. In all of these concerns, the general principle was to leave the child alone to develop according to nature. By the 1780s, foreign observers were noticing that English children were no longer swaddled and saw this as another English innovation.

The Child Grows

The dominant concern expressed by most British parents writing after 1750 is for the welfare of their children, described by Scotswoman Amelia Steuart as "a sacred charge."[50] There are numerous closely written observations of young children learning to walk, talk, and acquire the first stages of independence, as in Fanny Burney's 1796 description of her two-year-old son, Alexander, by her French husband:

> [He] has made no further advance but that of calling out, as he saw two watches hung on two opposite hooks over the chamber chimney-piece, "Watch papa,—watch, mama," so, though his first speech is English, the idiom is French.[51]

And again three months later, when her son's speech is noticeably improved, she wrote:

> He has repeated readily whatever we have desired; and yesterday while he was eating his dry toast, perceiving the cat, he threw her a bit, calling out, "Eat it, Buff!" Just now, taking the string that fastens his gown round the neck, he said, "Ett's tie it on, mama."[52]

Such observations suggest the mother's involvement in her child's upbringing, for, fundamentally, she is there to witness and record her child's development as well as her pride in recording these small steps for her correspondent. Ellen Weeton, a governess, shows that such tender observation of a child's development was not a privilege of the upper class when she wrote, just after the

Figure 24. Sir Joshua Reynolds, 1723–1792, *Lady Spencer with her Son,* ca. 1765–67, oil on canvas, 50 × 40 in. (127 × 101.6 cm), Collection of the Earl of Pembroke, Wilton House.

turn of the century, of her delight in her eleven-month-old daughter Mary's first walk:

> I have been much diverted with Mary today. I took her by the hand, and she walked all the way from hence as far as our late house in Chapel-lane. She had so many things to look at, that I thought we should scarcely ever arrive. She stopped at every door, to look into the houses. There were many groups of little children in the street, and she would walk up to them, and shout at them; she set her foot upon the step of a door where there happened to be a cake-shop, so I bought her a cake; and then she wanted to stand still in the street whilst she ate it.[53]

A sense of the child's distinct personality, most notably her intense curiosity in discovering the increasingly available world around her, is clear, as is the pleasure this brings her observant parent.

Implicit in these descriptions is the fact of the mother's involvement with her own children. Against a background in which it had been acceptable (if not actively encouraged) for a mother to abandon her children to the care of a governess in the nursery, the mother's participation in rearing her children beyond, perhaps, daily ceremonial visits is revolutionary. In the visual arena, Joseph Highmore's illustrations of 1744 to Richardson's *Pamela* are a supreme example of the new

domestic virtue of motherhood. Following in the tradition of the *Spectator,* Puritan family literature, and eighteenth-century books on social conduct, Richardson's *Pamela* is, in Frederick Antal's words, "the complete literary expression of the moral outlook of the middle class, with its new esteem for the wife and mother."[54] The last of Highmore's twelve illustrations, *Pamela Tells a Nursery Tale* (Fitzwilliam Museum, Cambridge), emphasizes the cozy domesticity of a scene of Pamela, the virtuous mother, surrounded by children in the nursery. Highmore has taken the unusual step of showing Pamela from over the shoulder, yet it is still possible to discern that she holds her youngest child in her arms. A painting of the Madonna over the fireplace emphasizes Pamela's Madonna-like status, a moral equation that suggests, in the novel's context, that a woman's highest virtue and greatest reward lies in her motherhood.

When Sir Joshua Reynolds takes up the formal mother and child portrait, he often retains the Madonna association. The portrait *Jane Hamilton, wife of the 9th Lord Cathcart, and her daughter Jane* (plate 25) of 1755 is based on a straightforward triangular composition centered on the mother's face and the delicate edges of the veil falling over her shoulders that links her visually with her baby. Reynolds then introduces the figure of a pet

greyhound at the right, incorporating the new convention of animals in the domestic portrait seemingly for the benefit of the infant Jane. The distraction provided by the dog injects the child with greater animation, as she reaches out to touch him, and thus emphasizes the difference between infant and mother, who remains unaware of or is unmoved by the dog. She is a serene Georgian madonna whose world is the domestic sphere of children and animals. Comparison with the equally rich portrait *Lady Spencer with her Son* (figure 24) of 1765 to 1767 suggests both how far Reynolds had already come in the 1750s in softening and enlivening formal aristocratic portraiture, and how he was able to convincingly rework the basic compositional strategy over the coming years.

Perhaps the most remarkable pairing of pictures of mothers from the Georgian period comes equally from the hand of Reynolds. The first of these, the unfinished *Mrs. John Spencer and her Daughter* (plate 26) of 1759, shows a mother with her young child standing behind her, a diminutive figure with large saucerlike eyes. The child Georgiana, later Duchess of Devonshire, is about two years old in this unfinished painting, often mistakenly described as a sketch. The reasons for which Reynolds gave up the painting are unclear, although one can speculate that the patron may have wanted a larger

Figure 25. Sir Joshua Reynolds, 1723–1792, *George Clive with his Family and an Indian Maidservant,* 1765–66, oil on canvas, 55 × 67⅜ in. (140 × 171 cm), Staatliche Museen zu Berlin, Preußicher Kulturbesitz, Gemäldegalerie.

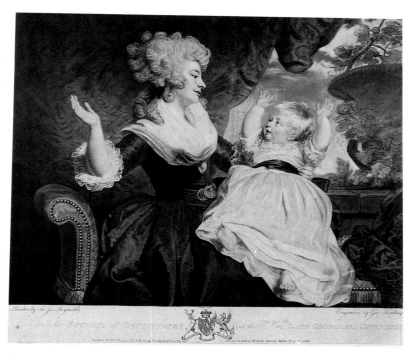

Figure 26. George Keating, fl. 1775–1776, *Georgiana, Duchess of Devonshire, with her Daughter,* 19 May 1787, mezzotint engraving after Sir Joshua Reynolds, 12 × 15⅝ in. (30.5 × 39.7 cm), Devonshire Collection, Chatsworth, reproduced by permission of the Chatsworth Settlement Trustees.

canvas. It is a charming portrait, whose unfinished condition only underlines the wide-eyed innocence of the young child. The double portrait Reynolds painted of the same sitters shortly after (Collection of the Earl Spencer, Althorp) is widely thought to be one of Reynolds's greatest achievements. He has retained the same basic composition, although moving the child to stand in front of her mother's right shoulder on a table that also supports a small dog, in order to focus our attention on the child. Like the portrait of Jane Hamilton, the dog serves a compositional function, but also underscores the domesticity of the grouping of mother, child, and pet. Lady Spencer clasps her daughter around the legs in a gesture at once protective and affectionate. The subject is both the child displayed to the viewer—a device Reynolds used again in the group portrait *George Clive with his Family and an Indian Maidservant* (figure 25)—and the domestic virtue of a great lady of the eighteenth century.

To what degree was this representation of domestic virtue a depiction of a larger truth? The usually perceptive Horace Walpole called Lady Spencer "the goddess of wisdom."[55] She seems not to have nursed her first three children but nursed the fourth, Charlotte, born in 1765. Lady Spencer was described some ten years later by Madame du Deffand as a "woman of the highest rank,

of a noble politeness, considerate, agreeable, superficial, and nothing more."[56] Perhaps Madame du Deffand did not know the countess well enough to offer a more penetrating judgment, for Lady Spencer's correspondence with her daughter is one of the century's great testaments to maternal devotion. Mutual love is expressed throughout the correspondence: daughter wrote mother in 1774, just after her marriage, "How can I express how much I love you and how much I felt at your going. Indeed you are my best, my dearest friend."[57]

When Reynolds returns to paint the young Georgiana, now grown and a mother herself, in the 1786 portrait *Georgiana, Duchess of Devonshire, with her Daughter* (plate 27), he created one of the most compelling maternal portraits of the century. Revealing Reynolds's close attention to a number of seventeenth-century masters, notably Van Dyck and Peter Paul Rubens, as well as a number of other possible sources,[58] this is at once a portrait of a modern mother and a Baroque drama. The duchess was renowned in her lifetime for her good and generous nature, admired as "the Beautiful Duchess" both for her warmth and her appearance. Here, she has chosen to be seen as the good mother, utterly absorbed in playing with her one-year-old daughter, who raises both arms in excitement to the tune of "Ride a cock-

horse/To Banbury Cross." Engraved by George Keating in 1787 (figure 26), a large public consumed this image of one of the grandest members of the aristocracy as a playful, indulgent mother, still only twenty-seven herself when she sat for this remarkable portrait.

From the first, the Duchess of Devonshire adored her children. She gave birth to her first child, a daughter also named Georgiana, in 1783 after some years of failing to conceive. After the child's birth, when all present thought the child would be stillborn, the duchess wrote Lady Elizabeth Foster:

> When it came into the world I said only let it be alive—the little child seemed to move as it lay by me but I was not sure when all at once it cry'd. Oh God! I cry'd and was quite Hysterical. The Duchess [of Portland, the Duke of Devonshire's sister] and my mother was overcome and they cry'd & all kissed me.[59]

The duke, also present, was not very supportive. When this child came to be christened, the duchess feared that the clothes and layette, some of which she had embroidered herself, were "foolishly magnificent. . . . I had been so extravagant about myself I c'd not bear indulging this occasion."[60] A disciple of Rousseau and someone whose temperament was suited to the cult of naturalness, Georgiana nursed the child herself. According to Lady Elizabeth Foster, "She was taken up with nothing so much as the prospect of nursing her child herself."[61] She became immensely attached to her daughter during nursing and postponed weaning until little Georgiana was well over a year old, against the opposition of her husband's conservative family. When she at last gave up breast-feeding the child, Georgiana wrote her mother:

> I do miss my Dear little girl so I do not know what to do—I have been twenty times going to take [her] up in my arms & run away and suckle her—I would give the world for her dear little eager mouth at my breast. This is the first night of my sleeping away from her for months and my room looks so dreary, but it is for her good.[62]

The child's presence as well as the intimacy of motherhood are seen to be exceptionally important, and not to be given up without a fight. Georgiana wrote her mother in 1783, "How thankful ev'ry hour makes me more and more for the goodness of God in granting me my child, for tho' my love for her is beyond any interested motive, and I declare to Heaven, I should be happy with her on a dunghill."[63] A son, born to Georgiana in 1790, is met with the same raptures of affection—he was breast-fed by

Figure 27. Benjamin West, 1738–1820, *Anne, Countess of Northampton, and her daughter, Lady Elizabeth Compton,* 1762, oil on canvas, 59 × 48 in. (149.8 × 121.9 cm) framed, Gift of John and Johanna Bass, Bass Museum of Art, Miami Beach.

his mother for nine months. Reynolds has clearly found an appropriate patron for his extraordinary composition; unfortunately, we do not know how he persuaded the aloof, conservative duke to accept the work.

Despite this devotion to her children, the duchess's social position and responsibilities made it difficult if not impossible for her to continue to supervise the care of her children. James Hare wrote her a fascinating letter, chiding her for the difficulty of her position:

> I shall be very glad to be acquainted with your children, and I dare say, I shall like them, tho' I think it is a great disadvantage to children to have five nurses and footmen to attend them, and to see their parents but seldom, and under a sort of constraint, which prevents their behaving naturally and being as entertaining as they would be otherwise.[64]

Hare invokes the word "naturalness" to discuss the desired behavior of children, and the issue is again one of control—having sufficient control over child-rearing to produce the desired effect or, as here, entertainment. The language Hare uses to discuss childhood is still at a divide with actual experience, in which the children are

Figure 28. Benjamin West, 1738–1820, *Mrs. Benjamin West and her son Raphael,* ca. 1770, oil on canvas, 35¾ in. (90.8 cm), Marriner S. Eccles Collection, Utah Museum of Fine Arts, University of Utah.

seen as extensions of their parents. Even though Georgiana's own preferences ran in the direction of the natural, sufficient control escaped her.

Although any link with the portraits of the Spencer women is general rather than explicit, elsewhere in his portraiture Reynolds was directly inspired by Madonna and Child imagery of the Italian Renaissance. This inspiration, or borrowing as some would have it,[65] ennobles the Georgian mother by relating her to the heroic role of the Virgin. Reynolds's use of the Madonna was observed in his own lifetime, most notably by his contemporary Nathaniel Hone, who suggested, in his satirical painting *The Conjuror,* that Reynolds had based his portrait of Lady Harewood and her daughter, Frances (1762 to 1764, Harewood House), on a Virgin and Child by the sixteenth-century Venetian Giovanni Battista Franco (Ashmolean Museum, Oxford). While Reynolds was known to have several of Franco's prints in his collection when it was sold at auction in 1798, Reynolds has dramatically altered the seriousness of Franco's image to incorporate a sense of Lady Harewood's good-natured tolerance. A similar translation is noted by both Hone

and, in the twentieth century, by Edgar Wind: a lunette of Eleazar by Michelangelo in the Sistine Chapel becomes Reynolds's striking portrait of the Duchess of Marlborough with her daughter (1764 to 1765, Blenheim Palace), where the mother holds her child upright in her lap. Although the question of Reynolds's borrowing is an important and a complicated one, in the present context it is the translation into contemporary images of ennobled mothers acting in a domestic guise that is most important.

Benjamin West took up Reynolds's call to paint modern figures in the guise of history painting when he turned to portraiture. West's *Anne, Countess of Northampton and Her Daughter, Lady Elizabeth Compton* (figure 27) of 1762 is a portrait remarkable for the soft rounded lines of its forms, the curvaceous folding of the mother's body around her sprawling infant. In coloring, drapery, and form, it derives largely from the work of Renaissance masters such as Raphael, suggesting the further secularization of the Madonna. Maternal love as painted here indeed seems to be the highest form of love, yet it remains somehow artificial, lacking the psychological penetration of Reynolds's best portraits. West does

Figure 29. Thomas Gainsborough, 1727–1788, *Study of Woman Seated, with Three Children,* mid to later 1780s, black chalk and stump, heightened with white, 14 × 9½ in. (35.6 × 24.1 cm), The Pierpont Morgan Library, New York.

Figure 30. Sir Thomas Lawrence, 1769–1830, *Priscilla Anne, Lady Burghersh with her son George Fane,* 1820, chalk and wash on paper, 9 × 7 in. (22.9 × 17.8 cm), F. & L. S. Herman Foundation.

better when he turns his attention to his own family. His *Mrs. Benjamin West and her son Raphael* (figure 28) of about 1770 expresses the profound bond of affection between mother and son, asserted by the circular format that allies mother and child with, for example, a Raphael tondo. At the same time, West has succeeded in more clearly individuating the figures than in the Northampton portrait.

Two drawings of mothers and their children illuminate the expressive possibilities of working in a less formal medium. The first, Gainsborough's *Study of a Woman Seated, with Three Children* (figure 29) from the 1780s, is not clearly a portrait although it certainly appears to have been drawn from life. Gainsborough adopts a triangular format, the mother's bonnet at its apex, to suggest compositionally the link of family affection binding the figures. The artist has vaguely suggested that the figures are in a landscape setting, the mother and one daughter sitting on a bank while a second daughter

stands before them. The lively use of line, even in so sketchy a drawing, succeeds in pulling the figures together. Far more polished is Thomas Lawrence's drawing of *Priscilla Anne, Lady Burghersh, with her son George Fane* (figure 30) of 1820. Described by Kenneth Garlick as a first study for a painting of the same title and date,[66] all we have of the mother in this drawing is her hand enveloping George's waist, but this hand and George's upturned eyes are the most finished parts of the drawing. Even here we can see the kind of technical facility for which Lawrence was applauded from childhood. As in the finished painting where Lady Burghersh is seen, the child is given center stage.

Motherhood as a worthy state of being and new aristocratic persona achieves perhaps its most extraordinary evocation in Reynolds's *Lady Cockburn and her Three Eldest Sons* (figure 31), exhibited at the Royal Academy in 1774. Lady Cockburn is literally surrounded, if not overwhelmed, by her young children, one of whom clambers on her back, one arm around her neck, physically supported by the serene mother. A partially clad child kneels on the side of her chair, while a third, a naked infant, lies in her lap. Lady Cockburn is consumed by her motherhood, an unusual position for an important member of the aristocracy. Reynolds's student James Northcote tells us that the curtain framing the figures,

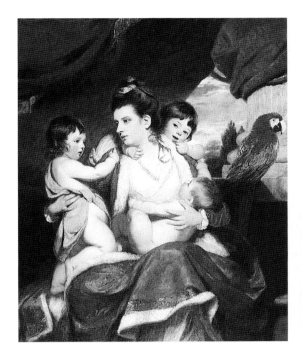

Figure 31. Sir Joshua Reynolds, 1723–1792, *Lady Cockburn and her Three Eldest Sons,* 1773, oil on canvas, 55¾ × 44½ in. (141.6 × 113 cm), The Trustees of The National Gallery, London.

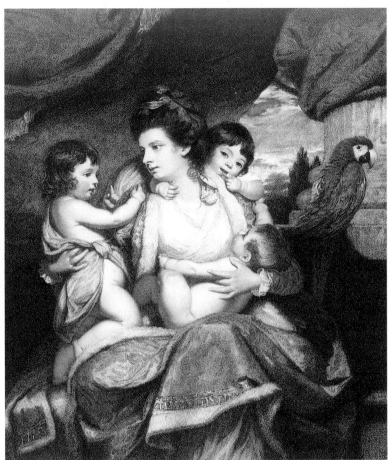

Figure 32. Charles Wilkin, 1750–1814, *Cornelia,* 1 December 1791, stipple engraving after Reynolds's *Lady Cockburn and her Three Eldest Sons,* 17 × 13⅜ in. (43.2 × 34 cm), Trustees of the British Museum.

the distant landscape, and the brilliantly colored macaw (a favorite member of Reynolds's household at the time) were last-minute additions.[67] Edgar Wind has convincingly shown that this image, too, derives from Renaissance sources—the motif of "Charity" by Michelangelo in a Sistine ceiling lunette as well as a drawing by Raphael in the Albertina in which Charity nurses one infant and coddles two others.[68] Again, the significance of this relationship resides in the application of mythological or historical emblems to contemporary aristocratic mothers. Surely this ennobling of the contemporary mother was not lost on early viewers. Northcote tells us, "When it [the painting] was brought into the Exhibition-room, at Somerset House, in 1775, all the artists then present, struck with its extraordinary beauty and splendour, testified their approbation by loud and simultaneous applause."[69] The *Public Advertiser* commented on the painting at length, noting that "The Action of the Lady is tender, and those of the Children sprightly and natural. There is a sameness of Character in most Children,

but in this Piece they are distinctly characterized."[70] By this, of course, he is speaking of character as a hybrid of appearance (physiognomy), pose, and personality, and it is noteworthy that he praises Reynolds for varying this between the children who, to modern eyes, may lack individuation. Another critic, however, from the *St James Chronicle,* wrote of the work, which he called "Charity," that "it would have been a more affecting Figure, if its Attention had been divided between the Innocence of Infancy & the Infirmities of Age."[71] The painting was engraved in 1791 (figure 32) by Charles Wilkin and given the title *Cornelia,* after the Roman mother who declared with pride that her children were her only jewels. Wilkin's print certainly helped disseminate the equation of charity and pride with motherhood. Ultimately, this movement toward the ennoblement of the mother is well brought out by Struve in his *Familiar Treatise on the Physical Education of Children* when he writes, "The greatest charms and dignity of a woman are derived from her maternal office . . . a good mother equally deserves

Figure 33. George Henry Harlow, 1787–1819, *Mother and Children,* ca. 1816, oil on canvas, 36 × 28¼ in. (91.4 × 71.8 cm), Philadelphia Museum of Art, The John H. McFadden Collection.

the affection of her husband and the esteem of the world."[72]

Reynolds's *Lady Cockburn* was an enormously important composition in the Georgian period, providing inspiration to Lawrence's pupil George Henry Harlow, among others. Harlow's *Mother and Children* (figure 33) of about 1816 adapts the Reynolds composition by bringing the figures forward and showing the unidentified mother in three-quarter view. More significantly, the exotic note of the macaw is missing, and the mother's costume is radically simplified into the plain white muslin and cap of the early nineteenth century. The intellectual conceit of *Lady Cockburn,* allowing herself to be overrun by her children for the purposes of high art, is lost, and this mother merely seems fatigued. She is a mother who might illustrate the slightly weary ideals of domesticity and motherhood seen so precisely in Jane Austen's nov-

els.[73] A composition that in Reynolds still has a Renaissance order is, in Harlow, on the edge of becoming chaotic. The highly pitched color, the sweeping lines of Harlow's brush, and the intensified energy of the child in this mother's lap—all to be found in works by Lawrence himself, such as *Mrs. Maguire and her son Arthur Fitzjames* (figure 34) of 1806, rather intellectually attempting to capture the passing moment[74]—take Reynolds's concept to a greater emotional pitch in a family portrait that is closer to the ideals of Victorian sentiment than to the relative restraint of Reynolds's cherubs.

Throughout these portraits, we must be aware that the mothers may be posturing to a greater or lesser degree. In relatively few cases do diaries and letters corroborate the maternal devotion of these specific women. It is not that their letters contradict the portraits but rather that they are silent on the relative importance

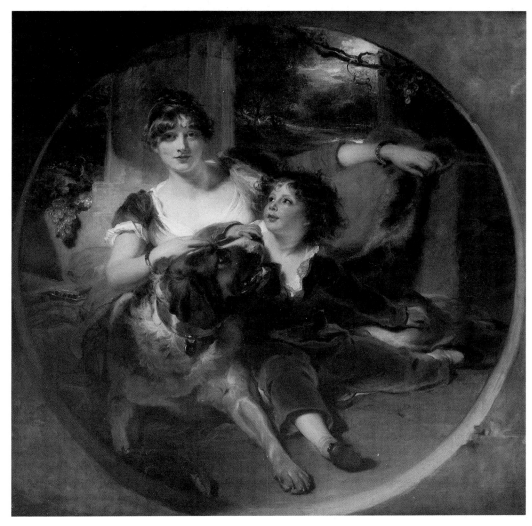

Figure 34. Sir Thomas Lawrence, 1769–1830, *Mrs. Maguire and her son Arthur Fitzjames,* 1806, oil on canvas, 66⅛ in. (168 cm), courtesy of the Abercorn Heirlooms Settlement.

placed on the duties of motherhood. In the case of at least one woman who sat to Reynolds, we have an acknowledgment of indifference to her own children. When her son Charles was one month old, Lady Sarah Napier wrote:

> I am not one of those who know how to nurse and make a fuss with a little child, she [her 14-year-old daughter Louisa] is always pressing me to attend more to it, & wondering how I can be so little taken up with it.[75]

Certainly many women of the late eighteenth century were uncomfortable as mothers but must have felt the pressure to assume the role of the indulgent parent.

Moving beyond portraiture, a number of plates and poems from William Blake's *Songs of Innocence* (1789) and *Songs of Innocence and of Experience* (1794) give vision to the artist's complex feelings concerning parenting and specifically the role of mothers. His "Cradle Song" (figure 35) from *Songs of Innocence* shows a mother leaning over her child, who is thickly wrapped and sleeping in his crib. She is, in her flowing burgundy robe and sulpice, a Madonna figure. The poem is written in this mother's voice, and reinforces the visual allusion to the Nativity, as her lullaby asks the mild angels to watch over her son and protect him from danger, pain, and mortality. Here, a mother is a form of God to her child, a relationship found in children's book illustrations such as one seen in Isaac Watts's *Celebrated Cradle Hymn* (figure 36) of 1812. In Blake's "Spring" (figure 37), the speaker is the infant child, held up on his mother's lap in a pose that may derive from a number of Reynolds's portraits, such as that of the Duchess of Marlborough and her daughter of about 1764, published as an engraving in 1768. In the child's view, nature convenes

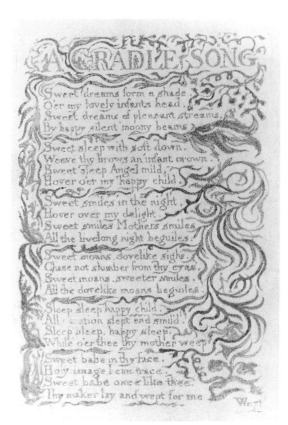
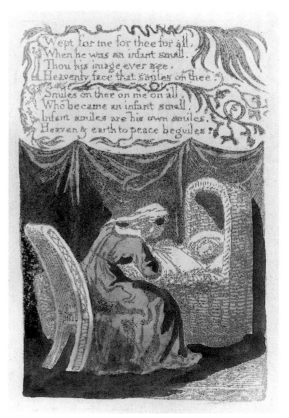

Figure 35. William Blake, 1757–1827, "A Cradle Song," from *Songs of Innocence* (London, 1789), copper plate etching, first plate 3¹⁄₁₆ × 4⅝ in. (7.7 × 11.7 cm); second plate 2¹⁵⁄₁₆ × 4⅝ in. (7.4 × 11.7 cm), photo courtesy of The Lessing J. Rosenwald Collection, Rare Book and Special Collections Division, Library of Congress.

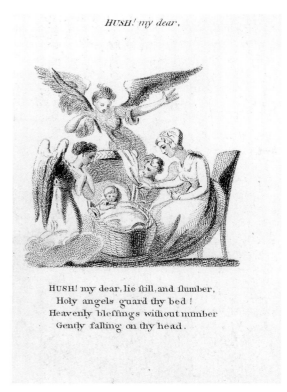

Figure 36. Anonymous, "Hush! my dear," from *Dr. Watts's celebrated Cradle Hymn, illustrated with appropriate engravings* (London, 1 August 1812), stipple engraving, 5⅛ × 3¾ in. (13 × 9.5 cm), The Pierpont Morgan Library, New York.

to welcome him, the "Little Boy Full of joy," both empowered and restrained by his mother. Also from *Songs of Innocence,* "Nurse's Song" (figure 38) combines the voices of the mother figure and children at play in a kind of dialogue. The nurse is comforted by the sounds of happy children until she is overcome by anxiety at the thought of the coming of night, or wisdom, or death. The children, however, are as yet free of anxieties and see the world—the little birds flying in the skies—clearly and without threat. The nurse is sensitive, responsive, and flexible to their demands, both united with and excluded from the circle of children who seem to invite her to enter in. She is separated by her responsibilities for them, and by her own experience of the world, yet does not fall into the position advocated by Susannah Wesley, in which the self-will of children is to be quashed at all costs.

With *Songs of Innocence and of Experience* we find Blake casting mothers in a different light. "Infant Sorrow" (figure 39) presents the mother previously seen in "Cradle Song," only now there is a rupture between old and young. The infant raises his arms in a cry, while his mother threateningly descends on him in what is to pass

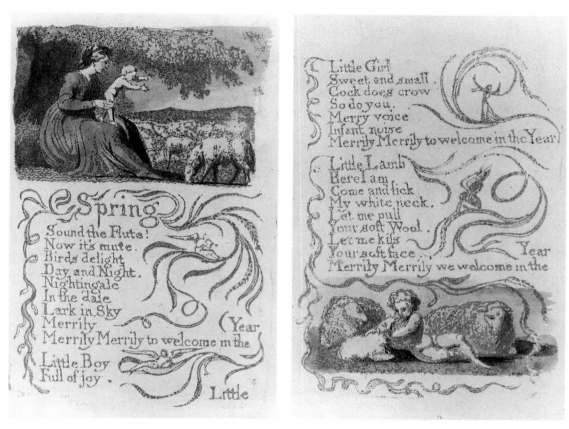

Figure 37. William Blake, 1757–1827, "Spring," from *Songs of Innocence* (London, 1789), copper plate etching, first plate 3⅜ × 4¹⁵⁄₁₆ in. (8.5 × 12.5 cm); second plate 3⁵⁄₁₆ × 4¾ in. (8.3 × 12.1 cm), photo courtesy of The Lessing J. Rosenwald Collection, Rare Book and Special Collections Division, Library of Congress.

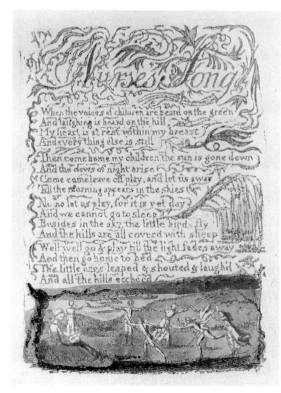

Figure 38. William Blake, 1757–1827, "Nurse's Song," from *Songs of Innocence* (London, 1789), copper plate etching, 3⁵⁄₁₆ × 4¹³⁄₁₆ in. (8.3 × 12.1 cm), photo courtesy of The Lessing J. Rosenwald Collection, Rare Book and Special Collections Division, Library of Congress.

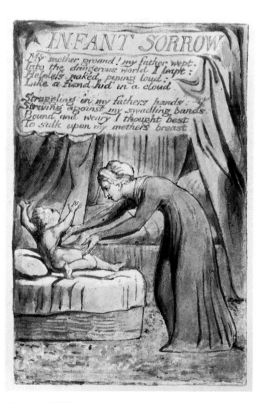

Figure 39. William Blake, 1757–1827, "Infant Sorrow," from *Songs of Innocence and of Experience* (London, 1794), copper plate etching, 2¹⁵⁄₁₆ × 4⁹⁄₁₆ in. (7.4 × 11.6 cm), photo courtesy of The Lessing J. Rosenwald Collection, Rare Book and Special Collections Division, Library of Congress.

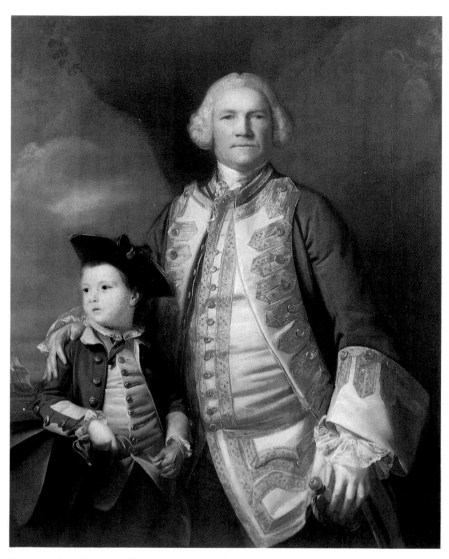

Figure 40. Sir Joshua Reynolds, 1723–1792, *Admiral Francis Holburne and his son,* 1756–57, oil on canvas, 58⅝ × 49 in. (149 × 124.5 cm) framed, National Maritime Museum, Greenwich, London.

for comfort. The boy's nakedness now contrasts with the heaviness of the mother's clothing, and he surrenders to her unwillingly. Blake's text tells us that the infant's birth was no happy event—"My mother groaned! my father wept"—and the boy himself came into the dangerous, threatening world hesitantly. He is exhausted from struggling against his swaddling and his father, but instead of turning to his mother for comfort he can only "sulk upon my mother's breast." The mother's breast is now bereft of spiritual sustenance. The point is reinforced in "Nurse's Song" from *Songs of Innocence and of Experience,* where the nurse is no longer allied with children but admonishes them. Her role is dispiriting and isolating; she tells her charge that he wastes his day in play.

In all of Blake's images from the *Songs of Innocence* responsibility for the child's upbringing clearly rests with the mother. Nowhere does the father ever take an active, effective part in the nurture of children. When the mother is absent, as in "The Chimney Sweeper," the child is lost. Blake is, of course, working in a didactic tradition whose format derived from children's books, but the father's absence in the work of Blake leads us to inquire into fathers in portrait painting. In this area, we can perhaps fruitfully start with the male artist looking at himself as a father. When, for example, Benjamin West paints himself with his son Raphael in 1773 (Yale Center for British Art, New Haven), maintaining the oval format of the 1770 portrait of his wife and son, we see how the artist manipulates content to suit the parental role. As West draws his self-portrait, engaging the viewer squarely, his young son peers over his shoulder to examine his work. The father is seen practicing his profession before his

son, who ultimately followed his father's path to become an artist as well. Benjamin acts as a role model for his son, while his wife in her portrait is allowed to do no more than be motherly. This, indeed, is her profession.

The question of the portrait of the father with his child is a complicated one. Far fewer portraits survive of the male-dominated family portrait than of the female, perhaps because, most often, the portrait was commissioned by the father and was intended to record *his* domestic achievement, which was the support of his family. This tends to separate the father from the world of domesticity, thought to be rightly the world of women, children, and animals, whereas the father might be painted on another occasion in his military, commercial, or courtly role. William Buchan chastised this separation, writing in 1772 that "men generally keep at such a distance from even the smallest acquaintance with the affairs of the nursery that many would reckon it an affront, were they supposed to know any of them."[76] This separation is also in evidence in numerous letters, as when Elizabeth Wynne's husband wrote her, counseling greater detachment of the kind he, the father, found natural:

> If there is any subject on which I feel diffident, it is that your kindness and affection for the Children will lead you to take too much care of them, believe me nothing tends more to health than exercise and Air, and that the more they are out of the house the better. . . . Consider what your boys must undergo before they arrive even at Manhood, and I am sure you will agree with me that it is not wise to bring them up too tenderly.[77]

Wynne's thinking—like other increasingly seen fears of parental incompetence—seems to derive more from Locke than Rousseau, with his awareness of the damage a parent could inflict by rearing a child incorrectly.

Nevertheless, a number of remarkable portraits of men with their offspring were carried out. Reynolds's portrait *Admiral Francis Holburne and his son* (figure 40) of 1756 to 1757 is outstanding for the contrast created between father and son. Admiral Holburne's demeanor is gruff. He is seen in three-quarter length with a stiff-lipped reserve. His son seems small, soft, and vulnerably childlike, although he is linked to his father by wearing a juvenile version of the admiral's naval uniform. Holburne's arm rests casually on his son's shoulders, suggesting an easy comfort between the two figures, yet the image reveals quite strongly the power relationship that exists between them. The admiral's severity suggests that his role in rearing a son is again that of modeling, here the

proper masculine, aggressive military role, with a focus on authoritarian leadership. The background seascape underlines the father's career and may allude, along with the son's costume, to the boy's future. It seems probable that, like Frances Boscawen's seafaring husband, Admiral Holburne was away from home when the small decisions of parenting were carried out.

Other male portraits focus on different aspects of the fatherly role. John Hamilton Mortimer's *Gentleman and Boy Looking at Prints* (plate 28) of about 1765 to 1770 moves the father-son relationship into the world of connoisseurship previously seen in Reynolds's painting of the Marlboroughs.[78] The father, probably the watchmaker John Ireland, who collected Hogarth's works and published *Hogarth Illustrated* in 1791, is seated at a large table and holds a print up for inspection, while his son looks over his right shoulder. Both figures are expressionless, seriously engaged in their study, if not, judging by the boy's face, absorbed. All around the two are objects populating the male world of the Georgian era: a classical bust of a Zeus or Homer type, a Greek vase, portfolios. The father has taken on the role of educating his son both aesthetically and historically, preparing him to go, one day, on his own Grand Tour and ultimately enter the male world of collecting. Yet, like the portrait of Admiral Holburne and his son, there is an emotional distance between the figures alien to the world of Reynolds's mothers.[79]

Johann Zoffany's *Reverend Randall Burroughs and his son Ellis* (plate 29) of 1769 has as its subject education of a similar kind. The Reverend Burroughs is in the process of teaching his son, a much younger child than the boy in Mortimer's portrait, from a large open folio, a volume of Joshua Kirby's *Perspective of Architecture* (1761). Like many of Zoffany's portraits, the arrangement of figures has a friezelike quality, emphasized by the Reverend Burroughs's black robe. His costume serves to accentuate the difference in age between father and son, much in contrast to the lively youth of Reynolds's Duchess of Devonshire. The father in William Hoare's *Christopher Anstey with his daughter Mary* (plate 30) of about 1779 describes an equally severe age difference, accentuated by Anstey's wig. Hoare's painting is unusual in depicting a father alone with his daughter, the least common familial combination in Georgian painting. The distance between them is unintentionally underlined by the father's distraction; he looks off in the distance, perhaps contemplating the text on which he is working,

while his daughter holds her doll, with its elaborate headdress, up to him and grasps his lapel to gain his attention. When Sir Henry Raeburn painted *John Tait and his Grandson* (plate 31) in about 1793, the age difference between man and child reaches its natural conclusion. The father figure is now grandfather, the boy now so young as to be still unbreeched, while theirs remains a male world. Like the preceding portraits of fathers, when a man is painted alone with a child, it is with a male and not a female heir. As an emblem both of family and of present joy, a child brought pleasure to grandparents: the Duke of Rutland spoke of his first grandson in 1822 as "a pledge of affection."[80]

Related to the close behavioral observation we have seen in both visual and verbal form are parental remarks about their children's clothing, a subject of particular importance in evaluating the age and "character" of child sitters in portraiture. Dr. Cadogan was influential in advocating greater adherence to nature in children's dress, recommending light, thin, and flimsy clothing and the absence of shoes until the child was old enough to "run out in the Dirt."[81] Cadogan's advice did not immediately bear widespread results, although by the early nineteenth century, certainly, the taste for clothing made of loose muslin was common. There are numerous descriptions of the clothing of early childhood, notably from the detailed cntries Mrs. Papendiek left of her children's upbringing in her journals, including this 1783 description of her eleven-month-old daughter Charlotte:

> Dr Khone had poor baby weaned, but she did not mind it, and at this time we put her into short coats. We made her four white frocks and two coloured ones, with the skirts full and three tucks and a hem; the bodies plain, cut cross-ways, and the sleeves plain, with a cuff turned up. These, with converting of underclothing, nurse, I, and a workwoman finished off in a week. The rest of her attire was, long cotton or thread mitts, without fingers, tied round the arm high above the elbow, a double muslin handkerchief crossed and tied behind in a bow, or if cold a silk pelerine, with same coloured bonnet, close front, high caul, with a bow in front. Baby's was blue, and very pretty did she look.[82]

The act of "short-coating" took place at around age one until the 1780s, when it took place at nine months. Both boys and girls then wore frocks, often boned, until boys were ceremonially "breeched" (put into trousers) at the age of about four, when they began to wear suits consisting of a coat, waistcoat, and breeches resembling their fathers' (although prior to 1750 this was done at age six or seven). But rather than indicating that the child was

thought to be no different than adults, this leap into adult clothing was, as Pollock has rightly suggested, a mark of gender differentiation.[83] The acts of short-coating and later of breeching boys have caused great difficulties for numerous historians and art historians, who have used the practice of breeching to suggest that children were rushed into adulthood throughout the eighteenth century. Yet, as shall become clear, gender differences were delineated even when boys and girls wore the same costume, just as later, when boyhood was understood as fundamentally distinct from adolescence and adulthood, although the costume remained basically the same.

Knee-breeches were worn by all boys until the 1780s and by older boys until the turn of the century. Boys sometimes also shared their fathers' taste for wigs, wearing them with shaved heads and eyebrows until the style of natural, unpowdered hair was popularized in the 1790s. The skeleton suit was introduced around 1790 and was the dominant fashion for boys until the 1830s. Girls over age two dressed like their mothers until the 1760s, when distinct styles such as the polonaise were developed. They did not again dress like their mothers until 1800, when childhood dress became the new adult fashion.[84] For a time, it was advocated by some that children should not wear shoes but should instead "get their feet wet," a habit observed by Sophie von la Roche on her 1786 visit to England:

> People, I noticed like to have their children with them out into the air, and they wrap them up well, though their feet are always bare and sockless.[85]

As a habit encouraging greater bonding with nature—and presumably intended to let them develop more freely—this practice seems to have died out by century's end.

The selection of clothing was not merely an aesthetic consideration nor was it limited to encouraging gender identification. Choice of clothing also involved an element of protection and thus reflected a mother's concern for her child's safety (as in Mrs. Papendiek's explanation of leading strings). The sculptor Joseph Nollekens and his biographer, J. T. Smith, both recount having worn a "pudding," a type of padded cap described by Smith as

> a broad, black silk band, padded with wadding, which went round the middle of the head, joined to two pieces of ribband crossing on the top of the head and then tied under the chin; so that by this most excellent contrivance, children's heads were often preserved uninjured when they fell.[86]

Puddings were favored by "those mothers who are fond of showing their good sense by taking care of their children,"[87] although Mrs. Papendiek tells us that they were not used in the higher ranks for children under the age of six or seven. We have numerous anecdotes of children falling, not merely because of their unwieldy bodies but because of neglect at the hands of a distracted or unqualified nurse—or even an uncaring parent. Northcote tells, for example, that one of Reynolds's sisters, Theophila, was killed "by falling out of a window from the arms of a careless nurse,"[88] and that the "beggar infant" who posed for Reynolds's *Children in the Wood* (Metropolitan Museum of Art, New York) was allowed by its mother to fall to the floor from a considerable height during one of their sittings, although the child was preserved "by great good fortune."[89] Hogarth gives us such a scene in his 1751 engraving *Gin Lane,* in which a child falls head first over a railing, victim to what Hogarth saw as the lower-class's destruction at the hands of inexpensive alcohol. The falling, unprotected child is the very embodiment of neglect. Besides the protective pudding, Smith praises the use of the go-cart, a type of early baby stroller in which the child could propel himself on casters but was prevented from falling, as the sign of "the affectionate and considerate mother."[90] Paintings, such as one in the collection of the Norwich Castle Museum dating from the 1650s, attest to the long history for the use of such protective objects, whose popularity grew throughout the Georgian period.

Health, Illness, and Death of the Child

With some justification, children were considered soft, weak beings in need of strengthening. In the post-*Emile* years, this continued to mean discipline for emotional strength and, more innovatively, cold-water bathing and fresh air for physical strength. Diseases of childhood continued to threaten the health of one's offspring, and parents took very seriously their need to watch over their children, where possible, arming them against disease. Childhood ailments included rickets and smallpox, at its height in the eighteenth century when 87 percent of smallpox deaths claimed children under the age of sixteen,[91] and tuberculosis, which reached a peak in the years around 1780.

In addition to the mild protection thought to be afforded by taking fresh air, one great innovation that is increasingly discussed in the diaries and letters of parents after mid-century is inoculation. The somewhat primitive procedure was fraught with the risk of developing the potentially deadly disease itself, and so was a source of anxiety for parents. Frances Boscawen's letters to her husband at the time of their three-year-old son Billy's inoculation against smallpox in 1755 provide a vivid account of such an experience. After one letter detailing the procedure to come, Mrs. Boscawen writes again three days later with relief:

> Pray Papa! Pray to God to bless us, for we are inoculated. This day exactly at noon it was done; no fuss, no rout, no assistance. Nobody with me but the servants. I held the child myself and so effectually employed his eyes and attentions (by a bit of gold lace which I was putting into forms to lace his waistcoat) that he never was sensible of the first arm. For the second, he pretended to wince a little, but I had a sugar plum ready which stopped the whimper before it was well formed. And he is now . . . tattling here by my bureau with some cards and papers, etcetera; for the weather is so very hot that I reckon that the chief service I can do him is to provide him such amusements as will keep him still and quiet. So that, instead of waggons, carts and post-chaises, we shall deal altogether in mills, pictures, dolls, London cries, and such sedentary amusements.[92]

Six weeks later, Billy was fully recovered. Mrs. Boscawen's account of her son's ordeal touchingly intermingles images—of the child being distracted from the needle, of him later playing by her desk while she writes—that are beautifully visual with details of their mother-son interaction that is at once mundane and profound.

Inoculation of her son against smallpox was also a trial for Fanny Burney. Against the doctor's advice, Burney refused to leave the room during the procedure. A maid attracted the boy's attention with a toy while Burney "began a little history to him of the misfortunes of the toy we chose, which was a drummer." Alexander screamed when the incision was made, but this was "momentary, and ended in a look of astonishment at such an unprovoked infliction, that exceeds all description all painting—and in turning an appealing eyie [*sic*] to me, as if demanding at once explanation and protection."[93]

Of course, not all childhood diseases could be dealt with by inoculation, and on another occasion Mrs. Boscawen wrote her husband that their three children, aged nine months to three years, had simultaneously developed measles. At the end of a long description of the entire ordeal she writes:

I have endured a great deal, and can never be enough thankful to the gracious providence that has comforted me and cured them. The boy and the little one now come down stairs. Frances keeps chamber still; but they have been purged, and tomorrow the two eldest begin asses' milk.[94]

The remedies described—purging and a diet of asses' milk—seem to have been the only common-sense remedies available, and providence was indeed forced to play a major role in the outcome. Another mother, Harriet Leith, writes in 1776 from Scotland of her son John's illness at age fifteen, for which similar treatment was prescribed:

I think John is considerable better within these last six or seven days. The heats upon his skin which gave him much uneasiness has I believe been chiefly carried off. . . . These complaints . . . alarmed me dreadfully at the time upon many accounts, and had they continued must have been very weakening, as well as increased his aptness to catch cold. But their having gone off without any remedy, but a mattress put above his bed, in place of under it, is a very agreeable circumstance.[95]

In each case, the mother's relief is obvious, although for Mrs. Leith it was short-lived, for two months later John was spitting blood and the goat's milk cure was stopped. Another four months later he was dead.

Arthur Young writes in his autobiography of his daughter Martha-Ann, aged fourteen, then, in June 1797, in an even more precarious state than that described by Mrs. Leith:

Dr Wollaston . . . gives little hope, but advises a milk and vegetable diet, and said that sea air and a humid mild climate would be good. I next wrote to Dr Thornton, who recommended an egg and meat diet; and Mr Martyn, in a letter, desired me to try the inhaling of ether, in fact, all has been done that the urgency of the case required, but, alas! She is past the assistance of all human power.[96]

We see here not only the father's anxiety but the sense of desperation no doubt added by the feeble and often conflicting medical advice available. One month later the child was dead.

The death of the child in many ways provides a litmus test for evaluating the child's place in the family, both practically and emotionally. The traditional argument put forward by Ariès, Stone, and others would lead us to expect that high child mortality rates would render parents hardened to, or at least prepared for, this loss.[97] Mortality rates for children were high by today's standards for developed countries—for children under the

age of one, rates were between 13 and 15 percent, peaking in the years 1700 to 1750 and again just after 1800.[98] For those children between the ages of one and nine, mortality was between 22 and 28 percent. Eighteenth-century writers estimated mortality rates to be much higher. William Cadogan, doctor to the Foundling Hospital, writing in 1748 suggested a mortality rate of 50 percent before age five;[99] William Buchan, writing in 1772, estimated the same mortality rate before age twelve.[100] Pollock suggests, even so, that "the infant mortality rate has been greatly exaggerated"[101] by both past and present writers on childhood, and with it the role of mortality in acting as a determinant of parental behavior. Certainly, richly varied written and visual documents suggest that familiarity with death did not induce parental indifference. It would be as hasty to infer that such high statistics signaled a lack of caring in the eighteenth century as it would be to assume the same for today's high mortality rates in underdeveloped nations. When the subject was represented in painting, in a work such as Philip Hoare's *Mother and Dead Child* shown at the Royal Academy in 1781, a critic could only remark, "Shocking indeed!"[102] Is it the subject itself, no matter how commonplace, that is shocking to the sensibilities of the viewer, or was the emotional tragedy, clearly seen as such, perhaps depicted too baldly for a Georgian aesthetic? More commonly, the dead child would be depicted in an apotheosis (see figure 17), a moralizing choice that both sought to make sense of a child's death and distanced it. Typical of these, Benjamin Heath Malkin's *A Father's Memoirs of His Child* (1806), written in honor of his son, dead at age six, is illustrated by a frontispiece by William Blake showing an angel taking the child from his mother to heaven. Both text and illustration participate in the Romantic apotheosis of childhood seen in Wordsworth and others.

Children themselves were prepared for the possibility of an early death, forced to read stories with titles such as "You Are Not too Young to Die," "The Dying Sunday Scholar," and "Happy Death of a Little Boy." The moral preparation for death, too, was part of the parent's job. Even given the prevalence of early death in the Georgian period, the language of these stories seems almost shocking in the immediacy with which physical death is evoked. For example, an evangelical pamphlet for children of 1827 contains the following warning:

Though now you may be blessed with health and strength and youth, yet soon you may be stretched

lifeless and breathless within the silent tomb. . . .
Many a lovely blossom has perished in the spring;
many a fragrant flower has been nipped in the bud;
many a little bird has just lived to sing, to flutter and to
die; and many a little child has just opened its eyes to
life, to close them in death forever. It may be thus with
you. A few days more, and your earthly existence may
close;—a few days more, and the blast of death may
pass over you, and you will feel the stroke and die.[103]

Such stories, combining charming evocations of nature
and a brutal sense of doom, were intended for both chil-
dren and their parents, intended to lead children to bet-
ter behavior and to strengthen parents mourning the loss
of pious children.

When death came for their children, many eigh-
teenth-century parents were anything but stoically re-
signed. The death of a child was, in fact, an often dev-
astating loss, experienced by father and mother alike.
Ariès's postulation that the expectation of death would
play a mediating role seems contradictory to the evi-
dence. Many of these testimonials by mourning parents
remain deeply moving. When, in April 1713, Ebenezer
Erskine's two-year-old child, Ralph, died of smallpox
and measles, to be quickly followed by his two elder
brothers, the grieving father recorded his thoughts:

My dear, sweet, and pleasant child, Ralph, died on
Thursday, last week, about a quarter after seven in the
morning. His death was very grievous and affecting to
my wife and me; but good is the will of the Lord. . . .
After his breath was gone and his body swathed, the
company having taken a little refreshment, I was called
to return thanks, which I did but towards the end,
when I came to take notice of the present providence,
that God had plucked one of the sweet flowers of my
family, my heart burst out into tears, so that I was able
to go no further.[104]

Erskine's reference to the "will of the Lord" is very
much in keeping with the religious tone of the date, yet
acknowledgment of the goodness of this seems to offer
this suffering father little solace. Faith in the divine also
colors a letter from John Verney to his sister in 1737 after
the death of his son John:

He left us yesterday morning, about nine o'clock, and
we can never see him more in this world, but I trust in
God we shall all meet in Heaven, where I daresay he
now is in perfect happiness, which I can never more
enjoy here for want of him.[105]

The death of a child is seen as a permanent loss of hap-
piness which is no less felt for being relatively common-
place. The child's absence has indeed deprived John

Verney from achieving perfect happiness in life—that
sense of completeness, of wholeness, that having a son
had afforded him. The son, John, is clearly seen as irre-
placeable. Similar feelings are evoked later in the century
by the Reverend William Jones, writing on the death of
his eighteen-month-old daughter:

What a gloom overspreads my soul! . . . My Soul
seems oppressed with a load, which no length of
time will ever lighten. O my dear little infant, lying
dead under this roof! whose spirit I watched depart-
ing yesterday.[106]

Yet there is evidence to suggest that many felt the loss of
an infant to be less mournful than the loss of older chil-
dren. John Boswell, for instance, tried at age fourteen to
comfort his mother on the death of her newborn with the
thought that "besides if he had been more advanced in
years it would have been much greater grief for you."[107]

Arthur Young, whose concern for his dying daugh-
ter we have seen, is especially articulate in the grief over
the loss of a child:

Thank God of His infinite mercy she expired without
a groan, or her face being the least agitated; her inspi-
rations were gradually being changed from being very
distressing, till they became lost in gentleness, and at
the last she went off like a bird.
 Thus fled one of the sweetest tempers and, for her
years, one of the best understandings that I ever met
with. . . . And there fled the first hope of my life, the
child on whom I wished to rest in the afflictions of my
age, should I reach such a period.[108]

Three days later, he returns home and writes:

Every room, every spot is full of her, and it sinks my
very heart to see them. . . . I buried her in my pew, fix-
ing the coffin so that when I kneel it will be between
her head and her dear heart. This I did as a means of
preserving the grief I feel, and hope to feel while
breath is in my body.[109]

Young's feelings for his lost child are a kind of summa-
tion of much that we have seen in parental devotion to a
child: she was to have been a solace for his later years, an
emblem of future security, but at the same time loved for
who she was as a small child, gifted with "one of the best
understandings." Young's desire never to overcome his
present grief was fulfilled, for he did not recover from his
daughter's early death, offering a moving testimony to
the possibilities of emotional attachment between an
eighteenth-century father and his child.

Chapter Four / *Child's Play, Toys, and Recreation*

The educational value of play seems to be a uniquely modern notion, infrequently seen until the eighteenth and nineteenth centuries. Parents in early eighteenth-century Britain were more likely to insist that play—along with affectionate behavior—be dispensed with when a child's education and the "age of reason" began, as early as age seven. Lord Chesterfield's letters to his son exemplify this idea, relegating play to only the earliest period of childhood. In a letter of 1741, written in Latin, Lord Chesterfield states:

> This is the last letter I shall write to you as to a little boy, for tomorrow, if I am not mistaken you will attain your ninth year; so that, for the future, I shall treat you as a *youth*. You must now commence a different course of life, a different course of studies. No more levity: childish toys and playthings must be thrown aside, and your mind directed to serious objects. What was not unbecoming to a child, would be disgraceful to a youth.[1]

Even in the 1740s, a time still heavily dominated by a Puritan seriousness of purpose, Lord Chesterfield was an exceptional figure for the strictness with which he demanded that his son mature in adherence to his prescribed rules. Chesterfield was particularly concerned that his illegitimate son would need all the resources at his disposal to win a place in society—he would need to surpass his peers in learning and conduct—and thus Chesterfield held this son to a perhaps unnaturally high standard. Even so, when Chesterfield's collected letters were published by the son's widow in 1774, they were widely read as a type of conduct book by which both parents and children could better learn the art of rearing children successfully. Even the childless painter Sir Joshua Reynolds is thought to have read them—as a philosophical text.[2] Other readers, including Dr. Johnson and Samuel Cowper, criticized the letters for their unsentimental quality.

Lord Chesterfield's letters found striking contemporary parallels, even in the less Puritanical 1770s, in the writings of other parents concerned that play was detrimental to children much past infancy. The Scotsman John Harrower held such a view in regard to his eight-year-old daughter, who was being brought up at home. He advised his wife in 1774:

> I suppose Betts is at home with yourself, pray keep her tight to her seam and stocking and any other household affairs that her years are capable of and do not bring her up to idleness or play or going about from house to house which is the first inlet in any of the sex to laziness and vice.[3]

Although the "course of studies" advised is different, in what was considered appropriate to the child's sex, the concept of what was appropriate to the child's years is similar and is aimed at producing a contributing member of society.

Figure 42. Attributed to William Blake, 1757–1827, plate from C. G. Salzman [J. C. F. Guthsmuths], *Gymnastics for Youth: or a practical guide to healthful and amusing exercises for the use of schools* (London, 1800), stipple engraving, 4½ × 2¹¹/₁₆ in. (11.5 × 6.9 cm), The Pierpont Morgan Library, New York.

Figure 41. Anonymous, "Six boys playing cricket," from Master Michel Angelo [Richard Johnson], *Juvenile Sports and Pastimes* (London, 1780), engraving, 1½ × 2¼ in. (3.8 × 5.7 cm), The Pierpont Morgan Library, New York.

The appearance of John Locke's *Some Thoughts Concerning Education* in 1693 broke the hold the Puritans had on advice literature concerning children. Locke saw the positive value of play and was the first to encourage the child's curiosity as an important learning tool. When Rousseau's *Emile* was published in Britain in 1762, proposing greater freedom for children, Calvinism's doctrine of original sin as the defining characteristic of a child bore the brunt of Rousseau's attack. Yet even Rousseau, who advocated letting children run about idly and at random between ages two and twelve, found certain children's playthings to be sources of corruption. Where Locke had wished to use baits such as children's stories to attract children into a love of reading and knowledge, Rousseau believed fables led children into vice, not virtue. Despite the extraordinary influence *Emile* had through the century's end, Rousseau could not entirely defeat more conservative notions of child-rearing and the role of play—or single-handedly create a construct of childhood modern in appearance. Methodism and Evangelical Anglicanism brought a late eighteenth-century return of the Puritan spirit,[4] which may together account for some of the popularity of tracts such as Lord Chesterfield's at that time. The founder of Methodism, John Wesley, suggested that the will of a child must be broken, and in this line play was again discouraged and games forbidden. Wesley led a campaign against children's fantasy and fairy literature, in part out of a fear of revolutionary contagion after 1789 since so many children's fables came from France. Maria Edge-

worth, too, spoke out against even educational toys in works such as her *Practical Education,* published in 1798. For the Evangelicals, curiosity and spontaneity were signs of sinfulness; toys, playthings, and juvenile literature were all prohibited.[5] The battle over children's books and playthings continued well into the nineteenth century. In 1802, Charles Lamb lamented the banishment of fairy tales and fables (which, we should recall, Reynolds had used to enthrall his child sitters), which he remembered fondly from his own nursery days; ultimately fairy tales did not return to Britain until 1823 and the publication of the Grimm brothers' tales in English. Yet the fairy tale was still an embattled genre into the Victorian period. Charles Dickens championed such stories in his novel *Hard Times* of 1854, arguing that it was real life that was rubbish and that hardened children to the plights of others.[6]

Still, the idea that child's play was not inherently sinful was surely born in the eighteenth century, despite Wesley's beliefs on the subject. Play could, of course, have instructive value, and the employment of entertainment as a way of tricking children into learning can be credited as a discovery of the eighteenth century. The themes of self-improvement and self-education ran throughout most children's amusements, including the invention of the jigsaw puzzle by John Spilsbury in 1762.[7] The market for toys expanded rapidly at this time, and production of manufactured toys grew enormously to meet this demand.[8] By 1800, there were at least two shops in London specializing in making rocking horses.

As children's games and amusements grew, they simultaneously came under increasing organization (and control) in the early nineteenth century. Literal regulation and codification of games were the eventual result, but well before this time parents were intervening more and more in their children's leisure time. For example, Lord Darnley, third Earl of Lennox, chastised his two sons boarding at Eton in 1780:

> I hear that you are *Both too Violent* at Foot Ball, bruise your Shins etc: etc: I desire that you will be less so, or I shall order Pierre [the boys' manservant] to Stop All Foot Ball.[9]

Lord Darnley took a strongly interventionist tone throughout his long correspondence with his sons at school, but comments such as these concerning play are relatively uncommon before this time. The admonition against being too rough at sports seems to stem from a desire to protect the boys from violence, and reflects the fact that Darnley is writing well before the cult of toughness and manliness took hold of the aristocracy in the face of revolution in France. At the other end of the spectrum there is great indulgence as well. The lively *Wynne Diaries,* written by the three middle-class Wynne sisters as children in the 1780s and 1790s, describe much game-playing with adult members of the household, including family and servants.[10]

The visual representation of children's games appears with frequency from the middle of the eighteenth century and offers some of the first images in which children are shorn of emblematic qualities. Joseph Highmore's rather winsome portrait *Henry Penruddocke Wyndham and his brother Wadham* (plate 32) of 1743 uses the motif of the racquet to suggest that the younger Wadham Wyndham, holding the racquet, is trying to lure his older brother, Henry (then aged seven), away from his book. The conflict between play and scholarship is implied, but no judgment is made. Notably, Highmore painted this work some two years *before* Nollekens's heavily emblematic scenes of children at play, such as his *Two Children of the Nollekens Family Playing with a Top and Playing Cards* (plate 6) of about 1745, suggesting how transitional was the depiction of childhood in the 1740s.

The use of sport as a motif in children's portraiture continued through the eighteenth century, with marvelous examples such as Joseph Wright of Derby's *Wood Children* (plate 33) of 1789. Here the motif is the newly popular sport of cricket, seen as being an inherently appropriate activity for children out of doors as well as a useful compositional device. The eldest boy, then about twelve, leans on his cricket bat, while a younger brother drives a wicket into the ground and a sister tosses the ball into the air, her eyes upturned and directed toward catch-

A GYMNASTIC EXERCISE GROUND.

Published Jan.ʸ 10.ᵗʰ 1827. by Sir R. Phillips &Cᵒ. 74 S.ᵗ Paul's Church Yard.

Figure 43. James and Josiah Neele, dates unknown, "A Gymnastic Exercise Ground," frontispiece from Gustavus Hamilton, *The Elements of gymnastics, for boys, and of calisthenics, for young ladies* (London, 1827), etching, 4¼ × 8 in. (10.8 × 20.3 cm), Yale Center for British Art, Paul Mellon Fund.

ing it. The Wood children are present in the landscape for a purpose, no longer for the mere sake of the land but for their recreation and health. Images of children at sport occur with remarkable frequency illustrating children's books, forming a kind of encyclopedia of recreational activities that tells us much about the rich variety of children's play. "Master Michel Angelo" (alias Richard Johnson) and C. G. Salzman (alias J. C. F. Guthsmuths), in works such as *Juvenile Sports and Pastimes* (figure 41) and *Gymnastics for Youth: or a practical guide to healthful and amusing exercises for the use of schools* (figure 42), described an array of sport for children intended to improve their health, whether at home or away at school. Gustavus Hamilton's *Elements of gymnastics, for boys, and of calisthenics, for young ladies* (figure 43) takes this a step further by specifying the activities appropriate to the sexes, and thus contributing to the gendering of the child reader. The plates illustrating all of these texts have a clear relationship with the fine arts of the day, drawing on some of the same spatial relationships and landscape settings to show, for example, children playing cricket in a park setting. It is thought that the plates for Salzman's *Gymnastics for Youth* were designed and executed by

William Blake, certainly the most prominent artist to work in this crossover medium.

A plate, presumably by Blake, from this volume provides a useful contrast with the artist's "The Ecchoing Green" from *Songs of Innocence* of 1789 and "The Fly" from *Songs of Innocence and of Experience* of 1794. The two plates illustrating "The Ecchoing Green" (figure 44) describe children's play, which is communicative in nature. In the first plate, children play beneath a parental, protective oak at the base of which two mothers, surrounded by their adoring children, are seated. Around them, older children form an enveloping circle around the oak and play cricket. Below this scene, two boys with a cricket bat and a hoop decorate the text itself, describing in a child's voice how "our sports shall be seen/On the Ecchoing Green." Here and in the second plate, the children are surrounded by vines that are accommodating to their games. When the second plate describes the journey home from play led by the shepherd/father, the text tells us how the younger children "Like birds in their nest/Are ready for rest" in their mothers' laps. Play is at the core of a healthy, nurturing familial scene, an innocent vision bound up with a sense of time's passage.

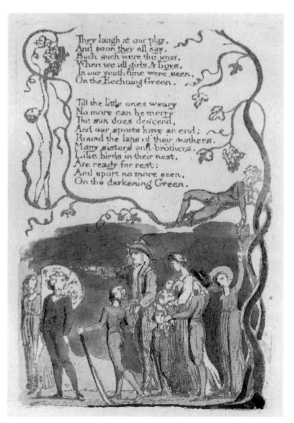

Figure 44. William Blake, 1757–1827, "The Ecchoing Green," from *Songs of Innocence* (London, 1789), copper plate etching, first plate 3 × 4⁹⁄₁₆ in. (7.6 × 11.6 cm); second plate 2¹⁵⁄₁₆ × 4⁹⁄₁₆ in. (7.3 × 11.6 cm), photo courtesy of The Lessing J. Rosenwald Collection, Rare Book and Special Collections Division, Library of Congress.

In "The Fly" (figure 45) a young girl plays shuttle-cock at the left, her back to the viewer and her racquet raised in anticipation of hitting the shuttlecock. To her right, a mother or nursemaid helps a young boy, who is unshod out of delicacy not poverty, learn to walk. While the woman's body seems to protect the child, the accompanying text alludes to the child's fragility, equated to the fly that can be accidentally "brush'd away." Blake has taken the element from contemporary child's play and made it a metaphor for the fragility of the child's life. The gendering of the two children is also important. The girl finds distraction in play, yet it is not the communicative play of "The Ecchoing Green"; rather it is indicative of thoughtlessness concerning living things. The shuttle-cock parallels a bird or a fly, both ennobled by Blake with a value of their own, unseen by the careless, unsuper-vised girl. The boy, under a barren tree on a grassless ground, is led away from living things, the nurse think-ing she is aiding him but in effect is doing him harm.[11] Significantly, the *Songs of Innocence and of Experience* was produced in a limited edition, each impression indi-vidually colored by the artist and his wife, with a philo-sophical purpose that is missing in the straightforward *Gymnastics for Youth.* The widespread dissemination of books such as the latter allowed for a wider audience— an audience of both adults *and* children—for images of children engaged in healthful activity. Collectively, such images promoted a more active construct of childhood in which children appear independent of adult authority, yet with at least a subliminal reference to this authority.

Many amusements for children, including zoos, puppet shows, circuses, panoramas, and museums such as Sir Ashton Levers's Museum of Natural History at Leicester House in London, attest to the new popularity of family excursions.[12] Visits to art exhibitions *en famille* arise at this time: Marjory Fleming, born in 1803, tells us in her childhood diary that she desires to participate in the still-new fashion of exhibition-going. In an entry from the spring or early summer of 1810, she writes, "I hear many people speak of the Exebition and I long very much to behold it but I have to little mony to pay the expence."[13] The tone of her entry suggests that such a visit might, but for her resources, be possible, whereas a visit to the theater is perhaps still too adult an enter-tainment: she writes that "I should like to see a play very much for I never saw one in all my life & dont believe I ever shall but I hope I can be content without going to one."[14] Paintings such as Joseph Wright of Derby's

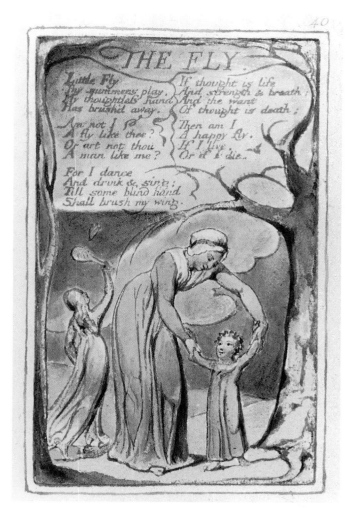

Figure 45. William Blake, 1757–1827, "The Fly," from *Songs of Innocence and of Experience* (London, 1794), copper plate etching, 3 1/16 × 4 7/8 in. (7.7 × 12.4 cm), photo courtesy of The Lessing J. Rosenwald Collection, Rare Book and Special Collections Division, Library of Congress.

Experiment with the Air Pump (figure 89) or his *Philoso-pher Giving a Lecture on the Orrery* (figure 90), fully dis-cussed in Chapter Eight, describe the excitement of a new world of science and technology that families could experience together. And for all of these destinations, it should be noted that parents accompanied their children. Travel had become newly available to families, and this development allowed even the rural family to visit Lon-don's distractions.[15] Collectively these entertainments presented children with a far more exciting visual world than ever before.

Many adults saw the educational role of diversion and described it in their writings. For example, Charlotte Papendiek, not a tract writer but an attendant to Queen Charlotte and, later, a memoirist, noted that the forma-tion of a child's mind took place

Figure 46. William Mulready, 1786–1863, frontispiece from William Roscoe, *The Butterfly's Ball and the Grasshopper's Feast,* London, 1 January 1807, engraving, 3 × 3 in. (7.7 × 7.6 cm), The Pierpont Morgan Library, New York.

principally in the hours of recreation, when the tutor or attendant should discover by imperceptible means, the inclinations and tastes of each pupil, directing their pastimes into such channels as may tend to divert evil propensities, and give encouragement to rational pleasures and pursuits."[16]

Thus, recreation is, for Mrs. Papendiek, "the great secret and difficulty of education."[17]

The illustrated children's book, including works from the influential John Newbery such as *The Child's Plaything* of 1744, must be seen as both toy and educational device (to be discussed at some length in Chapter Five). Books such as *Juvenile Sports and Pastimes* of 1773 by "Master Michel Angelo" acknowledged how learning, especially learning the alphabet and basic reading skills, could be made into and equated with a game. By example, the author suggests, in the voice of an imagined child, that "I was the more eager in the pursuit of this infant knowledge as I was made to believe it was rather an indulgence than a compulsion."[18] One of the most playful forms of children's literature, the nonsense verse, was initiated in 1806 with William Roscoe's *The Butterfly's Ball and the Grasshopper's Feast,* illustrated by William Mulready (figure 46). This imaginative, light-hearted book created a world of little creatures and little people who devise their own versions of adult galas. Roscoe's book unleashed a veritable craze in popularity,[19] yet it had taken some sixty years for the children's book as pure distraction to find its market, and its creator.

Despite the popularity of Lord Chesterfield's letters in the latter years of the eighteenth century, parents increasingly seemed to find in child's play something that was clearly special and worthy of notice. Many parents wrote at length about their children at play as a characteristic unique to childhood, often signaling their first concrete awareness of childhood as a distinct phase of life. As early as 1712 we find Nicholas Blundell writing a letter in which he describes his daughters, aged seven and five, engaged in mimicking adult activity:

> My daughters buried one of their dolls with a great deal of formality, they had a garland of flowers carried before it and at least twenty of their playfellows and others that they invited were at the burial.[20]

Blundell records without judging, implying acceptance without emotional commentary. The visual equivalent may perhaps be found in two remarkable conversation pieces of children at play by William Hogarth, *The House of Cards* (plate 34) and *The Children's Party* (plate 35), both painted in 1730. Evidently pendants depicting the children of the first Earl of Pomfret, the two canvases suggest complex narrative relationships with each other. In each, the arrangement of figures follows an elegant Rococo line probably derived from Watteau, whose *fêtes champêtres* Hogarth may have known through engravings. The landscape settings certainly refer to the children's aristocratic background, a sort of topographical portrait of the landed aristocracy commonly used in conversation pieces. In *The House of Cards,* a young girl at the apex of the composition builds a house of cards while another watches excitedly. A boy comes in from the left waving a banner, alluding to the formal presentation of regimental banners in the military. To the right, a boy and girl hold a basket of cut flowers, an occupation suggestive of adults romancing one another. In the center, a pug dog—often Hogarth's alter ego in his printed work—carries a stick, a reference to the dog's and perhaps the artist's labor. The motif of the house of cards—a game of delicacy and ultimately of futility—was, as we have seen, suggestive of the fragility of life generally and of childhood particularly, and occurs frequently in painting of this time, notably in Joseph Francis Nollekens's *Two Children of the Nollekens Family Playing with a Top and Playing Cards* (plate 6) of 1745 and the French-born Hubert Gravelot's and Francis Hayman's important collaborative work *Building Card Houses,* painted for the pleasure gardens at Vauxhall.[21]

While the children in Hogarth's *The Children's Party* are similar to those in their pendant, their activities and accoutrements have changed. A boy marches in from the left beating a drum, again referring to the boy's future military work. The broken architectural capital on the ground behind him seems a clear *vanitas* reference. A girl at the composition's apex reaches to face a mirror suspended on a tree trunk and turns it toward the viewer, gesturing toward it with her left hand. The mirror is then not only a traditional *vanitas* reference but a symbol of the girl's, and the viewer's, future (self-)knowledge. Two girls to the right stand in front of a funerary urn decorated with a garland of flowers. One reacts in alarm to the impending upturning of the tea table by a playful spaniel, the painting's central motif. The spaniel, certainly intended in contrast to the hard-working pug in *The House of Cards,* upsets the children's world, leaving a rigid doll to preside over the scene with her undisturbed toy kettle. The spaniel functions, in this world restricted to children, much as the child playing with the stack of books does in Hogarth's Cholmondeley family piece, upsetting the established order. In *The House of Cards* and *The Children's Party,* the children are engaged in playacting, simultaneously acting out their future roles and mimicking the world of their parents, who are notably absent from both pictures. The child's talent for mimickry was admired by Hogarth and Reynolds, who seem to have found in it the perfect (and theoretically innocent) critique of the adult world. While individually the symbolic role of the children's disparate objects and activities is clear, collectively they fail to give us a definite narrative, suggesting Hogarth's intentional distance from the separate world of childhood. This construct has a dreamlike quality, one that suggests the impenetrability of the child's world even to the perceptive adult.

The infusion of emotion into observation of children at play comes later in the century at the hands of witnesses such as William Blake, who, like Reynolds, was childless, yet wrote of children he saw playing in London's Fountain Court, saying, "That is heaven."[22] There is indeed substantial literary evidence for the indulgence of play in young children. Mary Hamilton addressed a letter in 1792 to her five-year-old daughter, who had just been given "a fine undressed doll," advising that "you must work very hard for dolly, for poor thing she is quite naked, and take care of her fine hair."[23] Learning through play is implicit: Mary Hamilton's

daughter will learn to care for herself and later for her own children by playacting with her doll. Similarly, a girl might learn her future role by playing with toy dishes. As an adult writing her memoirs, Charlotte Papendiek recalled an incident in which she "passed the afternoon with Augusta Petch, who had a new set of toy plates and dishes of a size exceeding the usual children's services. These so dazzled me that I secreted one of the largest dishes."[24] It was, however, her shame at the discovery of this theft that so embedded the moment in her memory. The equivalent for boys was play at being soldiers (or playing with toy soldiers), an activity described by the doting Duchess of Leinster in a letter to her husband of 1757 where she writes, "These dear boys . . . have been all morning exercising as soldiers; I wish you cou'd see how prettily they do it."[25] Maria Edgeworth, writer of Rousseau-inspired education and conduct books such as *Practical Education* of 1798, preferred educational to "useless" toys and favored mechanical toys for boys that would encourage their interest in invention and industry.

Children were also frequently described at play with objects that held little socializing value. Lady Harriet Cavendish, or Hary-O, as she was known, daughter of Georgiana, Duchess of Devonshire, described to her grandmother the effect of taking toys to her nephew and nieces:

> George's delight at the nest of Boxes is not to be described and I was charmed to find that the surprise continued as undiminished as the pleasure, for the effect each new box produced seemed to me much the same after I had gone through the whole process a dozen times, and if my patience had been as unwearied as his astonishment, we should probably be at it still.[26]

Observations such as these extend to the top of the social hierarchy. In 1798 Fanny Burney described taking her three-year-old son Alexander to visit the royal family. Alexander was shy at first until, she writes,

> Princess Elizabeth then entered, attended by a page, who was loaded with playthings, which she had been sending for. You may suppose him caught now! He seized upon dogs, horses, chaise, a cobbler, a watchman, and all he could grasp. . . . The Queen . . . had a Noah's ark ready displayed upon the table for him . . . he was now soon in raptures; and, as the various animals were produced, looked with a delight that danced in all his features; he capered with joy; such as, "O! a tow!" But, at the dog, he clapped his little hands, and

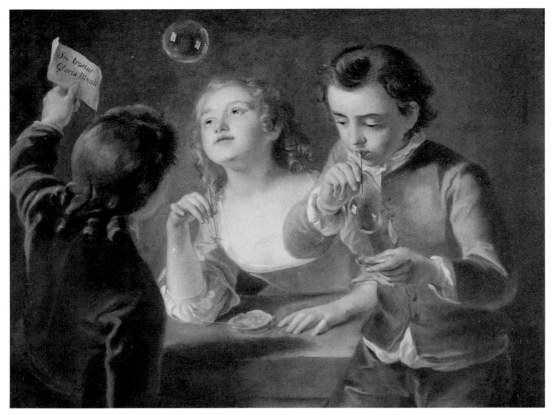

Figure 47. Philip Mercier, 1689–1760, *Three Children Blowing Bubbles*, 1747, oil on canvas, 27½ × 35½ in. (69.8 × 90.2 cm), Private collection, courtesy of the National Gallery, Washington.

running close to her Majesty, leant upon her lap, exclaiming "O; it's bow wow!" "And do you know this, little man?" said the Queen, showing him a cat.

"Yes," cried he, again jumping as he leant upon her, "its name is talled pussey!" And, at the appearance of Noah, in a green mantle, and leaning on a stick, he said, "At's the shepherd's boy!"[27]

Burney's passage provides an engaging account of the queen's domestic instincts—instincts that exerted a far-reaching influence on the rise of Georgian domesticity generally. Queen Charlotte was mother to thirteen children, and this description presents a much more relaxed picture of the queen as a mother figure than the one seen in Zoffany's conversation piece, itself a product of an increasing taste for domesticity.

Lord Chesterfield's harsh verdict on child's play was far from universally imposed. Often children past the age of Chesterfield's son were indulged by their parents, and, in a number of cases, the evidence comes from the diaries and letters of children themselves, although surviving children's diaries are exceptionally rare. An early child writer, John Verney, at the age of twelve wrote to his father from school in 1723 asking for a pair of battledores and shuttlecocks.[28] Later, two of the great child diarists,

the Wynne sisters Elizabeth and Eugenia, record playing games such as hide and seek and blindman's buff as well as less institutionalized games, such as playing tricks on the family servants.[29] Elsewhere, the Wynne girls entertainingly describe being taken to see art exhibitions, opera, and theater—but unfortunately record little of what they thought about what they saw. Marjory Fleming, who began keeping a diary at age seven, describes washing her doll's clothes as well as playing and bathing in the sunshine.[30] Mary Sewell wrote as an adult of her most treasured childhood toys—a "baby-house" and the "little tin and lead plates" that furnished its kitchen during her girlhood of around 1805.[31] By the nineteenth century the keeping of playthings could co-exist with the life of learning. Benjamin Heath Malkin, who wrote a moving memoir of his dead son, Thomas, a child prodigy, commented that Thomas at the age of four could read "any English book" and Greek words not exceeding four syllables. "When engaged in play . . . [he] was as much a child as other children; and derived as much pleasure from his diversions, as if his thoughts had never expatiated beyond them."[32] Henry Alford, looking back on his own childhood, remembered being allowed to keep his play-

Figure 48. Francis Hayman, 1708–1776, *Flying the Kite,* ca. 1740, pen and brown ink, gray and brown wash, 10¹¹⁄₁₆ × 7⁷⁄₁₆ in. (30.3 × 19 cm), Yale Center for British Art, Paul Mellon Collection.

things about him in 1820, at age ten, all the while that he was studying Ovid's "Epistles of Heroes" in Latin.[33]

Children also left a record of their recreation time not merely as a time for play but as the means for gaining in strength against possible illness and early death. Frances and Jane Grimston, aged about ten and nine, during a 1765 holiday at the seaside wrote the following poem for their father at home:

> Our health is good, our spirits cheerfull,
> Bathing we like . . . scorn to be fearfull.
> We ride, we walk, we pick up shells
> To day we guns have heard and bells
> In honour of great George our King
> You will suppose the bells did ring
> That was indeed the very thing.
>
> And now Papa, we pray excuse,
> These infant babblings of our Muse,
> The attempt is new, our time is short,
> If it contributes to your sport,
> Our end is answer'd; so shall We,
> Ever remain most cordially
> Your duteous daughters.[34]

The girls do their duty not only in the healthy outdoor pursuits of bathing, walking, and gathering shells but in writing their father and providing him with "sport" as well.

Artists came to depict children at play in less organized sport, again under the influence of emblematic scenes by Hogarth and Nollekens of children playing with tops or cards. Philip Mercier's *Three Children Blowing Bubbles* (figure 47) of 1747 must be counted here as a form of childish recreation, but one with an explicit *vanitas* reference: the girl gazes at an airborne bubble she has just released in which we see the reflection of a piece of paper inscribed *"sic transit Gloria mundi"* (thus passes worldly glory).[35] Francis Hayman's work at Vauxhall focused on the leisure habits of children and set an important precedent in the depiction of children. *Flying the Kite* is now known only through a charming preliminary drawing (figure 48) but was to have formed part of a general iconographic program devoted to childhood with titles such as *Birds-nesting* (Collection of Major A. S. C. Browne) and *The See-Saw* (Tate Gallery, London), where the children are really adolescents.[36] Hayman's *Flying the Kite* depicts a sport that grew in popularity among children throughout the eighteenth century. The style of Hayman's image probably derives from the French painter Lancret, whose image "L'Air"

Figure 49. William Hogarth, 1697–1764, "First Stage of Cruelty," plate 1 from *The Four Stages of Cruelty*, 1751, engraving, 15¹⁄₁₆ × 12 in. (38.3 × 30.5 cm), Grunwald Center for the Graphic Arts, UCLA.

from a series entitled *The Elements* (engraved both in England and in France) included kite flying among its carefree diversions.

George Morland adopted child's play as a frequent subject of his genre scenes, often drawn from direct observation. He spent much time in peasants' cottages observing and playing with their children, paying them for their time.[37] In addition, an early Morland biographer tells us that "he would ask all 'the children of the neighborhood' to come into his house, and play about in his rooms, and he made sketches of them 'whenever any interesting situations occurred.'"[38] In Morland's *Blind Man's Buff* (plate 36) of 1787 to 1788, a group of nine children play this seemingly timeless game in a pastoral setting: an overarching tree shelters these rural children, who are brilliantly and naturalistically arranged across the canvas. One child wanders about blindfolded, with her arms raised in front of her; another child prods her

with a stick; yet another holds up a dog to join in the game, while others hide in delight or boredom. Morland's goal appears to be sentimentalized observation—complicity in game playing by an artist known for his distaste for many aspects of the adult world. *Blind Man's Buff* was one of a series of thirteen unself-conscious scenes of childhood Morland seems to have drawn from nature.[39] Elsewhere in the series, as in the artist's *Playing at Soldiers,* Morland depicts children playacting at adulthood, but in *Blind Man's Buff* childhood is presented on its own terms. The Bristol artist Francis Danby carried this tradition of naturalistic representation of children at play into the nineteenth century, in works such as the diminutive *Boys Sailing a Little Boat* (plate 37). This is a peaceful, sun-dappled world, a still world of tentative reaching out—one boy stretches to prod the toy boat with his stick but just fails to touch it. Although the children's costuming is strikingly mature (by this time boys'

fashion was more referential of adult male trousers and hats), adults are not to be found in Danby's scenes of child's play. As in Morland's painting, the world of childhood is consciously seen as independent of that of adulthood, a post-Rousseauian innocent idyll in which adults are unnecessary, potentially intruders. Yet the very presence of the artist suggests adult mediation and projection.

Child's play was not, then as now, necessarily an outlet for unsullied innocence. Among painters Hogarth was most disposed to recognize a child's capacity for cruelty. His portrait of the Grey children (figure 10), where Hogarth has chosen as his subject the three-year-old Lord Grey tormenting a small dog, is perhaps the strongest depiction of childhood cruelty to animals, all the more pronounced for being a formal portrait. Hogarth returned to this subject again, claiming that one reason he carried out his print series of the *Four Stages of Cruelty* (1751) was to stop childhood cruelty to animals. The "First Stage of Cruelty" (figure 49) describes an array of atrocities committed by children (boys) against animals: two cats are hung from ropes by their tails, a dog has a poker forced into his anus, another has his leg cobbled to his body to render him lame. Hogarth's inscription to the engraving reads in part, "While various Scenes of sportive Woe/The Infant Race employ:/And tortured Victims bleeding shew/ The Tyrant in the Boy." Hogarth has entitled this the first *stage* of cruelty, the precursor to adult cruelty to other adults. The child is father to the man in a print that suggests the continuation of the Puritans' belief in the presence of original sin in children: Hogarth's boys here are not the sweet innocents of the *Graham Children* (plate 13). Beyond the work of this remarkable artist, the mindless abuse of animals by children increasingly came under attack throughout the Georgian period, and many early children's books took the prevention of cruelty to animals as their subject.[40]

Even with the new prevalence of toys for children and numerous records of parental involvement in and tolerance of child's play, we must be careful to question how much these toys and activities—and their images— tell us about a construct of childhood. The eminent historian J. H. Plumb has suggested that the sudden indulgence of children with toys and games indicates merely that children had become "luxury objects," even "superior pets."[41] It is clear that, at least in this area, the lives of many children may have been enriched, but does this signal that they were also increasingly thought of as occupying their own world? Even if we accept Plumb's argument that the material record suggests an increasing objectification of children, child's play does, I believe, suggest a reconstruction of childhood, a refiguring and, in the arts, a revisualization of the child's world.

Chapter Five / *The Child Learns: Academic, Religious, and Moral Education*

The most significant philosophical debate of the eighteenth century in regard to children arose concerning their education. Upbringing was no longer left to tradition but became an object of intense discussion, pitting the differences of pedagogical opinion over child care and education into the camps of utilitarian philosophy and evangelical religion. The century began with John Locke's insistence that all ideas are rooted in experience, and that from experience—and reason—arises the perfectability of man. Locke's writing, like Rousseau's some seventy years later, had a tremendous influence on British education and the development of British openness toward the arts: *Some Thoughts Concerning Education,* first published in 1693, was reprinted nineteen times before 1761. While emphasizing the need for the child's obedience, Locke suggested that the goal of education was not merely to secure this but to prepare him to achieve independent status in the world.[1] In practice this often meant controlling and concealing the child's true, perhaps unruly, feelings. For boys, this was to be accomplished outside the home as they were sent away to school. There, the natural father's absence—replaced by the multiple father-figures of a boy's tutors—was a blessing. Locke stressed the mutual duty of father and son, perhaps for the first time, and introduced the notion of parental restraint to a system that had been based on filial obedience, although such paternal restraint took some time to manifest itself. Ironically, the separation imposed by boarding school, which was intended to prepare the child for his role in society and to render him obedient to his elders—a tradition established by Locke and ultimately advanced by Rousseau—had as an outcome the simultaneous creation of a cult of childhood and its submission to adult control. The school, in providing a separate institution for children, gave childhood an independent and recognizable status. There, the child, the "other" in the adult world, was both coddled and placed in a position where he could be more effectively dominated.

Locke's theories were seen, in France at least, as the equation of the "good" with happiness and with pleasure, leading to a belief in the power of natural goodness that did much to overturn Puritan rigidity. A kind of religion of the family, even a secular sanctification of the innocence of childhood, was the result. The French response to Locke ultimately proved to be a vital factor in British childhood. Indeed, a number of French writers found themselves in Britain in the years after Locke: Voltaire fled to England in the 1720s; the Abbé Prevost, who translated Richardson's *Pamela* in 1742 and *Clarissa* in 1751, was in England in the late 1720s and early 1730s; and Rousseau arrived in the 1760s. Locke's ideas resurface in various English literary works, many of which emphasized the dissolution of the father-son relationship and thus were perhaps the result of Locke's removal of the son from the family home:[2] Defoe's novel *Robinson*

Figure 50. Sir Joshua Reynolds, 1723-1792, *The Schoolboy,* 1777, oil on canvas, 35½ × 27½ in. (90.1 × 69.8 cm), Private collection, courtesy of the Metropolitan Museum of Art.

Crusoe of 1719, Samuel Richardson's book of moral advice, *The Apprentice's Vade Mecum,* which appeared in 1733, and Lord Chesterfield's letters to his son.[3] All of this discussion and theorizing was enormously influential for the development of ideas of Sensibility, of theories of emotion and reception, in both Britain and France.[4]

Richard Wilson's painting *Prince George and Prince Edward Augustus with Their Tutor* (plate 38) of about 1748 to 1749 depicts a pupil-tutor relationship at the highest level. These two sons of Frederick, Prince of Wales (who died before he could inherit the throne from his father, George II), are shown with their tutor, Dr. Francis Ayscough, who at one time owned both the picture shown here and a larger version also by Wilson in the National Portrait Gallery, London. The lively handling and color of the princes contrasts with the austere figure of the tutor, cloaked in his black doctoral robes and cassock. Dr. Ayscough stands in a setting of classical niche statues representing the world of learning, while the princes are surrounded by the rich furnishings, the heavy drapery and twisted columns, of the court. The columns, known as "Solomonic," may refer to the proverbial wisdom the tutor wished to be seen as giving to his pupils.[5] The two princes seem awkwardly casual in their formal setting, the result of Wilson's effort to render them as children and not yet monarchs and to conform to the informal painting style favored by Frederick, the boys' father. Frederick is, of course, absent from the scene, having given responsibility for the boys' education to their tutor.

Rousseau was susceptible to the various theories and opinions, arguing in his writings of the 1760s, especially *Emile,* that experience is at best a mixed blessing and that a child's access to experience—through his moral and practical education—must be carefully controlled. Instead, a return to primitive innocence being impossible, the child is to be allowed full individual development in nature, protected from the harmful influences of civilization by his tutor, a sort of guide in developing independent judgment and character. Rousseau decried even traditional children's literature, with the exception of Defoe's "survival kit," *Robinson Crusoe.* Younger children, between the ages of two and twelve, are to be allowed to run about "idly at hazard." Proximity to nature was seen as an aid in education; boys were thought to benefit from lying in deep grass and sleeping in hard beds.[6] At their root, Rousseau's ideas fundamentally argue for respect for and a reinvention of childhood.

When *Emile* was translated into English in 1762, it made a sudden, dramatic impact reflecting a growing dissatisfaction with the harsh Puritan legacy on educational theory and juvenile literature. Rousseau's ideals were adopted primarily by upper- and upper-middle-class British families, which, as previously suggested, were already more interested in domesticity and more child-centered. Both Lady Caroline Fox (née Lennox) and her sister, Emily, Lady Kildare (later Duchess of Leinster and mother of nineteen), read *Emile* when it appeared and commented extensively on it in their letters.[7] Emily even used *Emile* to support her argument to rear her children at home. A telling testimony to Rousseau's penetration of British thinking comes in 1829 when the seven-year-old Frances Power Cobbe, exasperated by her governess's instruction, drew on the gravel walk of her parents' garden, "Lessons! Thou tyrant of the mind!" Her mother laughed, but did not change her daily schedule.[8]

Not surprisingly, other writers and philosophers detested Rousseau's ideas, including John Wesley who thought *Emile* "the most empty, silly, injudicious thing that a self-conceited infidel wrote."[9] With the French Revolution of 1789, Rousseau's ideas fell into disrepute in some quarters that associated them with the excesses of the Reign of Terror. Rousseau reminded Northcote, for instance, of "all the gloomy horrors of a mob-government . . . which attempted from their ignorance to banish truth and justice from the world."[10] Rousseau's writings were not, perhaps, well adapted to a rapidly industrializing British society. His British followers took recourse in reason to cure the faults of society (made obvious by revolution and industrialization), as opposed to resting with Rousseau's idea that the child should learn through personal experience. The ideal tutor is omnipresent throughout late eighteenth-century children's literature, notably in Thomas Day's Rousseau-inspired *History of Sandford and Merton* (1783 and after).[11] In this classic of children's literature—arguably the first novel about children for children—the tutor appears in somber garb on the beautifully engraved frontispiece, depicting the reconciliation of the two young boys in an arcadian landscape reminiscent of a canvas by George Stubbs.

Perhaps it is not surprising to see that numerous artists took a line somewhat opposed to the doctrinaire positions advanced by the educational philosophers and their followers. Sir Joshua Reynolds, despite his own tendency to adopt a rigid stance in his discourses to the students of the Royal Academy, professed to be opposed

by nature to all treatises on education, arguing in his Twelfth Discourse that

> they proceed upon a false supposition of life; as if we possessed not only a power over events and circumstances; but had a greater power over ourselves than I believe any of us will be found to possess. Instead of supposing ourselves to be perfect patterns of wisdom and virtue, it seems to me more reasonable to treat ourselves . . . like humoursome children, whose fancies are often to be indulged in order to keep them in good-humour with themselves and their pursuits. It is necessary to use some artifice of this kind in all processes which by their very nature are long, tedious, and complex, in order to prevent our taking that aversion to our studies, which the continual shackles of methodical restraint are sure to produce.[12]

Henry Fuseli, the Swiss-born artist who began exhibiting in Britain in 1775, saved much of his scorn for schoolmasters and indirectly praised *Emile* by suggesting that it succeeded by lack of precepts, writing that "there is not one schoolmaster in the kingdom, but what would heartily throw the book, and all its nonsense, in the Thames . . . could he but afford it."[13] William Blake rejected the educational writings of both Locke and Rousseau, believing that the former's reason bred passivity and hidden resentment in children. Instead, Blake favored feeling and instinct, but not of the Rousseauian variety.

Nevertheless, between 1762 and 1800 at least two hundred Rousseau-influenced treatises on education were published in Britain. Prominent among British writers affected by Rousseau, although too independent to be adequately called Rousseauian, is Mary Wollstonecraft, who wrote in works such as *Thoughts on the Education of Daughters* (1787) and *A Vindication of the Rights of Women* (1792) that artificial prejudice was taught to children before nature even made any distinction between the sexes. Unfortunately, many of the educational innovators, including Wollstonecraft and Thomas Day, lost sight of the individual child. When Blake came to illustrate Wollstonecraft's *Original Stories,* he attempted to right this by showing himself on the side of the children: the tutor, Mrs. Mason, is inevitably depicted as self-conscious and studied, while the children look wistfully at the wider world denied them.[14] Blake's illustrations for *Original Stories* cover much of the range of late eighteenth-century didacticism, from happy domesticity to the joys of learning to the necessity of charity, tempered by being centered in the child's present reality. The latter years of the century were an age of sharp divi-

sions in attitude toward education, seen in works of literature from around the turn of the century as diverse as Jane Austen's *Mansfield Park* and Walter Scott's *Waverley,* both of 1814, and Wordsworth's *The Prelude,* subtitled *Growth of a Poet's Mind.* Begun in 1798 to 1799, *The Prelude* is largely autobiographical and focuses on Wordsworth's childhood experiences and the challenges to and triumph of his imagination, two major Rousseau-inspired themes dear to the Romantic movement.

When artists in the years after *Emile* painted works on educational themes, the influence of Rousseau's naturalism was startling. Sir Joshua Reynolds's *The Schoolboy* (figure 50) of about 1777 is, with its rich color scheme, shadowy depths and white highlights, a deliberate reference to Rembrandt. Yet compared with his earlier work on this motif, *Boy Reading* of 1747, Reynolds's treatment has taken on a new subtlety, a sensitivity to the child subject. Both parent figures and tutors are now absent and the child is seen alone, monumentalized. Reynolds's friend and literary colleague William Mason tells us that the subject for *The Schoolboy* was one of Reynolds's favorite models for his fancy pieces and was not in actuality a student.

> This boy (at the time about fourteen) though not handsome, had an expression in his eye so very forcible, and indicating so much sense, that he was certainly a most excellent subject for his pencil. . . . He was an orphan of the poorest parents, and left with three or four brothers and sisters, whom he taught, as they were able, to make cabbage nets; and with these he went about with them, offering them for sale, by which he provided both for their maintenance and his own. What became of him afterwards I know not. Sir Joshua has told me, when talking of his beggars, that when he wanted them again, they were very frequently never to be found again. . . .[15]

Tellingly, Reynolds has not seen fit to intervene in the child's life; his ultimate welfare is immaterial to the matter of posing and mimicking the student. When exhibited at the Royal Academy, Horace Walpole admired *The Schoolboy* as "very fine, in the style of Titian."[16] Engraved by J. Dean in 1777 under the same title, *The Schoolboy* was purchased by the second Earl of Warwick two years later, and was hung—alone—in the library at Warwick Castle, siting an image of learning within an appropriate setting.

Reynolds was not alone in painting fancy pictures of this kind. Philip Mercier's *Boy Reading to a Girl* (figure 51) assigns gender to the act of learning: the boy reads

Figure 51. Philip Mercier, 1689–1760, *Boy Reading to a Girl*, 1747, oil on canvas, 35¼ × 27¼ in. (89.5 × 69.2 cm), Private collection.

while the girl is engaged in an appropriately domestic activity, within an unspecified interior. Reynolds's and Mercier's fancy pictures influenced later artists who chose to depict children at their studies, in part through the note of abstracted reverie that permeates both *Boy Reading* and *The Schoolboy*. Thomas Barker of Bath borrowed heavily from both for his ink drawing *Seated Boy with Book* (figure 52). In all three, learning seems little more than an appropriate device through which to depict children, almost a proto-Romantic sensibility in which thought wanders. John Augustus Atkinson, by contrast, in his *Going to School* (figure 53) of the first decade of the nineteenth century, shows a boy actively engaged in the process of learning. A knapsack hung over his shoulder, the boy reads while walking, perhaps on his way to school (a motif used as early as 1787 in a woodcut for the children's book *A Pretty Book of Pictures for Little Masters and Misses* illustrating "A Student").

He leaves behind him a simple rural cottage with the face of his mother peering through the doorway. The drawing suggests, without sentiment, the spread of literacy to working and rural populations, and it also relates to the illustrated books Atkinson produced after 1801 on the subject of contemporary social mores and costume.

At the same time, the formal school portrait continued to be painted in the years after Rousseau. One of the most common types of these portraits was the so-called "leaving picture," given by a boy to his school's headmaster on his leaving. This was most frequently the practice at schools such as Eton College, which in this way developed a fine collection of portraits by all the great portrait artists of the day. Late in the eighteenth century, leaving pictures generally showed boys at around the age of eighteen, well beyond the age of what might be described as childhood. John Hoppner's portrait of John James Waldegrave, sixth Earl of Waldegrave (plate 39),

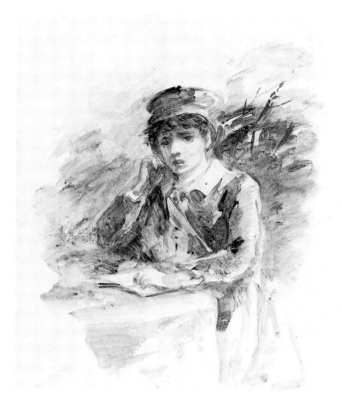

Figure 52. Thomas Barker of Bath, 1769–1847, *Seated Boy with Book,* early 19th century, ink and wash, 10 × 7¼ in. (25.4 × 18.4 cm), Grunwald Center for the Graphic Arts, UCLA.

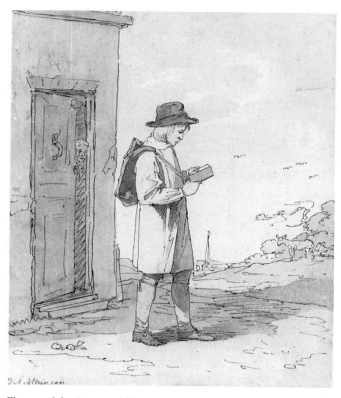

Figure 53. John Augustus Atkinson, 1775–1831/33, *Going to School,* ca. 1801–10, pen, black ink, and watercolor, 7½ × 6⅛ in. (19.1 × 15.6 cm), Yale Center for British Art, Paul Mellon Collection.

shows its sitter at age fifteen on leaving Eton after eight years as a student there. Such a portrait marks, in its formal elegance, the transition from adolescence to independence. Indeed, this portrait type can be thought of as part of the ritual passage to adulthood, part of the formalization of childhood development fostered late in the eighteenth century.

In practice, one of the great changes wrought by educational reform was the expectation, commonly held by the late 1760s, that a middle-class child could be taught to read in the home by the age of five or six. Dr. William Cadogan argued in his influential 1748 treatise on child rearing that children "cannot be made reasonable Creatures too soon";[17] to that end, parents should avoid the "Namby Pamby Stile" of speech to encourage children to develop language properly. Benjamin Heath Malkin provided testimony of an exceptional success in home education, writing with tremendous pride that his precocious son could read by the age of three: at three years and two months he was reading *Tit for Tat* during the evenings at home. Shortly thereafter the boy hoped to begin learning Greek; at age five, he wrote appreciatively of Dr. Aikin's and Mrs. Barbauld's "employing books for little boys."[18] At age six he wrote moralizing

fables himself, including one in which he wrote of the "weakness of the mind in infant time."[19]

Mothers, especially, often recorded the practice of early learning at home, as in the writings of Frances Boscawen, who wrote about the education of her children more than any other subject. She noted:

> The instant breakfast is over, we [she and her son] retire into another room to say our lesson . . . by which means he has made a considerable progress since we came into the country, and, if he had but half as much application as he has genius and capacity, he would read soon. But this same application is an ingredient seldom found in the composition of such a sprightly cub.[20]

Similarly, Scotswoman Amelia Steuart wrote in her diary:

> I believe the great difficulty in the education of children is allowed to be that of making them acquire habits of industrious attention & the power of studying— without giving them a disgust to learning by painful restraint.[21]

These perceptive mothers are aware of a potentially critical divide between the nature of the child (his sprightliness) and the need to form him—a divide of immense importance for many visual artists, as well.

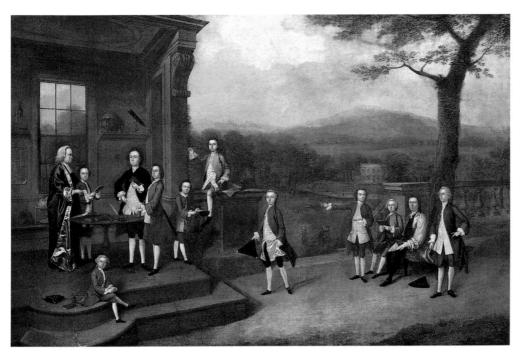

Figure 54. Arthur Devis, 1712–1787, *Breaking-up Day at John Clayton's School in Salford*, ca. 1738–40, oil on canvas, 47½ × 68¾ in. (120.6 × 174.6 cm), Tate Gallery, London.

A number of diarists comment on sending their children to boarding school, and all who do so suggest (perhaps conveniently) that it was for the children's good.[22] At school, eighteenth-century traditionalists placed great faith in the mental training offered by the classics, defined as Latin, Greek, ancient history, and geography. By the early nineteenth century, more than three-quarters of a schoolboy's time was spent on these subjects.[23] When artists come, albeit rarely, to depict boarding schools, as in Arthur Devis's *Breaking-up Day at John Clayton's School in Salford* (figure 54), the images are largely hierarchical, with an emphasis on visual order and control. Devis's painting ranges students of different ages and their tutors across the canvas as a kind of modern Socratic conversation in which actual learning is represented. The boys' natural instincts are entirely sublimated. Yet outside of lessons (and flogging), public schools were largely unregulated. The boys were left to themselves and often tyrannized each other; on more than one occasion the militia was called in to quell schoolboy riots at Eton, the kind of incident that famously led Henry Fielding to call the public schools "the nurseries of all vice and immorality."[24] William Cowper objected to public schools on the interesting grounds that they created a distance between father and son, the latter becoming shy and strange with the former. Surely, here, Cowper was

reacting to the more general dislocation of the father from the central role in child rearing.

Daughters were largely spared the particular indignity described by Fielding and were given different goals to strive for and an education based on preparing them for their future performance in the home. Daughters were more commonly educated at home, although there were also "female academies," boarding schools where daughters were taught what was termed the great "Art of Society." Many female academies, such as the one set up by Mary Wollstonecraft at Newington Green, taught little more than reading, sewing, and drawing. Jane Austen was sent to three boarding schools from the age of seven, but she still received most of her education from her clergyman father. Other prominent women, such as Elizabeth Lady Holland, recalled having been given almost no education beyond what they taught themselves. Lady Holland wrote in 1797, "Happily for me I devoured books. . . . I should be *bien autre chose* if I had been regularly taught."[25]

One of the by-products of the Rousseauians' call for greater parental involvement in child rearing[26] was a turn against the boarding school. George Morland created what must be one of the greatest documents in any medium opposing boarding school practice in his painting *A Visit to the Boarding School* (figure 55), also repro-

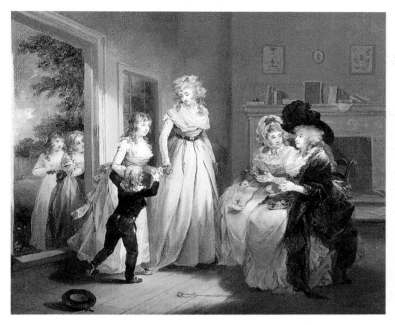

Figure 55. George Morland, 1763–1804, *A Visit to the Boarding School,* ca. 1789, oil on canvas, 25¼ × 29⅛ in. (64.1 × 74 cm), The Trustees of the Wallace Collection.

Figure 56. William Ward, 1766–1826, *A Visit to the Boarding School,* 1789, mezzotint printed in color after George Morland, 17⅜ × 21⅝ in. (44.5 × 55 cm), Yale Center for British Art, Paul Mellon Collection.

duced here in William Ward's engraving of 1789 (figure 56). Morland's subject is the visit of an upper-class mother to her daughter at boarding school, but the girl is clearly hesitant to see her mother, who does not even rise from her chair to greet her. The girl must be led into the room by one of her schoolmistresses and a young boy, while two of her friends peer shyly from outside the room. One of Morland's most accomplished pictures, *A Visit to the Boarding School* is intended, like its companion, *A Visit to the Child at Nurse* (plate 9), to arouse sentimental expectations. Yet, as E.D.H. Johnson has rightly pointed out, the mother continues to enjoy the luxury of emotion without the responsibility it should entail.[27] This mother has misunderstood Rousseau's message, and Morland takes as his task the attempt to teach other parents not to fall into the trap of irresponsible sentiment.

Numerous artists took as their subject the depiction of the classroom. John Opie's *The Schoolmistress* (figure 57) of about 1784 contrasts the youth and effort of the boy struggling to learn with the rigid, imposing figure of the aged schoolmistress. Opie uses the contrast both to engage the viewer's emotions and to set up a kind of classroom drama in which the child may become an unwilling protagonist. Education is here clearly one of the markers of childhood. John Harden's drawing, *Dame*

School at Elterwater (figure 58) of 1806, describes the schoolroom in straightforward reportage, describing the spread of schools throughout the country in the late eighteenth and early nineteenth centuries when such schools held a kind of novelty value and reinforced British notions of advancement in the face of perceived Continental perils. Many such depictions also were intended for a child audience, principally through the medium of the newly popular illustrated children's book. Dorothy Kilner's *The Village School,* published in 1780, contains a plate entitled "A View of Mrs Bell's School at Rose Green" (figure 59) allowing children to identify with the story of education in a small village and, thus, to further their own. The frontispiece to the anonymous *Primer for the use of the Mohawk children . . .* (figure 60) carries this to an exotic setting, one that sought to confirm English superiority (including the superiority of the English language) and benevolence. Notably, even the instructor here is intended to be a Mohawk. It is a captivating small engraving in which one young student turns to look over his shoulder, ignoring the lesson and directly engaging the viewer.

As these plates begin to suggest, the eighteenth century witnessed the first maturity of books specifically written for a child audience, including chapbooks, alphabets, and readers. John Newbery opened his book-

Figure 57. John Opie, 1761–1807, *The Schoolmistress,* ca. 1784, oil on canvas, 39 × 49 in. (99.1 × 124.5 cm), Private collection, courtesy of the Witt Library, Courtauld Institute of Art, University of London.

shop for children in London in 1745 and ran it until 1767, publishing and selling books meant to stimulate a child's interest. Newbery sensed the tenor of the times, creating a market for books that could be simply produced, enticing to the eye, and written and illustrated for children.[28] Newbery's work was fundamentally optimistic, taking children as his primary focus out of a belief that they could be trained away from vice toward good. Yet, of course, it was not as simple as this, for children did not buy these books, their parents did. Indeed, much of Newbery's work seems aimed at reforming the parents, targeting parental folly in careless child rearing among the idle rich, and the smug cruelty of middle-class parents. Even so, J. H. Plumb has argued that the mere presence of children's books must reflect changed attitudes toward children,[29] a statement substantiated by the generous tone of Newbery's publications. The advent of Newbery's books on the scene in the 1740s attest as strongly as Hogarth's paintings of the 1730s to a new and developing construct of childhood.

Children's books could be had from circulating libraries, although they soon began to come down in price. Published for as little as a half-penny, chapbooks, often illustrated with inexpensive woodcuts, were com-

mon even in poor households by late in the century. By that time, in the second generation of the children's book, writers were creating profoundly different books for boys and for girls. Writers such as Mary Ann Kilner created an affected standard for feminine nature that was part of a larger campaign to denature girls, to *re*form them in order to render them entirely delicate. One of

Figure 58. John Harden, 1772–1847, *Dame School at Elterwater,* 1806, watercolor, 8¹³⁄₁₆ × 11¹³⁄₁₆ in. (22.4 × 30 cm), Abbot Hall Art Gallery, Kendal, Cumbria, England.

Figure 59. Anonymous, "A view of Mrs Bell's School at Rose Green," from Dorothy Kilner, *The Village School*, vol. 1 (London, 1781–87), engraving, 3¹³⁄₁₆ × 3⅞ in. (9.7 × 9.9 cm), The Pierpont Morgan Library, New York.

Figure 60. James Peachy, dates unknown, frontispiece from Anonymous, *A Primer for the use of the Mohawk Children, to acquire the spelling and reading of their own, as well as to get acquainted with the English tongue* (London, 1786), engraving, 3⅝ × 2¾ in. (9.2 × 7 cm), The Pierpont Morgan Library, New York.

the aims of these books, such as *The Adventures of a Pincushion* and others we will see in Chapter Eight, was to restrict female self-expression and mold girls into what Mary Jackson has called the "guardians and weathervanes of social morality in general and of men's morals in particular, by 'soft persuasions' only."[30]

As early as 1763 James Boswell recalled how important children's books had been to him in his own childhood. In a diary entry for 10 July 1763, he wrote:

> Some days ago I went to the old printing-office in Bow Churchyard kept by Dicey. . . . There are ushered into the world of literature *Jack and the Giants*, *The Seven Wise Men of Gotham* and other story-books which in my dawning years amused me as much as *Rasselas* does now. I saw the whole scheme with a kind of pleasing romantic feeling to find myself really where all my old darlings were printed.[31]

The memory inspired Boswell to wish to write a "little story-book" in this style, a task that would require "much nature and simplicity" on his part.[32] The poet John Clare remembered with equal immediacy the role of children's books in his youth:

> I saved all the pence I got to buy [chapbook tales] for they were the whole world of literature to me and I knew of no other. . . . Nay, I cannot help fancying now that Cock Robin, Babes in the Wood, Mother Hubbard and her Cat, etc., etc., are real poetry in all its naive simplicity and as it should be . . . childhood is a strong spell over my feelings.[33]

Boswell and Clare seem to suggest the primacy of the child's view; nature and simplicity are the true province both of childhood and of "real poetry." Most of the new children's books sought to inspire adult modes of perception in children rather than giving import to modes of perception unique to childhood. The construct of child-

hood in which these early children's books participate is thus one in which the child is controlled as well as nurtured. It is in this light that we must see the profound importance of the appearance of the first books for children interested in pleasure for its own sake—notably William Roscoe's *The Butterfly's Ball* of 1807 (see figure 46).[34]

Some writers, in particular William Blake, instead wanted the ways of children to inspire the adult and rekindle the visionary flame of childhood. Blake used children's books as a source for works for adults, such as the *Songs of Innocence*, which was directly inspired by illustrated chapbooks for children. By the time a disillusioned Blake brought out his *Songs of Innocence and of Experience* in 1794, he had turned against education for its corrupting influence on innocent minds. He described experience itself as hazardous for the child, especially in the form of the artificial tutor. The text for "The School-Boy" (originally included among the *Songs of Innocence*) protests against the destruction of innocence and youthful joy in the dreary round of school, where sorrow, "sighing and dismay" reign. Blake writes of school as a cage:

Figure 61. William Blake, 1757–1827, "The School-Boy," from *Songs of Innocence and of Experience* (London, 1794), copper plate etching, 2¹⁵⁄₁₆ × 4⅝ in. (7.4 × 11.7 cm), photo courtesy of The Lessing J. Rosenwald Collection, Rare Book and Special Collections Division, Library of Congress.

> How can the bird that is born for joy,
> Sit in a cage and sing
> How can a child when fears annoy,
> But droop his tender wing.[35]

Self-development had been Blake's own education, and he advocated this freedom for others. Blake's illustration to this text (figure 61) shows three boys climbing up the stems of intertwining vines, again the vines of experience. A fourth boy sits at the top reading the book he was unable to enjoy in school, creating his own outdoor school, a true "learning's bower." On the ground three more children play at marbles.[36] "The School-Boy" is a cry for freedom from the cruelties of adult control, unlike the "sweet instruction" characterizing the *Songs of Innocence*. How striking, then, to recall that the models for Blake's *Songs* were children's books and educational treatises.[37]

When coupled with some of the parental attitudes outlined in Chapter Three, the debate over education could have profound implications for the child. Parental concern for a good education was partly aimed at pre-

paring children to be productive members of society, a concern shared by members of both the upper and middle classes. Charlotte Papendiek saw the education of her children as a way of safeguarding their future, an alternative to endowing them with money, which was in any case impossible in her meager situation. She writes in 1791:

> Schools at that time, for girls, as well as boys, were resorted to for every rank, from the nobility to the lowest classes. . . . My desire was that my girls should remain as day scholars with Mrs Roach, where they would continue under my guidance, and I could watch their daily progress, knowing at the same time that they were with a woman of strict principle if not altogether of the ornamental manner of good breeding. . . . Frederick for the present was going on remarkably well at Mr Ward's, and we hoped to be able to keep him there. . . .
>
> In starting young people in the world it was necessary then, as now, that they should have a good education or some fortune. As we could not amass the latter, we determined that our children should have as good an education as we could possibly manage to give them, and in this matter I assisted as far as in me lay. I was constantly looking after the progress they made, urging them to perseverance, and exhorting them against any inclination to indolence, idleness, or selfwill. This earnestness in me may be termed severity, and perhaps it savours of it, but to do my duty was ever my favourite theme. I loved my children more than life—I wished them to excel.[38]

As for the practical education of children who later became artists, Reynolds was educated at home by his father, a clergyman and a schoolmaster, who took a personal interest in his children, of which many revisionists might have approved. Sir Joshua's sister Elizabeth left a record of their father:

> He was a learned man and at times would call in his children into his study and give them lectures on different subjects, once she [Elizabeth] remembered the lecture was on a human skull which he had procured for the purpose.[39]

Reynolds, fond of discussing the "Advantages of Early Habits," credited his studious industry to the early lessons he gained in his father's library.[40] Henry Fuseli responded strongly to Rousseau's belief in the Man of Nature and specifically to the apotheosis of the child, perhaps because of the rigidity of his own upbringing. We learn of this in an entry for 1 October 1802 in Joseph Farington's diaries:

Fuseli gave us an account of his infancy. . . . *Letters* were *beat into him*. His father, as was the usage in Zurich, determined what his children should be without consulting their inclinations. He resolved that Fuseli should be a scholar and that his brother should be a painter, whereas it should have been reversed. He passed those early days in drawing and crying; every day floods of tears at being forced to read, which were relieved by stolen hours for his favourite amusement.[41]

Thomas Lawrence was, like Mrs. Papendiek's Frederick, sent away to school by his parents—as early as age six—but he has left no record of his thoughts on the experience.

As for the artistic training of children, it may have been, as in the case of Fuseli and the child prodigy Thomas Lawrence (who was from early childhood the principle support of his family), an avenue of raising revenue. In many cases, childhood artistic study was encouraged: Reynolds read Richardson's *Treatise on Painting* at age eight and began copying prints from his father's emblem books; Benjamin West's first drawing was reputedly that of his sister's baby sleeping in a cradle, executed at age seven;[42] a popular legend tells that Angelica Kauffman, whose father seems to have supported her talent, pretended to be a boy to attend art school; George Morland was encouraged by his artist-father but was not allowed to associate with other children or to study at the Royal Academy schools for fear of subverting his morals, even though George may have sold drawings as early as age twelve to pay for gin;[43] and Lawrence was taken at age eight to study the paintings in Paul Methuen's collection at Corsham. Other future artists received no encouragement. Reynolds's pupil and biographer, James Northcote, was critical of allowing children to draw, seeing this as the neglect of the mind, "the most common refuge of idleness, in order to escape from the labour of a loathsome task."[44] We know from an often-repeated anecdote that John Opie's father was inclined to see his child's artistic practice as pure frivolity until he saw the talent in it and, thus, the possibility of income.

Whatever Mrs. Papendiek may say about the popularity of schools among all the classes, education was strictly divided by class in order to prepare children to assume their proper stations in life in a highly hierarchical society. At the lowest levels, education consisted of the Sunday school movement, which began around 1784 under the direction of Dr. Joseph Priestley and his fellow "radicals" for poor apprenticed children. Uniting education and morality, London's charity school movement often paired schools with workhouses. Such educational opportunities for poor children ultimately derived from Locke's theory of the child as a *tabula rasa* and had the effect of improving literacy, except in the largest urban centers. By 1801, 13.8 percent of working-class children between the ages of five and fifteen attended Sunday schools.[45] With an increasing number of urban pauper children kept alive by the practice of sending them to the country to be nursed, London parishes began to set up schools for their education. St. James's Parish, for example, set up a school in 1782 to educate these children —increasingly the children of the labor aristocracy— whose lives already represented some investment on the part of the parish. As a result many children were saved from the miseries of the workhouses, where the chance of survival was only one in two. Children were not compelled to attend charity schools such as that in St. James's Parish, although the government act of 1782 regulating charity schools did require that indigent children either be sent to the poorhouse or to the charge of a guardian prior to their apprenticeship or service. The charity school movement—described by the Blake scholar Stanley Gardner as a "community of care" and recorded by Blake in the *Songs of Innocence*—was short-lived, however, a victim of avarice, indifference, and fear at the onset of the French Revolution. The Revolution posed an apparent threat to the social order (especially in the cities); turned priorities inward, away from social obligation; and encouraged distrust within formerly neighborly relationships. In 1789 the St. James's Parish school became a "school of Industry," a transition mirrored by the national government when William Pitt as prime minister proposed extending the scope of the schools of industry in 1796, crediting the educational philosophy of Hale and Locke. This transition, from charity school to "school of Industry" was further mirrored, as we shall see, by the work of artists such as William Blake.

Much of the parental concern for children's education centered on questions of spiritual welfare. Since children were still seen—although not so frequently as in the past—in the eighteenth century as innately sinful, a development of the theory of original sin stemming from Adam and Eve, the frequency of death in childhood demanded that their salvation be prepared. Children were thus made aware of sin from a very early age, even after Rousseau's *Emile* radically proposed the divinity of childhood (an idea that inadvertently coincided with the Evangelical desire to return education to the home as a

moral practicality). Religious instruction might take the form of casual conversation, such as the many religious conversations Boswell had with his four-year-old daughter, Veronica, in 1777.

> I talked to her of the beauties and charms of Heaven, of gilded houses, trees with richest fruit, finest flowers and most delightful music. I filled her imagination with gay ideas of futurity instead of gloomy ones, and she seemed to lift her eyes upwards with complacency. Yet when I put it to her if she would not like to die and go to Heaven, the *natural* instinctive aversion to death, or perhaps the *acquired*, by hearing it mentioned dismally made her say, "I hope I'll be spared to you." I for the first time mentioned *Christ* to her; told her that he came down to this world for our good; that ill men put him to death; that then he flew up with silver wings and opened the great iron gates of heaven, which had long been shut, and now we could get in. He would take us in. She was delighted with the idea, and cried "O I'll kiss him." One cannot give rational or doctrinal notions of Christianity to a child. But it is a great blessing to a child to have its affections early engaged by divine thoughts.[46]

When, two years later, Veronica expressed a disbelief in the existence of God, Boswell was alarmed, until he came to understand this as an expression of her fear of death. Faced with what he felt were inadequate personal resources to reason with his daughter, he turned, tellingly, to an educational tract, Cambray's *Education of a Daughter*, but found it of no use in explaining the existence of God, for this was "taken for granted."[47]

Fanny Burney also felt the difficulty of finding a proper approach to the religious education of her children, particularly concerning the different needs of boys and girls and the biblical material appropriate to each sex. When called on for advice in 1801, she turned to her practice with her own seven-year-old son, Alexander:

> My first aim is to instil into him that general veneration for the creator of all things, that cannot but operate, though perhaps slowly and silently, in opening his mind to pious feelings and ideas. His nightly prayers I frequently vary; whatever is constantly repeated becomes repeated mechanically: the Lord's Prayers, therefore, is by no means our daily prayer. . . . When we repeat it, it is always with a commentary. In general, the prayer is a recapitulation of the error and naughtiness, or forbearance and happiness, of the day.[48]

In each case, the child is encouraged to see the world through adult eyes, yet with concessions to the peculiar state of childhood.

Painted scenes of religious instruction from the period are relatively scarce, although Philip Mercier painted

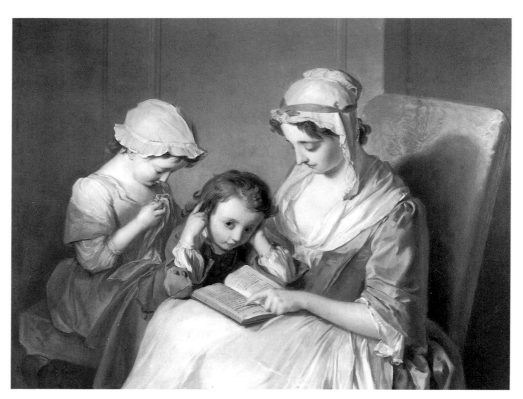

Figure 62. Philip Mercier, 1689–1760, *The Bible Lesson,* ca. 1736, oil on canvas, 54 × 72 in. (137.2 × 182.9 cm), Private collection, courtesy of the Paul Mellon Centre for Studies in British Art.

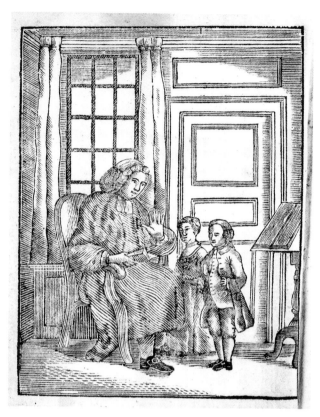

Figure 63. Anonymous, frontispiece from *The Children's Bible* (London, 1763), engraving, 4³/₁₆ × 3½ in. (10.6 × 9 cm), The Pierpont Morgan Library, New York.

such a work with his fancy picture *The Bible Lesson* (figure 62). Here, Mercier uses a psychologically apt angle so that the viewer peers down into the picture, observed only by the boy who is bored with the lesson. The title is traditional, although it is quite possible that the instruction taking place here is not specifically religious. When engraved, the work was called only "Lady and Children." Children's books commonly illustrated scenes of religious instruction, such as the frontispiece to the anonymous *The Children's Bible* (figure 63) published in 1763, where the setting is an elegantly panelled Georgian interior, the teacher wears clerical robes, and two young children stand attentively. The child reader is encouraged to identify with the didactic image before him.

Happily for searching parents, the Anglican Evangelicals stepped in to provide religious tracts for the instruction of children. In the years 1795 to 1798 alone, some 114 such tracts were written in England, selling two million copies in the first year alone—although even this great number did not necessarily indicate a genuine mass market. Forty-nine of these tracts were written by Hannah More. Friend to Samuel Johnson, More produced pious tales that urged the poor, through religious example, to

stay in their place. Under More's influence, children's books lost their amusement and became serious, moral-minded tales. Frances Sherwood, also participating in this movement, ultimately published over three hundred books, tracts, and chapbooks on childhood morality. After the turn of the century, a new series of religious magazines for children was launched, emphasizing virtue and good nature, and further expanding the infantile market for didactic religious texts. The first, begun in 1824, was *Child's Companion; or, Sunday Scholar's Reward*, written in the voice of a concerned father. Most of these publications seem to have been purchased by conscientious parents for their children, implying that these children had the necessary leisure time to read them.[49]

Religious instruction, notably in the widely used stories of hellfire, could backfire and evoke extreme responses among children. To cite only one instance of many, John James Bezer, born in 1816, the son of a Spitalfields hairdresser, later remembered the effect of being forced to listen to the brimstone preaching of a Dissenting Sunday school teacher at age eight. He writes that later, being alone in his parents' house,

> I actually undressed myself to the skin, got out of the cupboard father's sawdust bag, wrapped myself in it, poured some ashes over my head, and stretched myself on the ground, imploring for mercy, with such mental agony and such loud cries that the people in the house heard me, and told my parents about it.[50]

Fear could be a useful weapon in the hands of a parent, but it could also evoke horror in a susceptible child. Fear was a common instrument in the stories of dying children, popular with writers of children's books, especially the Evangelicals. The joyful death of a child could be equated with obedience to one's parents, and reading about it could offer children, in Kirsten Drotner's words, "a mental space where they could negotiate their daily defeats,"[51] the daily submission to the parent's will necessitated by the search for unsanctioned love. The death of a sinful child offered child readers the reward of thinking that their very survival was the reward for submission, but could also invoke terrible fear.

The development of a religious morality within the child is the subject of William Mulready's *Mother Teaching her Child* (figure 64) of 1859, well after the end of our period but interesting nevertheless in showing how the Georgian taste for moralizing genre scenes was increasingly sentimentalized in the Victorian period. Mulready's scene directly derives from Renaissance images of the

Figure 64. William Mulready, 1786–1863, *Mother Teaching her Child,* 1859, oil on canvas, 17⅜ × 13⅜ in. (44.1 × 34.1 cm), The Board of Trustees of the Victoria and Albert Museum, London.

Madonna and Child, complete with classicizing drapery, a pudgy, unrealistically proportioned and nearly naked child on her lap being taught to fold his hands together in prayer. The mother is now individually responsible for the moral and religious upbringing of her child—there are no bibles or books here to aid her. The nobility of her status, the holy nonsecular mother, is elevated by association with the mother of Christ.

Related to religious instruction was, of course, the instilling of proper moral values, for which the Bible was the most common authority and on which many manuals were written during the course of the eighteenth century. Lord Chesterfield, whose published letters eventually became one such manual,[52] undertook to teach his son moral values from what may seem to us an early age (although again this was necessitated by the

fear of early death), in part by setting his own example before the boy as well as classical role models such as Alexander the Great. He writes to his son Philip, aged ten, in 1742:

> I am sure you know that breaking of your word is a folly, a dishonour, and a crime. It is a folly, because nobody will trust you afterwards; and it is both a dishonour and a crime, truth being the first duty of religion and morality. . . . Therefore I expect, from your truth and your honour, that you will . . . excel in everything you undertake. When I was of your age, I should have been ashamed if any boy of that age had learned his book better, or played at any play better than I did; and I would not have rested a moment till I had got before him. . . . The sure way to excel in anything, is only to have a close and undissipated attention while you are about it.[53]

Lord Chesterfield is, as ever, demanding, pushing his son to achieve out of a competitive instinct that he portrays as truth to self and to family. He closes this particular letter by implying that failure to excel sufficiently will result in the withholding of his feelings, setting up the notion that the newly fashionable expression of parental affection is not the child's right but is to be earned. Reginald Heber writes more tenderly to his nine-year-old son in 1783, already away at school, concerning the need to attend to the lessons of his tutor and to do his best:

> You can never be too thankful my dear for this blessing [the capacity to learn], and it would be very ungrateful and culpable in you not to cultivate and improve the talents, the bounty of heaven has bestowed upon you. I make no doubt you have many clever boys in your class and I doubt not you will feel and be incited by an honest emulation to keep pace with the best of them in running the race of honour and improvement in learning that is set before you. . . . I know, my love, you have now an honest and a good heart, and I trust and hope by God's grace it will be preserved.[54]

While expressing greater affection than that found in Chesterfield's letter, Heber, too, exhorts his son to learn by example and to fulfill his potential, the failure to do so presented as a moral and religious betrayal.

In literature, the course of the eighteenth century brought an increasingly didactic application of works whose moralizing content became their chief attribute. Works by Fielding, Richardson, and Sterne reappeared in editions with subject headings such as "Parents' Duty to Children" and "Children's Duty to Parents," or in special compilations such as the cumbersomely titled *A Collection of the Moral and Instructive Sentiments, Maxims, Cautions and Reflections Contained in the Histories of Pamela, Clarissa, and Sir Charles Grandison, Digested under Proper Heads* (1755). Original works intended for children were also produced in large numbers, with a view to piety and conformity. Titles were often forthright, such as *The Good Boy's Soliloquy; containing his parents' instructions relative to his disposition and manners* (1811). This charming little volume by Richard Ransome was illustrated (figure 65) to convey again the relationship between proper conduct and proper morality, the concept of reward made explicit even in the title. Aimed at privileged children in Regency England, the book's expectations that all the illustrated acts of misbehavior—notably a scene in which a boy has drawn a charcoal caricature on a whitewashed wall—will be scru-

The things my parents bid me do

Let me attentively pursue.

Published April 15th 1811, by W. Darton Junr. 58 Holborn Hill.

Figure 65. Anonymous, frontispiece from Richard Ransome, *The Good Boy's Soliloquy; containing his parents' instructions relative to his disposition and manners* (London, 1811), engraving, 4¾ × 3½ in. (12 × 9 cm), The Pierpont Morgan Library, New York.

pulously avoided by its readers is touchingly naive. A work by Tommy Littleton entitled *Juvenile Trials for Robbing Orchards, Telling Fibs, and Other Heinous Offences* of 1786 makes clear what awaits the child who misbehaves; the engraved frontispiece, of unusually high quality, depicts an actual courtroom in which boys are being tried for their crimes. And in the 1787 edition of *Dr Watts' Divine and Moral Songs for Children*, one of the great classics of English children's literature and in print throughout the nineteenth century, we find a plate entitled "Against Lying," in which a young boy is violently birched over his mother's knee. Books such as these were often intended to be read by parent and child together, so that the parental instructions offered by Ransome and others might teach them both. Other children's books, such as Mrs. Sarah Trimmer's *Sacred History*, were intended for the use of Sunday school children. When Mrs. Trimmer, who was engaged to teach the

Duchess of Devonshire's children, used this book at her Sunday school at Brentford, she wrote that the children "who were in a very rude state are now wonderfully civilised."[55]

Discipline

The question of discipline and varying degrees of severity and tolerance in its administration occupied much thought among Georgian parents and theoreticians of childhood. The proper application of discipline was that which would allow the child to develop into the upstanding and productive citizen he would need to become. What is perhaps most remarkable in Georgian writing on discipline was a new tone of tolerance, a measure of respect for the child that is without precedent. As early as 1690 John Locke had advocated that children were not to be treated harshly, while Puritanical sects continued to promote severe discipline throughout the eighteenth-century. For many Georgian parents, discipline emerges as a kind of shared bond with the child. The eighteenth-century pastor John Taylor has left a detailed record in his memoirs of the principles he employed in rearing his children, based to a great extent on a view of them as his equals. Drawing on his memories of the "imperfect" method used by his father, Taylor had a biblically inspired desire to preserve the love of his children, a compassion for their happiness and well-being, and a desire not to overburden them with work any more than he was overburdened. In what was a remarkable reversal of rigid authoritarian codes, he wrote, "If I know of their misery, I cannot but be miserable too."[56] Part of their upbringing was naturally religious, but, significantly, Taylor pays equal attention to "making them wise," remarking that to this end "I made a practice of talking with my children to instruct them and to impress their minds."[57] This kind of discipline *cum* education, in which the parent modeled correct behavior for the child, was clearly the proper parental role, the abdication of which was cause for serious rebuke. Failure to model appropriately was indeed cause for public attack, as seen in the letter, published in the *Virginia Gazette* in 1767, of an Englishman's unpleasant trip to America:

> On my arrival here I found a house full of children, who are *humoured* beyond measure, and indeed absolutely spoiled by the ridiculous indulgence of a fond mother. . . . In the morning, before my friend is up, I generally take a turn upon the gravel walk, where I could wish to enjoy my own thoughts without interruption; but I am here instantly attended by my little tormentors, who follow me backwards and forwards, and play at what they call *Running after the Gentleman*. My whip, which was a present from an old friend, has been lashed to pieces by one of the boys, who is fond of horses; and the handle is turned into a hobby horse. . . . Once as an amusement for the evenings, we attempted to begin reading *Tom Jones,* but were interrupted, in the second page, by little *Sammy,* who is suffered to whip his top in the parlour. . . . It is whispered in the family that . . . I cannot *talk to children.*[58]

What is interesting here is not only the reprobation of the visiting Englishman, perhaps looking critically on the colonies as a place where society's rules have failed, but the implication that within the Virginia family children are being excessively indulged (allowed to play at will) in a Rousseauian manner. Dr. Johnson shared the form of this gentleman's reprobation, criticizing Bennett Langton, the father of nine, for having his children "too much about him."[59] Clearly the point made privately by letter writers such as Frances Boscawen and Fanny Burney, of being actively with one's children, has not fallen on universal acclaim—not surprisingly with the notoriously prickly Dr. Johnson. Perhaps, in general, it was a question of finding a balance between being with children and not being ruled by them.

Great emphasis was placed on obedience, especially in the first half of the century, although this was not to be instilled through fear. John Locke writes very strongly on discipline, authority, and obedience and, in discussing the application of these issues, tends thoroughly to objectify the children whose interests he professes to wish to advance. For Locke, discipline walked a fine line. While writing against excessive punishment, he could also cite the following anecdote:

> A prudent and kind Mother of my Acquaintance, was, on such an occasion, forced to whip her little Daughter, at her first coming home from Nurse, eight times successively the same Morning, before she could master her *Stubborness*, and obtain a compliance in a very easy and indifferent matter. If she had left off sooner, and stop'd at the seventh Whiping, she had spoiled the Child for ever.[60]

Again, however, the trend after 1760 is toward a less authoritarian parent-child relationship. The child begins to have certain rights, including the right to be treated with a reasonable eye to his or her point of view and to the needs specific to childhood. Just behavior toward children is clearly in the Reverend John Taylor's

mind when writing late in the century that he found it unjust for parents to punish their children for certain behaviors without first instructing them that these actions were wrong.[61]

Like many parents, James Boswell expressed fears of his inadequacy as a parent, specifically concerning discipline. When his son was an infant, Boswell wrote, "I dreaded that he would be spoilt by indulgence, and had poor hopes of my own authority as a Father."[62] Four years later, he regretted his "too little authority" over his children,[63] yet Boswell was capable of physically disciplining his children. In 1780, he wrote about one such incident, emphasizing the lesson he hoped to instill by punishing his three-year-old son, Alexander:

> I this morning beat Sandie for telling a lie. I must beat him very severely if I catch him again in falsehood. I do not recollect having had any other valuable principle impressed upon me by my father except a strict regard to truth, which he impressed upon my mind by a hearty beating at an early age, when I lied, and talking of the *dishonour* of lying. I recollect distinctly having truth and honour thus indelibly inculcated upon me by him one evening in our house.[64]

Boswell has learned how to mete out punishment from the memory of his own father, yet he has reserved physical punishment for the most serious of transgressions.

Like Boswell, the formidable Mrs. Thrale would strike her children if they disobeyed her, but she tells us she habitually cautioned them first. She tended to be harsh but still encouraged her children to think for themselves. Still, Mrs. Thrale feared her own temperament: she had one sickly, "peevish" child whom she disliked and, fearing that she would punish the child too severely, sent the child away to boarding school at age four. Amelia Steuart, too, records difficulty in disciplining her children. Her favorite punishment was to deprive her children of their after-dinner fruit. On one occasion, she used it on her son John to little effect:

> John told a fib to Charles in the morning about a play thing wch he said was below stairs, tho' it was under his arm ... [he] seemed to feel the punisht a little—it was very mild however—but that was because he has heard such little fibs said by older people & was not so much to blame as for other ones—but if he falls into the same fault now that he has heard so much about it he must be severely punished.[65]

Mrs. Steuart's concern for the appropriateness of her discipline is paramount, even as she acknowledges the problem of teaching by example.

Of the few eighteenth-century child diarists, none make reference to physical punishment. The closest we come here is Elizabeth Wynne's observation that her four-year-old sister "went to bed without any supper because she gave the cook such a smack that for two hours she could not open her eye."[66] The relative softness of this punishment surely has to do with the fact that the child hit a social inferior. Marjory Fleming's journal,[67] kept as a child of ten, is centered on disobedience and its possible punishments but contains no references to physical punishment, perhaps because the diary was kept to be corrected by her seventeen-year-old cousin/governess and therefore may have been self-censored. More frequently, we have record of adult memories of punishments received as children; indeed autobiographers in general note a stricter upbringing than do diarists, suggesting that cruel parents either seem not to have written diaries, or to have omitted the cruelty. Remembered punishments again range in type and severity. Frances Shelley thought her mother was not strict enough:

> She was not judicious in the management of her "lambkin" (as she used to call me). . . . I disliked her impetuous caressing, and early learnt to allow myself, as a favour to *her*, to be kissed; and not, as is usual with most children, to receive a caress as the reward of good conduct and maternal affection.[68]

By contrast, Elizabeth Grant, born in 1797, recalled being whipped as a child to make her eat, being shut up in a dark cupboard for any misdemeanor, and being given cold-water baths:

> A large long tub, stood in the kitchen court, the ice on the top of which had often to be broken before our horrid plunge into it; we were brought down from the very top of the house, four pairs of stairs, with only a cotton cloak over our night-gowns, just to chill us completely before the dreadful shock. How I screamed, begged, prayed, entreated to be saved . . . all no use.[69]

Likewise, Fanny Kemble was once imprisoned for a week in a toolshed for being naughty. Indeed, from the writings of many memoirists it seems that discipline increased markedly in its severity in the early nineteenth century. Rousseau's influence in this area evidently was short-lived. Nevertheless, during after-dinner play, Elizabeth Grant's father, "no longer the severe master, [could be] the best of play fellows."[70]

For most parents, discipline was best established through surveillance and by even and fair application.

When inconsistently applied, rebellion could result as the child's sense of fairness was contradicted. Frances Boscawen described such an occasion in 1755 after the relaxing of discipline toward her three-year-old son in the weeks following his inoculation against smallpox:

> It [her discipline] has been slackened so long it is unknown. How perverse and saucy we are, and how much we deal in the words won't, can't, shan't, etcetera. Today he would not eat milk for breakfast, but the rod and I went to breakfast with him, and though we did not come into action, nor anything like it, yet the bottom of the porringer was very fairly revealed and a declaration made by him; indeed he could not but say it was very good milk.[71]

The long-suffering Mrs. Boscawen, forced to resolve all these disciplinary questions single-handedly with her husband still away at sea, resorts to the threat of punishment. Yet perhaps the most important point here is that she refrains from actual physical punishment, the clear symbol of the rod having been enough to carry the day.

Such restraint, in which physical punishment is threatened but withheld, does not mesh well with the view of Lawrence Stone and others who have seen pre-twentieth-century parenting as particularly abusive. But within the framework of the eighteenth century, what constituted abuse? For some, the symbol of the rod was in itself especially cruel, as it was for the founder of Methodism, John Wesley, who remembered the rod as an instrument of fear. Wesley wrote that he was disciplined from infancy to "fear the rod and to cry softly,"[72] and it is tempting to see some of the roots of early Methodist severity in this early training. His mother, Susannah Wesley, in a single paragraph of her program for rearing children uses the word "conquer" four times as well as "subjecting," "subduing," "governing," and "breaking" to characterize her assault on the child's will.[73] Although John Wesley had no children of his own, the regimen he devised for his Kingswood school was tyrannical, all out of a hope of preserving what he called the child's "baptismal innocence." Wesley's is a memory in which childhood is at once both light and dark, but certainly not allowed to intrude into the world of adults.

Even devotees of Rousseau could be merciless disciplinarians. The reformer Thomas Day, who had taken charge of two young orphan girls whom he intended to rear as his own daughters along "enlightened" educational principles, practiced, in Paul Langford's words, physical discipline and mental control "to a horrifying

degree. Not surprisingly they failed to live up to ideals of feminine development."[74]

Newspapers frequently give notice of exceptional cases of cruelty toward children, notable in part for treating these cases as rarities and for giving evidence beyond that of the usually upper-class memoirists and letter writers. The *Times of London*, for example, reported on 11 December 1787 a case of cruelty to a child by his guardian in which the three-year-old boy was physically deformed by the abuse. His appearance in court, says the *Times*, "drew tears from almost everybody." The case was one "of the most savage transactions heard by the court" and was thought to be "very rare" with reference to the extent of the cruelty.[75] Similarly, the *Times* reported in 1810 the case of a mother charged with "barbarously beating and ill-treating her own child," a daughter aged four. When the mother was taken out of the court after the trial, "it was with the greatest difficulty she could be protected from the fury of the women on the outside."[76] In 1824 the *Times* reported the case of a Patrick Sheen who beat his eight-year-old son until blood flowed because the child would not stop crying, and then threw the child on the fire. Sheen said he "'thought every father had a right to do as he pleased with his own child, and that he did not see what right other people had to interfere.' The magistrate replied that 'the law must teach the defandant [sic] that this doctrine of his was very erroneous.'"[77] Many such records attest to both the protective role of the courts and the sense of popular indignation concerning abuse, paralleling response to similar cases in the late twentieth century.

More reasonably, a post-Rousseau mother, Margaret Woods, wrote frequently in her journal of the difficulty of choosing the right disciplinary means that would be neither too strict nor too lenient, in order to keep her children properly obedient yet not in "awe" of the parent. In an entry for 1815, she writes:

> I have always wished that they should be afraid of doing wrong, but not afraid of me. I would encourage them to lay open their little hearts, and speak their thoughts freely; considering that by doing so, I have the best means of correcting their ideas, and rectifying whatever may be amiss. I am, from judgement, no great disciplinarian; if I err, I had rather it should be on the lenient side. Fear and force will, no doubt, govern children while little, but having a strong hold on their affections will have most influence over them in their progress through life.[78]

This may be the crux of the Georgian parent's dilemma: how to enter into the world of children, encouraging them to "lay open their little hearts," and at the same time instilling a fear (or distaste) for wrongdoing. And, of course, that wrongdoing is the parent's to define.

Discipline is finally at the heart of the larger paradox of children and childhood, the division between behavior and language. The closer family ties of the Georgian period along with the growing middle-class desire to *control* the child's behavior ironically fostered more social contradictions, in the form of parental supervision and repression, seen by children as individual conflicts. In turn, this close proximity engendered more deeply ingrained conflicts of love and hate—what Kirsten Drotner has called the "paradox of childhood."[79] Well-meaning parents who intended to encourage their children's individualism simultaneously, and perhaps inevitably, had to control its expression. In this regard, a belief in the child's innocence would not guarantee a happier childhood; indeed, as John Sommerville has suggested, there may be a correlation between a presumption of the innocence of the child and increasingly repressive efforts to preserve that innocence.[80] This repression, in turn, may have played a part in the new emphasis on the child's imagination and thus the rise of juvenile literature.

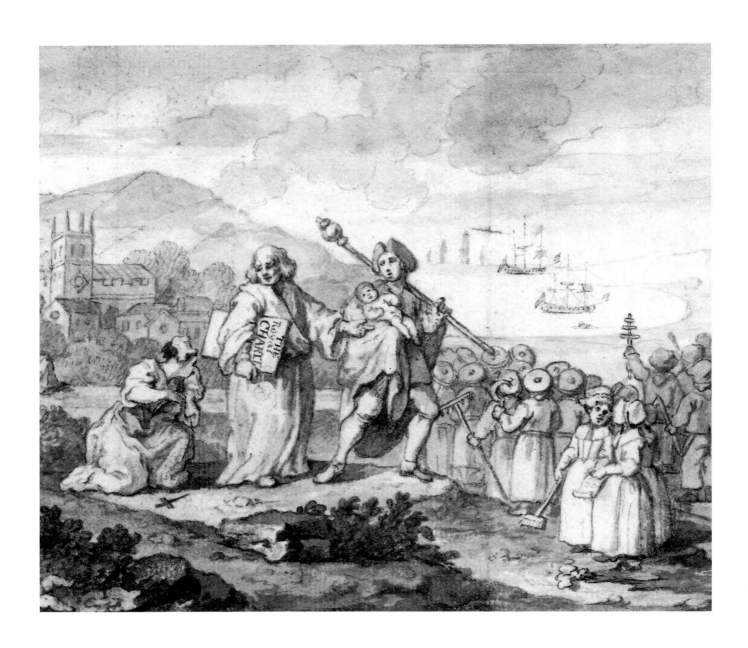

Chapter Six / *Children and Charity:*
The Double-Edged Didactic Sword

Charity affected children in the Georgian period in two ways: they were the direct recipients of the period's charitable instincts and the focus of teaching concerning charity. Whether children were receiving the benefits of charitable societies and individuals or learning about the merits of charity, the emphasis placed on charity affected both the dialogue about childhood and the reality of children's lives.

Perhaps the most extraordinary example of charity directed at children, with its own didactic purposes, was the establishment of London's Foundling Hospital.[1] Although both Joseph Addison, writing in the *Guardian* in 1713, and Daniel Defoe, in his *Augusta Triumphans* of 1728, had called for some provision for foundling children, the founding of a hospital for their care did not take place until 1739, and the actual opening did not occur before 1741.[2] Captain Thomas Coram was moved to establish the hospital by the sight of dead and dying children abandoned by the roadsides of greater London. Such a scene was recorded by William Hogarth in his 1739 *Study for The Foundlings* (figure 66) and was engraved repeatedly throughout the 1780s and early 1790s. In Hogarth's drawing and in engravings after it, children are brought to the hospital while others lie neglected in the rushes, awaiting discovery and rescue. A tearful woman gives her child to Thomas Coram, founder of the hospital, shown here carrying its royal charter. This woman is thus saved from having to kill her child out of poverty, a fate that does not escape the woman drowning her baby in the stream in the background. To the right, children are massed outside the hospital door, carrying the instruments of their future trades. Hogarth's design was intended for the headpiece of hospital entry certificates, engraved by Morgellan La Cave.[3] The middle-class audience that would have seen Hogarth's image was thus given a clear visual summation of the purposes of the hospital. Dr. William Cadogan, doctor to the Foundling Hospital, laid out the merits of the hospital in his *Essay upon nursing:*

> The Foundling Hospital . . . will be a Means not only of preventing the Murder of many, but of saving more, by introducing a more reasonable and more natural Method of Nursing which means taking this Business out of the Management of Women who don't know enough.[4]

According to Cadogan, the Foundling Hospital's aims ranged from the most basic—preventing the murder of unwanted babies—to improving on the inadequate care of insufficiently skilled nurses. Cadogan felt the hospital was legitimately concerned with what he termed the "Ease and Comfort of the Little ones," an attitude he promoted himself. The cause is thus expanded from assuring the survival of the child to contributing toward his happiness.

Detail of figure 66, William Hogarth, *Study for The Foundlings*, 1739, Yale Center for British Art, Paul Mellon Collection.

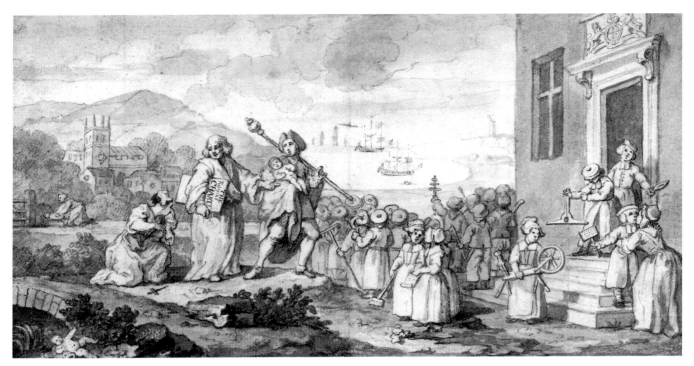

Figure 66. William Hogarth, 1697–1764, *Study for The Foundlings,* 1739, pen, brush, and gray ink, 4⁷⁄₁₆ × 8⅜ in. (11.4 × 21.4 cm), Yale Center for British Art, Paul Mellon Collection.

In the Foundling Hospital's first four years, some 15,000 children were admitted,[5] prior to being placed with families, schools, and workhouses. Hogarth himself housed two of these children at his home in Chiswick for a period of four years. The hospital initially met with much support from artists, including Hogarth, Joseph Highmore, Francis Hayman, and James Wills, each of whom donated important paintings of children meant as prototypes of and models for the children at the hospital. These artists saw the hospital and their own work there as part of a reintegration of poor children into a network of social relations.

Despite the work of the Foundling Hospital, it remained a common custom late in the eighteenth century to leave infants on doorsteps of the well-to-do in the hope that charity would prevail and the inhabitants would adopt the deserted children. In 1790, an eighteen-month-old child was deposited on Sir Joshua Reynolds's doorstep in Leicester Fields, London, and a crowd gathered demanding that he take it in, but he did not. The *Morning Herald* criticized Reynolds's lack of charity, acerbically commenting:

> The attribute of Charity[6] on Sir Joshua's canvas, was not sufficiently inspiring; and the benevolence of a gentleman walking by being resorted to, the innocent adventurer was ordered to be carried to his home.[7]

Society had by this time come to demand charity, especially of its cultural leaders.

The history of the Foundling Hospital must be seen in the larger context of the eighteenth-century charity movement in which many artists participated in the second half of the century.[8] The philosophical underpinnings for this can again be found in the writings of John Locke, who wrote of the utility of virtue, and of the political leader Lord Shaftesbury, who saw benevolence as a principal moral virtue and art as a culture-creating force with a pedagogic role in advancing the cause of benevolence.[9] Definitions of charity, and a sense of what was just in regard to the poor, were much discussed, as in *Life of Johnson,* by James Boswell, who writes:

> Charity . . . is not definable by limits. It is a duty to give to the poor; but no man can say how much another should give to the poor, or when a man has given too little to save his soul. In the same manner, it is a duty to instruct the ignorant, and of consequence to convert infidels to Christianity.[10]

Boswell's concept of charity involves an absolute—the giving of charity itself—beyond which he can offer little direction. Charity is, however, part of a continuum of moral characteristics that reflected the nation's Christian heritage. Boswell later describes Dr. Johnson's charity to the poor as

uniform and extensive, both from inclination and prin-
ciple. He not only bestowed liberally out of his own
purse, but what is more difficult as well as rare, would
beg from others, when he had proper objects in view.
This he did judiciously as well as humanely.[11]

Ultimately, the charity movement must be seen as part of
the cult of Sensibility, in which the individual's emotions
and sense of moral or spiritual duty became engaged in
the plight of the less fortunate.

The work of the Foundling Hospital seems truly
benevolent in contrast to earlier attempts at solving the
problem of unwanted and vagrant children. Attempts
had been made in 1703 and 1717 to rid London's streets
of begging and thieving boys by shipping boys as young
as ten out of the country, first by impressing them into
the navy then, in 1717, by allowing for penal transporta-
tion of boys as young as age fifteen. In 1732 the justices
of the London parishes of Westminster, Middlesex, and
Southwark petitioned the House of Commons, com-
plaining of the mischief caused by vagrant children who,
in their words,

> infest the Streets unapprehended . . . and instead
> of being employed in apprenticeships or services, ac-
> cording to the law, habituate themselves to an idle and
> profligate course of life and become dangerous
> as well as unprofitable to the Publick.[12]

The complaint yielded no result. Already it is telling that
the law demanded that vagrant boys be pressed into ap-
prenticeship or domestic service, a system of control if
not of welfare.

Clearly one of the problems here was an indiffer-
ence to the causes of delinquency in children. A leading
magistrate, Sir John Fielding, wrote in 1758 that the
majority of London's "Shoplifters, Pilferers, and Pick-
pockets" were boys aged twelve to fifteen, who were the
children of "idle and profligate parents."[13] When con-
victed, these children were still commonly hanged as
young as age thirteen, at least until reforming magistrates
like Fielding took up the issue of prevention.[14] Fielding
was concerned with girls, too, who, he argued, were of-
ten forced into prostitution "from necessity before their
Passions can have any share in their Guilt."[15] Many of
these were girls age twelve or even younger, for whom
Fielding hoped to set up a "public laundry" to employ
girls between ages seven and fifteen. As a result, the
Female Orphan Asylum opened in Lambeth in 1758,
supported by popular subscription, for girls ages nine
to twelve to prevent them from becoming prostitutes.
There, the girls served seven-year apprenticeships after

which they were to be placed in private service. Between
1758 and 1768, the asylum admitted 282 girls, placed 125
of them, and still, in 1768, had 146. During this time
eleven girls died at the asylum.[16]

Other options were available for the care of or-
phaned children of slightly better economic or social
situation, or with better connections to provide for
them. Most commonly, children somehow connected
with a landed estate might be provided for by the estate
owner. Elizabeth Wynne, one of the rare child diarists
of the Georgian period, wrote an entry for 3 December
1789 (at the age of ten) concerning the disposition of a
family on her English father's estate:

> The coachman's wife has died in the greatest misery,
> no one wanted to take charge of the two children of
> whom the eldest is a little girl of ten years old quite
> crippled, she cannot use any of her limbs the other a
> little boy of three. Now a woman will take them and
> will be given 20 francs a month.[17]

Elizabeth Wynne's entry is perhaps inadvertently reveal-
ing: she describes the event with detachment, yet is
clearly sufficiently moved to have recorded the death
and disposal of the children at all. It cannot have escaped
her notice that the crippled girl was her own age. More
to the point, she observes without judgment the fact that
the coachman will not care for his own children, nor will
anyone else on the estate do so without pay. The incident
again seems to suggest the presence of emotion without
responsibility, the privilege of feeling without the respon-
sibility for action, as well as a rather fluid construct of
family.

One of the pitfalls of charitable efforts such as the
Lambeth asylum for girls was the failure to distinguish
between vagrancy and delinquency (a failure not uncom-
mon in our own time), and a traditional conviction that
a juvenile delinquent of any age was merely a miniature
criminal. Rather than engaging in a larger rethinking of
society's obligation to these indigent children, these
charitable establishments tended to objectify them, to
seek to eliminate problem children from sight. This, too,
became increasingly problematic in the nineteenth cen-
tury. A witness to the Select Committee on the Police of
1816 to 1818 commented wisely:

> It is very easy to blame these poor children, and to
> ascribe their misconduct to an innate propensity to
> vice; but I much question whether any human being,
> circumstanced as many of them are, can reasonably
> be expected to act otherwise.[18]

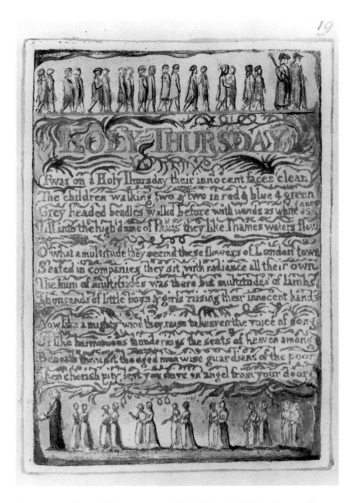

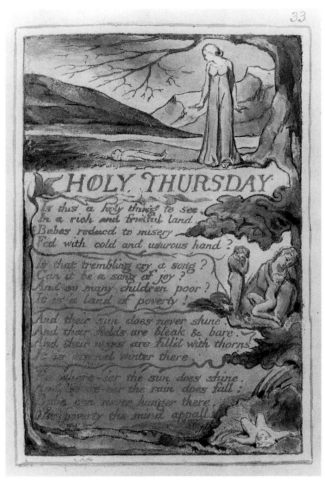

Figure 67. William Blake, 1757–1827, "Holy Thursday," from *Songs of Innocence* (London, 1789), copper plate etching, 3⁵⁄₁₆ × 4¾ in. (8.4 × 12.1 cm), photo courtesy of The Lessing J. Rosenwald Collection, Rare Book and Special Collections Division, Library of Congress.

Figure 68. William Blake, 1757–1827, "Holy Thursday," from *Songs of Innocence and of Experience* (London, 1794), copper plate etching, 3¹⁄₁₆ × 4⅝ in. (7.7 × 11.7 cm), photo courtesy of The Lessing J. Rosenwald Collection, Rare Book and Special Collections Division, Library of Congress.

We here see suggested the link between circumstance and development, clearly related to the ongoing rationalist debate about the extent to which a child's upbringing could affect his adult life. Yet this insight is not to imply that institutions of child welfare were rapidly increasing in success. On the contrary, the continuing failure of charitable institutions for children is readily known to readers of Dickens's didactic novels of Victorian London. One of the most spectacular failings in the attempt to solve the problem of poor children and somehow to care for them—the workhouse movement—will be seen in Chapter Seven.

A more successful example of charity aimed at children can be found in the charity school movement, begun in 1699 with the Society for the Propagation of Christian Knowledge. By 1729 the society had established over 1,600 schools in Britain with 34,000 students. Joseph Farington recalled in his diary a sermon preached in church for the benefit of female charity children. Farington writes that the Reverend Gerrard Andrewes

> dwelt on our responsibility for whatever we possess of faculties; riches; religion; . . . He concluded by shewing that education of Female Children for whom their parents could do little; by which means, we should protect them from vicious habits; impress on their minds proper notions of religion and morality; and rescue them from the temptations of depraved men.[19]

For Reverend Andrewes and his listeners, the charity school movement was a cause that might appeal to soul, intellect, and wealth, for the protection of children and the preservation of their innocence.

Late-eighteenth-century Londoners took great pride in their charity schools, parading charity school children in the streets on important occasions.[20] Such an event is the subject of William Blake's "Holy Thursday" from the *Songs of Innocence* (figure 67) of 1789, record-

ing what was the marching of some six thousand charity school children to St. Paul's Cathedral for a compulsory exhibition of their piety and obedience before the benefactors of the schools. The plate shows two bands of children marching two by two led by their beadles and matron, the boys in one band and the girls in another as if on opposite sides of the street or as if they are but excerpts from an immense line of children.[21] Although the tone of Blake's poem is one of great pleasure at the sight of so many innocents "with radiance all their own," a note of irony is sounded when Blake describes the elders, these "aged men wise guardians of the poor." Are they indeed, in Blake's eyes, so wise? The last line of the poem—"Then cherish pity, lest you drive an angel from your door"—suggests pity was allowable in the face of so much poverty, and injects the strongest sense of real emotion in the poem. Blake's scene suggests that he was genuinely moved by the sight of charity school children, in the words of Zachary Leader, "unconsciously attracted to those very qualities—energy, life, movement, and creativity—which set them apart from their adult supervisors."[22] Although I believe Blake was indeed quite conscious of this attraction, Leader is right in emphasizing the element of "otherness," this elusive quality that both attracted adults to children and brought out in them a desire to control something they could not comprehend.

When Blake came to illustrate "Holy Thursday" again for his *Songs of Innocence and of Experience* (figure 68), he vents his true feelings on the subject by returning to the image of the abandoned child. In this plate, a woman, certainly not the mother, walks by a child dead in the fields of nature, where privation is not just condoned but fed by society. Below her, mournful children cling to their mother in a scene of poverty. At the bottom of the plate, another child lies dead, naked, and abandoned, splayed out as if fallen from Blake's traditional vine wrapping up the side of the plate. Blake's text condemns poverty and infant hunger "in a rich and fruitful land." The selfishness of the English has, for Blake, turned the country into a land of eternal winter, where the child's cry is no longer one of joy but the trembling cry of fear and hunger. Blake, left cynical by antirevolutionary retrenchment in Britain, has lost his belief in the possibility of redemption in human society, and sees the neglect of a child not as a passive event but an active one.

The recurrence of the motif of the abandoned child suggests not a cyclical shift in attitude toward children—

Blake's image tends to confirm the special place of the child—but a shift in ideas of social responsibility. For Blake in the 1790s, the Foundling Hospital and society generally could do little to oppose the trend of disintegrating social institutions. The optimism felt by Hogarth and others was lost, and the meaning of this change had profound reverberations in the artistic vision of childhood. If, for Blake, society had abandoned its children, then society had failed to act as an expanded family. Society, out of a fear of revolutionary contagion and the backlash of religious fundamentalism, had been, in a sense, privatized.[23] The domestic urge that had championed the child first in the 1730s and again some thirty years later resulted in a narrowing of vision concerning other people's children. Could the nuclear family fulfill the needed nurturing role? And what of the role of the visual arts in this regard?

Beyond their work at the Foundling Hospital, artists *were* directly involved in the charity movement. Artistic societies were established that provided support for the children of indigent or deceased artists, including, as early as July 1761, the Incorporated Society of Artists. After the foundation of the Royal Academy in 1768 this support became increasingly common, and numerous incidents can be found detailed in society records. For example, Sir William Chambers, secretary of the Royal Academy, wrote to Joshua Kirby of the Incorporated Society of Artists on 13 March 1769 proposing that they join forces to help the youngest son of the deceased artist Lucius Barbor,

> a very fine boy of seven or eight years of age, entirely destitute. It will be a noble act of charity to educate and preserve this boy, and however separate our Societies may be in other respects let us be unanimous in good works.[24]

Artists' organizations also granted funds directly to suffering artists, as when the Royal Academy came to the aid of Francis Wheatley toward the end of his life when he was in ill health.[25] In other cases, aid was of a personal nature. W. T. Whitley tells the story that Thomas Gainsborough wished to adopt the "beautiful beggar boy" Jack Hill, who sat to him as the model for his *Shepherd Boy* of 1781.[26] Gainsborough was evidently known for his charity to his infant "cottage" sitters and their families. The *Morning Herald* of 4 August 1788, for example, paints a noble, even exaggerated picture of Gainsborough's generosity:

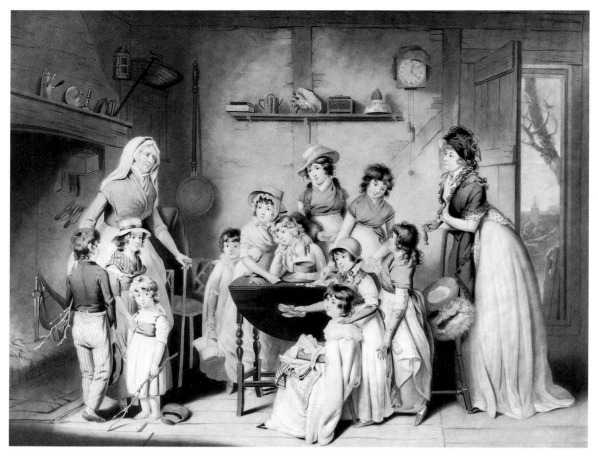

Figure 69. William Ward, 1766–1826, *The Sailor's Orphans, or the Young Ladies' Subscription,* 1 June 1800, mezzotint printed in color after William Redmore Bigg, 18 × 23¾ in. (45.7 × 60.5 cm), Yale Center for British Art, Paul Mellon Collection.

If he selected, for the exercise of his pencil, an infant from a cottage, all the tenants of the humble roof, generally participated in the profits of the picture; and some of them frequently found in his habitation, a permanent abode.[27]

Exaggerated or not, clearly the *Morning Herald* views this as a laudable practice, perhaps increasing the value of the painted work.[28] Sir Thomas Lawrence, too, intervened personally in the fate of children, in 1792 coming to the aid of the widow and young children of the artist John Foldsone.[29]

The second side of the charity question is the issue of teaching children the quality of charity. As much as the Foundling Hospital or any other endeavor, this dedication to fostering charitable habits attests to the importance British society placed on the concept of charity during the Georgian period, especially in the years after 1800. Ironically, these years when the most strongly didactic images of charity are to be found are also the years when Blake and others despaired of the entire movement.

A principal avenue for teaching middle- and upper-class children the value of charity came in the form of visits to the poor, guided by a parent or tutor. Such visits clearly made a powerful impression on many children, including the aristocratic Hary-O Cavendish, who wrote in a letter of 1796, at age eleven, after one such visit:

> I did not tell you before you went of my plan for the biggest of my drawers, I mean to keep in it all manner of Cloths of different sorts for the poor people and when I hear of any in distress I shall always have my drawer ready.[30]

On other occasions poverty naturally presented itself to privileged children as they made the rounds of London and heard its cries. Elizabeth Wynne recorded one such incident, not in London but in Padua, while traveling with her family at age eleven:

> Today we had an example of poverty and misery which are at Padua. Whilst at our lessons we heard a lamentable voice, we ran to the window and saw a little

boy who was naked but for a little petticoat. He cried for the cold. We gave him some clothes.[31]

Wynne and her sisters seem to have kept their diaries for their own purposes, without thought of adult readership, so we can perhaps take Betsey at her word that she was moved by the poor boy's "lamentable" voice. Certainly the gift of clothing must have come from or was sanctioned by her parents.

Many images have survived in which children are provided with the lesson of charity. Francis Wheatley's *The Benevolent Cottager*, engraved by Nutter in the 1790s (British Museum, London), portrays a simple country-woman and her three children giving food to an old beggar who has come to their doorstep. William Redmore Bigg's *The Sailor's Orphans, or the Young Ladies' Subscription* of 1799, engraved by William Ward (figure 69), transfers this simple charitable impulse to a higher socio-economic class. A group of well-dressed girls, shepherded by their schoolmistress into a peasant cottage, offers their gift—money and shoes—to the cottager standing in front of a fire with her three children. The presence of the older woman reinforces the educational quality of this act of charity, the sense of an organized outing to relieve the distress of a local family. Bigg's didactic purpose can only succeed by flattering the viewer, who will associate with the charitable scene before him urging him to imitate this behavior by appealing to his sensibilities. Such a scene could be aimed directly at a juvenile audience through children's book illustrations, such as the plate entitled "The Giving of Charity" from the anonymously written *William Sedley; or, The Evil Day Deferred*. In this publication of 1783, the evil day—of poverty and homelessness—is deferred by an act of charity. More directly related is William Blake's illustration entitled "Oeconomy & Self-denial are necessary, in every station, to enable us to be generous" in Mary Wollstonecraft's *Original Stories* (1791), where the tutor and her three students again appear in an impoverished cottage. This plate, as well as Bigg's scene, has parallels in the work of the French artist Greuze of some twenty years before, such as *La Dame bienfaisante* ("The Charitable Woman"), engraved by Massard in 1778, where a mother pushes her child forward to give charity to a sick, elderly man in a humble cottage. Blake and Bigg have, however, doubled the role of children in the image: they are both the givers of charity and the recipients of it. When the anonymous critic known as the Ear-

Wig saw another work by Wheatley of the same subject in 1781, she described it as "a sweet picture—Nature pursued with taste and real sentiment."[32] Charity, as well as the setting, is both tasteful and worthy of the age of Sensibility.

Bigg was one of the most prolific artists to describe the rewards of charity, returning to the subject in his thematically paired works, *The Rapacious Steward, or the Unfortunate Tenant* of 1801 and *The Benevolent Heir, or the Tenant Restored to His Family* of 1797 (both Yale Center for British Art, New Haven). In the former, an overweight, mounted steward indicates with a gesture of his hand that a tenant farmer is to be taken from his family and home for failure to pay rent. The tenant's wife and one of his children plead with the steward for a reprieve but are denied, while a daughter leans against the cottage wall, covering her eyes in despair. In the second work, the tenant is welcomed home by his surprised and excited family, his children swarming about him in greeting while the "benevolent heir" and his wife look on. Here, the tenant gestures toward his landlord, indicating that it is by his charity that he has been brought home. In each work, the subject is again the dependence of the rural poor on the generous or selfish whims of the wealthier classes, a theme brought out largely through the emotional responses of the children and the emphasis on the family. Bigg tells us that it is the family itself which is most threatened or rewarded by greed or charity. Family, domesticity, and sensibility are fully integrated in such works.

Artists such as Bigg, along with Thomas Gainsborough, Francis Wheatley, and William Collins, ultimately developed a new category of genre picture, that of the Rustic Charity. In most of these, women and children—the innocent but also weak and "protected" members of British society—give alms to the even weaker poor, who are protected only by the charity of these women and children. Working at the very end of the period, William Mulready presents a darker image of charity in response to the continued public embarrassment of beggary, his *Train Up a Child in the Way He Should Go; and When He Is Old He Will Not Depart from It* (plate 40). Painted in 1841, Mulready's work illustrates the moral lesson we have already seen: teaching a child his future role of alleviating distress. However, the object of the boy's charity here is no longer a charming country peasant or street beggar, but three Lascars, Indian sailors who represented

the most commonly seen class of Indians in nineteenth-century Britain. The boy approaches the Lascars with palpable anxiety—anxiety even more exaggerated in a preparatory drawing in the Victoria and Albert Museum where the boy stands open-mouthed—and no wonder. The Indians are fearsome but above all foreign, representing Britain's new imperial role, and the boy reenacts imperial generosity on a domestic scale. It is a complex statement combining many of the threads already seen: the child learning from adults, standing in for them in a kind of theatrical world, and simultaneously mimicking them; a world in which childhood is seen for itself *and* for its reference to the adult to come; a world in which the quality of otherness of the child is mediated by making it appear less than that of the dark-skinned Indians. It may be no accident that Mulready has chosen as his foreigners representatives of a people thought in the nineteenth century to engage in the practice of infanticide.[33]

Another much safer form of didactic charity is found in a new type of fable developed for children by Edward Augustus Kendall. Published by the Newberys, Kendall's stories feature birds that take on human attributes and offer criticisms of human failure. Stories such as *The Crested Wren* (1799) and *The Swallow* (1800) capture a new sensitivity to birds and animals and show the child reader that cruelty to animals is the mark of an evil child. Dorothy Kilner's *Life and Perambulations of a Mouse* (1783), as well as being one of the most famous children's books of the period, helped establish the genre of the animal biography, with the effect of reinforcing charity through a child reader's identification with an animal.[34] In Kilner's book, Charles is severely beaten by his father when caught teasing a cat with a mouse on a string. Kilner's text tells the reader that

> every action that is cruel and gives pain to *any* living creature, is wicked, and is a sure sign of a bad heart. I never knew a man, who was cruel to animals, kind and compassionate towards his fellow-creatures.[35]

Ultimately traceable to Locke's writing on the need for kindness to animals, animals often served in children's books as didactic devices to lead children away from cruelty and toward benevolence. All these works suggest that a child's inability to value properly the animal life about him implied that he did not understand God's plan for man, the earth, and its lesser creatures. The lesson to be learned is that charity and benevolence, even to animals, will make a child happy and bring him social rewards.

All the same, children could be given terribly confusing messages concerning the proper attitude to adopt in the face of poverty and need. Perhaps the most remarkable example of this confusion comes from the groundbreaking children's book *The History of Little Goody Two-Shoes*. Published anonymously but probably authored by Oliver Goldsmith,[36] *Little Goody Two-Shoes* is a kind of *bildungsroman* in which a newly orphaned girl must bear responsibility for her own support and maturation. At the death of her parents, she is left ragged and hungry with only one shoe. Through hard work she learns, becomes admired, and, eventually, wealthy. Yet she is on her own economically, socially, and morally in a child's world soon rendered obsolete by industrialization and urbanization. While clearly the intended message is one of self-sufficiency and hard work, this charming story also sends out a message that charity can impede the discovery of one's truth, and that one might well be left, even as a child, to make one's own way. The frontispiece, one of the most charming in eighteenth-century children's literature, shows the story's heroine with her famous second shoe, the symbol of her success without charity. For the impatient child reader, even the book's title foretells the heroine's success.

Two images spanning the period in question suggest the extent to which didacticism invaded images of children and charity. The first, Joseph Nollekens's *Children Playing with a Hobby Horse* (plate 41) of about 1741 to 1748 fits neatly into the artist's work with children after 1730. Three elegant children play about a hobbyhorse while a fourth pulls the horse across an expensively tiled terrace. To the right two children play with masks, suggesting not only the playacting seen in previous examples but an element of posing, of impersonating, that alludes to childhood's troubled position. This lovely painting, evocative of the French Rococo achievement of Watteau and Fragonard, is both descriptive of children's play and emblematic of the fleeting nature of childhood, elements we have already seen combined in the artist's work. Some fifty years later, the image of the hobbyhorse recurs in James Ward's work *The Rocking Horse*, known only in an engraving of 1793 (see figure 3). While the motif of children at play with a rocking horse is still central, it is entirely subservient to the larger moralizing theme. The two privileged children at play, surrounded by cast-off toys and an excited spaniel, are watched through the garden gate by two impoverished children and their mother. The youngest child at the gate points at the playing chil-

dren's toys and looks at his sister, seemingly unable to understand the distance and barriers separating the two pairs of children. Ward's engraving is one of the strongest juxtapositions of class to be found within a single image of the Georgian period and serves as a veiled commentary on privilege and a challenge to the viewer to do more for those who have less. Once again an understanding of the backdrop of contemporary politics in France is critical, for many in Britain feared revolutionary contagion unless those in positions of economic superiority could be seen as espousing the needs of the poor. Yet criticism such as this is best done through the lens of childhood, at a safe remove from the world of power. Childhood has become, in Ward's engraving, a suitable vehicle for advocating change. Comparison of the works by Nollekens and Ward suggests the distance traversed in fifty years, both in terms of pure aesthetics and the development of a new conception of the image's role in the evolution of social values.

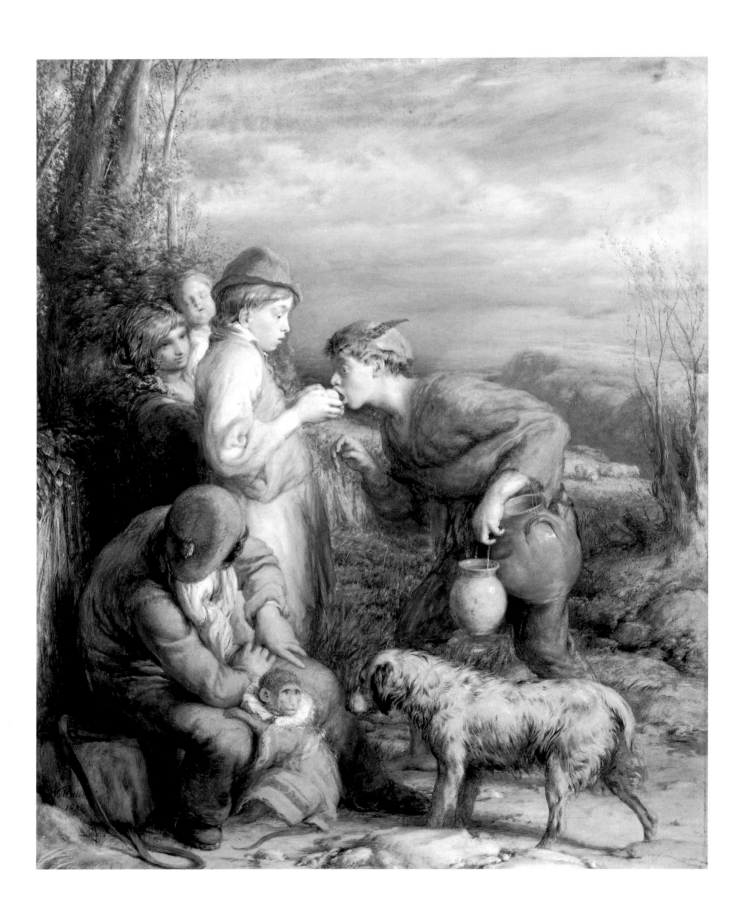

Chapter Seven / *Children, Class, and Countryside*

One of the difficulties of constructing an adequate history of childhood or a history of children in the visual arts is the paucity of documents pertaining to lower-class children. The majority of extant documents come from middle-[1] and upper-class families: very few lower-class diaries or autobiographies exist from the eighteenth and nineteenth centuries. Instead, much of the textual and visual evidence that has been left concerning charity, the workhouse movement, and child labor comes from writers and artists working from a position of relative privilege. The child labor reform movement offers the most evidence about the reality of poor children's lives: most had little leisure time, and that was spent sleeping or with friends; most had only one outfit of clothing, and so were constrained in their activities; the oft-observed hooliganism arose from a lack of parental supervision, which was brought about by the parents' long hours at work.[2]

The impoverished were the recipients of the gifts of the charity movement and, simultaneously, much fear from the more privileged classes, not the least of which stemmed from a fear of moral contagion. As James Boswell wrote in his *Life of Johnson,* "Poverty takes away so many means of doing good, and produces so much inability to resist evil, both natural and moral, that it is by all virtuous means to be avoided."[3] By this, I think Boswell means not only avoiding falling into poverty oneself, but avoiding contact with it—as long as this can be done virtuously, without contradicting the appropriately charitable position demanded by sensibility, the equation of acute feeling with true virtue. Many observers noted that even a virtuous man's children could be ruined by poverty.[4]

Class enters the discussion of childhood and children's lives at the most basic level, that of child mortality. An important workhouse movement existed well before the 1720s,[5] yet this method for aiding the poor peaked later in the century. Such workhouses admitted indigent, often orphaned or abandoned children at very young ages, raising them for a life of physical labor, and had horrific mortality rates. According to the reformer Jonas Hanway, 40 percent of children under the age of three admitted to London's St. Giles's workhouse in 1765 died after one month; at St. George's workhouse in Middlesex, nineteen young children were admitted in 1765 and twelve died within fifty days, four more within nine months, and the other three were removed. Hanway wrote, in *An Earnest Appeal for Mercy to the Children of the Poor* of 1766:

> There is *no wonder* in this when it is considered, that these children were put into the hands of indigent, filthy or decrepit women, three or four to one woman. . . . The allow-

Figure 83. William Mulready, 1786–1863, *Giving a Bite,* 1834, oil on canvas, 19¾ × 15⅜ in. (50.4 × 39 cm), The Board of Trustees of the Victoria and Albert Museum, London.

Will Wander got tiered
And dropped in the Fields,
So they carryed him home
By his head and his heels.

Figure 70. Anonymous, "The London Beggars," from *The Cries of London* (London, 1760), engraving, 3⁹⁄₁₆ × 2⁹⁄₁₆ in. (9.1 × 6.5 cm), The Pierpont Morgan Library, New York.

Figure 71. Anonymous, title page from *Will Wander's Walk, with both his companions and all of their talk* (London, 9 August 1806), engraving, 4⁵⁄₁₆ × 3⁹⁄₁₆ in. (11 × 9 cm), The Pierpont Morgan Library, New York.

ance to these women being scanty, they are tempted to take part of the bread and milk intended for the poor infants. The child cries for *food,* and the nurse beats it *because* it cries. Thus with *blows, starving and putrid air,* with the additions of *lice, itch, filthiness,* he soon receives his *quietus.*[6]

St. James's workhouse in Westminster was perhaps the best of the lot, paying bonuses to nurses whose charges lived beyond their first birthday or who recovered from illness. Yet the workhouse and the boarding-out system were both obviously inadequate. In 1767 Parliament passed an act for the better regulation of parish poor children, pertaining only to London's workhouses.[7] Nine years later, a Commons committee was established to study mortality rates of children under age eight in workhouses throughout England. Only in 1802 was a bill passed that would allow magistrates to punish nurses for neglect of their charges. It has been estimated that as late as 1839 one of two children born into artisan or servant families was dead before the age of five. In professional circles, the statistic drops to one in eleven.[8]

Artists were certainly conscious of class distinctions among children; indeed, most of the images presented thus far speak at least indirectly of class, of a complicity between privileged sitter or patron and privi-

leged artist. A number of artists recruited child sitters for their genre and fancy subjects from the ranks of poor working children. Some artists, such as William Blake (himself from a lower-middle-class family), were explicitly concerned with the causes and effects of child labor. And in one case, we are told of an artist coming from a working-class background. According to J. T. Smith in an anecdote related to his father by the artist in question, the artist Isaac Ware was originally "a thin sickly little boy, a chimney-sweeper."[9] Ware was rescued, possibly by Lord Burlington, by his talent for drawing in chalk when caught in the act by his benefactor during a break from his sweeping. Despite this early rescue, Smith relates, "I've heard my father declare, that Ware retained the stain of soot in his skin to the day of his death."[10]

Many artists, however, spoke more directly in their work of class, specifically of child labor and the deprivation that drove poor children to it. These include a large number of illustrators of children's books, from the anonymous *Cries of London* (figure 70) of 1760, with its child beggars, to *Will Wander's Walk, with both his companions and all of their talk* (figure 71) of 1806. Both are intended, through word and image, to educate the child reader about class distinctions and the dangers inherent

in bad behavior. Begging occupied the absolute low end of the scale and was adopted out of desperation by orphaned and abandoned children, but it was also a use to which children were put by their indigent parents. One of the more brutal examples was that of a beggar woman sent to prison for a mere two years in 1761 for putting out the eyes of her juvenile charges to improve their "usefulness" as beggars.[11]

The *Cries of London* and other children's books on the theme of London street life explored the range of child labor in Georgian Britain, which consisted primarily of domestic service, field service, and shop apprenticeships. All of these pursuits were directly or indirectly encouraged by the charity schools and flourished not just of necessity but of a desire indulged by some parents to send children away at the difficult time of their sexual development.[12] Child labor, made possible and even necessary by the budding industrial revolution, was in effect a transference of medieval practice wrenched from its original communal context. Children now labored outside of the family or communal setting, due in part to the growing value placed on family privacy (and an abandonment of the extended family) and in part to the breakdown of urban social institutions. The impact of child labor was quickly widespread. In 1793, 18 percent of Robert Owen's workforce was under the age of nine.[13] One liberal cotton mill owner was unusual in 1816 for employing only children over the age of ten,[14] but adhering to these better conditions allowed him to pay the children less. By the early 1830s, one third to one half of all laborers in cotton mills were under the age of twenty-one, and masses of these were children between the ages of six and eight.[15]

Juvenile chimney sweeps reflected the changing life of eighteenth-century Britain as new terraced houses were built with smaller chimneys, necessitating the engagement of smaller sweeps to clean them. Child sweeps often went up the chimneys naked to allow them to fit into even tighter chimneys, a reality Blake reminds us of in "The Chimney Sweeper" from *Songs of Innocence*, where the clean white skin of the innocent contrasts with the blackened flesh of the sweeps. Although these very young chimney sweeps officially numbered only about six hundred in 1785,[16] they were the most affecting cases in what has been called "a boundless landscape of urban despair."[17]

Child chimney sweeps often appear in children's morality tales for the benefit of ill-clad and undernour-

ished Sunday scholars. One such text, the *Child's Companion* for May 1826, tells its juvenile readers:

> If the chimney sweeper looks black *outside,* remember you are black *inside.* . . . We ought to be very much obliged to the chimney sweepers for the great trouble they take to be useful to us. . . . Be kind to the little sweeps, and to all that are poorer than yourself, for it is by the grace of God, and not on account of your own goodness, that you are any better off than they.[18]

The chimney sweep is held up as the lowest of all children. But the lesson is oddly contradictory to that seen previously, as in *Little Goody Two-Shoes*. Here, the child is taught resignation before fate, resignation to his class position, rather than the moral that hard work (i.e., goodness) will allow the poor child to better himself.[19]

William Blake's "The Chimney Sweeper" from *Songs of Innocence and of Experience* (figure 72) is one of the artist's strongest statements about the corruption of childhood by a cruel society. We see a blackened child carrying a bag of soot and a wire brush through driving snow in the city streets. The doors and windows he passes are shut against him. The boy has been snatched

Figure 72. William Blake, 1757–1827, "The Chimney Sweeper," from *Songs of Innocence and of Experience* (London, 1794), copper plate etching, 4⁵⁄₁₆ × 2¾ in. (11 × 7 cm), The Keynes Family Trust, courtesy of the Fitzwilliam Museum, Cambridge.

Figure 73. William Mulready, 1786–1863, *The Chimney Sweep,*
ca. 1815–20, pen and brown ink, 2¾ × 2½ in. (7.2 × 6.6 cm),
The Whitworth Art Gallery, The University of Manchester.

from the fields of nature, where he was "happy upon
the heath," and forced to put on "the clothes of death."
Although he cries, "weep, weep in notes of woe" (a
child's weeping as well as a corruption of the sweep's
cry), the boy's spirit is not entirely broken, he is not en-
tirely blighted—a fact that allows his parents to feel they
have done nothing wrong. The text tells through the
child's voice that his labor is condoned by his parents
and, by extension, by the church, where his parents have
gone to pray.[20] The snowy bleakness is thus the chill of
parental neglect. The child displays an unchildlike rea-
soned analysis and understanding by his ability to see
through his parents' self-deceptions to the true enemies
of his well-being—God, church, and king. The redemp-
tion offered by the church is merely a ploy to keep the
poor in their place and, indeed, to sanctify their poverty.
Compared with Blake's plate of the same title from *Songs
of Innocence,* this work has as its target a wider social in-
justice, the corruption of innocent childhood.

William Mulready later took up the theme of the
child chimney sweep, but without betraying any of the
sympathy for the child's exploitation seen in Blake and
that can be found in the writings of Charles Lamb or
Charles Dickens.[21] Mulready's undated drawing *The
Chimney Sweep* (figure 73) is instead a scene of confron-
tation between four well-dressed boys and the bare-
footed, begging sweep, who extends his hand asking for

charity. There is no recognition between one child and
another, but merely the representation of fear, even hor-
ror, in the face of the most degraded class of laborers.
Mulready shows no compassion for the sweep; indeed,
he seems to side with the privileged boys whose equa-
nimity is threatened by the reality of poverty. By placing
the confrontation within the world of children, Mulready
has tried to create a safe image of class conflict, but in the
end it merely emphasizes—and distances—the "other-
ness" of the poor child.

By the turn of the nineteenth century, Blake's *Songs,*
themselves in the tradition of children's chapbooks but
now aimed at adults, were influencing the writers of chil-
dren's books. Ann and Jane Taylor's *Original Poems, for
Infant Minds* appeared at this time, bearing the strong
imprint of Blake's social conscience. When their heavily
didactic work *City Scenes; or, A Peep into London for
Children* (1801) was revised and reprinted in 1818, it in-
cluded Blake's "Holy Thursday" from the *Songs of Inno-
cence* in their chapter on "Charity Children." But this is
the more optimistic Blake, when God and angels might
still save poor children, presenting through the filter of
the Taylors' work a picturesque view of London's poor
children to a comfortable child audience. Blake's image
had, after all, been intended for a limited and highly spe-
cialized audience. The plates themselves were critiqued
by contemporaries as "eccentric" for the absurdity of the
designs, "like the conceits of a drunken fellow or a Mad-
man."[22] When transferred to a mass audience, "The
Chimney Sweeper" was co-opted into advocating pity
for the poor, a safely controlling emotion passing under
the guise of charity.

The development of morality stories for children
played a more general role in constructing an under-
standing of class for children. Privileged children were
taught charity, while poor children were taught the im-
portance of piety over wealth. One of Ellenor Fenn's
innovations was to insist on class distinctions between
children in her stories. A servant and a child might get
along, but a poor child could not aspire to little miss's
place in society. Fenn and other writers of children's sto-
ries including Sarah Trimmer were profoundly distrust-
ful of the imagination, which might lead to, among other
evils, a dangerous fluidity in social structure. It was at
this time, in the 1790s, that *Little Goody Two-Shoes* came
to be seen as anarchic because the heroine changed her
class position. Fear of the imagination, and of its power
to inspire change, altered the nature of storytelling for

children well into the nineteenth century. The result was a literature in which wealthy children were always scrupulous and fair, the highborn always generous and kindly —part of a larger movement to reassert reigning religious, moral, social, and political "truths."

What, then, are we to make of the fact that the cult of innocence coexisted with the increasing abuse of child labor? Was one necessary to the other? Or did innocence simply not apply to impoverished children? The absence of laws to safeguard children, especially in the area of child labor, was the product of a predominantly rural society. The concept of innocence in children seems, too, to have stemmed from a time when Britain at least *thought* of itself as primarily rural, when nationalism drew on this concept of a rural land—a land that was harmonious with Rousseau's ideas of the child of nature. Yet late eighteenth-century society was being increasingly commercialized on every level, with implications for the privatization of family structure as well as for tastes in art and literature. This privatization meant a breakdown of the larger network of social relationships, one in which community had traditionally acted as an extended family. One of the consequences of this breakdown was that the child was increasingly removed from the economic life of the family, an extraordinary evolution considering that the child had always been relied upon for work on the family farm or in the shop. Instead, two extremes of attitude and practice exist side by side: the cult of the innocent child and child labor divorced from its traditional family setting. The first is controlling, the second, distancing. The innocent child sits in relationship to the cult of domesticity, to perceived threats to the rural tradition, and to the resulting cult of the pastoral. The laboring urban child was too much the emblem of the threat itself to be subject, at first, to the same controlling spirit affecting children of higher classes. The eventual introduction of child protection laws following investigations in the 1830s and 1840s (a parliamentary committee heard testimony against child labor for the first time in 1832) can then be related to the entrenchment of industrialization and urbanization, while at the same time relating to evolving parental attitudes. Protection cannot be divorced entirely from control, even when it stems from laudable humanitarian impulses.

Class meant something else entirely for rural children, removed from the presence of urban benefactors as well as the possibilities of street begging. Traditionally, to the connoisseurs of art, the life of the countryman stood for the contemplative life, for freedom from hardship and worry, and for the pleasured ease afforded those with time on their hands.[23] Pastoral poetry and portraiture were associated with the court and the elite, although the poetry had a wider market than the paintings. The long-standing idea that goodness resided in the country, to which so many eighteenth-century British children, both rich and poor, were sent for nursing, rearing, or education, was revitalized by the late-eighteenth-century industrialization of towns.

The revival of interest in the goodness of the countryside created, from the 1780s, an audience eager for tranquil literary and pictorial images of a carefree cottage existence, prettified and seen from a distance. Rousseau's view of the country as the suitable habitat in which to rear the "natural" child further altered the ideal of the country way of life and was even translated into terms of adult fashion with the establishment of *le Hameau* (the Hamlet) at Versailles by the court of Marie Antoinette. This raises the question of what society really knew of rural life, which was, for the vast majority of the rural population, a life of poverty. Ultimately, this question becomes one of great significance not just to writers but to artists painting the rural landscape and poor rural children. Were these children, as Patricia Crown has suggested, "mere pictorial paraphernalia?"[24]

Two paintings by George Morland, both rich in documentary detail, suggest in visual terms the ideal of rural living in Georgian Britain. *St. James's Park* (figure 74) and *The Tea Garden* (figure 75), both painted about 1790, take the rural idyll to the city. In the first, an officer with his wife and three children are seen drinking milk in London's St. James's Park, where cows were driven each day from their home in Spring Gardens to provide milk to citizens on an outing for a penny a mug. The dairywoman is shown at the left milking a cow and turning to listen to the young boy extending his mug to her. In the second picture, a prosperous merchant and his family are seen at the pleasure gardens at Bagnigge Wells, once the site of Nell Gwynne's country home, with a small pond and arbor in the background. Two children in the foreground add to the sense of realistic observation: the boy feeds some of his tea cakes to the ubiquitous spaniel; his sister, who has lost her hat, pets the spaniel; a toy horse is attached to the string she clasps in her left hand. In the background, a servant is scarcely seen pouring tea behind the monstrosity of the mother's hat. But this woman *is* a mother: an infant sits in her lap, his back to

Figure 74. George Morland, 1763–1804, *St. James's Park,* ca. 1790, oil on canvas, 16 × 19 in. (40.6 × 48.3 cm), Paul Mellon Collection, Upperville, Virginia.

Figure 75. George Morland, 1763–1804, *The Tea Garden,* ca. 1790, oil on canvas, 16 × 19⅝ in. (40.6 × 49.8 cm), Tate Gallery, London.

Figure 76. Robert Dighton, 1752–1814, *Mr. Deputy Dumpling & Family Enjoying a Summer Afternoon*, 1781, mezzotint engraving, 13¹³⁄₁₆ × 10¹⁄₁₆ in. (35.2 × 25.4 cm), Yale Center for British Art, Paul Mellon Collection.

exchange of money. The nature of the relationship is purely economic. One senses the awkwardness of the encounter, the squire's wife as eager to be rid of this urchin as the cavorting spaniel is to be off on their outing. Although she acts with the charity required by sensibility, this woman's charity is devoid of personal commitment to the impoverished child before her.

In their comments on poor families and rural poverty, many late-eighteenth-century writers assuage their guilt over rural poverty by locating true happiness in the countryside and, specifically, within the bosom of the family. The occasional child writer acknowledges having received this message, as in the case of Marjory Fleming. Marjory, who lived only to the age of eight and died in 1811, wrote fondly of time spent at her family's country home. There, she wrote, "I enjoy rurel filisity to perfection, content, retirement rurel quiet frienship books, all these dwell here."[26] Thomson's *Seasons* was the perfect embodiment of this pastoral idyll, and Marjory acknowledges having read it and being "very fond" of parts of it.[27] In a letter of 26 July 1811 to her cousin and tutor Isabella Keith, Marjory writes her own poem on the subject of rural bliss:

> The watter falls we go to see
> I am as happy as can be
> In pasture sweet we go & stray
> I could walk there quite well all day
> At night my head on turf could lay
> There quite well could I sleep all night
> The moon would give its tranciant light.[28]

the viewer. The two scenes are devoid of direct moralizing commentary, instead situating domesticity within the pleasant if artificial "rural" outdoor setting.

Morland's *Tea Garden* represented a type of genre painting already sufficiently known as to have been satirized by Robert Dighton in his mezzotint engraving *Mr. Deputy Dumpling and Family Enjoying a Summer Afternoon* (figure 76), published in 1781. The middle-class family is on its way to Bagnigge Wells, dressed in a caricature of fashionable garb, a mockery of their pretensions. Dighton brings out the discomfort of the outing: Deputy Dumpling is sweating profusely under his ill-fitting wig; his wife is excessively aware of the viewer's regard. Their obeisance to the vogue for pleasure gardens is merely a posture.

A third painting by Morland, *The Squire's Door* (figure 77) of about 1790, raises the issues of class and rural poverty.[25] A fashionably attired woman leaves her porticoed home, her stable hand at the left with horses to the ready. She is waylaid by a small child in rags, who has taken off her hat in deference to her social superior. The squire's wife places a few coins in the girl's hand, directing her gaze downward not at the girl but at the

Marjory Fleming's diary and letters are a combination of direct observation of her daily life and moral lessons, written for an adult audience. Even her diary was kept with the explicit intent of having it corrected, daily, by her tutor. Marjory is thus not giving us an unfiltered view of her life and feelings, but one that was calculated to be pleasing to adults. Marjory gives them back the thoughts on rural life she has learned they wish to hear. The Rousseauian linkage of child to nature is evident here—the desire to sleep on a turf pillow—as it is frequently in the writings of parents who emphasize their children's happiness in nature. Hary-O Cavendish, for example, wrote from Castle Howard as an adult to her grandmother, the Countess Spencer:

> The little children are quite wild with the joy of running about all day in the woods and garden, and there is a great child who enjoys Castle Howard about as much. Indeed, George said to me yesterday upon my expressing more delight upon some subject than

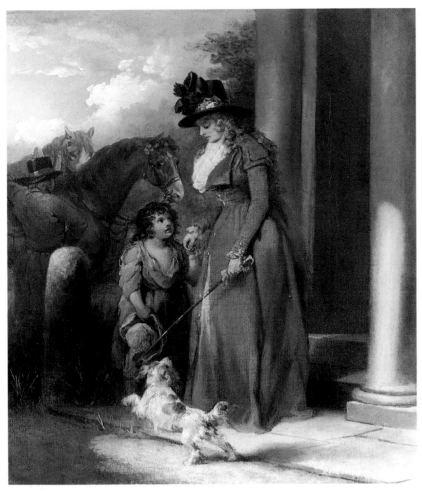

Figure 77. George Morland, 1763–1804, *The Squire's Door,* ca. 1790, oil on canvas, 15⁵⁄₁₆ × 12⁷⁄₈ in. (39 × 32.7 cm), Yale Center for British Art, Paul Mellon Collection.

I suppose suited my years and dignity, "Don't be baby-ish, Aunt."²⁹

Hary-O is by this time a grown woman, evidently still engaging in childish behavior or, at the least, enthusiasm. The natural setting she is describing and in which the children are wild with joy is the park at Castle Howard, scarcely nature unadulterated but nature controlled, in the form of a great eighteenth-century landscape garden —a vision of Britain made safe.

In the literature of rural living, children become the poor man's *raison d'être* as well as the justification for his acquiescence to his place in the world. The utilitarian philosopher William Paley writes in 1792 that he had frequently heard it said

> that if the face of happiness can any where be seen, it is in the summer evening of a country village; where, after the labours of the day, each man at his door, with his children, amongst his neighbours, feels his frame and his heart at rest, every thing about him pleased

and pleasing, and a delight and a complacency in his sensations far beyond what either luxury or diversion can afford. The rich want this; and they want what they must never have.³⁰

Paley argues that fundamentally the condition of the poor is to be preferred to that of the rich, for each must locate his happiness in his family and the poor can find this while the rich cannot. Paley reaches the height of domestic sensibility when he questions, "Now have the poor anything to complain of here? the poor man has his wife and children about him; and what has the rich more?"³¹ If we still fail to understand that it is the family, not one's financial situation, that is primary, he continues,

> I have no propensity to envy any one least of all the rich and great; but if I were disposed to this weakness, the subject of my envy would be, a healthy young man, in full possession of his strength and faculties, going forth in a morning to work for his wife and children, or bringing them home his wages at night.³²

Paley's view fundamentally misses the crisis prevalent in rural England after 1770, brought on through the enclosure movement and the resultant loss of livelihood for rural families dependent on the land.[33] Enclosure attested to the power of the land-owning nobility, and to the extent to which paternalism, despite the charity movement, had worn thin. From 1774, four thousand parliamentary acts enclosed some six million acres of land, destroying villages and the bulk of the yeoman class, rendering independent laborers subservient to landowners for their livelihoods. While enclosure suggested the more efficient, healthier cultivation of fields, it dealt a death blow to those among the poor who had taken a small stake in common lands, and created a dispossessed rural proletariat for the first time.[34] A way of life was destroyed.

Most writers of the time, particularly late in the century, steadfastly refused to focus on the realities of rural poverty. Such blindness can certainly be related to the late-eighteenth-century conception of "taste" that demanded an emphasis on innocence and happiness rather than the hardships of life, leading artists in turn to emphasize the influence of "the Feminine," which is to say women and children.[35] At best, the artist or writer could depict the simple joys of rural living alternating with heart-rending misfortune suitable to the rising tide of Sensibility. John Barrell argues, rightly I think, that this was a fundamental cyclical shift as writers moved from a "Georgic" view of the poor rural family, in which the truth of poverty could be acknowledged, to a "Pastoral" view, typified by Oliver Goldsmith and *The Deserted Village*.[36] Goldsmith's poem, published in 1770, evokes the idyllic pastoral village, now lost along with its "bold peasantry, their country's pride," to excessive mercantilism. In the 1790s, the pendulum swung again, back to an ultimate Georgic, or rural, triumph in which sympathy for the poor was a type of moral compensation for having forcibly exchanged the paternalist system of rural living for a capitalist one.[37] The wealthy distributors of charity are thus not consumers of new wealth but spectators of the poor family's fight to survive. This description certainly corresponds with larger shifts in taste and accords with contemporary evidence in which the poor were no longer seen as barbarian or criminal. We shall see that painters of the 1760s helped the nation collectively submerge the uncomfortable facts of the agrarian and industrial revolutions while remaining morally uncommitted, despite personal charitable impulses.

Various Georgian tract writers, particularly the Evangelicals, make the point that those in a position to distribute charity do not wish to see all kinds of poverty but rather the clean, self-respecting poor to whose children a good measure of self-discipline has been taught. Hannah More writes in the 1790s that it is a "common mistake, that a beggarly-looking cottage, and filthy-ragged children" raise the most compassion, "for it is neatness, housewifery, and a decent appearance, which draws the kindness of the rich and charitable, while they turn away disgusted from filth and laziness."[38] The implication is, as Barrell points out, that for observers of the rural poor, and for the artists who painted them, "those who *look* like beggars are ragged only through their idleness."[39] At this point in the century, work has become equated with virtue, and leisure time, fundamentally a privilege of the upper classes, with improvement of the mind and morals. This reveals the paradox that it is the deserving poor—those who at least in appearances deny the rural crisis of poverty by putting on a facade of prosperity—who need help least but will attract it most. Typical of this conundrum is More's *The Shepherd of Salisbury Plain* of 1795, the best known of her *Cheap Repository Tracts* directed at reforming the conditions of the poor.[40] Selling two million copies in four years, *The Shepherd of Salisbury Plain* is the story of a young girl who spends all day collecting the sparse tufts of wool left by the family sheep on the bramble bushes, and who proudly announces her success to her father, who stands before a gentleman making a display of his pious poverty. The gentleman is so impressed that the girl has been taught the proper attitude toward hard work and is inured to a life of endless toil that he rewards her with the charitable gift of five shillings.[41] Like a number of the paintings we will examine in this chapter, More's story illustrates the transition from Rococo frivolity (a mode in which children basically mirror adults) to Evangelical industriousness, a changing view of the world in which poverty is part of God's system to teach industry and self-improvement—and, of course, is also a by-product of enclosure and industrialization.

The pastoral ideal can be found in a number of potent images and texts focused on the "cottage" motif. Typically, these scenes cluster around the picturesque cottage or village, peopled with figures evocative of wholesome rusticity. Thomas Gainsborough's cottage scenes, to which he turned repeatedly in the 1770s and 1780s, update the French pastoral tradition of Claude

Lorraine or Watteau in response to enclosure and his own nostalgia for the countryside, after moving first to Bath in 1759 and then to London in 1774. Uvedale Price, who published the influential *Essays on the Picturesque* in 1794, recalled riding through the countryside with Gainsborough and coming across cottage scenes:

> When we came to cottages or village scenes, to groups of children, or to any objects of that kind which struck his fancy, I have often remarked in his countenance an expression of particular gentleness and complacency.[42]

Gainsborough would actually compose his landscapes in the studio, peopling them with figures which might, on a larger scale, form the subject of a fancy picture. Gainsborough wrote, however, that the landscape itself was more important than the figures that peopled them "to fill a place (I won't say stop a Gap) or to create a little business for the Eye to be drawn from the Trees in order to return to them with more glee."[43] For Gainsborough, the countryside has become a long-remembered idyll. *The Cottage Door with Children Playing* (Cincinnati Museum of Art), shown at the Royal Academy in 1778, is one of the most successful of these large-scale scenes. An eruption of children descends from the cottage door where their mother stands beneficently. The composition of lively children is based on a flowing diagonal line moving toward the open landscape and the figure of the father, engaged in an act of labor (carrying firewood home for the evening), and thus appropriately separated from the children's world of play. John Barrell rightly points out that labor must be divided from pastoral domesticity: beyond their work as mothers, women cannot be shown at work as this would "contaminate their delicacy."[44] Neither should children be shown laboring—to do so was to indulge in Blake's eccentricity. Yet unlike Barrell, I would argue that the focus is not so much class as family: the father's labor is the embodiment of the family's sustenance. Gainsborough's *Peasant Smoking at Cottage Door* (plate 42) continues the same subject while moving the father into the family group and injecting a tone of greater tranquility. Indeed, like the *Cottage Door* of 1786 (Huntington Library, San Marino), the atmosphere of quiet evening is suggestive of Claude. Gainsborough has moved from a horizontal to a vertical format, which has the effect here of further accentuating the sheltering setting afforded the cottage by the dramatically overarching trees. The emphasis is on the family unit: they are literally drawn into a harmonious, protected circle and the children focus their attention obediently on the parents.[45]

Poetry of the 1770s similarly extolled the virtues of the cottage life. One poem, published in the *Gentleman's Magazine* for 1773 concludes:

> Oh! to thy charming Cottage let me rove,
> That scene of beauty and domestic love;
> There could I gaze for ever, and admire
> Thy Genius, judgement, elegance and fire.

The poet strikes a note of nostalgia similar to that of the works of Gainsborough, coming even closer to the mood of the *Cottage Door with Children Playing* in a second poem published in the same year:

> . . . like a rushing torrent out they fly
> And now the grassy cirque have covered o'er
> With boisterous revel, rout and wild uproar.

In painting and poem, it is the emotions perceived to be resident in the cottage setting that arouse the onlooker's greatest admiration. Clearly this is not the entire story of rural life, yet Gainsborough's paintings were admired by early critics for their honesty. Sir Joshua Reynolds, for example, praised Gainsborough's cottage landscapes in his Fourteenth Discourse to the Royal Academy for combining honest observation of the mean and vulgar with that of the "interesting simplicity and elegance of his little ordinary beggar-children."[46] Another early critic noted especially the central figures of mother and children, describing this as "a scene of happiness that may truly be called Adam's paradise."[47]

Reynolds clearly admired Gainsborough's rustic pictures for in 1782 he bought one of them, *Girl with Pigs* (figure 78), lauded by many critics as the finest work shown at the Royal Academy in 1782 and later described by Reynolds as "by far the greatest Picture he ever painted or perhaps ever will."[48] In this canvas Gainsborough has functionally taken the small figures of the cottage door paintings and enlarged them to assume the importance of figures in a typical fancy picture or genre piece. This girl sits wistfully on a log, her chin resting on her hand, while nearby two of her pigs drink from a basin. The girl is now sufficiently enlarged to give us a clear sense of her tattered clothing, her bare feet, her youth. Hers is a rustic poverty comfortable to the privileged viewer. She is lost in contemplation—or perhaps resignation—and her contemplation invites ours, of both the simplicity and the tranquility of the girl's situation. When Reynolds made his laudatory observation of the work, he may have had in mind this celebration of the simple, although we also must allow that he was perhaps

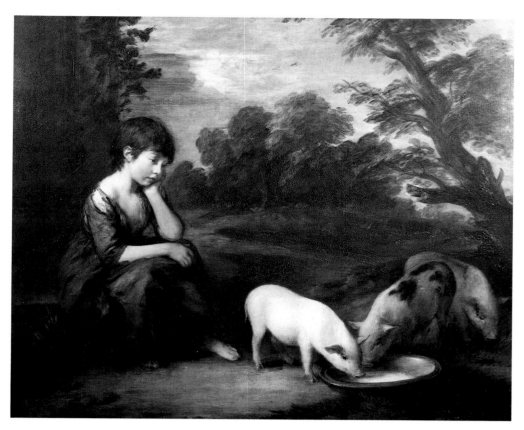

Figure 78. Thomas Gainsborough, 1727–1788, *Girl with Pigs*, 1782, oil on canvas, 49½ × 58½ in. (125.7 × 148.6 cm), from the Castle Howard Collection.

being disingenuous concerning his greatest rival, belittling Gainsborough's achievement by suggesting that it reached its apex in a work of a peasant girl and pigs (instead of a grand mythological portrait from Reynolds's own oeuvre). Sir Henry Bate-Dudley, editor of the *Morning Herald* questioned Reynolds's motives when he wrote in that paper in 1786:

> Why does Sir Joshua hang Mr Gainsborough's little picture of the pigs in his cabinet collection of all the great masters of past times? Does Sir Joshua really intend this as a compliment to his contemporary or is it to afford room for invidious comparison? Let Sir Joshua mean as he will, the merits of the painting cannot be destroyed.[49]

Bate-Dudley recognizes that the painting has intrinsic merit, but he does not name what it is. It must reside, at least in part, in the idea that this simple girl seen with her pigs represents the goodness of the child of nature, a transaction with child poverty that renders it nonthreatening. The following year Bate-Dudley wrote of Gainsborough's *Cottage Door with Children Playing* that "it cannot fail to impart delight to every beholder. . . . A pastoral innocence and native sensibility give inexpressible beauty to these charming little *objects*. They cannot be viewed without the sensations of tenderness, and pleasure, and an interest for their humble fate."[50] Bate-Dudley's fascinating commentary both objectifies poor children and suggests that concern for their poverty naturally mingles with taking pleasure in it. Other contemporary writers were more critical of Gainsborough's subject. One, William Jackson, faulted the cottage girl paintings, such as *Peasant Girl Gathering Faggots* (figure 79), for their artificiality, pointing out that a town girl with her clothes in rags is not at all the same thing as a ragged country girl.[51] Jackson has missed the point, however, that the cottage girl is for Gainsborough an embodiment of peace, and in this sense more than a simple rural idyll. We return to this girl in Chapter Nine, but for the moment it is enough to say that Gainsborough was not alone in admiring the simple charms of a cottage girl. William Wordsworth's poem "We are Seven," extolling the beauty of a young cottage girl, was actually reprinted as a chapbook for children, accompanied by an inexpensive woodcut illustration startlingly like Reynolds's painting of

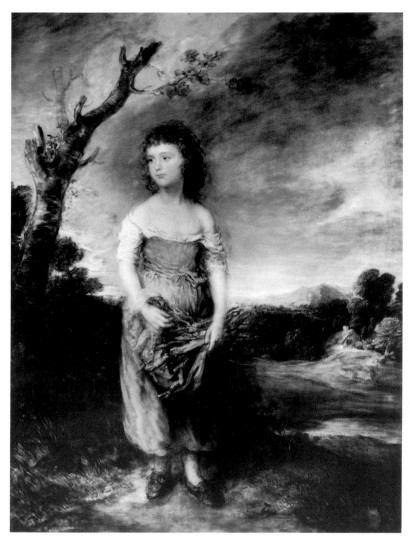

Figure 79. Thomas Gainsborough, 1727–1788, *Peasant Girl Gathering Faggots*, 1782, oil on canvas, 67 × 49 in. (170.2 × 124.5 cm), City of Manchester Art Galleries.

Miss Crewe, an iconic image of the child in a rural landscape setting. Wordsworth praises such a girl, writing,

> I met a little cottage girl,
> She was eight years old she said;
> Her hair was thick with many a curl
> That cluster'd round her head.
> She had a rustic woodland air,
> And she was wildly clad;
> Her eyes were fair, and very fair,
> Her beauty made me glad.[52]

This brings Wordsworth's vision of the Romantic child directly to a child audience, with the accompanying image a simplification of a Reynolds icon, transferred to a child of a lower class, now "wildly clad."

The male equivalent of *Girl with Pigs* can perhaps be found in Gainsborough's rather static early work,

The Shepherd Boy (figure 80), or, more compellingly, in his lively *Two Shepherd Boys with Dogs Fighting* (plate 43). A contemporary critic found these two works to be examples of Gainsborough's fondness "of giving a little rustic boy or girl a place in his landscapes," showing how "Nature was his teacher."[53] Yet the boys in the latter are clearly more than staffage in a landscape. Something of Gainsborough's intent in *Two Shepherd Boys with Dogs Fighting* emerges in a letter he addressed in 1783 to Sir William Chambers, first treasurer of the Royal Academy:

> I sent my fighting dogs to divert you. I believe next exhibition I shall make the boys fighting & the dogs looking on—you know my cunning way of avoiding great subjects in painting & of concealing my ignorance by a flash in the pan. If I can do this while I pick pockets in the portrait way two or three years longer I

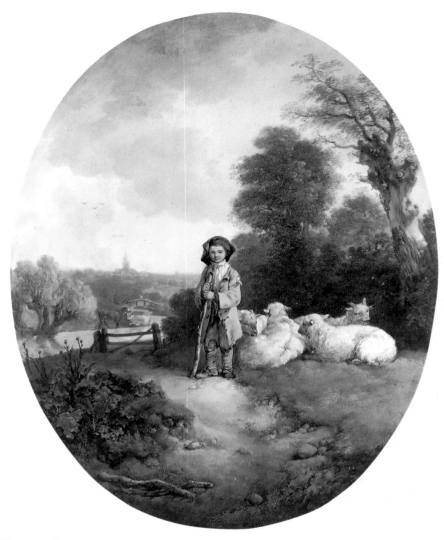

Figure 80. Thomas Gainsborough, 1727–1788, *The Shepherd Boy*, ca. 1757–59, oil on canvas, 32¾ × 25¾ in. (83.2 × 65.4 cm), The Toledo Museum of Art, gift of Arthur J. Secor.

intend to turn into a cot & turn a serious fellow; but for the present I must affect a little madness.[54]

Here Gainsborough not only responds to critiques that he couldn't paint, but he cleverly rejects Reynolds's instruction (which Reynolds himself did not follow) to paint only noble subjects. Gainsborough's choice of painting rural fancy pictures is a way of hiding his ignorance of these noble subjects while giving him greater pleasure than his lucrative portrait painting business afforded. Gainsborough nostalgically avows that he would like to become a cottager himself, but in the meantime pictures such as this are a kind of feigned "madness." Perhaps most importantly, *Two Shepherd Boys with Dogs Fighting* is a diversion, a subject as simple as the rural idyll—although painted with Gainsborough's lush and intricately textured brushwork. The

diversion succeeds not only because of the work's painterly quality, but because the subject is childhood: these boys need not work; they are so much of nature that Gainsborough suggests he could have easily exchanged the dogs for the boys. Another contemporary critic, writing in the *Morning Herald* and the *Daily Advertiser,* commented at length on the parallel between boys and dogs, describing the similarities in expression and attitude, one boy "pale with defeat, the other flush with conquest,"[55] although it is the dogs who fight. This critic concluded, "This admirable composition attracts universal notice, and is deservedly commended by the science as a performance of unrivalled excellence."[56]

Francis Wheatley helped carry forward the rustic genre piece into the next generation with his Royal Academy diploma work *A Peasant Boy* (figure 81) of about

Figure 81. Francis Wheatley, 1747–1801, *A Peasant Boy,* ca. 1790, oil on canvas, 30½ × 41 in. (77.5 × 104.1 cm), Royal Academy of Arts, London.

1790. The scene of a boy and a dog is given a convincing liveliness through Wheatley's attention to details of setting (a quality absent in the Gainsboroughs we have seen). The warm details painted in brown, red, and yellow, highlighted by the gleam of an upturned pot, suggests Wheatley's interest in direct observation. That this subject should have been Wheatley's official submission to the Royal Academy is revealing of the value attached to such scenes and to their official acceptance. Labor is still at best alluded to here, the child's rustic innocence protected. A later work, *Spring* (figure 82), is one of a series Wheatley executed on the theme of the four seasons, peopled with children. Here, a boy seated in a tree hands down a bird's nest to two young girls, one of whom extends her apron to receive it. The children's clothing is quite proper, they are clean and correctly shod, so we know Wheatley is depicting children of a higher class engaging in a rural adventure (but not too rural—a church steeple is visible in the distance). The bird's nesting motif is one that held great appeal in Georgian Britain from the time of Francis Hayman's pictures for the supper boxes at Vauxhall, and was frequently illustrated in children's books. Wheatley has intricately plotted the children's gazes so that they connect with each other and with the bird's nest, creating a believable link of children with nature. Again, however, it is a sanitized nature— nature that is the subject of a child's diversion rather than a powerful force to be reckoned with.

Contemporary critics saw Wheatley's propensity to gloss over the truth of rural life, especially in the depiction of his figures. In responding to Wheatley's work at the Royal Academy in 1788, the anonymous reviewer The Bee observed that Wheatley "is apt to sacrifice expression to beauty; but, alas! who can excel in all things?"[57] John Williams found Wheatley at the Royal Academy exhibition for 1794 to lack fundamental truth and wrote:

> Whenever Mr Wheatley presents us with a rural Nymph whom he wishes to be peculiarly impressive, he decorates her head with a profusion of party coloured ribbands, like a maniac in Coventry, which play in the breeze, offensive to thought and propriety. As this is not the character of our village Daphnes, why make them so prodigiously fine at the expence of truth?[58]

Figure 82. Francis Wheatley, 1747–1801, *Spring,* 1793–94, oil on canvas, 35 × 27¼ in. (88.9 × 69.2 cm), Los Angeles County Museum of Art, Marion Davies Collection.

The short answer is that truth is not what consumers of rural images in the age of sensibility demanded.

If Wheatley has poised himself to carry forward Gainsborough's mantle, a painting of 1786 by the Scotsman Sir Henry Raeburn suggests he has inherited the coloristic interests and nobility of Reynolds. Raeburn's *Boy and Rabbit* (plate 44) places his sitter far forward within the frame using the monumentalizing format Reynolds had employed in portraits such as *Penelope Boothby* (plate 16). The boy crouches in the landscape, his right arm tenderly wrapped around a rabbit. A white ruffled shirt and dark cap delicately frame the boy's face, dominating a canvas of luminous yellow and brown. He is, from his costume, clearly middle class or better. *Boy and Rabbit* is, then, another case of the child sitter placed in a landscape setting for the sake of the rural idyll and associated with animals for purposes of symbolic affiliation. According to an early Raeburn biographer, the sit-

ter here was Raeburn's nephew, a boy who had been stricken deaf and dumb by illness. What impact did knowledge of these disabilities have on viewers in the age of Sensibility? In the absence of direct critical evidence, one can only imagine that it heightened the pathos of the boy as a true innocent, capable of evoking heights of real feeling but saved from excessive sentiment by the nobility of the painting's execution.

William Mulready carried the rural genre picture of children well into the nineteenth century, with, as evidenced in his *Chimney Sweep* (figure 73), a previously unseen edge. While seeking to pass as an amusing children's genre scene, Mulready's *Giving a Bite* (figure 83, page 172) of 1834 contains scarcely concealed elements of aggression and cruelty.[59] A boy is bullied into giving a bite of his apple to another boy, their relationship being repeated in the animal world between the frightened monkey and the threatening dog in the foreground. As

Figure 84. William Mulready, 1786–1863, *A Dog of Two Minds*, 1829–30, oil on panel, 24⅜ × 20⅜ in. (62 × 51.7 cm), The Board of Trustees of the National Museums & Galleries on Merseyside (Walker Art Gallery).

we have already seen, the affinity of children and animals, and the tendency to play out or heighten strong emotion through animals, are both hallmarks of the Romantic art of childhood. The cruelty of children, already seen in Hogarth's *Grey Children* and his "First Stage of Cruelty," has lost its satirical edge and here seems merely unpleasant. The aggression and greed of the scene comments on both the selfishness of childhood (a theme we have scarcely seen elsewhere, except perhaps in the oblivious wealthy children of Ward's *Rocking Horse*) and the potentially harsh conditions of the countryside, for again the scene is set in nature. Yet Mulready's personality was inclined to see the child's covetous aggression not as restricted to the poor but as universal. He was genuinely drawn to such scenes as part of the nineteenth century's love of a good scrap, with philosophical underpinnings in Charles Darwin's stress on conflict as the natural con-

dition of survival. William Powell Frith recalled of Mulready:

> I saw him one day with an intense expression of interest on his face, looking from the street into a small alley which ran at right angles with it; and when I reached him, I saw the cause of his interest in the form of two boys who were pummeling one another, displaying what he called true British pluck.[60]

In Mulready's *A Dog of Two Minds* (figure 84) of 1829 to 1830, a similar conflict is played out between boys of a higher station. Now the conflict centers upon the dog: the boy on the right urges his dog to do his fighting for him, while the other boy holds a whip in his hand to defend himself. Faced with the proddings of his master and the potential retaliation of the whip, the dog understandably hesitates between the two, a symbol of the results of aggression. Mulready suggests that aggression and

Figure 85. Thomas Barker of Bath, 1769–1847, *Young Boy Seated*, 1803,
pen lithograph, 11½ × 7¾ in. (29.2 × 19.7 cm), University Art Museum
and Pacific Film Archive, University of California, Berkeley.

cruelty are the way of nature, a reality beautifully con-
veyed by the exceptional naturalism of the dogs. In both
these lively pictures, the boys who fight or menace are
not faced with their own comeuppance. Mulready has
altered the construct of childhood, expanded the possi-
bilities of representation to include the capacity for evil,
but it is an evil without didacticism, without moral for
the adult or the child viewer.

Despite the idealizing sensibilities reigning in the
work of Gainsborough, Wordsworth, and their respec-
tive contemporaries, some Georgian writers more vividly
suggested the suffering inherent in a life of rural poverty.
The poet George Crabbe, friend to Edmund Burke,
Dr. Johnson, and Reynolds, turned against the pastoral
tradition (specifically Goldsmith's *Deserted Village* and
its mythical golden age) and argued that the role of the
poet and painter was to reconcile the peasant to his lot,
not to distract him with dreams of improvement. In prac-
tice this meant that Crabbe focused attention on the dis-
parity then reigning between poetic fiction and harsh

reality. In *The Village* of 1783, Crabbe wrote, "I paint
the Cot,/As Truth will paint it, and as Bards will not,"[61]
a goal of writing realistic portraits of rural poverty he un-
fashionably maintained through the years of the Roman-
tic movement. Crabbe's was a grim, detailed vision of
rural poverty and a blighted landscape that harkens back
to Blake's words in *Songs of Innocence and of Experience*
—so much hunger in a rich land. Truth and Crabbe are
painting on the same side of the battle line, unlike most
of the visual artists we have seen, who allow only a part
of the child's experience of poverty to invade their vision.
In his poem "The Parish Register," published in 1807,
Crabbe declares that the search for a rural idyll of cottage
contentment where there is no suffering is a false one:

> Is there a place, save one the Poet sees,
> A land of love, of liberty and ease;
> Where labour wearies not, nor cares suppress
> Th' eternal flow of rustic happiness;
> Where no proud mansion frowns in awful state,
> Or keeps the sunshine from the cottage-gate;
> Where Young and Old, intent on pleasure, throng,
> And half man's life is holiday and song?
> Vain search for scenes like these! no view appears,
> By sighs unruffled or unstain'd by tears;
> Since vice the world subdued and water's drown'd,
> *Auburn* and *Eden* can no more be found.[62]

In what must now seem misguided advice, Crabbe then
goes on to recommend forced labor for the children of
paupers.[63] Although artists also turned their pens and
brushes to images that depicted some of the realities of
rural poverty—as in Thomas Barker of Bath's *Young Boy
Seated* (figure 85), printed in 1803 as one of the first pen
lithographs—poverty rarely extends beyond tattered cos-
tume and bare feet. The construct of childhood we have
seen under development does not allow for the realism
Crabbe has hoped to paint with his literary pen.

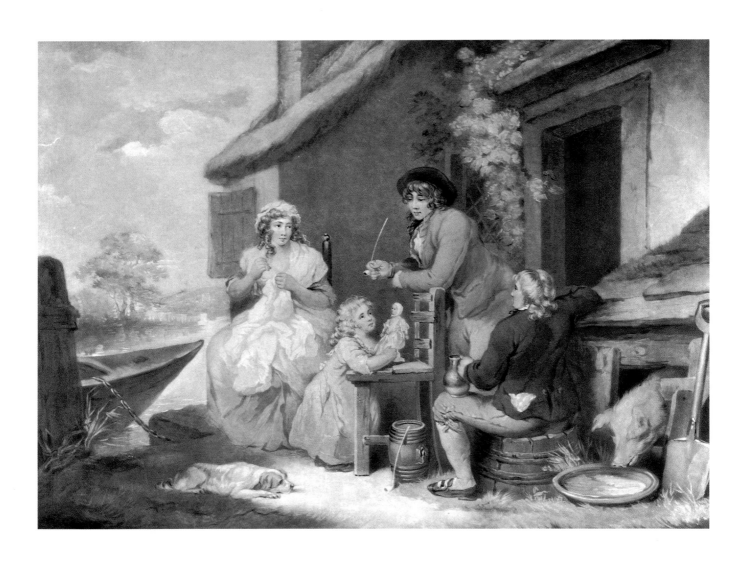

Chapter Eight / *The Family and Sentiment*

The family found an ardent champion in Samuel Richardson's *Pamela, or Virtue Rewarded,* appearing in 1740 to 1741, a work in the new and fundamentally middle-class genre of the novel. Richardson's heroine, seen in Joseph Highmore's charming painting *Pamela in the Nursery* (Fitzwilliam Museum, Cambridge), triumphs over adversity to become the much-admired paragon of virtue to her family and friends. *Pamela* follows in the tradition of the *Spectator,* the tradition of Puritan family literature and books on social conduct characterized by Frederick Antal as "the complete literary expression of the moral outlook of the middle class, with its new esteem for the wife and mother."[1] This is an expression paralleled in the work of a number of Georgian artists (although not necessarily in the work of William Hogarth, who does not consistently represent family life as happy), who underlined the positive happiness of middle-class family life and the concern of the mother (or the nurse as mother substitute) for her children. Although *Pamela* may have led the way of emotional hedonism toward sensibility,[2] it was hardly alone, rapidly followed by the publication of Oliver Goldsmith's *Vicar of Wakefield* in 1766; Laurence Sterne's *Sentimental Journey* in 1768,[3] with its narrator who adores "dear Sensibility" and its pictorial imagery; and Henry Mackenzie's *The Man of Feeling,* the picaresque adventures of a refined and gentle hero, in 1771. The English translation of Goethe's *Sorrows of Young Werther,* with its emotionally distraught dis-ease with self and the world, followed in 1779. Visual representations of bourgeois family life thus found a profound resonance in contemporary literature and the stage.[4]

Richardson's focus on the family sought to imbue the gentry with what were seen as middle-class virtues, and as such his book contributed to a mid-century blurring of lines separating the middle class and the aristocracy. This blurring, especially by comparison to the more rigid hierarchy of the seventeenth century, had a liberating effect on artists. By the time of George III's accession to the throne in 1760, British middle-class culture had no need to be directed against the aristocracy. Artists were free to paint their sitters in more varied manners, and aristocratic sitters could be seen engaged in formerly middle-class pursuits. How, then, should we see representations of childhood and family life relative to the rise of sensibility and shifting class lines?

Hogarth's appeal was fundamentally middle class, and he largely failed to attract aristocratic sitters, although he did on occasion as in *The Cholmondeley Family.* He also adapted aristocratic formulas for domestic genre paintings of children, as in *The House of Cards.* Although Hogarth approached the court and aristocracy more in the years

Figure 86. William Ward, 1766–1826, *At Home,* undated, colored mezzotint after George Morland, 14³⁄₁₆ × 18 in. (36 × 45.7 cm), Grunwald Center for the Graphic Arts, UCLA, gift of Mrs. Katharine Siemon.

after 1750, typical, perhaps, of the period's increasingly "courtly," Tory tone, his popularity waned between the years 1760 and 1790, in which Reynolds and Gainsborough dominated. One of the more vexing questions concerning the social context of Georgian art is why Hogarth's art should have experienced a revival in the 1790s, in the guise of his latter-day heirs George Morland and Francis Wheatley (who illustrated many of the major literary works of sensibility, including Sterne's *Sentimental Journey* and Goldsmith's *Deserted Village*). Frederick Antal has argued that the revival grew out of a "democratic trend" in these years, which swept through the country after a time when all liberal ideas had been suppressed.[5] Certainly, many reforming ideas originated in the middle class, and their adoption by the aristocracy in the 1770s may be seen as a conservative trend. Against this, however, is the disbanding of the English Radical movement in the 1790s, in response to fears of the Terror in France, and the consequent disillusionment of artists such as William Blake. Further, the infiltration of Rousseau's thinking into middle-class and aristocratic constructs of childhood argues against the conservative suppression of the 1770s and 1780s posited by Antal. Instead, it is the 1790s, with its comfortable domesticity and sensibility, that saw a clamping down of progressive social ideas and led, two generations later, to Victorian sentiment. This is what might be called "the rise of virtue," in which the late eighteenth-century revival of religious fervor, a turn against sex, and the cult of childhood innocence all played a part.

Much of the new emphasis on domesticity after 1760, accompanied by a privatization of values affecting every aspect of family life, must be attributed to the personal style and tastes of the new monarch and his wife, who were famed in their time for their "Germanic" bourgeois, domestic tastes. In painting, the rise of the conversation piece, which was introduced in the 1730s but revived and even peaked in popularity in the 1760s, can be attributed to a trickle-down effect from the patronage of George III, under whom the genre domesticated courtly traditions of portraiture. During the twenty-year drop-off in taste for conversation pictures, the genre was in demand almost entirely by the lesser landed gentry (never the traditional arbiters of taste) and was executed by regional artists such as Arthur Devis with an eye toward family continuity and the hereditary transmission of property. In this first flush of mostly rural popularity, the artist John Russell in 1744 encouraged his recently

married brother to have a large family to suit the conventions of the new visual style:

> It may yield me the opportunity of displaying the utmost of my art in a conversation-piece. In which my Sister[-in-law] and you must be the principal figures, with a group of my nephews and nieces, on each side, represented at employments or diversions proper to their age and sex.[6]

The genre's emphasis on family relationships and on the role of the individual within the social order ultimately was very much in keeping with the mood of the 1760s and found its most perfect expression in the work of Johann Zoffany. Even in Zoffany's encyclopedic depictions of domestic interiors, family relations prevail; we need only recall the gently reprimanding father and the mildly disobedient son in *Lord Willoughby de Broke and His Family* (plate 22).

The emphasis on this kind of small-scale, affective domestic portraiture led to an increasingly child-centered representation of the family. Children were a suitable subject for the rise of sensibility, their appeal residing in their perceived helplessness, their dependence on adult, specifically parental, benevolence and enlightenment—and control.[7] At least one historian of childhood, Edward Shorter, has argued that the making of the modern family has to do with the rise of sentiment, which he isolates in courtship, the mother-infant relationship, and affection within the family. Yet Shorter is unclear about the direction in which cause and effect worked: did Sensibility bring about the modern family, or did the modern family help bring about the rise of Sensibility?[8] Another historian, Randolph Trumbach, has suggested that the rise of domesticity came about as a result of the newly commercialized economy cutting ties between masters and servants, while at the same time normalization of political control within the aristocracy allowed this class to disregard patrilineal norms in favor of more egalitarian kinship norms.[9] I would suggest, however, that all of these features—domesticity, the modern family, sensibility, and the innocent child—arise from a rethinking, from Locke onwards, of the concept of nature: if nature is good, then children must also be good.

James Beattie's poem *The Minstrel; or, The Progress of Genius*, first published in 1771, is a central text in the cult of nature and the innocent child. Written, according to Beattie, in the style of Edmund Spenser because the Gothic structure suited its spirit, *The Minstrel* is the story of young Edwin, who at an early age for-

sakes the company of other children for that of benefi-
cent nature:

> His heart, from cruel sport estranged, would bleed
> To work the woe of any living thing,
> By trap, or net; by arrow, or by sling.[10]

For all Beattie's admiration of the boy, he admits that
Edwin is an oddity:

> In Truth he was a strange and wayward wight,
> Fond of each gentle, and each dreadful scene.
> In darkness, and in storm, he found delight.[11]

Edwin has, even as a child, inherited the wisdom of
nature, he is a "visionary boy."[12] His soul is fired by the
imagination and he delights in change, whether for good
or bad. Beattie applauds Edwin's imagination and im-
plores the child:

> Perish the lore that deadens young desire!
> Pursue, poor imp, th' imaginary charm,
> Indulge gay Hope, and Fancy's pleasing fire:
> Fancy and Hope too soon shall of themselves expire.[13]

Indeed, Beattie tells us that Hope and Fancy will ex-
pire in the face of wealth and power, the province of
adulthood. For the poet, optimism and the imagination,
intimately intertwined, are the legitimate province of
childhood—an extrapolation of the cult of nature insti-
gated by Rousseau. This Edwin is a product of the
Enlightenment ideal of every man thinking for himself,
determining his own destiny, and ultimately finding his
own personal fulfillment and happiness.[14]

The new appreciation for the countryside and its
transmission to children—of which Beattie's *Minstrel*
is but a rather extreme example—has been addressed in
Chapter Seven. Equally, the bonds of affection between
parent and child, clearly touching on the issue of sensi-
bility, have been explored in Chapter Three. Nature has
been frequently invoked in teaching mothers to nurse
their own children. Beattie's *Minstrel* suggests a slightly
different direction, one that helps to answer the question
of changing taste in the 1790s: the didacticism of virtue,
good behavior, and their reward, happiness, are now
firmly situated within the domestic family.

Paired works and paintings conceived as series
served the didactic purposes of many artists mining
the themes of virtue and domesticity. George Morland,
for example, paired a painting he titled *The Comforts
of Industry* (plate 45) with another work of 1790, *The
Miseries of Idleness* (plate 46), as a kind of sentimentally
didactic counterpart to Hogarth's *Industry and Idleness*.

The first of these depicts the return of a father at the end
of the day, the setting sun seen through an open cottage
door. He returns to a scene of comfort: his wife holds a
baby in her lap, their daughter plays with a doll on the
floor, plates and a gun are neatly displayed over the
hearth, and food (a large joint and a head of cabbage)
is plentiful. To make the point more clear, this industri-
ous father drops a couple of coins into his wife's lap,
symbols of a wise frugality. By contrast, everything in
The Miseries of Idleness suggests want within the same
cottage setting and the same family unit of man, woman,
two children, and a baby: their clothing is torn, the par-
ents turn their heads down in despair or sleep, the boy
gnaws on a meatless bone, a dog begs at his knee, the
baby cries desolately in his crib on the floor. In place of
coins we have only overturned barrels and tankards and
broken pottery. The message in each work suggests that
it is the children who truly reap the benefit or harm of
industry or idleness—a message intended to reinforce
the concept of responsibility to family. The contrast with
Hogarth's paintings on the same theme could not be
more striking. Where Hogarth's work conveys a simulta-
neously serious and satirical tone, Morland's paintings
seem calculated to evoke a purely emotional response,
teaching by example.

Francis Wheatley's *Marriage* series of 1791 explores
a similarly didactic vein, as something of an optimistic
successor to Hogarth's *Marriage A-la-Mode* (National
Gallery, London), 1743 to 1745. The series traces the life
of a woman from youth, courtship, and wedding to a
final scene entitled *The Happy Fireside—Married Life*
(plate 47). The setting in each is one of rustic simplicity,
but only the last fully develops the subject of the family
and incorporates children as the epiphany and emblem
of domestic bliss. The young woman is now a mother,
with her devoted husband at her side, his arm casually
draped about her while she does her needlework. The
fireside is indeed happy because the father is both pres-
ent and at rest; he acts as a father rather than as a bread-
winner. The implication, then, is that the happy fireside
is the result of his labor in particular and the parents' vir-
tue in general. When the series was exhibited at the Royal
Academy in 1792, a critic for the *Morning Herald* ad-
mired its combination of didactic morality and pleasure:

> By elevating the arts to the dignity of a moral in
> this series of pictures, he has, with singular felicity,
> employed his pencil in delineating the progress and
> manners of humble life—pursuing and attaining

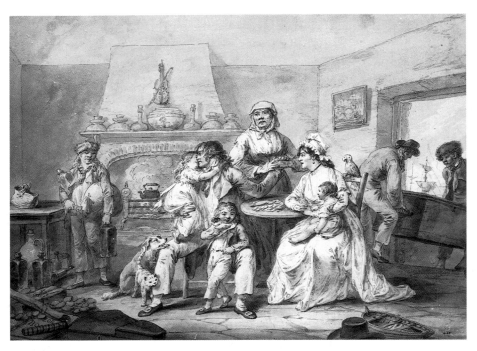

Figure 87. Julius Caesar Ibbetson, 1759–1817, *The Sailor's Return Home*, 1795, watercolor, 11¾ × 15¾ in. (29.8 × 40 cm), The Board of Trustees of the Victoria and Albert Museum, London.

happiness through the channels of prudence and industry. . . . The scene in *The Happy Fireside* is particularly interesting. If we knew a man whose mind, soured and contracted by the presence of undeserved calamity, was verging to misanthropy, we should place this picture before him, and we think his social affections would revive.[15]

For this critic, the painting has a cathartic effect beyond that of the usual morality picture. It can inspire even the jaded to more acceptable "social affections," affections to be modeled on the happy domestic relationship of parents and children. Wheatley's image presents us with the family sanctified.

Morland and Wheatley returned to these themes repeatedly in the last twenty years of the century, altering details of costume, setting, or composition for a large, predominantly middle-class market. Following his return to England in 1783 from a lengthy sojourn in Ireland, Wheatley turned increasingly from painting conversation pieces in the style of Zoffany to the lucrative field of genre pieces. Inspired by the work of the French painter Etienne Aubry,[16] Wheatley prospered under the patronage of printsellers who could disseminate his images nationwide to an eager market. The more than two hundred engravings made from Wheatley's paintings were exceeded in number only by those after Morland, such as William Ward's engraving of *At Home* (figure 86, page 190). This riverside cottage setting has all the markers of domestic tranquility—the peaceful relationship of a family and their animals (the ubiquitous dog notably at rest) in a rural setting, with a child at its center.

Julius Caesar Ibbetson's watercolor *The Sailor's Return Home* (figure 87) of 1795 makes explicit the rewards for hard work and self-denial. This motif was frequently part of a pair exploring departure and return, with the potential for eliciting strongly contrasting emotional responses. Here, the sailor has returned home to a loving family: his children surround him, his son having abandoned his toy boat (alluding to the boy's playacting of his father's career in his absence); the sailor's elderly mother holds and caresses his hand; his wife smiles from across the table where she holds their youngest child. While the room is modest, the crockery and violin over the mantelpiece and the steaming kettle on the fire attest to the family's relative comfort. The fruit of this sailor's labor is manifest in a pile of coins between husband and wife, while throughout the room men and boys disperse the bounty of his profession—a chest, bottles, and a log book. The children, too, must be seen as the fruit of his labors; like the children of Cornelia, they are the parent's greatest jewels.

Along with departure and return, the theme of loss and recovery provided a suitable outlet for the heightened emotions of sensibility. Two such pictures were Edward Penny's *A Boy Drowned* and *The Boy Recovered,* shown at

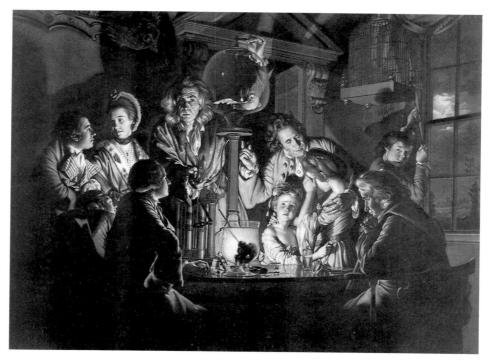

Figure 89. Valentine Green, 1739–1813, *Experiment with the Air Pump,* 1769, mezzotint engraving after Joseph Wright of Derby, 18¹⁄₁₆ × 23³⁄₁₆ in. (45.9 × 58.9 cm), Grunwald Center for the Graphic Arts, UCLA.

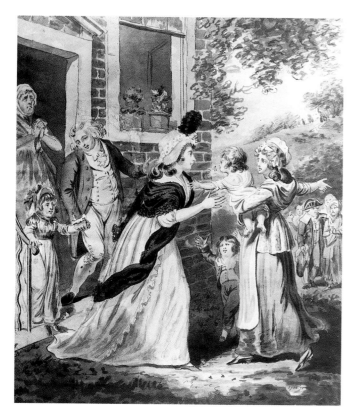

Figure 88. Issac Cruikshank, 1757/58–1810/11, *The Child Found,* ca. 1790, watercolor, 12½ × 9¹⁵⁄₁₆ in. (31.7 × 25.2 cm), The Board of Trustees of the Victoria and Albert Museum, London.

the Royal Academy in 1780 and subsequently engraved. Of Penny's work, a critic wrote in 1780:

> There is more of the truly pathetic in this story than in any that we have seen wrought up into a picture for some years. . . . The expression in all this is very fine; but the excess of sorrow and despair does not work so powerful an effect upon the spectator, as on the transition to the excess of joy and gratitude.[17]

Nevertheless, the pairing of despair and joy is necessary to provide the catharsis of the latter. And for the pathos of the narrative to succeed, through loss and recovery, it must be focused on a child. Isaac Cruikshank mined this emotionally rich vein as well in a pair of preparatory drawings, *The Child Lost* (Victoria and Albert Museum, London) and *The Child Found* (figure 88). In the latter of these, a mother rushes to greet her child, who in turn, from the arms of a servant, reaches out to embrace her (the opposite emotion of Morland's *Visit to the Child at Nurse*). The lost child's siblings rejoice at his return, while a grandmother gives thanks within the threshold of their middle-class home. Only the family that has returned the lost boy, seen in the distance under the gesturing arm of the servant, injects a note of sadness. There is no explicitly didactic project here. Rather, Cruikshank's intent seems merely to confirm the importance of a child-centered sensibility.

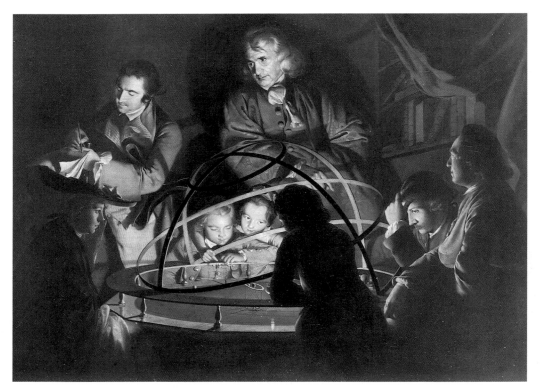

Figure 90. Studio of Joseph Wright of Derby, 1734–1797, *Philosopher Giving a Lecture on the Orrery,* ca. 1768, oil on canvas (grisaille), 17⅝ × 23½ in. (44.8 × 59.7 cm), Yale Center for British Art, Paul Mellon Collection.

Even the new world of science and technology provided an outlet for the display of sensibility in the world of children. When, for example, Joseph Wright of Derby painted his *Experiment with the Air Pump,* reproduced here in the Valentine Green mezzotint engraving of 1769 (figure 89), he introduced the figure of a girl weeping at the fate of the dove that may die from lack of oxygen during a vacuum experiment. The apparatus Wright of Derby depicts here can be seen in the background of Devis's *The John Bacon Family* (plate 21), where it allies the father figure with the world of learning and science. Despite the central arrangement of the experiment itself, Wright's interest in lamplight focuses the viewer's attention on the circle of onlookers and specifically on the two children, the one averting her tearful gaze, the other transfixed with pity. As Hugh Honour has observed, for Wright of Derby and for his friends and patrons in the Lunar Society,[18] man was still the most interesting and most important product of nature.[19] The children are again aligned with the animal world and, specifically, with an animal in an even weaker and more precarious position than the one they occupy as children. The tearful girl may be thinking of her own mortality; in any event, she has clearly learned the lesson of sensibility.

Along with the *Air Pump,* Wright of Derby's *Philosopher Giving a Lecture on the Orrery* formed part of the new world of visual excitement for children. In this second painting, of about 1767 to 1768, for which a grisaille study is reproduced (figure 90), Wright repeats certain devices from the earlier picture. The apex of each composition is the figure of the scientist or philosopher. A brooding thinker, pondering the meaning of scientific advance, appears in each work. The lighting effects, derived from the Utrecht painters Gerrit van Honthorst and Hendrick Terbruggen, create an atmosphere of suspense, even of mystery. And two children, this time enrapt, focus the viewer's attention on the orrery—a device for showing the rotation of the planets around the sun—and engage us in the theme of discovery. The children, as creatures still in need of forming, are the perfect recipients of the lecture.

A number of artists working at the century's end carried out works devoid of the narrative interest seen in Morland and Wheatley but which nevertheless sought to generate an emotional response. Artists such as John Opie, in his atmospheric *Street Singer with Her Child* (figure 91), painted evocative images on sentimental themes, such as the poor but respectable woman carry-

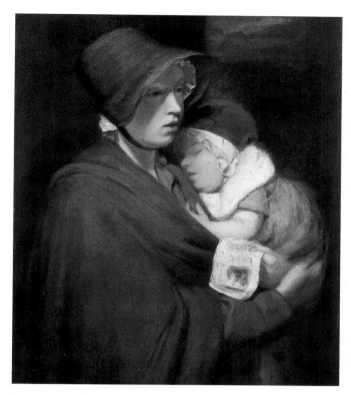

Figure 91. John Opie, 1761–1807, *Street Singer and Child,* undated, oil on canvas, 30 × 25¼ in. (76.5 × 64.3 cm), © The Cleveland Museum of Art, 1994, gift of Mr. and Mrs. J. H. Wade, 16.1030.

Figure 92. John Flaxman, 1755–1826, *Little Girl,* ca. 1787–92, graphite on pale gray paper, 11 × 6½ in. (27.9 × 16.5 cm), Museum of Fine Arts, Boston.

ing out her work in order to care for her child.[20] In such a work, a kind of fancy picture, the woman must be established as a mother: without the child, her function would be quite different, and perhaps suspect. Because of her child, the mother's work, possibly related to the *Cries of London,* has a nobility of purpose. Elsewhere, in drawings of children, such as John Constable's delicately colored *A Suffolk Child* (plate 48) or John Flaxman's *Little Girl* (figure 92), children are depicted without any of the attendant symbolic motifs found in the emblematic works presented in previous chapters. Instead, we are left with images that focus on the isolation and dependency of children, on what Henry Fuseli saw as the inherent "picturesque" qualities of the youth of any species.[21] Constable's child, for instance, is seen seated, her hands clasped in her lap and her gaze upturned to suggest her position of subservience to artist and viewer. Flaxman's girl is substantially younger than Constable's and is turned further in on herself in her absolute absence of power. Her head is set almost unnaturally low on her shoulders, while she looks down, suggesting a kind of embarrassment. Without showing these children as necessarily poor, the artists remind the adult viewers of their duty to care for and control children. In such works, the

viewer's response, one of compassion touching on charity and class issues, becomes central, the second subject of the work of art. A proper Georgian was also to be sensitive *to* portraiture and genre pieces. Such works serve to remind us that the growth of sentiment also had its own risks for children. As their lives became richer in material objects, their private lives became more rigidly disciplined and controlled.

How then were children to discover the rewards of virtue? The painted works presented thus far were aimed primarily, if not exclusively, at an adult audience, although children may have seen them or prints after them. Fuseli argued that Rousseau's *Emile* was of no use, merely "insinuating virtue, without giving one single precept; at the first of precepts the book ends."[22] Much of Lord Chesterfield's writings to his son were concerned with the boy's development of the proper moral virtues, especially important to his future success because of his bastard status and his position outside the sanctification of the traditional family. Lord Chesterfield's were moral virtues based on religion and an abstract, rather Stoical morality, the sternness of which found a ready audience from the 1770s. As we have seen, the fear that fairy stories were dangerous took hold in the latter years of the

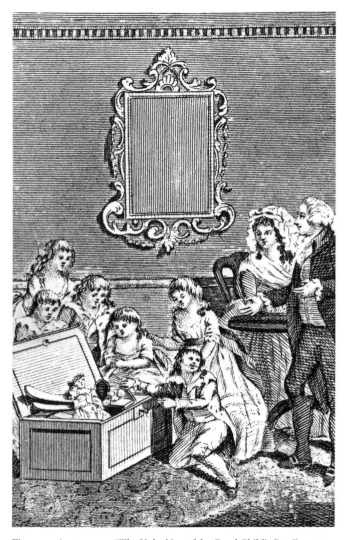

Figure 93. Anonymous, "The Unlocking of the Good Child's Box," from Dorothy Kilner, *The Holyday Present* (London, ca. 1788), engraving, 4⅝ × 2¹⁵⁄₁₆ in. (11.8 × 7.5 cm), Houghton Library, Harvard University, gift of W. S. Poor.

Late in the century, only fictional biographies of animals and inanimate objects were thought appropriate novels for children, appropriate vehicles for teaching about virtue (which for children meant in practice good behavior). Even these were gendered forms of instruction, with, for instance, Mary Ann Kilner's *The Adventures of a Pincushion* aimed at the domestic world of girls and her less "polite" *Memoirs of a Peg-Top* (1783) for the more rough and tumble world of boys. Dorothy Kilner's *Life and Perambulations of a Mouse* (figure 94) of about 1783 also sought to teach the merits of virtue through the picaresque adventures of infant mice. The morals of virtue are quite narrow here: the juvenile mice are punished for not following their mother's instructions. Thus virtue must be equated with obedience. Further, the young mice learn the need to be content with their station in life, a form of obedience. The mouse Nimble says:

> We ought to have been contented when we were at peace and should have considered that if we had not every thing we could wish for, we had every thing that was *necessary;* and the life of a mouse was never designed for *perfect happiness.*[23]

The child, once again identifying with animals he is not to abuse, learns that he, too, is not designed for perfect happiness. This moral appealed to Sarah Trimmer, who described Kilner's book as "one of the prettiest and most instructive books that can be found for very young readers,"[24] and Mary Wollstonecraft, who recommended it as part of a girl's upbringing.[25]

These children's tales did, of course, call on the child's imagination in order to see the world through the eyes of a pincushion or a peg-top carried in the pocket of its owner. Yet when imagination returned for its own sake, as in William Roscoe's *Butterfly's Ball* of 1806, as a vitally constructive part of human nature, this was part of the rise of Romanticism. In Roscoe's world of childhood, children still live in the world of nature but seemingly for the purposes of pleasure and entertainment. At the same time, descriptions of animals in children's books began to be sentimentalized, leading ultimately to the sweetness of Winnie the Pooh and the animals of Beatrix Potter. Rousseau had begun this trend, arguing against the mutilation of animals in nature, and he and his followers—notably Thomas Day in the domain of children's books—already tended to sentimentalize the natural world. Other writers of children's books, such as Anna Barbauld in her *Hymns in Prose for Children,* wedded natural theology to Locke's account of human

eighteenth century, demanding purely educational playthings, such as alphabet books that entertained for a purpose. Ultimately this fear derived from Locke, via Watts, and the idea of the malleability of children. This malleability could be good as well as dangerous: the same attribute that allowed them to be educated allowed them to be misshaped. They could, for example, be taught to believe in the dangerous concept of class fluidity—thus the turn against the educational fable *Little Goody Two-Shoes* and its plea against superstition. Instead, books such as Dorothy Kilner's *The Holyday Present* (about 1788) were preferred, where the child reader could identify with the nurturing domestic environment and find reward personified in illustrations such as "The Unlocking of the Good Child's Box" (figure 93). A proper sort of domesticity suggested its own reward.

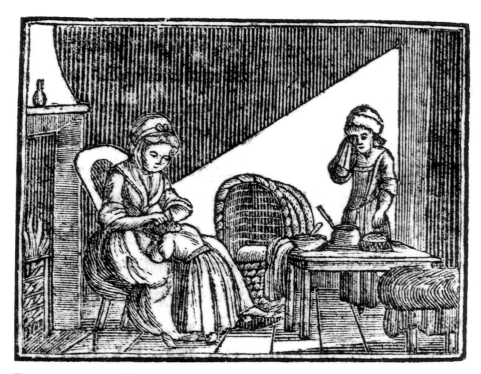

Figure 94. Anonymous, "Allegory of good behavior," from M. P. [Dorothy Kilner],
The Life and Perambulations of a Mouse (London, 1783?), engraving, 1⅞ × 2⅜ in.
(4.7 × 6 cm), The Pierpont Morgan Library, New York.

development. Barbauld's theology, however, was gentle and imaginative, as in the following passage:

> Come, let us go forth into the fields, let us see how the flowers spring, let us listen to the warbling of the birds, and sport ourselves upon the new grass. The winter is over and gone, the buds come out upon the trees, the crimson blossoms of the peach and the nectarine are seen, and the green leaves sprout. . . . The young animals of every kind are sporting about, they feel themselves happy, they are glad to be alive—they thank him that has made them alive. They may thank him in their hearts, but we can thank him with our tongues; we are better than they, and can praise him better.[26]

Although some late-century writers such as Charles Lamb favored more imaginative writing for children, Mary Wollstonecraft admired Barbauld's work for making faith and virtue "obvious to the senses."[27] Barbauld's work calls strongly on the child's imagination in finding the path of virtue, and in this way can be linked to Wordsworth's poetry about childhood, notably his *Prelude*. Although Barbauld was a practical educator trying to shape her juvenile readers through her text and Wordsworth was writing for adults, both suggest that the imagination is more important to a child's early development than the intellect, and both believed that natural objects possessed a spiritual life. English Romanticism, equating simplicity with Truth, finally came to value animals for their own sake rather than as emblems of man's cruelty.[28] Much the same could be said of children, seen as occupying a world of their own even if this was a world painted through the nostalgic lens of adult viewers. It is of course a truism to say that all modern adults have themselves passed through the state of "childhood," and no less true to say they have had to leave it behind.

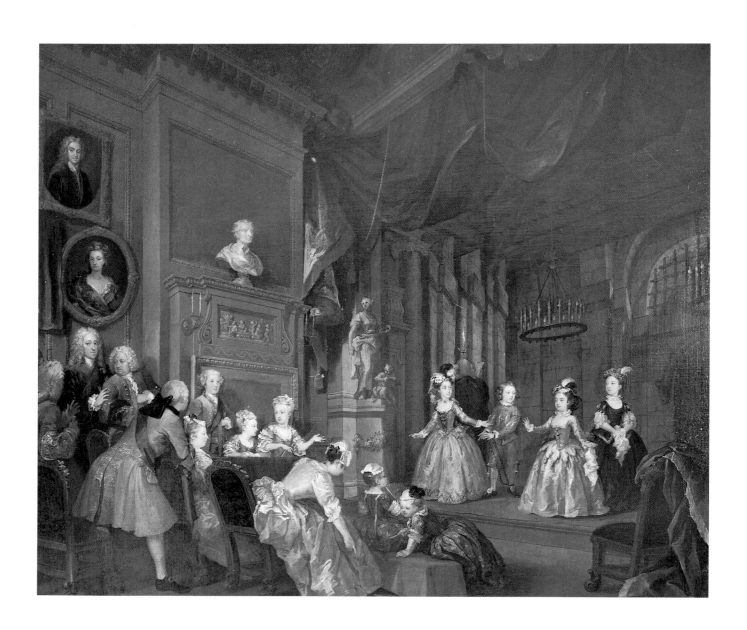

Throughout this study we have seen images of children that push at the boundaries of representing childhood, as it came to be understood across what can be termed the "long eighteenth century." Is a child acting, strictly speaking, as a child when he or she is shown with emblematic accoutrements, or does that child then take on larger significance for adult viewers remembering their own childhood? Is a child really a child when he or she engages in mimicking, and perhaps lampooning, adulthood? This is not to suggest the importance of artificial boundaries between the two—it is notoriously difficult for scholars to arrive at consensus concerning the ages at which childhood ends, adolescence begins, or adulthood itself is entered into. Rather, we must ask these questions in order to understand the outer limits of Georgian representations of childhood, limits that include child labor, for example, only when the child is poor or when the labor is part of Rousseau's natural world.

Beginning again with William Hogarth and his explorations of child playacting, his painting *Conquest of Mexico, Act IV Scene IV from Dryden's Indian Emperor* (figure 95) of 1732 to 1733, with literal playacting at its core, may be the greatest of his conversation pieces. Here a group of children performs John Dryden's elegant play of the same name before an audience of members of the royal family (including three of the king's children) and the high nobility in the house of John Conduitt, Master of the Mint,[1] where such a juvenile performance actually took place among these figures. The theme of the play, which is Hercules, is heroic but also suggests the choice facing children, a fictive one in reality but one that adults have often projected in terms of innocence and experience. Hogarth's composition, owing much to the French Rococo, is brilliantly contrived along a diagonal line to give equal weight to both performers and audience, and the format is perfectly suited to such a subject. The interplay of public and private and the presence of identifiable figures assuming costumes or roles within a realistic setting are all typical of the conversation piece, and are here adapted to a piece of mock theater. This world of children affords Hogarth the opportunity to depict what Ronald Paulson has called "the psychological ties linking various orders of experience"[2]—the real, the feigned (acted), the carved, and the painted. Hogarth seems to have thought of the picture as a kind of mock theater in itself, writing in *The Analysis of Beauty* that

> my Picture was my Stage and men and women my actors who were by Mean of certain Actions and express[ions] to Exhibit a dumb shew.[3]

The theatricality of the composition is thus also adapted to its content. The fact that the actors (players, after all) are children—and like Reynolds, Hogarth admired the natural mimicry of children[4]—only heightens the sense of acting.

Figure 95. William Hogarth, 1697–1764, *Conquest of Mexico, Act IV Scene IV from Dryden's Indian Emperor*, ca. 1732–33, oil on canvas, 51½ × 57¾ in. (130.8 × 146.7 cm), Private collection.

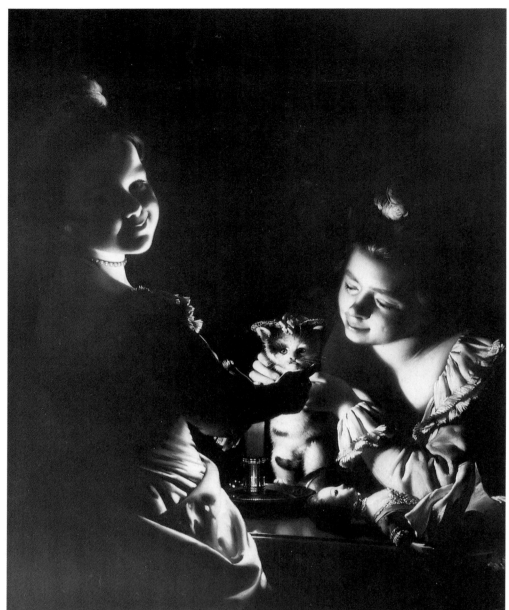

Figure 96. Joseph Wright of Derby, 1734–1797, *Two Girls Dressing a Kitten by Candlelight,* ca. 1768–70, oil on canvas, 35¾ × 28½ in. (90.8 × 72.4 cm), Private collection, courtesy of English Heritage.

The gestures of Hogarth's child players in *Conquest of Mexico* are mannered yet discreet, and it is at this point that we face a potent conundrum in the conservative form of the conversation picture. The rather adult characteristics of children such as these have traditionally been regarded as a denial of childhood. Yet Hogarth injects elements to suggest he is participating in a reevaluation of the child's nature and the development of a construct of childhood, notably in the inclusion of an inattentive child in the audience, oblivious of and turning his back on the play to retrieve something from the floor. Like the children playing in *The Cholmondeley Family* or the dog upsetting the tea table in *The Children's Party,* this child has the effect of subtly undermining the expected hierarchy, in which the child should be subordinated to the principal action, the play itself. In that sense, this child is not a child, for he betrays the common understanding of how a child was to "act" in society.

Hogarth returned to the childhood playacting theme in the series *The Four Times of Day* (painted in 1736 and engraved by 1738). In *Day,* he uses the figure of a little prig played off against a boy crying over a broken plate to lampoon the French Huguenots living in the London quarter facing St-Giles-in-the-Fields. In the artisan's

family of *Evening* of 1736, he shows a young girl bullying her brother into surrendering his gingerbread man in a transparent mockery of their parents' ignoble behavior, seen to the right. The adult male has been cuckolded by his wife, who bullies him just as the girl does. The mimicry suggests that children learn by imitating their parents, on occasion learning the lesson so well and so early as to possess characteristics somehow "unnatural" to such a young age.

The Frenchman Philip Mercier, in England by 1715, was concentrating on painting fancy pictures by 1737, under the influence of Chardin's "little pieces of common life,"[5] which he may have known from Paris. Mercier's *Playing Soldier (The Dog's Education)* (plate 49) of about 1744, also known as "Setting a Dog Sentinel" or "Playing at Soldiers," is one of the finest of these. The boy's action of play soldiering with the dog alludes, like Hogarth's *House of Cards,* to the boy's adult career. The dog, however, introduces a second level of mimicry, even mockery: the dog is taught to imitate the child's playacting which in turn is based on the child's observation of adulthood. The dog serves as a kind of symbol for the child's own education, which Mercier depicted in works such as *The Bible Lesson* or *Boy Reading to a Girl.* The common association of the boy with his dog appears again to underscore the sense that this playacting is entirely natural, unmediated by intellect. Wright of Derby regendered this kind of playacting years later with his

Two Girls Dressing a Kitten by Candlelight (figure 96) of 1768 to 1770, where the artist explores his customary interest in light effects in a scene in which the actors are now full-cheeked young girls and the play is their future maternal role. Wright of Derby has given these children a precocious self-consciousness happily absent in Mercier's painting, perhaps a result of the later age's increasing interest in sentiment.

Mercier returned to the theme of the child's mimicry with *The Young Artists* of about 1745, an image of three young boys engaged in artistic practice. One boy draws a sculpted head on the table, one stands watching him, and a third boy is seated sharpening his drawing pencil. At the far left, a putto on a square plinth provides a classical allusion, and in the right foreground a cello leaning against the table suggests that art and music are part of a child's education. A large painting of "Peace and Plenty" on the rear wall suggests that only in conditions of prosperity is artistic practice possible. *The Young Artists* serves the double purpose of deflating the pretensions of the artist and looking ahead, anticipating the children's future adulthood and to this degree negating childhood per se. It is this constant to and fro between observation of behavior of childlike simplicity and projection into adult modes of being that imparts much of the meaning to paintings of children of the 1730s and 1740s.[6]

Other artists, too, took up the theme of the juvenile artist. Hogarth's delicate drawing *Infants Copying*

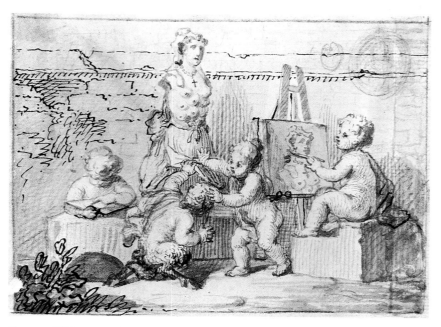

Figure 97. William Hogarth, 1697–1764, *Infants Copying Nature,* 1731, pencil and gray wash, touched with pen and black ink, 4 × 5½ in. (12.2 × 13.3 cm), The Royal Collection, © 1994 Her Majesty Queen Elizabeth II.

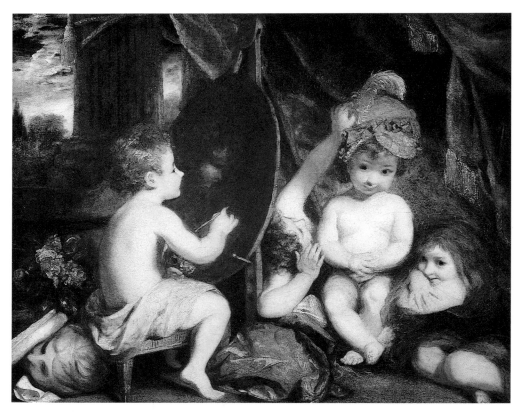

Figure 98. Sir Joshua Reynolds, 1723–1792, *The Infant Academy*, 1782, oil on canvas, 44⅞ × 56 in. (114 × 142 cm), The Iveagh Bequest, Kenwood–English Heritage.

Nature (figure 97) translates the theme to true infants, who have more the quality of putti than of children capable of the act of drawing. Yet they are engaged in "copying nature," an act of mimicry that suggests Hogarth's construct of the nature of the child itself. Reynolds's *The Infant Academy* (figure 98), exhibited at the Royal Academy in 1782 makes clear the notion of art as mimicry, with close antecedents in the school of Watteau and Francois Boucher, specifically Carle Van Loo's *Allegory of Painting* (Fine Arts Museums, San Francisco). While he retains the Rococo setting of drapery and columns and the nudity of the children in the Van Loo, Reynolds injects a more comic note into the scene, underlining the satirical edge to the infant artists and lampooning the contradiction between British artists' newfound ambitions and their still feeble situation. It is an act of mimicry that works on two levels: the child who apes the adult who in turn "copies" nature. The artists' model in the Van Loo could be a budding Venus, but in Reynolds she becomes, in Robert Rosenblum's words, "more hat than mythology,"[7] more mischievous than allegorical. One of the child artists even smirks at the viewer in an expression familiar from the figure of Lady Charlotte in Reyn-

olds's *Marlborough Family* (plate 4). In the rethinking of Reynolds's achievement in the generation after his death, *The Infant Academy* was admired as one of the "most exquisite specimens" among the works of "a less dignified but more generally pleasing nature," which is to say the fancy pictures.[8] By this time, the cult of Sensibility and the Romantic movement had reconditioned viewers to favor the works that sought to please over those that sought to elevate.

Even a painting as iconic as Gainsborough's *Blue Boy* (Huntington Library, San Marino) raises questions about the limits of childhood in Georgian art. This engaging image at first appears to be a portrait, one in which the boy is actually wearing an anachronistic costume, the Van Dyck dress that became a popular form of fancy dress (literally dress-up costuming) around 1730 and that later in the century was used to ally a boy's portrait with aristocratic modes.[9] Moodiness, melancholia, and contemplation were all associated with Van Dyck dress (owing to an eighteenth-century construct of Elizabethan malcontent), especially when the figure wearing it was posed out of doors. Already, a kind of playacting is going on with the boy, who wears the clothing of the previous

century for both visual and expressive purposes. William Seward takes the painting to another level of performance when he tells us about Gainsborough's motivation for this picture in a note in the *European Magazine* for August 1798:

> Gainsborough had seen a portrait of a boy by Titian for the first time, and having found a model that pleased him, he set to work with all the enthusiasm of his genius. "I am proud," he said, "of being in the same profession with Titian," and was resolved to attempt something like him.[10]

Gainsborough, then, is involved in a kind of playacting as well as painting a work with allusions to the Old Masters that might then hang comfortably in a collector's Old Master gallery. That the model for the *Blue Boy* was the son of an ironmonger in London's Soho only injects a third level of playacting, describing a boy who was at best middle class in terms of an aristocratic mode of representation. For all its later acclaim by nineteenth-century critics who successfully canonized the painting as one of the iconic statements of Georgian style, the *Blue Boy* seems to have gone unnoticed by critics for nearly twenty years after it was painted.[11]

Reynolds's painting *Master Crewe as Henry VIII* (plate 50) of 1775 to 1776 takes the question of performance, the child pretending to be something he is not, to another level. This is again the portrait of a known child, the then four-year-old son of the great Whig hostess Lady Crewe and the first Lord Crewe. Master Crewe is wearing the costume and has adopted the pose of Holbein's well-known portrait of Henry VIII, but the manifest absurdity of the pose is clearly present and serves to mock the pomposity of the monarch as well as the tyranny in the boy. The viewer is everywhere reminded that this is a young boy wearing fancy dress: the boy's dog sniffs at his leg and the unfamiliarity of the costume (in what Richard Wendorf has called a process of "defamiliarization"[12]); the boy's regular coat lies tossed over the seat of a chair to one side. Reynolds seems to have drawn on a number of sources for inspiration for *Master Crewe*. James Northcote relates that the scene derived from an incident in which Reynolds was directly observing the behavior of children. Northcote writes in his biography of Reynolds:

> Sir Joshua being in company with a party of ladies and gentlemen, who were viewing a nobleman's house, they passed through a gallery of portraits, when a little girl, who belonged to one of the party, attracted the particular attention of Sir Joshua by her vivacity and the sensible drollery of her observations; for whenever the company made a stand, to look at each portrait in particular, the child, unconscious of being observed by any one, imitated by her actions, the air of the head, and sometimes awkward effect of the ill disposed position of the limbs in each picture; and this she did with so much innocence and pure feeling, that it was the most just and incontrovertible criticism that could be made on the picture.[13]

Northcote's description is revealing on a number of points. First, he suggests that Reynolds based his picture on the behavior of a real child, although he has regendered the behavior. Second, he admits that the true worth of art can be perceived by even the most untrained, "natural" child, who points out the infelicities and pomposities of adult poses. Northcote even invokes the language of Sensibility—the girl is innocent and acts with "pure feeling"—to describe the girl's art criticism. Further, we are told elsewhere that the costume of Henry VIII was especially popular among adults for fancy dress parties at this time—the great chronicler of Georgian society Horace Walpole commented, "We have had a crowd of Henrys the Eighth and Wolseys" at a masquerade in 1770.[14] Holbein's *Henry VIII* itself figured in the most important eighteenth-century masquerade pattern book, Thomas Jeffery's *A Collection of the Dresses of Different Nations, Antient and Modern.* . . . The adult wit of Reynolds's *Master Crewe* is a more sophisticated version of the behavior he witnessed: he sends up the bloated pomposity of the monarch and Holbein's picture, the contemporary popularity of adult masquerade, the child's gift for mimicry, and his own borrowing from the Old Masters.[15] The multilayered masquerade theme was clearly acceptable to the patron, for Lord Crewe paid a hundred guineas for it in 1777.

Reynolds used the motif of the child in a sort of fancy dress in another sub-genre, paintings of the imagined childhoods of historical, religious, or mythological figures. His *Infant Jupiter,* for example, exhibited at the Royal Academy in 1774 but now destroyed and known only through J. R. Smith's mezzotint of 1775, presents a convincingly childlike Jupiter in the guise of a "sturdy young gentleman sitting in a doubtful posture."[16] The child seems suspicious of the weight of iconographic reference he is forced to carry, specifically the figure of the eagle perched above his head.[17]

Child Baptist in the Wilderness (figure 99) of about 1776[18] may be Reynolds's most compelling representa-

Figure 99. Sir Joshua Reynolds, 1723–1792, *Child Baptist in the Wilderness,* ca. 1776, oil on canvas, 49½ × 39⅞ in. (125.7 × 101.3 cm), The Minneapolis Institute of Arts, The Christina N. and Swan J. Turnblad Memorial Fund.

tion of the historical child, far from being merely the first of Reynolds's public incursions into the field of religious painting. This child is nearly nude in a vigorous pose of splayed legs and upraised arm, as if preaching, his hair tossed by the tempestuous wind and his own turbulent posture. The child Baptist's pose may derive from a number of sources, including similar adult subjects by Raphael, Guido Reni, and Guercino, here imposed on one of Reynolds's "beggar boy" models. It has been suggested that the boy's facial expression comes from Le Brun's *étonnement* (surprise) from the 1702 *Traité des passions.*[19] What seems surprising, however, is the passion injected into the young figure, whose costume is reminiscent of a child's loose swaddling. Allying this figure to that of the great preacher creates an odd disjunction between youth, wisdom, and passion, one that is both arresting and disturbing. It is somehow unfit for a

child, the unformed Rousseauian child, to adopt such a dynamic, committed posture.

The boundaries of childhood were most severely tested in depictions of a child's nascent sexuality. It is, after all, sexual awakening that tends to define the transition to adolescence, with sexual activity being a marker of adulthood. The presence of images in which childhood sexuality is suggested or explored is thus particularly meaningful, raising issues of control and coercion. One such image is Gainsborough's *Cottage Girl with Dog and Pitcher* of 1785 (plate 7), engraved by John Whessell in 1806 (figure 100). Here, the girl holds a broken pitcher in one hand, a commonly understood symbol for the loss of sexual innocence. In the other hand she holds a small puppy (which the model for the picture was apparently carrying when the artist encountered her on Richmond Hill), as a reminder that she is still a

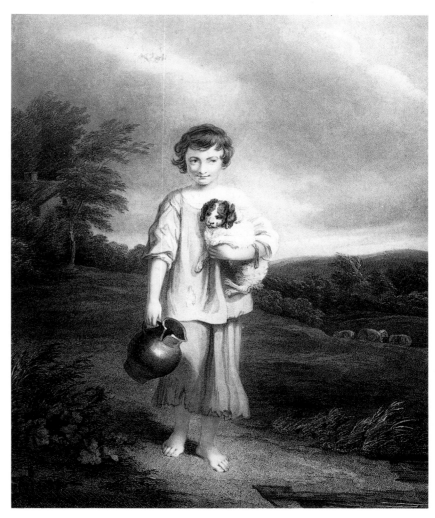

Figure 100. John Whessell, fl. 1760s, *The Young Cottager,* 1806, engraving after Gainsborough's *Cottage Girl with Dog and Pitcher,* 24¹³⁄₁₆ × 19¹¹⁄₁₆ in. (63 × 50 cm), Trustees of the British Museum.

child. More vividly than the French painter Greuze's depictions of young girls mourning the death of pet birds for similar symbolic purposes,[20] this girl is shown at the point of battling between childhood and sexual loss. Like Greuze's girls, however, she is sad not simply because she is poor and alone, but because she mourns the loss of innocence. In this way she is still related to Rousseau's construct of the innocent child. Yet it is suggestive, certainly, that this kind of sexual association should be projected onto a child. Is this what we are to think of when we see a child of, as here, perhaps ten? The point of the sexual loss is that it hasn't happened yet (just as death hasn't come for all the children seen earlier as *momento mori* or with *vanitas* references), but is projected onto her by a presumably sexually experienced painter or adult viewer. To engage in this projection is to lessen the "otherness" of the child, to somehow mediate the dis-

tance between the adult and the child, and to lessen her ability to maneuver as a child.

It is important to remember that while Gainsborough's creative imagination often demanded a live model (here the same model as in his *Girl with Pigs*), all of his painted images were carried out in the studio in a combination of the observed and the contrived that is closely related to contemporary poetry by figures such as Wordsworth.[21] Early critical response to the *Cottage Girl* was generally positive, one critic admiring it for a "pleasing naturalism,"[22] while Reynolds noted the "interesting simplicity and elegance"[23] characteristic of all of Gainsborough's cottage children. A generation later, response to the *Cottage Girl* was mixed. C. R. Leslie, in his *Handbook for Young Painters* of 1814, described it as "unequalled by anything of the kind in the world. I recollect it at the British Gallery, forming part of a very noble

assemblage of pictures, and I could scarcely look at or think of anything else in the rooms."[24] In the same year, William Hazlitt took quite a different position and critiqued it for "a regular insipidity, a systematic vacancy, a round, unvaried smoothness to which real nature is a stranger, and which is only an idea existing in the painter's mind."[25] Such a critique says as much about Hazlitt and his time as it does about the work itself. The language—insipidity, vacancy—suggests that for Hazlitt the *Cottage Girl* has failed the test of Sensibility. Its evident intent to play with the viewer's sentiment is neither as narrational as the images of Sensibility were to become in later years nor as representative of the cruelty in rural life evidenced in works by Mulready.

Reynolds, too, worked in this genre, in works such as the often reproduced *The Strawberry Girl* of 1773 (Wallace Collection, London). Again mixed with childhood sweetness and charm is the evidence of nascent sexuality in the guise of this waiflike girl gathering berries— commonly understood in Reynolds's time as an allusion to sexual awakening—in her apron.[26] Yet Reynolds's sitter is even younger than Gainsborough's cottage girl. Despite *The Strawberry Girl*'s obvious debts to Rembrandt in characterization, lighting, and technique,[27] Reynolds thought this to be one of the few truly original works of his career.[28] Others, such as the critic signing himself "Fresnoy" in the *Morning Chronicle* for 3 May 1773, admired it for its "*simple* knowledge of the art."[29] Sir Thomas Lawrence wrote Reynolds in praise of *The Strawberry Girl:*

> That magnificent display of impudent knowledge that kicks modesty out of the door, and makes you say, "Aye, let her go," has never been from my recollection or eyes since I saw it.[30]

Once again we have gone from a language emphasizing simplicity to one that suggests an immodest knowledge of childhood on the part of the artist.

Reynolds's early biographers have left numerous anecdotes describing his relationship with his child sitters. James Northcote records:

> He was for ever painting from beggars, over whom he could have complete command, leaving his mind perfectly at liberty for the purposes of study. Good God! how he used to fill his painting room with such malkins; you would have been afraid to come near them, and yet from these people he produced his celebrated pictures. When any of the great people came, Sir Joshua used to flounce them into another room until he wanted them again.[31]

Another source reports that it was Reynolds's custom

> on meeting a picturesque beggar in the street,—man, woman, or child—to send him or her to his house, to wait his leisure in a lower apartment: and in the intervals between his appointments he would order one of them into his painting-room to set for a fancy picture. . . . Northcote, who sat at work in the next room, would often hear the voice of a child, "Sir,—Sir,—I'm tired." There would be a little movement, another half hour would pass, and then the plaintive repitition, "Sir,—I'm tired."[32]

Each writer relates that Reynolds made use of poor models because they offered him greater control—he could literally fling them out when they became inconvenient. During the modeling, he could presumably manipulate them more effectively as well, asking them to pose in ways that would not be acceptable to his "great people." At the same time, the beggar offered the picturesque opportunities we have seen elsewhere. From these passages it is clear that Reynolds, like Gainsborough, preferred to paint even the fancy pictures from direct observation. The poor child offers the artist the greatest distance in terms of power relationships, a distance Reynolds made use of in refusing to acknowledge such a child's needs. Yet at the same time Northcote suggests that Reynolds was less put off by the poverty of these "malkins" than he imagines the reader would be. For Northcote there is still a sense of surprise that a celebrated canvas could come from such an undistinguished sitter.

Paintings such as Gainsborough's *Cottage Girl* and Reynolds's *Strawberry Girl* raise the question, at least for the modern viewer, of abuse. Certainly there was an awareness in the eighteenth century of child abuse as an evil, most frequently seen as a by-product of severe poverty.[33] Oliver Goldsmith discussed it in this light in his *An Enquiry into the Causes of the Encrease and Miseries of the Poor in England* (1738).[34] Despite the development of laws to protect children, there were famous cases of the abuse of apprentices, especially young girls, well into the nineteenth century. A special danger was seen to exist in apprenticing children at a great distance from home, a growing practice owing to the expanding industrial centers of the north of England. Catherine Cappe's report of 1805, *Observations on charity schools, female friendly societies, etc.,*[35] cites the notorious case of John Toms beating and abusing a fourteen-year-old girl apprentice, and another in which Toms kept a "black hole" in which he locked up parish apprentices. Cappe's report shows a genuine empathy for the child, but tells only of the abuse

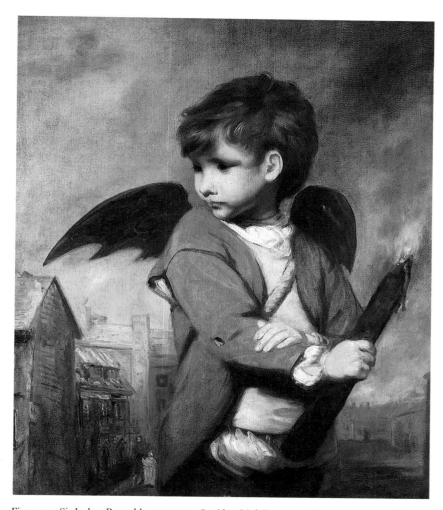

Figure 101. Sir Joshua Reynolds, 1723–1792, *Cupid as Link Boy,* 1774, oil on canvas, 30 × 25 in. (76.2 × 63.5 cm), Albright-Knox Art Gallery, Buffalo, New York, Seymour H. Knox Fund.

of lower-class children, usually as part of what might already be seen as a system of exploitation.[36] As for what constituted sexual abuse, we should recall that the age of consent was only twelve until 1871, and then it was only raised to thirteen. Not until 1885 was it raised to sixteen in an attempt to curb child exploitation and prostitution. Throughout the period of this study, then, sexual intercourse with a twelve-year-old would have been within the letter of the law, despite the fact that girls and boys of that age were seen, by the great majority of writers and artists looking at them, as children.

Two misunderstood fancy pictures by Reynolds bring the genre to its evident limits. The pair, *Cupid as Link Boy* and *Mercury as Cut Purse,* both of 1774, are perhaps the most sexualized representations of small children to be painted by a society artist of the first rank. Even they, however, have been seen simply as examples of masquerade and role-playing.[37] In the *Link Boy* (plate 8 and figure 101), a young boy of perhaps five or six car-

ries a torch, a London street scene in the background. His identity as a link boy (named by Reynolds himself) is imperative to a full reading of the picture, for link boys acted as torch-carriers to guide people through the unlit city streets of Georgian London. They were frequently associated in the public imagination with the more disreputable inhabitants of the streets, especially with prostitutes whose liaisons they would assist by guiding them home. Contemporaries understood the link boy as both an aid to and a victim of these sexual liaisons, yet the link boy was also well known as a thief, victimizing those who might victimize him.

Reynolds was not the first to memorialize the link boy. The boy's association with sexual encounters goes back at least as far as a poem of 1680 by the satiric poet Lord Rochester entitled "The Disabled Debauchee," written as a memoir of an old man of his past exploits, a story to fire the blood of "some cold-complexioned sot." Rochester writes:

Figure 102. John Dean, 1750?–1798, *Mercury as Cut Purse,* 15 August 1777, engraving after Reynolds, 15½ × 10¹³⁄₁₆ in. (39.5 × 27.5 cm), Trustees of the British Museum.

Nor shall our love fits, Chloris, be forgot
When each the well-looked link-boy strove t'enjoy,
And the best kiss was the deciding lot
Whether the boy fucked you, or I the boy.[38]

Lord Rochester may well have been the most explicit writer on sex before the twentieth century, and it is unlikely that Reynolds, in painting the *Link Boy,* would have wished to be connected with him, but the relationship of link boy to sex—here bisexual—is clear. Reynolds was not the first to offer a visual representation of a link boy, for L. P. Boitard had included a link boy in his satirical engraving of London street life, *The Covent Garden Morning Frolic* of 1747.[39] In the work by Boitard, however, the figure was quite homely, even maimed, and was small and incidental. Reynolds has brought his link boy right to the front of the picture plane in the monumentalizing technique we have seen used before to great effect (even in *Master Hare*). The most extraordinary change he has made, however, is in making the child so young. Surely this boy, many years before adolescence, would

have been seen as an inappropriate participant of any kind in a sexual liaison. Yet the sexual element is suggested throughout Reynolds's picture: in the erect shape of the boy's torch, the lewd gesture he makes with his arm, and the act of two cats engaged in a mating dance on a distant rooftop. The boy is, after all, named for the mythological intermediary of love.

In both this remarkable picture and its companion, *Mercury as Cut Purse* (plate 51), Reynolds is playing on traditional associations of the gods and classical subjects, all the while bringing them down to the earthiness of observed eighteenth-century urban life. Mercury was a messenger as well as the god of commerce; he was often depicted with a money bag. In *Mercury as Cut Purse* and the John Dean engraving after it (figure 102), Reynolds's Mercury holds his purse limply,[40] so that the two pictures become a kind of before and after pair, an infantine sexual progress from the erect to the pendulous. It seems probable, too, that Georgian viewers would have understood the meaning of the works without decoding (hav-

ing been prepared by Hogarth's works on the before and after theme),[41] although it should be stressed that these were fundamentally private pictures. Both were purchased and, in all probability, commissioned by the Duke of Dorset, widely known in his day for his disreputable and extravagant private life[42]—as well as being one of Reynold's most adventurous patrons.

Finally, pictures such as these must be seen as part of the broader desire to control this new construct of childhood—not, of course, one construct but many—and children themselves. The closer family ties of the eighteenth century ultimately fostered more social contradictions—in the form of adult supervision and repression—seen as individual conflicts by children themselves.[43] Closer proximity, whether within the family or in a larger societal context as Britain verbally and visually embraced its children, ingrained more deeply conflicting feelings of love and hate—the paradox of childhood. Kirsten Drotner has argued that "the historical development of childhood and youth at once fostered a gendered individualism and jeopardized its means of autonomous expression."[44] An emphasis on childhood inevitably focused on the development of individuality, which then became a threat against family and even social solidarity—especially when Rousseau advocated avoidance of social institutions. From this perception stemmed a desire to control children and in particular juvenile sexuality, evidenced as early as 1710 with a violent antimasturbation movement. As J. H. Plumb has put it, children "were to stay firmly in Eden with their hands off the apples and deaf to the serpents."[45] The controlling urge peaked with the reassertion of family over individuality in the nineteenth century, at a time when the cult of childhood was seemingly at its height. Even to depict juvenile sexuality was in some measure to control it, in the relationships of power between parent/adult and child.[46]

Child care manuals, educational treatises, and many of the visual representations of children from the eighteenth century participated in a discussion about control of the child's body and his or her sexual expression—a discussion that was often disguised in religious terms and not necessarily in conflict with domesticity. Control, stemming (like much of the innovation we have seen concerning childhood) from a middle-class desire to underline its separateness from the masses, ultimately emphasized the separateness of the adult from the child as well. Adults became serious while the new construct

made children childish. In the Victorian period, sentiment concerning childhood grew in direct response to frightened reactions in the face of urbanization, utilitarianism, and industrialization, an apprehension present as early as the 1770s. A dread of adulthood emerged that simultaneously embraced childhood, drawing children physically near, and insisted on its separateness. Perhaps this is what Wordsworth had in mind when he savagely attacked his contemporaries for having engendered a "monster birth," inventing a child who was not a child but a "dwarf Man."[47]

The history of the Godwin family offers a case study in issues of controlling childhood. As part of the English Radical movement, William Godwin focused on radical individualism and targeted the family, advocating weaker nuclear families whose role was entirely spiritualized.[48] Godwin's *Enquiry Concerning Political Justice* of 1793 was an unequivocal attack on the family as standing in the way of wider moral sympathies. The impact of the French Terror aside, most Radical adherents gave up the attack on the family when they married. This was also true of Godwin. His marriage to Mary Wollstonecraft, who died giving birth to the future Mary Shelley, led him to say that men would do more good generally by devoting themselves to their wives and children. When Mary Shelley eventually went looking for a school for her own son, someone suggested that it should be one in which he would be free to think for himself. "To think for himself," Shelley replied. "Oh my God, teach him to think like other people!"[49]

The texts we have examined, both literary and visual, speak then to the instruments of control in both social relations (gender, class, age, and race) and social structures (family, school, leisure, and the adult world). The resultant construct of childhood innocence[50] finally says more about the projection of something called childhood by adults than it does about the lived experience of children in Georgian Britain. Values may have changed, but the actual treatment of children may not have improved—perhaps only more guilt was felt about that treatment—with important ramifications for how we look at, talk about, and treat children at the close of the twentieth century.

Notes

Chapter 1

1. Jean-Jacques Rousseau, *"Les Rêveries du promeneur solitaire"* in *Oeuvres complètes* (Paris: Editions Gallimard, 1959), 1:1088. Translations are my own.

2. Ibid., 1089.

3. Ibid., 1087.

4. Entry for 8 January 1763 in Frederick A. Pottle, *Boswell's London Journal 1762–1763* (New York: McGraw-Hill, 1950), 129.

5. William Wordsworth, *The Complete Poetical Works of William Wordsworth* (New York: Crowell, 1902), 405.

6. See on this subject Iain Pears, *The Discovery of Painting: The Growth of Interest in the Arts in England, 1680–1768* (New Haven and London: Yale University Press, 1988).

7. One may well add that an interest in individual psychology was not the watchword of most figurative art before the eighteenth century, especially in the emblematic nature of most religious works.

8. It is worth remembering that many paintings of the Madonna and Child exhibit a greater sense of familial interaction than do many contemporary family portraits.

9. By this I mean they receive the greatest degree of attention from the artist, are the central focus of whatever narrative interest the work may reveal, or are invested with meaning apart from the purely symbolic.

10. Mary Frances Durantini, *The Child in Seventeenth-Century Dutch Painting* (Ann Arbor, Mich.: UMI, 1983); Simon Schama, *The Embarrassment of Riches: An Interpretation of Dutch Culture in the Golden Age* (London: William Collins Sons, 1987), especially Chapter Seven, "In the Republic of Children."

11. Schama, *The Embarrassment of Riches*, 483.

12. Ibid., 481–561.

13. Suggested by Lawrence Stone, *The Family, Sex and Marriage in England 1500–1800* (London: Weidenfeld & Nicolson, 1977), 70. In Chapter Three, we will examine the role of child mortality in eighteenth-century British life and art.

14. It is unclear to what extent artists of this time were concerned with concepts of "character" as revealed through a painted portrait; its application to children would have therefore been immaterial.

15. H. W. Janson, *A History of Art* (London: Thames & Hudson, 1962), 375.

16. For a brief discussion of the identity of the sitter in this painting, and thus of her role as mother, see John Walker, *The National Gallery of Art, Washington* (New York: Abrams, 1982), 224.

17. Velázquez's *Las Meninas* falls outside these areas as it was not widely known outside Spain until the nineteenth century; the first known English or French engraving of it seems to date from 1799.

18. Previously attributed to Thomas Hill (1661–1734).

19. A tradition of unknown origin suggests that she entered Reynolds's studio wearing the attire seen in this picture while Reynolds was painting her brother, Charles, and that he insisted on painting her as well.

20. Quoted in National Gallery of Art, *The Treasure Houses of Britain* (New Haven: Yale University Press, 1985), 532.

21. This new meaning has been entirely overlooked by a number of past critics, including Sacheverell Sitwell who wrote that "in compensation, as if to placate the father and mother for the fidgeting and interruption, Hogarth has painted a pair of cupids above their heads playing with a tassel and pulling back a curtain." See *Conversation Pieces: A Survey of British Domestic Portraits and Their Painters* (London: Batsford, 1936), 14.

22. Royal Academy of Art, *Reynolds* (London: Royal Academy of Art, 1986), 279.

23. See Frederic G. Stephens, *English Children as Painted by Sir Joshua Reynolds* (London: Seeley, Jackson & Halliday, 1867), 11.

24. A taste for domestic portraiture at court can be identified much earlier—as in the work of Knapton—but this is outside the scope of this study.

25. The room is identified as the Centre Room or Crimson Boudoir at Buckingham House; see Oliver Millar, *The Queen's Pictures* (London: Weidenfeld & Nicolson, 1977), 229, n. 4.

26. See the diary entry by Lady Charlotte Finch in O. Hedley, *Queen Charlotte* (London: John Murray, 1975), 83–84.

27. Here I exclude emblematic paintings of more strictly religious meaning, such as paintings of the Christ Child, as these have been mentioned previously.

28. Grand Palais, *Chardin 1699–1779* (Paris: Grand Palais, 1979), 230. Rosenberg's identification allows the child to belong to a lower economic class than would be the case if the attendant was a nurse or governess. This also emphasizes the idea of education as taking place within the family.

29. See Royal Academy, *Reynolds,* 264.

30. In Yale Center for British Art, *The Pursuit of Happiness: A View of Life in Georgian England* (New Haven: Yale Center for British Art, 1977), 4.

31. We will see other documentary evidence for this type of wet-nursing establishment in Chapter Three, suggesting the accuracy of Morland's image in relation to contemporary wet-nursing practices.

32. Anita Brookner, *Greuze: The Rise and Fall of an Eighteenth-Century Phenomenon* (London: Elek, 1972). Rosenblum, in *The Romantic Child,* sees Greuze, mistakenly I believe, along with Chardin and Vigée-Lebrun as the greatest proponents of "authentic childhood."

Chapter 2

1. See Philippe Ariès, *L'Enfant et la vie familiale sous l'ancien régime* (Paris: Editions du Seuil, 1973); Stone, *The Family, Sex and Marriage;* and Ivy Pinchbeck and Margaret Hewitt, *Children in English Society,* 2 vols. (London: Routledge and Kegan Paul, 1969, 1973); and many others. In art historical studies, this is the point of view that has been accepted unquestioningly by Carol Duncan in articles bearing titles such as "Happy Mothers and Other New Ideas in French Art."

2. Ariès, *L'Enfant et la vie familiale,* ii.

3. See especially Pollock, *Forgotten Children.*

4. Summarized by Linda Pollock, *A Lasting Relationship: Parents and Children over Three Centuries* (Hanover, New Hampshire, and London: Fourth Estate, 1987), 11.

5. For this I am much indebted to Pollock's work in gathering documentary evidence from a wide number of historical voices.

6. Ariès argues that family size was quite large, believing that the extended family existed only in the minds of moralists like Alberti and in certain Mediterranean areas. The idea of the extended family is advanced by Stone and others.

7. "Il ne sortait pas d'une sorte d'anonymité," Ariès, *L'Enfant et la vie familiale,* ii.

8. Pollock, *A Lasting Relationship,* 12.

9. Ibid. Ariès argues, conversely, that from circa 1700 the family began to limit the number of children so as to focus their energies and resources on the survival of children already born. Mistakes over changes in family size led Anita Schorsch in *Images of Childhood: An Illustrated Social History* (New York: Mayflower Books, 1979) to argue that changes in the representation of children were because of a reorganization away from the extended family.

10. See Albert Boime, *Art in an Age of Revolution 1750–1800* (Chicago: University of Chicago Press, 1987), 20. Later chapters will explore what is "private" about images of family life.

11. See Pollock, *A Lasting Relationship*, 12.

12. Stone suggests that childhood mortality fell after 1750, citing a death rate in 1764 of 49 percent by age two and of 60 percent by age five.

13. Pollock, *A Lasting Relationship*, 19. While Pollock criticizes Stone for relying excessively on statistical evidence, it is important to establish both actual mortality rates *and* parental attitudes toward the death of a child or a mother in childbirth.

14. Alastair Smart, *The Life and Art of Allan Ramsay* (London: Routledge & Kegan Paul, 1952), 48.

15. Ibid., 63.

16. James Northcote, *The Life of Sir Joshua Reynolds, comprising original anecdotes of many distinguished persons, his contemporaries; and a brief analysis of his discourses*, 2nd ed. (London: Colburn, 1819), 1:7.

17. D. E. Williams, *The Life and Correspondence of Sir Thomas Lawrence, Kt.* (London: Henry Colburn & Richard Bentley, 1831), 1:31.

18. Pollock, *A Lasting Relationship*, 21.

19. This issue will be addressed in depth in Chapter Five, "The Child Learns."

20. Northcote remarks that the once-fashionable doctrine that "Hell was paved with infants' skulls" was objected to by late eighteenth-century women. See William Hazlitt, *Conversations of James Northcote, R.A.*, ed. Edmund Gosse (London: Henry Colburn & Richard Bentley, written 1830, published 1894), 64.

21. Edmund Malone, *The Works of Sir Joshua Reynolds*, 4th ed. (London: T. Cadell, 1809), 1:lxxxviii.

22. Ibid.

23. Frances Boscawen, *Admiral's Wife*, ed. Cecil Aspinall-Oglander (London and New York: Longmans, Green, 1940), 28.

24. Brian FitzGerald, *Emily Duchess of Leinster 1731–1814: A Study of her Life and Times* (New York and London: Staples Press, 1949), 28–29.

25. See David Dabydeen, *Hogarth's Blacks* (Kingston-upon-Thames, Surrey: Dangaroo, 1985), 34.

26. Hogarth uses the typical device of a curtain at the right, perhaps derived from looking at Van Dyck, to remind the viewer of the stagelike quality of the conversation piece. At the same time, the curtain was also merely a convention of the genre, so whether Hogarth intended it to be a pointer of artifice is a question of interpretation.

27. Watteau visited London in 1719 to 1720 to consult Dr. Richard Mead, physician to George II, and to promote the sale of his works in London. By the time Watteau returned to France, two of his paintings were in Mead's collection, which was open to visitors. We also know from the posthumous sale of Hogarth's art collection that he owned several engravings after Watteau. See Frederick Antal, *Hogarth and His Place in European Art* (London: Routledge & Kegan Paul, 1962), 35, and "Mrs. Hogarth's Collection," *The Burlington Magazine* 84 (October 1944), 237–39.

28. When Hogarth was commissioned to paint George II and his family, Hogarth was only allowed to paint the Duke of Cumberland from life—the others were carried out from second-hand sources. Even so, this marked the height of Hogarth's social success. See Antal, *Hogarth and His Place*, 39, and Ronald Paulson's discussion of Hogarth's difficulty with patrons in *Hogarth: His Life, Art, and Times* (New Haven and London: Yale University Press, 1971), 1:423–64.

29. See Venice, Fondazione Cini, *William Hogarth: Dipinti, disegni, incisione*, ed. Alessandro Bettagno, catalogue by Mary Webster (Vicenza: Neri Pozza Editore, 1989).

30. Elizabeth Einberg, exhibition review in *The Burlington Magazine* 130 (November 1988), 798–99.

31. See Robert A. Wark, "A Note on Van Dyck's Self-Portrait with a Sunflower," *The Burlington Magazine* 98 (February 1956): 53–54, and J. Bruyn and J. A. Emmens, "The Sunflower Again," *The Burlington Magazine* 99 (March 1957): 96–97.

32. John Bunyan, *A Book for Boys and Girls* (London, 1686).

33. Richard Wendorf, "Hogarth's Dilemma," *Art Journal* 46 (Fall 1987): 205.

34. William Hogarth, *The Analysis of Beauty with the rejected passages from the manuscript drafts and autobiographical notes*, ed. Joseph Burke (Oxford: Oxford University Press, 1955), 141.

35. For full details, see Eileen Black, *Irish Oil Paintings 1572–c. 1830*, A Catalogue of the Permanent Collection, 3 (Belfast: Ulster Museum, 1991): 46–48.

36. O. F. Christie, ed., *The Diary of Reverend William Jones, 1777–1821* (London: Brentano's, 1929), 2:97.

37. It would be surprising if Jones were to admit directly to these feelings in a diary entry, but such a tone does not even enter indirectly.

38. David Bindman, *Hogarth* (London: Thames & Hudson, 1981), 142.

39. Sara Coleridge, *Memoirs and Letters of Sara Coleridge, Edited by Her Daughter* (London: H. S. King, 1873) 1:4–5.

40. Geoffrey Keynes, ed., *The Letters of William Blake* (Oxford: Clarendon Press, 1980), 9.

41. Blake, *Four Zoas* (London; New York: Oxford University Press, 1913), 9.121.9–10.

42. Among the vast literature on Wordsworth, see, for example, Jonathan Wordsworth, *William Wordsworth: The Borders of Vision* (Oxford: Clarendon Press, 1982); and Heather Glen, *Vision and Disenchantment: Blake's Songs and Wordsworth's Lyrical Ballads* (Cambridge: Cambridge University Press, 1983).

43. Letter to James Unwin reprinted in Mary Woodall, *Thomas Gainsborough, His Life and Work* (London: Phoenix House, 1949), 18.

44. Quoted in William Cotton, *Sir Joshua Reynolds and His Works: Gleanings from his diary, unpublished manuscripts, and from other sources* (London: Longman, Brown, 1856), 107.

45. See, for example, a review by "The Ear-Wig" claiming that Reynolds "is never more successful than in his children," quoted in Cotton, *Sir Joshua Reynolds*, 156.

46. Hazlitt, *James Northcote*, 108.

47. The contemplative *Charles William Lambton* should also be seen in relationship to Wright of Derby's masterful portrait of the Rousseauian dreamer Brooke Boothby in a landscape setting.

48. *The Morning Herald* (London) 3 May 1825.

49. An unnamed critic quoted in D. E. Williams, *Sir Thomas Lawrence, Kt.*, 366.

50. Ibid., 363.

51. Ibid., 334. Williams also provides charming details of the Calmady girls' sittings, 334–35.

52. Quoted in Nadia Tscherny, "Beyond Likeness: Late Eighteenth Century British Portraiture and Origins of Romanticism" (Ph.D. diss., New York University, 1986), 233.

53. And many others, such as Edwin, the often-illustrated boy hero of James Beattie's *The Minstrel; or, The Progress of Genius* (London: E. C. Dilly, 1771).

54. Two other nieces lived with Reynolds through the 1770s, one eventually running his household from about 1777 on.

55. F. W. Hilles, ed., *Letters of Sir Joshua Reynolds* (Cambridge: Cambridge University Press, 1929), 54–55, letter 39.

56. Ernest Fletcher, ed., *Conversations of James Northcote R.A. with James Ward on Art and Artists* (London: Methuen, 1901), 78.

57. In W. T. Whitley, *Artists and Their Friends in England 1700–1799* (London and Boston: Medici Society, 1928), 1:369.

58. Malone, *Works of Sir Joshua Reynolds*, 1:xvi.

59. Fletcher, *Conversations*, 185–86.

60. To Thomas Harvey, n.d., in Mary Woodall, ed., *The Letters of Thomas Gainsborough* (London: Cupid Press, 1963), 71.

61. George C. Williamson, *George Morland: His Life and Works* (London: George Bell & Sons, 1904), 49, although his sources were Collins's 1805 *Life*, Blagdon's 1806 *Authentic Memoirs*, and Dawe's 1807 *Life*.

62. Quoted in Johann Caspar Lavater, *Aphorisms on Man*, (London: J. Johnson, 1789), E589.

63. Boscawen, *Admiral's Wife*, 207.

64. In William Hayley, *The Life of George Romney, Esq.* (Chichester and London: T. Payne, 1809), 201.

65. Margaret Woods, *Extracts from the Journal of the late Margaret Woods, from 1771 to 1821* (London, 1829), 85.

66. Should we find Ramsay's portrait surprising, he was not alone in the impulse. Thinking of the deaths of his wife, Princess Charlotte, and of their child in childbirth, Prince Leopold exclaimed in 1816, "My grief did not think of it, but if I could have had a drawing of it!" Quoted in George Somes Layard, ed., *Sir Thomas Lawrence's Letter-Bag* (London: George Allen, 1906), 111.

67. This drawing, now in the British Museum, seems to be a preparatory study for the youngest child in Hogarth's painting *The Graham Children*, a child that died before the painting was carried out.

68. *Emblems of Mortality* (London: T. Hodgson, 1789).

69. Discussed in Richard Wendorf, *The Elements of Life: Biography and Portrait-Painting in Stuart and Georgian England* (Oxford: Clarendon Press, 1990), 18–19.

70. James Granger, *Biographical History of England* (London: T. Davies, 1769), 3:325.

71. Wendorf, *The Elements of Life*, 10.

72. Quoted in Cotton, *Sir Joshua Reynolds*, 36.

73. From the *Idler*, no. 45, 1759, reprinted in W. J. Bate, ed., *Samuel Johnson: The Idler and Adventurer* (New Haven: Yale University Press, 1963), 140, and in Northcote, *Life of Reynolds*, 1:239, with minor variations. This is a view derived from Jonathan Richardson in his "An Essay on the Theory of Painting" from 1715 in *Works* (1792 edition), 6:78–79.

74. Whitley, *Artists and Their Friends*, 1:396.

75. Quoted in William T. Whitley, *Thomas Gainsborough* (London: Smith, Elder & Co., 1915), 76.

76. Jane Austen, *Persuasion* (London, 1815; reprint, New York: Hill & Wang, 1978).

77. Quoted from John Thomas Smith in Tate Gallery, *Thomas Gainsborough* (London: Tate Gallery, 1982), 29.

78. Sir Joshua Reynolds, Fourth Discourse in *Discourses on Art*, ed. Robert R. Wark (New Haven: Yale University Press, 1970), 70.

79. Wendorf, *The Elements of Life*, 17.

80. Reynolds, Third Discourse in *Discourses*, 41.

81. We will see that the very concept of intimacy changed over the period, from Devis's emblematic interior settings to Reynolds's heroically sized children.

82. Reynolds, Fourth Discourse in *Discourses*, 57–58.

83. Northcote, *Life of Reynolds*, 1:243.

84. Discussed in Tscherny, "Beyond Likeness." Ellis K. Waterhouse suggests that this change, from dignity to character, took place about 1755; see "English Painting and France in the Eighteenth Century," *Journal of the Warburg and Courtauld Institutes* 15 (1952): 122–26.

85. Hazlitt, *James Northcote*, 14 (emphasis mine).

86. Fletcher, *Conversations*, 215.

87. Quoted in Whitley, *Artists and Their Friends*, 1:370.

88. Letter of 13 April 1771 to the Earl of Dartmouth, in Woodall, *The Letters of Thomas Gainsborough*, 51, letter 17.

89. Quoted in Ralph Wornum, ed., *Lectures on Painting by the Royal Academicians. Barry, Opie and Fuseli* (London: H. G. Bohn, 1848), 257. Such sentiments are familiar in academic writing from Renaissance Italy or seventeenth-century France, but it is Opie's concern with character and sentiment that interests me here.

90. Northcote, *Life of Reynolds*, 1:242.

91. This, representatively, is the phrasing of M. L. D'Otrange-Mastai in "'Simplicity and Truth'—Reynolds, Painter of Childhood," *Apollo* 65 (June 1957): 201.

92. William Gilpin, *Three Essays: On Picturesque Beauty; on Picturesque Travel; and on Sketching Landscape*, 2nd ed. (London: R. Blamire, 1794), 8. This book was first published in 1792, but it was written before 1776.

93. Malone, *Works of Reynolds*, 1:xxiv.

94. Whitley, *Gainsborough*, 71.

95. Anthony Pasquin [John Williams], *Memoirs of the Royal Academicians* (London: H. D. Symonds, P. McQueen, and T. Bellamy, 1796), 66–67.

96. Pasquin, *Memoirs*, 67–68.

97. Ibid., 115.

98. Ibid., 12.

99. Quoted in Lady Victoria Manners and Dr. G. C. Williamson, *Angelica Kauffmann, R.A., Her life and her works* (London: John Lane, 1924), 47.

100. Lavater was a friend of Fuseli's in Switzerland.

101. Johann Caspar Lavater, *Essays on Physiognomy* (London: John Murray, 1789).

102. Hogarth, *The Analysis of Beauty*, 136–37.

103. Ibid., 142.

104. Reynolds, Fourth Discourse in *Discourses*, 61.

105. Hazlitt, *James Northcote*, 179.

106. Ibid., 63.

107. Henry Fuseli in *Analytical Review* 20 (November 1794): 264–65.

108. John Knowles, ed., *Life and Writings of Henry Fuseli* (London: H. Colburn and R. Bentley, 1831), aphorism 45.

Chapter 3

1. Sitwell wrote in *Conversation Pieces* that "in compensation, as if to placate the father and mother for the fidgeting and interruption, Hogarth has painted a pair of cupids above their heads playing with a tassel cord and pulling back a curtain" (p. 14). Even allowing for the missed iconographic meaning of the putti, it is difficult to read this as "compensation" for the playful boys.

Much later, Rosenblum suggests in *The Romantic Child* that "children who squirm within the confines of adult decorum" (p. 13) are not to be found in European painting until very late in the eighteenth century.

2. Ronald Paulson, *Popular and Polite Art* (West Bend: Notre Dame University Press, 1979), 63.

3. All of the figures are identified in Mannings's catalogue entry in Royal Academy, *Reynolds*, 164–65.

4. Cotton, *Sir Joshua Reynolds*, 135.

5. Quoted by Mannings in Royal Academy, *Reynolds*, 281.

6. *The General Evening Post* (London), Saturday, 25 April–Tuesday, 28 April 1778, 2.

7. *The Public Advertiser*, (London), Saturday, 25 April 1778, 3.

8. Quoted in Cotton, *Sir Joshua Reynolds*, 222.

9. Curatorial files for this painting at the Dulwich Picture Gallery suggest that this man is not the father but another servant, but I find this reading unconvincing.

10. Details on the Edwardses' marriage are to be found in Paulson, *Hogarth*, 1:334–35.

11. Sold at Christie's, London, 17 November 1989, for a record-setting price for a Zoffany, and now jointly owned by Agnew's and Leger Galleries, London.

12. [Roger Shanhagan], *The Exhibition, or a second anticipation: being Remarks on the principal Works to be Exhibited next Month, at the Royal Academy* (London: Richardson and Urquhart, 1779), 47.

13. *Morning Chronicle* (London), Friday, 25 April 1777.

14. *General Advertiser* (London), April 1777.

15. Yale Center for British Art, *Pursuit of Happiness*, 4.

16. Elisabeth Badinter, *L'Amour en plus* (Paris: Flammarion, 1980), 168, translated as *The Myth of Motherhood* (London: Souvenir Press, 1981).

17. Lloyd De Mause, *The History of Childhood* (New York: Psychohistory Press, 1974), 52.

18. Stone, *The Family, Sex and Marriage*, 405.

19. Jay Mechling, "Advice to historians on advice to mothers," *Journal of Social History* 9 (fall 1975), 44–63.

20. Geoffrey Scott and Frederick A. Pottle, eds., *The Private Papers of James Boswell from Malahide Castle in the Collection of Lt Colonel Ralph Heward Isham* (New York: privately printed, 1928–34), 10:235–36.

21. Melesina Trench, *The Remains of the Late Mrs. Richard Trench,* ed. The Dean of Westminster (London: Parker, Son & Brown, 1862), 16.

22. Lady Elizabeth Foster [the Duke's mistress] to a Parisian banker, 27 May 1790, Hervey MSS Acc. 941/58/1, West Suffolk Records Office.

23. Judith Schneid Lewis, *In the Family Way: Childbearing in the British Aristocracy, 1760–1860* (New Brunswick: Rutgers University Press, 1986), 53.

24. Frances Lady Morley to her sister-in-law Mrs. Villiers, 6 April 1810, Morley Papers, Add. MSS 48233, British Museum, London.

25. Boscawen, *Admiral's Wife,* 54.

26. Lord Morley to the Hon. Mrs. Villiers, 22 October 1809, Morley Papers, Add. MSS 48227, British Museum, London.

27. Pollock, *A Lasting Relationship,* 53. There are many examples of parents from lower classes who used wet nurses, including those of Thomas Lawrence, who was put out to nurse.

28. Chatsworth MSS, V, 516.

29. See, for example, Robert Cleaver, *A godlie forme of householde government* (London, 1598).

30. William Cadogan, *An essay upon nursing, and the management of children from their birth to three years of age* (London: J. Roberts, 1748), 15. Paulson, in *Popular and Polite Art,* goes so far as to suggest, mistakenly, I believe, that Cadogan single-handedly "registered or brought about" (p. 172) a transformation in child rearing, although Cadogan's importance is undeniable.

31. Cadogan, *An essay upon nursing,* 24.

32. Christian August Struve, *A Familiar Treatise on the Physical Education of Children* (London: Murray and Highley, 1801), 211.

33. Of 27 diaries consulted by Pollock in *Forgotten Children,* 213, thirteen parents breastfed, nine wet-nursed (three others mention a nurse but don't specify who did the feeding), and five tried both.

34. See, for example, Elizabeth Bishop, unpublished diary, no. S83, The Friends' Society Library, London, entry for 3 April 1787, where she writes that her second baby, one week old, was "brave & very quiet considering she has no brest."

35. Scott and Pottle, *The Private Papers of James Boswell,* 10:257.

36. Earl of Ilchester, ed., *The Journal of Elizabeth Lady Holland 1791–1811* (London: Longmans, Green & Co., 1909), 1:136.

37. Stanbury Thompson, ed., *The Journal of John Gabriel Stedman* (London: The Mitre Press, 1962), 5.

38. See Stanley Gardner, *Blake's Innocence and Experience Retraced* (London: Athlone Press, 1986), 6.

39. Ibid., 7.

40. Sarah Pennington, *Letters on Different Subjects,* 4th ed. (London, 1770), 3:123; 4:12.

41. Betty Bishop diaries, 4 March 1787, MS S.83, The Friends' Society Library, London.

42. See Royal Academy, *Reynolds,* 393.

43. Mrs. Vernon Delves Broughton, ed., *Court and private life in the time of Queen Charlotte: being the journals of Mrs. Papendiek, assistant keeper of the wardrobe and reader to her Majesty* (London: Richard Bentley & Son, 1887), 1:229.

44. John Stedman bought them for his child at eight and a half months; the child began walking at fifteen and a half months, and the strings were used until twenty-eight months.

45. Leading strings seem to have been largely symbolic on most girls' frocks from the 1760s.

46. Evidence such as this leads Phillis Cunnington and Anne Buck, in *Children's Costume in England: From the Fourteenth to the End of the Nineteenth Century* (London: Faber & Faber, 1965), 103, to conclude that the movement against swaddling owes more to Locke than to Rousseau.

47. Samuel Richardson, *Pamela, or Virtue Rewarded* (London: A. Dodd, 1740–41).

48. Cadogan, *An essay upon nursing,* 7.

49. The full title is *On the Rearing and Treatment of Children in Their First Years of Life; A Handbook for all Mothers Who Care in Their Hearts for Their Children's Health* (London, 1801–1803).

50. Amelia Steuart Diary, MS no. 983, fol. 95, The National Library of Scotland, Edinburgh.

51. Frances Burney, *Diary and Letters of Madame D'Arblay,* ed. C. F. Barrett (London: H. Colburn, 1854), 6:79.

52. Ibid., 6:91.

53. Edward Hall, ed., *Miss Weeton, Journal of a Governess* (London: Oxford University Press, 1936–39), 2:143–44.

54. Antal, *Hogarth and His Place,* 48.

55. Quoted in Randolph Trumbach, *The Rise of the Egalitarian Family: Aristocratic Kinship and Domestic Relations in Eighteenth-Century England* (New York: Academic Press, 1978), 217.

56. Quoted in Horace Walpole, *Correspondence,* ed. W. S. Lewis et al. (London and New Haven: Yale University Press, 1937–83), 5:370. Translation is my own.

57. The Earl of Bessborough, ed., *Georgiana: Extracts from the Correspondence of Georgiana, Duchess of Devonshire* (London: John Murray, 1955), 13.

58. Mannings in Royal Academy, *Reynolds,* 311, has suggested a group by Kneller at King's Weston in the eighteenth century as one such source, which in turn derived from a classical source as suggested by J. D. Stewart in the National Portrait Gallery catalogue *Sir Godfrey Kneller* (London: National Portrait Gallery, 1971), 57, or two sources illustrated in Johann Winckelmann's *Monumenti antichi inediti* (Rome: Winckelmann, 1767), 1: plates 54, 143, known to have been in Reynolds's library.

59. Quoted in Iris Palmer, *The Face without a Frown: Georgiana, Duchess of Devonshire* (London: F. Muller, 1947), 76, from Chatsworth MSS 508.1.

60. Elizabeth Foster, *Children of the Mist: A True and Informal Account of an Eighteenth-Century Scandal* (London: Hutchinson, 1960), 29.

61. Countess of Ilchester and Lord Stavordale, *The Life and Letters of Lady Sarah Lennox, 1745–1826* (London: John Murray, 1902), 2:36.

62. Palmer, *Face without a Frown,* 90–91.

63. Bessborough, *Georgiana,* 67.

64. Chatsworth MSS 991, quoted in Bessborough, *Georgiana,* 157.

65. Edgar Wind, "Humanitatsidee und heroisiertes Porträt in der englischen Kultur des 18. Jahrhunderts," *Vortrage der Bibliothek Warburg* (1930–31): 156–229.

66. Kenneth Garlick, *Sir Thomas Lawrence: Portraits of an Age 1790–1830* (Alexandria, Va.: Art Services International, 1993), 108.

67. Northcote, *Life of Reynolds,* 2:29–30.

68. Edgar Wind, "Charity: The Case History of a Pattern," *Journal of the Warburg and Courtauld Institutes* 1 (1937–38): 322–30. Wind also shows that Van Dyck had followed the same sources in a painting of Charity in the Dulwich Picture Gallery that Reynolds may have known.

69. Cotton, *Sir Joshua Reynolds,* 167.

70. *Public Advertiser* (London), Thursday, 28 April 1774, 2.

71. *St James Chronicle* (London), 24–27 April 1779, 4.

72. Struve, *A Familiar Treatise,* 121.

73. See Denis Monaghan, *Jane Austen in a Social Context* (London: Macmillan, 1981).

74. Mrs. Maguire was not a nobleman's wife but his mistress, which may account for the high spirits of Lawrence's painting. The *Sun* (London) for 17 May 1806 found its playfulness to be more appropriate for a sister and brother than for a mother and son.

75. Ilchester and Stavordale, *The Life and Letters of Lady Sarah Lennox,* 344.

76. William Buchan, *Domestic Medicine* (London: Strahan and Cadell, 1769), 2.

77. Anne Fremantle, ed., *The Wynne Diaries* (London: Oxford University Press, 1935), 3:96.

78. The composition itself may derive from Reynolds's painting of James Paine and his son of 1764, now in the Ashmolean Museum, Oxford.

79. Zoffany has given us one of the few images of a father with a child at play in his portrait (1770s) of a man, probably George Fitzgerald of Turlough, with two of his sons, sold at Christie's, London, in July 1994. Resting his arm on one son's shoulders, Fitzgerald watches a second son flying a kite. The three are more successfully united emotionally than we have seen in other portraits of fathers and sons. Although Fitzgerald does not enter in the game in the way that we have seen the Duchess of Devonshire interacting with her baby, he at least witnesses the play with affection.

80. Duke of Rutland to Andrew Robert Drummond, 28 November 1822, Drummond of Cadland MSS A6/17/1, property of Maldwin Drummond, J.P., of Cadland, Fawley, Hants.

81. Cadogan, *An essay upon nursing,* 11.

82. Broughton, *Court and private life,* 1:220–21.

83. Pollock, *A Lasting Relationship,* 55.

84. Cunnington and Buck, *Children's Costume,* 144.

85. Sophie von la Roche, *Sophie in London, 1786, being the diary of Sophie von la Roche,* trans. Clare Williams (London: Jonathan Cape, 1933), 262.

86. John Thomas Smith, *Nollekens and His Times* (London: H. Colburn, 1829; reprint, London: Century Hutchinson, 1986), 196–97.

87. Ibid., 197.

88. Northcote, *Life of Reynolds,* 1:7.

89. Ibid., 1:285.

90. Smith, *Nollekens,* 197.

91. Pollock, *A Lasting Relationship,* 93.

92. Boscawen, *Admiral's Wife,* 170.

93. Burney, *Diary and Letters,* 6:88–90.

94. Boscawen, *Admiral's Wife,* 75.

95. Leith Hay Papers, Scottish Records Office GD30.

96. M. Betham-Edwards, ed., *The Autobiography of Arthur Young* (London: Smith, Elder & Co., 1898), 277.

97. Interestingly, Ariès posits that the "privatization" of death was a late eighteenth-century invention. See Philippe Ariès, *L'Homme devant la mort* (Paris: Editions du Seuil, 1977), translated as *Images of Man and Death,* trans. Janet Lloyd (Cambridge, Mass.: Harvard University Press, 1985).

98. Pollock, *A Lasting Relationship,* 94.

99. Cadogan, *An essay upon nursing,* 6.

100. Buchan, *Domestic Medicine,* 1.

101. Pollock, *Forgotten Children,* 51. Alan MacFarlane concurs: see his review of Stone's *The Family, Sex and Marriage* in *History and Theory* 18 (1979): 103–26, on the lack of correlation between mortality rates and the development of affection.

102. *The Ear-Wig; or An Old Woman's Remarks on the present Exhibition of the Royal Academy* (London: G. Kearsley, 1781), 9.

103. *Child's Companion; or, Sunday Scholar's Reward* 5, no. 37 (January 1827): 21–22.

104. Donald Fraser, ed., *The Life and Diary of Reverend Ebenezer Erskine* (Edinburgh, 1831), 266.

105. John Verney, *Letters of the Eighteenth Century from the Manuscripts at Claydon House,* ed. Margaret Maria, Lady Verney (London: E. Benn Ltd., 1930), 146.

106. Christie, *Reverend William Jones,* 99–100.

107. Scott and Pottle, *The Private Papers of James Boswell,* 1:48.

108. Betham-Edwards, *Autobiography,* 279–80.

109. Ibid., 281.

Chapter 4

1. Eugenia Stanhope, ed., *Letters written by the Late Right Honourable Philip Dormer Stanhope to his Son Philip Stanhope Esq.* (London: J. Dodsley, 1774), 1:171–2.

2. See British Museum MSS. Eg. 2165, f. 18, and Malone, *Works of Reynolds,* 2:263.

3. "Diary of John Harrower," *American Historical Review* 6 (1901): 91.

4. Attesting to the importance of these movements, by 1812 there were only 186 Anglican places of worship in London, compared to 256 dissenting establishments. See Roy Porter, *English Society in the Eighteenth Century* (Harmondsworth: Penguin, 1982), 191.

5. For a fuller discussion of this, see Kirsten Drotner, *English Children and Their Magazines, 1751–1945* (New Haven: Yale University Press, 1988), 39.

6. See Samuel F. Pickering, Jr., *John Locke and Children's Books in Eighteenth-Century England* (Knoxville: University of Tennessee Press, 1981), 60, 69.

7. See Linda Hannas, *The English Jigsaw Puzzle 1760–1890* (London: Wayland, 1972).

8. See Pauline Flick, *Discovering Toys and Toy Museums* (Princes Risborough: Shire Publications, 1977), 7–8.

9. Esme Wingfield-Stratford, *The Lords of Cobham Hall* (London: Cassell, 1959), 238.

10. Fremantle, *The Wynne Diaries.*

11. I am indebted to David Erdman's *The Illuminated Blake* (Garden City: Anchor Press, 1974) for this suggestion.

12. The earliest museum guidebook expressly for children I have found is Anonymous, *The school-room party, out of school hours: A little work, that will be found for young ladies and gentlemen of every description; a most pleasing companion to the Leverian Museum* (London: T. Hurst, 1800), a guide to Sir Ashton Lever's "Holophustikon," or museum of quadrupeds and birds in London.

13. Frank Sidgwick, ed., *The Complete Marjory Fleming: Her Journals, Letters & Verses* (London: Sidgwick & Jackson, Ltd., 1934), 6.

14. Ibid., 9.

15. On family travel, see Esther Moir, *The Discovery of Britain* (London: Routledge & Kegan Paul, 1964), 77–107.

16. Broughton, *Court and private life,* 1:94.

17. Ibid.

18. Master Michel Angelo [Richard Johnson], *Juvenile Sports and Pastimes,* 2nd ed. (London, 1776), 3–9.

19. On the popularity of *The Butterfly's Ball,* see Mary V. Jackson, *Engines of Instruction, Mischief, and Magic: Children's Literature in England from its Beginnings to 1839* (Lincoln: University of Nebraska Press, 1989), 210–13.

20. J. J. Bagley, ed., "The Great Diurnall of Nicholas Blundell," *Record Society of Lancashire and Cheshire,* 112:29.

21. On Gravelot, see H. A. Hammelmann, "A French Master of English Illustration," *Country Life* 126 (3 December 1959): 1087. On Hayman and the pivotal influence of Vauxhall, see Lawrence Gowing, "Hogarth, Hayman and the Vauxhall Decorations," *The Burlington Magazine* 95 (January 1953): 4–19, and (April 1953): 142; Brian Allen, "The Landscape," in *Vauxhall Gardens* (New Haven: Yale Center for British Art, 1983), and the same author's "Francis Hayman and the Supper-box Paintings for Vauxhall Gardens," in *The Rococo in England:*

A Symposium, ed. Charles Hind (London: Victoria & Albert Museum, 1986), 113–33.

22. G. E. Bentley, Jr., *Blake Records* (Oxford: Clarendon Press, 1969), 566.

23. Elizabeth and Florence Anson, eds., *Mary Hamilton, At Court and At Home* (London: John Murray, 1925), 301.

24. Broughton, *Court and private life,* 44.

25. Letter of 28 June 1757 in Brian Fitzgerald, ed., *Correspondence of Emily, Duchess of Leinster (1731–1814)* (Dublin: Stationery Office, 1949), 1:55.

26. Sir George Leveson-Gower and Iris Palmer, eds., *Hary-O: The Letters of Lady Harriet Cavendish 1796–1809* (London: John Murray, 1940), 198–99.

27. Burney, *Diary and Letters,* 6:152–57.

28. Verney, *Letters,* 2:134.

29. Fremantle, *The Wynne Diaries.*

30. Sidgwick, *The Complete Marjory Fleming.*

31. Mary Sewell, *The Life and Letters of Mrs Sewell,* 3rd ed. (London: J. Nisbet, 1889), 26–27.

32. Benjamin Heath Malkin, *A Father's Memoirs of His Child* (London: Longman, Hurst, Rees, and Orme, 1806), 30. Malkin also boasts that his son had memorized four of William Blake's *Songs of Innocence and of Experience,* a testimony to the importance of the *Songs* for at least some children by this date.

33. F. Alford, *Life, Journals and Letters of Henry Alford, D.D.* (London: Rivingtons, 1873), 9.

34. M. Edward Ingram, *Leaves from a Family Tree being the Correspondence of an East Riding Family* (Hull and London, 1951), 101.

35. On Mercier's fancy pictures, see Robert Raines, "Philip Mercier's Later Fancy Pictures," *Apollo* 80 (July 1964), 29.

36. See Brian Allen, *Francis Hayman* (New Haven and London: Yale University Press, 1987).

37. George Dawe, *The Life of George Morland (1763–1804)* (London: Vernor, Hood, and Sharpe, 1807), 70.

38. Williamson, *George Morland,* 37. Williamson is quoting George Dawe's biography of 1807.

39. See E. D. H. Johnson, *Paintings of the British Social Scene from Hogarth to Sickert* (New York: Rizzoli, 1986), 111.

40. See James Walvin, *A Child's World: A Social History of English Childhood 1800–1914* (Harmondsworth: Penguin, 1982), 92.

41. J. H. Plumb, "The New World of Children in Eighteenth-Century England," *Past and Present* 67 (May 1975): 90.

Chapter 5

1. For a full view of this complex topic, see Nathan Tarcov, *Locke's Education for Liberty* (Chicago: University of Chicago Press, 1984).

2. Paulson, in *Popular and Polite Art,* 136, describes Locke's influence in these terms. On the breakdown of patriarchal structures, see Stone, *The Family, Sex and Marriage,* part 3.

3. On Locke's influence on Fielding (and by extension Hogarth), see Chapter One in C. J. Rawson, *Henry Fielding and the Augustan Ideal under Stress* (London: Routledge & Kegan Paul, 1972).

4. For a discussion of this, see Brookner, *Greuze,* 1–53.

5. See David Solkin, *Richard Wilson* (London: Tate Gallery, 1982), 152.

6. The Evangelicals took this much from Rousseau and later added an emphasis on mental hardening to strengthen children against worldly temptations.

7. See, for example, Fitzgerald, *Emily Duchess of Leinster,* 1:217–18, 251, 285, 343, 354, 514.

8. Frances Power Cobbe, *Life of Frances Power Cobbe as Told by Herself* (London, 1894; reprint, London: Swan Sonnenschein, 1904), 39.

9. Quoted in W. A. C. Stewart and W. P. McCann, *The Educational Innovators: 1750–1880* (London: Macmillan, 1967), 33, 39.

10. Hazlitt, *Conversations,* 189.

11. Day (1748–1789) was not the only Rousseau-inspired writer of books for children; others included Erasmus Darwin (1731–1802), grandfather to Charles, and Richard Lovell Edgeworth (1744–1817).
 The latter raised his son on Rousseau's plans and the results were disastrous: the boy became peevish, gauche, and unstable, and was ultimately banished to America, *after* having been presented to Rousseau in Paris as a new *Emile.*

12. Reynolds, *Discourses,* 208. Even so, Reynolds comes close to Chesterfield in the *Discourses.* See Paulson, *Popular and Polite Art,* 266–67.

13. Henry Fuseli, *Remarks on the Writings and Conduct of John James Rousseau* (London: T. Cadell, J. Johnson and B. Davenport, 1767), 35–36.

14. See Zachary Leader, *Reading Blake's Songs* (London: Routledge & Kegan Paul, 1981), 184.

15. William Mason, "Anecdotes of Sir Joshua Reynolds chiefly relative to his manner of coloring," in Cotton, 57–58.

16. Ibid., 135.

17. Cadogan, *An essay upon nursing,* 34.

18. Malkin, *A Father's Memoirs,* 19.

19. Ibid.. 85. When the young Malkin died, the presiding doctor felt it was due to the pressure of water on the brain, caused from too much intelligence and learning. The despairing father wrote, "but who would kill the darling of his heart with knowledge?" (155–56).

20. Boscawen, *Admiral's Wife,* 92.

21. Amelia Steuart Diary, fol. 133, 140.

22. The most interesting diarist and letter-writer in this regard may be the third Earl of Lennox, quoted extensively in Wingfield-Stratford, *The Lords of Cobham Hall.*

23. Pollock, *A Lasting Relationship,* 204.

24. Widely quoted, as in Porter, *English Society,* 177.

25. Ilchester, *Journal of Elizabeth Lady Holland,* 1:158–59.

26. It should be noted that, prior to the Georgian period, most child-rearing manuals were intended for fathers, as their essential subject was authority. From the mid-eighteenth century, they were more focused on mothers and their role in educating children.

27. Johnson, *Paintings of the British Social Scene,* 104.

28. Numbers of datable editions published by John Newbery and his descendants were calculated by Plumb in "The New World of Children," 84, n. 88, as follows:

 1742–50: 18
 1751–60: 47
 1761–70: 111
 1771–80: 129
 1781–90: 167
 1791–1800: 218

 For the extraordinary role of John Newbery and his family, see S. Roscoe, *John Newbery and his Successors, 1740–1814: A Bibliography* (Wormley, Herts.: Five Owls Press, 1973), and William Noblett, "John Newbery, Publisher Extraordinary," *History Today* 22 (April 1972): 265–71.

29. Yale Center for British Art, *The Pursuit of Happiness.*

30. Jackson, *Engines of Instruction, Mischief, and Magic,* 139.

31. Pottle, *Boswell's London Journal,* 299.

32. Ibid.

33. E. Robinson and G. Summerfield, eds., *Selected Poems and Prose of John Clare* (Oxford: Oxford University Press, 1978), 100.

34. A point first made by Madge Garland in *The Changing Face of Childhood* (New York: October House, 1963), 71.

35. William Blake, *Songs of Innocence and of Experience* (London, 1794; reprint, Oxford and New York: Oxford University Press, 1967), 121.

36. This can also be seen as children gathering the fallen fruits of the tree of experience, with-

out adult instruction. This motif can be found in illustrated children's books, as in the frontispiece to the anonymous *Mirth without Mischief* of about 1780, where six young children gather the literal fruit of learning (the alphabet) from the tree above them.

37. See the Introduction to Leader, *Reading Blake's Songs*.

38. Broughton, *Court and private life*, 2:279–82.

39. F. W. Hilles, *The Literary Career of Sir Joshua Reynolds* (Cambridge: Cambridge University Press, 1936), 3.

40. Ibid., 5.

41. Joseph Farington, *The Diaries of Joseph Farington*, ed. K. Garlick and A. Macintyre (London and New Haven: Yale University Press, 1978–84). Similarly, writing of Philippe de Loutherburg, a newspaper for 14 August 1789 commented, "It is frequently seen, that the intentions of their children are frustrated, especially when the inclinations of the child are not consulted." Quoted in F. W. Hilles and P. B. Daghlian, eds., *Anecdotes of Painting in England (1760–1795) . . . collected by Horace Walpole* (New Haven: Yale University Press, 1937), 5:101.

42. Williams, *Correspondence of Lawrence*, 1:57.

43. According to William Collins, *Life* (London: H. D. Symonds, 1805).

44. Northcote, *Life of Reynolds*, 1:11.

45. From Thomas Laqueur, *Religion and Respectability: Sunday Schools and Working-Class Culture, 1780–1850* (New Haven: Yale University Press, 1976), 44.

46. Scott and Pottle, *The Private Papers of James Boswell*, 12:180–81.

47. Ibid., 14:5–6.

48. Burney, *Diary and Letters*, 6:223–24.

49. For further details on religious magazines for children see Kirsten Drotner, *English Children and Their Magazines, 1751–1945* (New Haven: Yale University Press, 1988).

50. Quoted in David Vincent, *Bread, Knowledge and Freedom: A Study of Nineteenth-Century Working Class Autobiography* (London: Methuen, 1982), 88–89.

51. This, and the following observation concerning negotiating submission, come from Drotner, *English Children and Their Magazines*, 56–57.

52. Thought by Dr. Johnson to teach "the morals of a whore and the manners of a dancing master." Quoted in Porter, *English Society*, 88.

53. Stanhope, *Letters*, 1:211–12.

54. Reginald Heber, Heber Manuscripts, Bodleian Library, English letters, C.203, ff. 7–8.

55. Quoted in Betsy Rodgers, *Cloak of Charity: Studies in Eighteenth-Century Philanthropy* (London: Methuen, 1949), 123.

56. Adam Taylor, ed., *Memoirs of the Reverend John Taylor* (London: John Murray, 1820), 118–20.

57. Ibid., 120.

58. Quoted in Anita Schorsch, *Images of Childhood: An Illustrated Social History* (New York: Mayflower Books, 1979), 85–86. I have been unable to locate the original.

59. James Boswell, *Life of Johnson*, ed. G. B. Hill and L. F. Powell (Oxford: Oxford University Press, 1934–50), 3:128.

60. John Locke, *Some Thoughts Concerning Education* (London: A. and J. Churchill, 1693), 117–18.

61. Taylor, *Reverend John Taylor*, 118–20.

62. Scott and Pottle, *The Private Papers of James Boswell*, 12:106.

63. Ibid., 15:17.

64. Ibid., 14:20.

65. Amelia Steuart Diary, fol. 94.

66. Fremantle, *The Wynne Diaries*, 1:18.

67. Sidgwick, *The Complete Marjory Fleming*.

68. Richard Edgcumbe, ed., *The Diary of Frances, Lady Shelley* (London: John Murray, 1912), 1:1.

69. Lady Strachey, ed., *Memoirs of a Highland Lady* (London: John Murray, 1911), 56.

70. Ibid., 61.

71. Boscawen, *Admiral's Wife*, 179.

72. Quoted in Schorsch, *Images of Childhood*, 40, no source given.

73. In Maldwyn Edwards, *Family Circle: A Study of the Epworth Household in Relation to John and Charles Wesley* (London: Epworth Press, 1949), 49.

74. Paul Langford, *A Polite and Commercial People: England 1727–1783* (Oxford: Oxford University Press, 1989), 501.

75. *The Times of London*, 11 December 1787, 3.

76. *The Times of London*, 28 May 1810, 3e.

77. *The Times of London*, 17 November 1824, 3c.

78. Margaret Woods, *Extracts from the Journal of Margaret Woods* (London: John and Arthur Arch, Cornhill, 1829), 427.

79. Drotner, *English Children and Their Magazines*, 45.

80. C. John Sommerville, *The Discovery of Childhood in Puritan England* (Athens and London: University of Georgia Press, 1992), 30.

Chapter 6

1. See F. A. Wray and R. H. Nichols, *The History of the Foundling Hospital* (London: Oxford University Press, 1935); Ruth K. McClure, *Coram's Children: The London Foundling Hospital in the Eighteenth Century* (New Haven: Yale University Press, 1981); and Donna T. Andrew, *Philanthropy and Police: London Charity in the Eighteenth Century* (Princeton: Princeton University Press, 1989).

2. The delay in establishing a hospital for foundlings arose partly due to fears that such a place would encourage sexual misconduct among the poor, a belief that was widely maintained as late as 1760.

3. On Hogarth's own position concerning philanthropy, see Frederick Antal, "The Moral Purpose of Hogarth's Art," *Journal of the Warburg and Courtauld Institutes* 15 (1952): 169–97.

4. Cadogan, *An essay upon nursing*, 3.

5. Cited in Antal, *Hogarth and His Place*, 221, n. 72.

6. Referring to Reynolds's design for the stained-glass windows for New College, Oxford, or, less probably, to his portrait of Lady Cockburn with her children which became known by the name *Charity*.

7. Whitley, *Artists and Their Friends*, 2:127–28.

8. Northcote objected to this as meddling in moral issues, especially after Reynolds's death.

9. For a discussion of Shaftesbury, charity, and art, see Antal, "The Moral Purpose of Hogarth's Art," 169–97. On the dissemination of these ideas by Addison and Steele in the *Tatler* (1709–11) and the *Spectator* (1711–12, 1714), see page 171.

10. Boswell, *Life of Johnson*, 540.

11. Ibid., 1168.

12. *Journals of the House of Commons* (1732), 12:931.

13. Sir John Fielding, *An Account of the Origin and Effects of a Police* (London: A. Millar, 1758), 19–20.

14. Between 1801 and 1836, 104 children were sentenced to death at the Old Bailey, but none were actually killed, according to James Walvin, *A Child's World: A Social History of English Childhood 1800–1914* (Harmondsworth: Penguin, 1982), 160.

15. Fielding, *An Account*, 44–45.

16. Statistics from Pinchbeck and Hewitt, *Children in English Society*, 1:119.

17. Fremantle, *The Wynne Diaries*, 1:23.

18. Quoted in J. J. Tobias, *Crime and Industrial Society in the Nineteenth Century* (Harmondsworth: Penguin, 1972), 95–96.

19. Farington, *The Diaries*, 2:440.

20. For further details see Pinchbeck and Hewitt, *Children in English Society,* 1:289–90.

21. Blake's poem may derive from the ironic tone of Mandeville's *Essay on Charity and Charity Schools* (London: John Gray, 1728), in which he describes the city's share of ownership in well-dressed charity children.

22. Leader, *Reading Blake's Songs,* 19.

23. Judith Schneid Lewis goes further and argues that the "rising principles of competitiveness and individualism" led to a privatization of family life, a position that relies heavily on Lawrence Stone's writings on the family. See Lewis's *In the Family Way,* 9.

24. Whitley, *Artists and Their Friends,* 1:228.

25. Farington wrote in his diary that Wheatley "was very low last night at the thought of applying for money"; "shd. He [Wheatley] become a Cripple, the Academy must allow him an Annuity for He must not be allowed to starve." *The Diaries,* 2:597, 601.

26. Whitley, *Gainsborough,* 232, although no source is given. According to Mary Woodall, *Thomas Gainsborough: His Life and Works* (London: Phoenix House, 1949), 108, it is Gainsborough's daughter Margaret who wished to adopt the beggar boy, but the boy's mother declined, "loath to lose the income derived from his consummate powers of begging."

27. *The Morning Herald* (London) 4 August 1788.

28. For the intersection of painting and class issues, see Chapter Seven.

29. George Somes Layard, ed., *Sir Thomas Lawrence's Letter-Bag* (London: G. Allen, 1906), 19.

30. In Leveson-Gower and Palmer, *Hary-O,* 3.

31. Fremantle, *The Wynne Diaries,* 56.

32. *The Ear-Wig,* 7.

33. See Kathryn Moore Heleniak, *William Mulready* (New Haven and London: Yale University Press, 1980), 101 and notes.

34. Or, in another famous Kilner work for children, a pincushion stands in for a child narrator and allows for an entirely different narrative stream.

35. Dorothy Kilner, *Life and Perambulations of a Mouse* (London: John Marshall and Company, 1783), 24.

36. See Jackson, *Engines of Instruction,* 3.

Chapter 7

1. The term "middle class" appears to have originated between 1810 and 1820. See Asa Briggs, "The Language of Class in Early Nineteenth-Century England," in *Essays in Labour History,* ed. Asa Briggs and John Saville (London: Macmillan, 1967), 43–73.

2. See Drotner, *English Children and Their Magazines,* 34 ff.

3. Boswell, *Life of Johnson,* 1185, entry of 3 June 1782.

4. Sophie von La Roche put it that they could either be ruined by poverty or else remain with their parents "in stricken and sickly state." This suggests a distinction between moral/spiritual ruin (perhaps hooliganism, prostitution, etc.) and physical ruin. See Von la Roche, *Sophie in London, 1786,* 266.

5. See Pinchbeck and Hewitt, *Children in English Society,* 1:146–66.

6. Jonas Hanway, *An Earnest Appeal for Mercy to the Children of the Poor* (London: J. Dodsley, J. Rivington, H. Woodfall, and N. Young, 1766), 41–43.

7. Act of Parliament George III, c. 39. It is interesting to note, in regard to the workhouse movement, that Locke had favored school for the poor as part of poor-law reform in 1697 only in order to free the parents to work and to habituate children to the idea of work themselves.

8. Frances B. Smith, *The People's Health, 1830–1910* (London: Croom Helm, 1979), 68.

9. Smith, *Nollekens,* 142.

10. Ibid., 143.

11. Schorsch, *Images of Childhood,* 143.

12. Suggested by Schorsch, ibid., 132.

13. Porter, *English Society,* 344.

14. *Parliamentary Papers* (London, 1816), III, 235: 20–22.

15. See E. P. Thompson, *The Making of the English Working Class* (1963; reprint, Harmondsworth: Penguin, 1975), 341.

16. According to Langford, *A Polite and Commercial People,* 503.

17. Ibid. Stanley Gardner tells us that of two hundred master chimney sweeps in London in the 1780s, only some twenty were reputable and refused to hire children under the age of eight. See Gardner, *Blake's Innocence and Experience Retraced* (London: Athlone Press, 1986), 66–68.

18. *The Child's Companion* 4, no. 29 (May 1826): 130–31.

19. Despite such evidence, it should be noted that the English class system was somewhat more fluid than elsewhere in Europe, as only first-born sons inherited, leaving other children to rise or fall on the class ladder.

20. Gardner has suggested that the parents' church-going habits indicate they are of "the better sort" and have not sold their child out of necessity.

21. Charles Lamb, "The Praise of Chimney-Sweeps," in *Essays of Elia* (New York: Macmillan, 1931), 153; Charles Dickens, *Oliver Twist,* first published in 1838. Lamb also chose to include Blake's poem in James Montgomery's *Chimney Sweeper's Friend and Climbing Boy's Album* (London: A. & R. Spottiswoode, 1824), a book advocating against social injustice.

22. John Hoppner quoted by Farington in *The Diaries,* entry for 12 January 1797.

23. Examined in Alison McNeil Kettering, *The Dutch Arcadia: Pastoral Art and Its Audience in the Golden Age* (Montclair, N.J.: Allanheld & Schram, 1983).

24. Patricia Crown, "Portraits and Fancy Pictures by Gainsborough and Reynolds: Contrasting Images of Childhood," *British Journal for Eighteenth-Century Studies* 7, no. 2 (autumn 1984): 162.

25. We are told by an early Morland biographer that he copied both Gainsborough's *Girl with Pigs* and *Two Shepherd Boys with Dogs Fighting* when they were displayed at the Royal Academy. See Dawe, *The Life of George Morland,* 9–11.

26. Sidgwick, *The Complete Marjory Fleming,* 22–23.

27. Ibid., 12.

28. Ibid., 165.

29. Leveson-Gower and Palmer, *Hary-O,* 202–203.

30. William Paley, "Reasons for Contentment addressed to the Labouring Part of the British Public," 1792, in *Natural Theology and Tracts* (London, 1824), 220–21.

31. Ibid., 221.

32. Ibid.

33. The crisis is described from an admittedly leftist perspective in John Barrell, *The Dark Side of the Landscape: The Rural Poor in English Painting 1730–1840* (Cambridge: Cambridge University Press, 1980).

34. See Porter, *English Society,* 225–30.

35. See John Steegman, *The Rule of Taste* (New York: MacMillan, 1936), 121.

36. Oliver Goldsmith, *The Deserted Village* (London: W. Griffin, 1770; reprint New York. D. Appleton & Co., 1956).

37. Barrell, *The Dark Side of the Landscape,* 85.

38. Hannah More, *Black Giles the Poacher,* from the series of *Cheap Repository Tracts* (1795–98; reprint, London: J. Marshall, 1830), 3.

39. Barrell, *The Dark Side of the Landscape,* 77.

40. See Mary Gwladys Jones, *Hannah More* (London: Cambridge University Press, 1952; reprint, New York: Greenwood Press, 1968).

41. Hannah More, *The Shepherd of Salisbury Plain* (1795; reprint, London: J. Marshall, 1830).

42. Uvedale Price, quoted in Johnson, *Paintings of the British Social Scene*, 117.

43. Letter to William Jackson, 23 August [1767?], quoted in Woodall, *Letters of Thomas Gainsborough*, no. 49, 99.

44. Barrell, *The Dark Side of the Landscape*, 70.

45. See C. P. Barbier, *William Gilpin* (Oxford: Clarendon Press, 1963), 114, for Mary Hartley's comments to Gilpin on the affective qualities of Gainsborough's cottage pictures.

46. Robert R. Wark, ed., *Reynolds's Discourses on Art* (New Haven: Yale University Press, 1975), 249.

47. Whitley, *Thomas Gainsborough*, 170.

48. Quoted in Oliver Millar, *Thomas Gainsborough* (London: Longman, Green & Co., 1949), 14.

49. Quoted in Whitley, *Thomas Gainsborough*, 261.

50. Ibid., 291. Emphasis added.

51. William Jackson, *The Four Ages* (London: Cadell and Davies, 1798), 156.

52. The plate and text of this edition are reproduced in Geoffrey Summerfield, *Fantasy and Reason: Children's Literature in the Eighteenth Century* (Athens: University of Georgia Press, 1985), 28.

53. *The Morning Herald*, London, 4 August 1788.

54. Woodall, *The Letters of Thomas Gainsborough*, 43.

55. *The Morning Herald, and Daily Advertiser* (London) 30 April 1783, 3.

56. Ibid., 3.

57. *The Bee; or, The Exhibition Exhibited in a new light: being a complete Catalogue-Raisonné of all the Pictures . . .* (London: 1788), 15.

58. Antony Pasquin [John Williams], "A liberal critique on the present exhibition of the Royal Academy," in *Memoirs of the Royal Academicians* (London: H. D. Symonds, P. McQueen & T. Bellamy, 1796), 31–32.

59. Mulready first explored this motif in a painting of 1819, *Lending a Bite*. For preparatory drawings, see Heleniak, *William Mulready*, 92, 211.

60. Quoted in Johnson, *Paintings of the British Social Scene*, 166–67.

61. In George Crabbe, *Poetical Works* (London: John Murray, 1840), 2:76.

62. George Crabbe, "The Parish Register," 1807, in *The Life and Poetical Works of the Rev. George Crabbe* (London: John Murray, 1847),

lines 15–26. Auburn is the name of Goldsmith's village in *The Deserted Village*.

63. Ibid., lines 194–203.

Chapter 8

1. Antal, *Hogarth and His Place*, 48.

2. Fielding's *Tom Jones* (1749) also suggests the incipient road toward heightened emotion with its heroine's admission, "I love a tender sensation, and would pay the price of a tear for it any time." Fielding's own position is one of gentle ridicule for these tender sensations, which sets his novel apart from what was to follow.

3. It is worth remembering here that Sterne visited France in 1762, part of a wave of English influence that ended only with the Revolution of 1789.

4. Prototypes for the genre dramatizing bourgeois life were George Lillo's play, *The London Merchant: or the history of George Barnwell*, 1731, followed by the plays of Diderot, e.g., *Le Père de famille*, 1758.

5. Antal, *Hogarth and His Place*, 185.

6. Quoted in Johnson, *Paintings of the British Social Scene*, 275, n. 7.

7. See Langford, *A Polite and Commercial People*, 503 ff.

8. See Edward Shorter, *The Making of the Modern Family* (New York: Basic Books, 1975), 5. By contrast, Ariès, in *Centuries of Childhood*, and Pinchbeck and Hewitt, in *Children in English Society*, argue with equal simplicity that the emergence of a concept of childhood was due to the emergence of a system of education. They fail to convince, however, that it wasn't the other way round, or due to a variety of impulses. If education was indeed responsible for childhood, one would need to establish why the system of education took the form it did.

9. See Trumbach, *The Rise of the Egalitarian Family*, 120–23.

10. Beattie, *The Minstrel*, 20:11.

11. Ibid., 24:13.

12. Ibid., 32:17.

13. Ibid., 33:17.

14. Roy Porter has suggested that Enlightenment individualism was itself in part a product of the commercialization and popularization of culture, made accessible to a larger audience. Printmaking and illustrated books must then be seen in this light. For a general discussion of this issue, see Porter, *English Society*, 264–66, 274.

15. Quoted in Johnson, *Paintings of the British Social Scene*, 84–85.

16. See David Winter, *George Morland (1763–1804)* (Ann Arbor: UMI, 1977), 32.

17. "An Artist," *A Candid Review of the Exhibition (being the twelfth) of the Royal Academy*, 2nd ed. (London: T. Evans, 1780), 27.

18. Wright was himself the son of a solidly middle-class attorney based in the industrial midlands, where scientific progress held particular meaning.

19. Hugh Honour, *Neo-classicism* (Harmondsworth: Penguin, 1968), 98.

20. Like Morland and Wheatley, Opie was a prolific artist. An early biographer catalogs 1,147 paintings, of which 825 were portraits and 246 were fancy pictures or "poetical" pieces. See Ada Earland, *John Opie and His Circle* (London: Hutchinson, 1911), 358.

21. See Fuseli's review of Uvedale Price's *Essay on the Picturesque* in *Analytical Review* 20 (November 1794): 264–65.

22. Fuseli, *Remarks on the Writings*, 35.

23. Kilner, *Life and Perambulations*, 29–31.

24. Sarah Trimmer in *The Guardian of Education* (London: J. Hatchard, 1802), 1:435.

25. Mary Wollstonecraft, *Thoughts on the Education of Daughters* (London: J. Johnson, 1787), 16–17.

26. Anna Barbauld, *Hymns in Prose for Children* (London: J. Johnson, 1781), 5–12.

27. Wollstonecraft, *Thoughts on the Education of Daughters*, 17.

28. See Samuel F. Pickering, Jr., *John Locke and Children's Books in Eighteenth-Century England* (Knoxville: University of Tennessee Press, 1981), 34.

Chapter 9

1. Details of the commission and the identities of the figures are given in Paulson, *Hogarth*, 1:301–302.

2. Ibid., 1:304.

3. Hogarth, *The Analysis of Beauty*, 202.

4. In his *Autobiographical Notes*, Hogarth wrote that "I had naturally a good eye, shews of all sort gave me uncommon pleasure when an infant and mimickry to all children was remarkable in me." Ibid., 22.

5. Daniel Wray, then living in London with the art dealer Arthur Pond, writing to Philip Yorke in Paris, urging him to call in at Chardin's. Quoted in Whitley, *Artists and Their Friends*, 1:31.

6. The emblematic quality of many of Mercier's fancy pictures has led Robert Raines to argue that the children are not the children of the eighteenth century itself, but rather of eighteenth-century literature. They are "the children of Locke and Richardson, whose minds, *tabulae rasae* at birth, could be formed by example, precept and instruction." See Raines, "Philip Mercier's Later Fancy Pictures," 29.

7. Robert Rosenblum, "Reynolds in an International Milieu," in Royal Academy, *Reynolds*, 47.

8. *The Observer*, 16 May 1813, quoted in Farington, *Memoirs of the Life of Sir Joshua Reynolds*, 152.

9. See J. L. Nevinson, "Vogue of the *Vandyke Dress*," *Country Life Annual* (1959): 25 ff.

10. Quoted in Whitley, *Artists and Their Friends*, 1:263.

11. Its first notice seems to come in William Jackson, *The Four Ages* (London: Cadell and Davies, 1798), when he describes it as perhaps Gainsborough's best portrait.

12. Richard Wendorf, *The Elements of Life: Biography and Portrait Painting in Stuart and Georgian England* (Oxford: Clarendon Press, 1990), 249.

13. Northcote, *Life of Reynolds*, 2:43–44.

14. Quoted in Royal Academy, *Reynolds*, 269.

15. *Master Crewe* is not the only example in Reynolds's oeuvre in which he allies the child with a historical figure. He did so with his *Master Coke as Hannibal* of 1759. Benjamin West also worked in this area, painting a "Hannibal at age 9, swearing enmity to the Romans, before the Altar of Jupiter," for the Queen's House, Greenwich.

16. William Hazlitt, *Essays on the Fine Arts* (London: Reeves and Turner, 1873), 33.

17. The same can be said of Reynolds's *Infant Hercules* (The Hermitage, Leningrad), one of the artist's few true history paintings, illustrating Hercules strangling the serpents in the cradle from Cowley's translation of Pindar. For Reynolds's account of the commission in a letter of 20 February 1786 to the Duke of Rutland see F. W. Hilles, ed., *Letters of Sir Joshua Reynolds* (Cambridge: Cambridge University Press, 1929), 149.

18. This painting exists in at least two versions, one in the Wallace Collection, London, and a less finished but perhaps more fluid version, shown here, from the Minneapolis Institute of Arts.

19. John Ingamells, *The Wallace Collection: Catalogue of Pictures* (British, German, Italian and Spanish Schools) (London: Wallace Collection, 1985), 1:77. The image Ingamells has in mind is Lebrun Figure 2, facing page 16, in the 1702 Amsterdam edition of the *Traité*.

20. Reynolds worked quite explicitly in this genre when he painted his *Lesbia, or the Dead Sparrow* (about 1788, private collection), where a young girl cradles a dead sparrow in her lap, an open birdcage beside her. For Greuze's work on the theme, see Brookner, *Greuze*.

21. See, for example, Wordsworth's "Lucy" poems, published in the *Lyrical Ballads* of 1800 (London: Longman; reprint, London: Longman, 1992).

22. Quoted in Tate Gallery, *Thomas Gainsborough* (London: Tate Gallery, 1980), 147.

23. Wark, *Reynolds's Discourses*, 249.

24. Quoted in W. T. Whitley, *Gainsborough*, 242.

25. Quoted in Millar, *Thomas Gainsborough*, 14.

26. With reference to both this and the Gainsborough *Cottage Girl*, it is interesting to note that James Walvin's *A Child's World: A Social History of English Childhood 1800–1914* (Harmondsworth: Penguin, 1982) devotes a chapter —"The Facts of Life"—to child sexuality in the lower classes purely as a function of overcrowding.

27. Specifically, Christopher White has suggested that it may be related to Rembrandt's *Young Girl Holding a Medal*, at Rousham in Oxfordshire in the eighteenth century.

28. Reynolds's early biographer William Cotton tells us that "Sir Joshua considered this one of his best pictures, observing that no man could ever produce more than about half-a-dozen really original works in his life; and, he added, pointing to the 'Strawberry Girl,' that picture is one of mine. Northcote says he repeated it several times, not so much for the sake of profit, as for improvement." In Cotton, *Sir Joshua Reynolds*, 118.

29. Quoted in Whitley, *Artists and Their Friends*, 1:291.

30. Quoted in Johnson, *Paintings of the British Social Scene*, 112.

31. Fletcher, *Conversations*, 121.

32. C. R. Leslie and Tom Taylor, *The Life of Sir Joshua Reynolds* (London: John Murray, 1865), 1:358.

33. See Thompson, *The Making of the English Working Class*, 368–69.

34. See Oliver Goldsmith, *An Enquiry into the Causes of the Encrease and Miseries of the Poor in England* (London: A. Bettesworth and C. Hitch, 1738), 43.

35. Catherine Cappe, *Observations on charity schools, female friendly societies, etc.* (London: J. Hatchard, J. Johnson, and J. Mawman, 1805).

36. I have not found record of abuse, physical or sexual, against children of other classes.

37. See, for example, Crown's otherwise thoughtful appraisal of Reynolds's works of fancy, "Portraits and Fancy Pictures," 159–67.

38. David M. Vieth, ed., *The Complete Poems of John Wilmot, Earl of Rochester* (New Haven: Yale University Press, 1968), 117, lines 37–40.

39. This link boy was known as "Little Cazey," described as "a little fellow, extremely ugly and vicious, a complete blackguard, without shoes or stockings; would lay on the dung-hills; was much noticed, being a link-boy of the Garden."

From John Green's *Odds and Ends About Covent Garden*, quoted in Smith, *Nollekens*, 203, n. 1.

40. This type of purse is fully detailed in Mannings's catalogue entry in Royal Academy, *Reynolds*, 264.

41. A point made by Mannings in Royal Academy, *Reynolds*, 264.

42. The Duke of Dorset bought at least fourteen paintings from Reynolds, nine of which were fancy pictures. See Malone, "Some Account of Sir Joshua Reynolds," in *Works of Reynolds*, 1:lxii–lxiii.

43. Randolph Trumbach has also suggested that the rise of domesticity stemmed from a male desire to control women and children on the grounds that "men believed they could not love what they did not own." He argues that at the same time the father wished to keep his distance from nurturing roles—perhaps like the position of Christopher Anstey in Hoare's portrait—due to fears of appearing to be effeminate, womanly, and ultimately homosexual. See Trumbach, *The Rise of the Egalitarian Family*, 123, 284.

44. See Drotner, *English Children and Their Magazines*, 45–46.

45. Plumb, "The New World of Children," 93.

46. A number of scholars have seen the development of modern child-rearing practices as the result of post-Puritan embitterment being taken out on the powerless, but have not fully explored the import of power relationships and control. See, for instance, Sommerville, *The Discovery of Childhood*, or Gordon Rattray Taylor, *The Angel Makers: A Study in the Psychological Origins of Historical Change*, rev. ed. (New York: Dutton, 1974). Randolph Trumbach goes further to suggest that one definition of patriarchy is the father's control over his children's sexuality in *The Rise of the Egalitarian Family*, 146.

47. Quoted in Pickering, *John Locke and Children's Books*, 167.

48. I am indebted here to Sommerville, *The Discovery of Childhood*, for his account of the course of Radicalism, page 166 ff.

49. Elton Smith and Esther Smith, *William Godwin* (New York: Twayne, 1965), 121.

50. Such a construct was not, of course, universally accepted. Edward Gibbon, for example, may be seen as having turned his *Memoir* into an attack on the cult of the child by chronicling the delusions of his youth. See Robert Folfenflik, "Child and Adult: Historical Perspective in Gibbon's Memoirs," *Studies in Burke and His Time* 15 (1973): 37–38.

Checklist of the Exhibition

Section 1

Sir Peter Lely, 1618–1680
Lady Charlotte Fitzroy, ca. 1674
Oil on canvas, 50 × 40 in. (127 × 101.5 cm)
York City Art Gallery (presented by the
National Art-Collections Fund)
Plate 10

Sir Joshua Reynolds, 1723–1792
Master Hare, 1788
Oil on canvas, 30⅜ × 25 in. (77.2 × 63.5 cm)
Musée du Louvre, département des Peintures
Plate 2

John Hoppner, 1758–1810
Miss Charlotte Papendiek as a Child, 1788
Oil on canvas, 30 × 25 in. (76.2 × 63.5 cm)
Los Angeles County Museum of Art, William
Randolph Hearst Collection
Plate 17

Sir Thomas Lawrence, 1769–1830
Charles William Lambton, R.A. 1825
Oil on canvas, 55½ × 43⅜ in. (140.9 × 110.2 cm)
Trustees of the Lambton Estate
Plate 18

Strickland Lowry, 1737?–ca. 1785
The Bateson Family, 1762
Oil on canvas, 64⁷⁄₁₆ × 104 in. (163.7 × 264 cm)
Ulster Museum, Belfast
Plate 14

Johann Zoffany, 1733–1810
The Blunt Children, 1768–70
Oil on canvas, 30¼ × 48¾ in. (76.8 × 123.8 cm)
Birmingham Museums and Art Gallery
Plate 15

John Singleton Copley, 1738–1815
The Children of Francis Sitwell, Esq., 1787
Oil on canvas, 71 × 81 in. (180.3 × 205.7 cm)
framed
Sir Reresby Sitwell, Bt DL, Renishaw Hall,
Derbyshire
[Berkeley and Dixon Gallery and Gardens
only]
Figure 8

Arthur W. Devis, 1762–1822
Emily and George Mason with their Ayahs,
ca. 1794–95
Oil on canvas, 39 × 42½ in. (99 × 108 cm)
Yale Center for British Art, Paul Mellon
Collection
Plate 12

Octavius Oakley, 1800–1867
Sir Reresby Sitwell with his Brother and Sister,
ca. 1828
Watercolor, 32½ × 27 in. (82.6 × 68.6 cm)
framed
Sir Reresby Sitwell, Bt DL, Renishaw Hall,
Derbyshire
Figure 9

Benjamin West, 1738–1820
Sketch for A Group of Five Children, undated
Chalk on paper, 9⅞ × 13¼ in. (25.1 × 33.6 cm)
The Board of Trustees of the Victoria and
Albert Museum, London
Figure 7

Hans Holbein, 1497–1543
"Death seizing a child," from T. Hodgson,
Emblems of Mortality, London, 1789
Woodcut engraving, 3⅛ × 2⅛ in. (8 × 5.4 cm)
The Pierpont Morgan Library, New York.
PML 4082. Purchased in the Toovey Collec-
tion, 1899
Figure 16

Benjamin West, 1738–1820
*Study for The Apotheosis of Princes Alfred and
Octavius,* undated
Pen, brown ink and brown wash on cream
paper, 17⁷⁄₁₆ × 11¹⁵⁄₁₆ in. (44.3 × 30.3 cm)
Museum of Fine Arts, Boston. Gift in memory
of John Hubbard Sturgis by his daughters,
Frances C. Sturgis, Mabel R. Sturgis, Mrs.
William Haynes-Smith, and Evelyn R. Sturgis.
1942.607
Figure 17

Allan Ramsay, 1713–1784
Sketch of a Dead Child, ca. 1743
Oil on canvas, 12⅝ × 10¾ in. (32 × 27.3 cm)
National Galleries of Scotland, Edinburgh
Plate 19

Section 2

Arthur Devis, 1712–1787
The John Bacon Family, ca. 1742–43
Oil on canvas, 30 × 51⅝ in. (76.6 × 131.1 cm)
Yale Center for British Art, Paul Mellon
Collection
Plate 21

William Hogarth, 1697–1764
A Fishing Party (The Fair Angler), ca. 1730
Oil on canvas, 21½ × 18⅞ in. (54.9 × 48.1 cm)
The Trustees of Dulwich Picture Gallery
[Berkeley only]
Plate 20

Henry Walton, 1746–1813
Sir Robert and Lady Buxton and their daughter Anne, ca. 1786
Oil on canvas, 29 × 36½ in. (73.7 × 92.7 cm)
Norfolk Museums Service (Norwich Castle Museum)
Plate 23

David Allan, 1744–1796
The Family of the 7th Earl of Mar at Alloa House, 1783
Oil on canvas, 60⅜ × 85¼ in. (153.4 × 216.5 cm)
Trustees of the late Lord Mar and Kellie, courtesy of the Scottish National Portrait Gallery
Plate 24

Sir Joshua Reynolds, 1723–1792
Jane Hamilton, wife of the 9th Lord Cathcart, and her daughter Jane, 1755
Oil on canvas, 48¾ × 39 in. (123.8 × 99.1 cm)
Manchester City Art Galleries
Plate 25

Thomas Hudson, 1701–1779
Catherine Compton, Countess of Egmont, and her Eldest Son, 1758
Oil on canvas, 49¾ × 40 in. (126.4 × 101.6 cm)
Private collection, courtesy of Lane Fine Art Ltd., London
[not illustrated]

Sir Joshua Reynolds, 1723–1792
Mrs. John Spencer and her daughter, 1759
Oil on canvas (unfinished), 30 × 25 in. (76.2 × 63.5 cm)
The Duke of Devonshire and the Chatsworth Settlement Trustees
Plate 26

George Keating, fl. 1775–76
Georgiana, Duchess of Devonshire, with her Daughter, 19 May 1787
Mezzotint engraving after Sir Joshua Reynolds, 12 × 15⅝ in. (30.5 × 39.7 cm)
The Duke of Devonshire and the Chatsworth Settlement Trustees
Figure 26

Charles Wilkin, 1750–1814
Cornelia, 1 December 1791
Stipple engraving after Reynolds's *Lady Cockburn and her Three Eldest Sons,*
17 × 13⅜ in. (43.2 × 34 cm)
Trustees of the British Museum
Figure 32

Benjamin West, 1738–1820
Mrs. Benjamin West and her son Raphael, ca. 1770
Oil on canvas, 35¾ in. (90.8 cm) diam.
Marriner S. Eccles Collection, Utah Museum of Fine Arts, University of Utah
Figure 28

William Blake, 1757–1827
"Spring," from *Songs of Innocence,* London, 1789
Copper plate etching, first plate, 4¹⁵⁄₁₆ × 3⅜ in. (12.5 × 8.5 cm); 4¾ × 3⁵⁄₁₆ in. (12.1 × 8.3 cm)
[See Illustrated Books at end of checklist]
Figure 37

Thomas Gainsborough, 1727–1788
Study of Woman Seated, with Three Children, mid to later 1780s
Black chalk and stump, heightened with white, 14 × 9½ in. (35.6 × 24.1 cm)
The Pierpont Morgan Library, New York, Acc. No. III, 59
[Berkeley only]
Figure 29

Sir Thomas Lawrence, 1769–1830
Priscilla Anne, Lady Burghersh with her son George Fane, 1820
Chalk and wash on paper, 9 × 7 in. (22.9 × 17.8 cm)
F. & L. S. Herman Foundation
Figure 30

Sir Joshua Reynolds, 1723–1792
Admiral Francis Holburne and his son, 1756–57
Oil on canvas, 58⅝ × 49 in. (149 × 124.5 cm) framed
National Maritime Museum, Greenwich, London
Figure 40

John Hamilton Mortimer, 1740–1779
Gentleman and Boy Looking at Prints, ca. 1765–70
Oil on canvas, 30 × 25 in. (76.2 × 63.5 cm)
Yale Center for British Art, Paul Mellon Collection
Plate 28

Johann Zoffany, 1733–1810
The Reverend Randall Burroughs and his son Ellis, 1769
Oil on canvas, 28 × 35¾ in. (71.1 × 91 cm)
Musée du Louvre, département des Peintures
Plate 29

William Hoare, 1707–1792
Christopher Anstey with his daughter Mary, ca. 1779
Oil on canvas, 49⅝ × 39¼ in. (126 × 99.7 cm)
National Portrait Gallery, London
Plate 30

Sir Henry Raeburn, 1756–1823
John Tait and his Grandson, ca. 1793
Oil on canvas, 49⅝ × 39⅜ in. (126 × 100 cm)
National Gallery of Art, Washington, Andrew W. Mellon Collection
Plate 31

William Dickinson, 1746–1823
A Family Piece, 1781
Stipple engraving after the drawing by Henry William, 9⅞ × 14½ in. (25.1 × 36.8 cm)
Print Collection, The Lewis Walpole Library, Yale University
Figure 21

Section 3

George Morland, 1763–1804
A Visit to the Child at Nurse, ca. 1788
Oil on canvas, 24¼ × 29½ in. (61.6 × 74.9 cm)
Syndics of the Fitzwilliam Museum, Cambridge
Plate 9

James Gillray, 1757–1815
The Fashionable Mamma,—or—The Convenience of Modern Dress, 15 February 1796
Hand-colored etching, 12⅜ × 8¹¹⁄₁₆ in. (31.4 × 22.1 cm)
Print Collection, The Lewis Walpole Library, Yale University
Figure 23

Anonymous [Thomas Rowlandson, 1756–1827]
Political Affection, 22 April 1784
Engraving, 8¾ × 12⅞ in. (22.3 × 32.7 cm)
Trustees of the British Museum
Figure 22

William Blake, 1757–1827
"A Cradle Song," from *Songs of Innocence,* London, 1789
Copper plate etching, first plate, 3¹⁄₁₆ × 4⅝ in. (7.7 × 11.7 cm); second plate 2¹⁵⁄₁₆ × 4⅝ in. (7.4 × 11.7 cm)
[See Illustrated Books at end of checklist]
Figure 35

William Blake, 1757–1827
"Nurse's Song," from *Songs of Innocence,* London, 1789
Copper plate etching, 4¹³⁄₁₆ × 3¹⁵⁄₁₆ in. (12.1 × 8.3 cm)
[See Illustrated Books at end of checklist]
Figure 38

William Blake, 1757–1827
"Infant Sorrow," from *Songs Innocence and of Experience,* London, 1794
Copper plate etching, 4⁹⁄₁₆ × 2¹⁵⁄₁₆ in. (11.6 × 7.4 cm)
[See Illustrated Books at end of checklist]
Figure 39

Anonymous
"Hush! my dear," from *Dr. Watts's celebrated Cradle Hymn, illustrated with appropriate engravings,* London, 1 August 1812
Stipple engraving, 5⅛ × 3¾ in. (13 × 9.5 cm)
The Pierpont Morgan Library, New York. PML 85528. Gift of Miss Elisabeth Ball, 1965
Figure 36

Section 4

William Hogarth, 1697–1764
The House of Cards, 1730
Oil on canvas, 25 × 29⅞ in. (63.5 × 75.9 cm)
National Museum of Wales
[Berkeley only]
Plate 34

William Hogarth, 1697–1764
The Children's Party, 1730
Oil on canvas, 25 × 28⅞ in. (63.5 × 73.3 cm)
National Museum of Wales
[Berkeley only]
Plate 35

Joseph Francis Nollekens, 1702–1747/48
Two Children of the Nollekens Family Playing with a Top and Playing Cards, 1745
Oil on canvas, 14⅛ × 12¼ in. (36 × 31 cm)
Yale Center for British Art, Paul Mellon Collection
Plate 6

Joseph Highmore, 1692–1780
Henry Penruddocke Wyndham and his brother Wadham, 1743
Oil on canvas, 50 × 40 in. (127 × 101.6 cm)
Private collection, courtesy of Lane Fine Art Ltd., London
Plate 32

Joseph Wright of Derby, 1734–1797
The Wood Children, 1789
Oil on canvas, 66 × 53 in. (167.6 × 134.6 cm)
Derby Museums and Art Gallery
Plate 33

George Morland, 1763–1804
Blind Man's Buff, 1787–88
Oil on canvas, 27½ × 35½ in. (69.9 × 89.8 cm)
The Detroit Institute of Arts. Gift of Elizabeth K. McMillan in memory of her sisters, Mary Isabella McMillan and Annie McMillan
Plate 36

Francis Danby, 1793–1861
Boys Sailing a Little Boat, ca. 1822
Oil on panel, 9¾ × 13¼ in. (24.8 × 33.7 cm)
Bristol Museums & Art Gallery
Plate 37

William Hogarth, 1697–1764
"First Stage of Cruelty," plate 1 from *The Four Stages of Cruelty,* 1751
Engraving, 15¹⁄₁₆ × 12 in. (38.3 × 30.5 cm)
Grunwald Center for the Graphic Arts, UCLA, anonymous gift
Figure 49

William Blake, 1757–1827
"The Ecchoing Green," from *Songs of Innocence,* London, 1789
Copper plate etching, first plate, 4⁹⁄₁₆ × 3 in. (11.6 × 7.6 cm); second plate 4⁹⁄₁₆ × 2¹⁵⁄₁₆ in. (11.6 × 7.3 cm)
[See Illustrated Books at end of Checklist]
Figure 44

William Blake, 1757–1827
"The Fly," from *Songs of Innocence and of Experience,* London, 1794
Copper plate etching, 4⅞ × 3¹⁄₁₆ in. (12.4 × 7.7 cm)
[See Illustrated Books at end of Checklist]
Figure 45

Anonymous
"Six boys playing cricket," from Master Michel Angelo [Richard Johnson], *Juvenile Sports and Pastimes,* London, 1780
Engraving, 1½ × 2¼ in. (3.8 × 5.7 cm)
The Pierpont Morgan Library, New York. PML 85544. Gift of Miss Elisabeth Ball, 1965
Figure 41

Attributed to William Blake, 1757–1827
Plate from C. G. Salzman [J. C. F. Guthsmuths], *Gymnastics for Youth: or a practical guide to healthful and amusing exercises for the use of schools,* London, 1800
Stipple engraving, 4½ × 2¹¹⁄₁₆ in. (11.5 × 6.9 cm)
The Pierpont Morgan Library, New York. PML 62952. Purchased on the Ball Fund, 1972
Figure 42

James and Josiah Neele, dates unknown
"A Gymnastic Exercise Ground," frontispiece from Gustavus Hamilton, *The Elements of gymnastics, for boys, and of calisthenics, for young ladies,* London, 1827
Etching, 4¼ × 8 in. (10.8 × 20.3 cm)
Yale Center for British Art, Paul Mellon Fund
Figure 43

William Mulready, 1786–1863
Frontispiece from William Roscoe, *The Butterfly's Ball and the Grasshopper's Feast,* London, 1 January 1807
Engraving, 3 × 3 in. (7.7 × 7.6 cm)
The Pierpont Morgan Library, New York. JPW 7309. Gift of Miss Julia P. Wightman, 1991
Figure 46

Section 5

Richard Wilson, 1713–1782
Prince George and Prince Edward Augustus with their Tutor, ca. 1748–49
Oil on canvas, 25 × 30⅛ in. (63.5 × 76.5 cm)
Yale Center for British Art, Paul Mellon Collection
Plate 38

John Hoppner, 1758–1810
John James Waldegrave, 6th Earl of Waldegrave, 1800
Oil on canvas, 30 × 26 in. (76.2 × 66 cm)
The Provost & Fellows of Eton College
Plate 39

William Mulready, 1786–1863
Mother Teaching her Child, 1859
Oil on canvas, 17⅜ × 13⅜ in. (44.1 × 34 cm)
The Board of Trustees of the Victoria and Albert Museum, London
Figure 64

William Ward, 1766–1826
A Visit to the Boarding School, 1789
Mezzotint printed in color after George Morland, 17⅜ × 21⅝ in. (44 × 55 cm)
Yale Center for British Art, Paul Mellon Collection
Figure 56

Thomas Barker of Bath, 1769–1847
Seated Boy with Book, early 19th century
Ink and wash, 10 × 7¼ in. (25.4 × 18.4 cm)
Grunwald Center for the Graphic Arts, UCLA
Figure 52

John Augustus Atkinson, 1775–1831/33
Going to School, ca. 1801–10
Pen, black ink, and watercolor, 7½ × 6⅛ in. (19.1 × 15.6 cm)
Yale Center for British Art, Paul Mellon Collection
Figure 53

William Blake, 1757–1827
"The School-Boy," from *Songs of Innocence and of Experience,* London, 1794
Copper plate etching, 4⅝ × 2¹⁵⁄₁₆ in. (11.7 × 7.4 cm)
[See Illustrated Books at end of Checklist]
Figure 61

Anonymous
"A view of Mrs Bell's School at Rose Green," from Dorothy Kilner, *The Village School,* vol. 1, London, 1781–87
Engraving, 3¹³⁄₁₆ × 3⅞ in. (9.7 × 9.9 cm)
The Pierpont Morgan Library, New York. PML 82797. Gift of Miss Elisabeth Ball, 1965
Figure 59

John Harden, 1772–1847
Dame School at Elterwater, 1806
Watercolor, 8¹³⁄₁₆ × 11¹³⁄₁₆ in. (22.4 × 30 cm)
Abbot Hall Art Gallery, Kendal, Cumbria, England
Figure 58

Anonymous
Frontispiece from *The Children's Bible,* London, 1763
Engraving, 4³⁄₁₆ × 3½ in. (10.6 × 9 cm)
The Pierpont Morgan Library, New York. PML 85502. Gift of Miss Elisabeth Ball, 1965
Figure 63

James Peachy, dates unknown
Frontispiece from Anonymous, *A Primer for the use of the Mohawk Children, to acquire the spelling and reading of their own, as well as to get acquainted with the English tongue,* London, 1786
Engraving, 3⅝ × 2¾ in. (9.2 × 7 cm)
The Pierpont Morgan Library, New York. PML 85496. Gift of Miss Elisabeth Ball, 1965
Figure 60

Anonymous
Frontispiece from Richard Ransome, *The Good Boy's Soliloquy; containing his parents' instructions relative to his disposition and manners,* London, 1811
Engraving, 4¾ × 3½ in. (12 × 9 cm)
The Pierpont Morgan Library, New York.
PML 80883. Gift of Miss Elisabeth Ball, 1965
Figure 65

Section 6

William Hogarth, 1697–1764
Study for The Foundlings, 1739
Pen, brush, and gray ink, 4⁷⁄₁₆ × 8⅜ in. (11.4 × 21.4 cm)
Yale Center for British Art, Paul Mellon Collection
Figure 66

Joseph Francis Nollekens, 1702–1747/48
Children Playing with a Hobby Horse, ca. 1741–48
Oil on canvas, 18 × 22 in. (45.7 × 55.9 cm)
Yale Center for British Art, Paul Mellon Collection
Plate 41

James Ward, 1769–1859
The Rocking Horse, 1793
Engraving, 18 × 21⅞ in. (45.7 × 55.6 cm)
Trustees of the British Museum
Figure 3

William Ward, 1766–1826
The Sailor's Orphans, or the Young Ladies' Subscription, June 1, 1800
Mezzotint printed in color after William Redmore Bigg, 18 × 23¾ in. (45.7 × 60.5 cm)
Yale Center for British Art, Paul Mellon Collection
Figure 69

William Blake, 1757–1827
"Holy Thursday," from *Songs of Innocence,* London, 1789
Copper plate etching, 4¾ × 3⁵⁄₁₆ in. (12.1 × 8.4 cm)
[See Illustrated Books at end of checklist]
Figure 67

William Blake, 1757–1827
"Holy Thursday," from *Songs Innocence and of Experience,* London, 1794
Copper plate etching, 4⅝ × 3¹⁄₁₆ in. (11.7 × 7.7 cm)
[See Illustrated Books at end of checklist]
Figure 68

William Mulready, 1786–1863
Train Up a Child in the Way He Should Go; and When He Is Old He Will Not Depart From It, 1841
Oil on canvas, 25½ × 31 in. (64.8 × 78.7 cm)
The FORBES Magazine Collection, New York
Plate 40

Section 7

Thomas Gainsborough, 1727–1788
Girl with Pigs, 1782
Oil on canvas, 49½ × 58½ in. (125.7 × 148.6 cm)
From the Castle Howard Collection
Figure 78

Thomas Gainsborough, 1727–1788
Two Shepherd Boys with Dogs Fighting, 1783
Oil on canvas, 88 × 62 in. (223.5 × 157.5 cm)
The Iveagh Bequest, Kenwood–English Heritage
[Berkeley only]
Plate 43

Thomas Gainsborough, 1727–1788
Peasant Smoking at Cottage Door, 1788
Oil on canvas, 77 × 62 in. (195.6 × 157.5 cm)
Collection Wight Art Gallery, UCLA. Gift of Mrs. James Kennedy
Plate 42

Francis Wheatley, 1747–1801
A Peasant Boy, ca. 1790
Oil on canvas, 30½ × 41 in. (77.5 × 104.1 cm)
Royal Academy of Arts, London
Figure 81

Sir Henry Raeburn, 1756–1823
Boy and Rabbit, 1786
Oil on canvas, 40 × 31 in. (101.6 × 78.7 cm)
Royal Academy of Arts, London
Plate 44

Francis Wheatley, 1747–1801
Spring, 1793–94
Oil on canvas, 35 × 27¼ in. (88.9 × 69.2 cm)
Los Angeles County Museum of Art, Marion Davies Collection
Figure 82

George Morland, 1763–1804
The Squire's Door, ca. 1790
Oil on canvas, 15⁵⁄₁₆ × 12⅞ in. (39 × 32.7 cm)
Yale Center for British Art, Paul Mellon Collection
Figure 77

William Mulready, 1786–1863
Giving a Bite, 1834
Oil on canvas, 19¾ × 15⅜ in. (50.4 × 39 cm)
The Board of Trustees of the Victoria and Albert Museum, London
Figure 83

William Mulready, 1786–1863
A Dog of Two Minds, 1829–30
Oil on panel, 24⅜ × 20⅜ in. (62 × 51.7 cm)
The Board of Trustees of the National Museums & Galleries on Merseyside (Walker Art Gallery)
[Berkeley only]
Figure 84

Thomas Barker of Bath, 1769–1847
Young Boy Seated, 1803
Pen lithograph, 11½ × 7¾ in. (29.2 × 19.7 cm)
University Art Museum and Pacific Film Archive, University of California, Berkeley
Figure 85

Robert Dighton, 1752–1814
Mr. Deputy Dumpling & Family Enjoying a Summer Afternoon, 1781
Mezzotint engraving, 13¹³⁄₁₆ × 10¹⁄₁₆ in. (35.2 × 25.4 cm)
Yale Center for British Art, Paul Mellon Collection
Figure 76

Anonymous
"The London Beggars," from *The Cries of London,* London, 1760
Engraving, 3⁹⁄₁₆ × 2⁹⁄₁₆ in. (9.1 × 6.5 cm)
The Pierpont Morgan Library, New York.
PML 81988. Purchased as the gift of the Viscount Astor, 1975
Figure 70

William Blake, 1757–1827
"The Chimney Sweeper," from *Songs of Innocence and of Experience,* London, 1794
Copper plate etching, 4⁵⁄₁₆ × 2¾ in. (11 × 7 cm)
The Keynes Family Trust, courtesy of the Fitzwilliam Museum, Cambridge
Figure 72

William Mulready, 1786–1863
The Chimney Sweep, ca. 1815–20
Pen and brown ink, 2¾ × 2½ in. (7.2 × 6.6 cm)
The Whitworth Art Gallery, The University of Manchester
Figure 73

Anonymous
Title page from *Will Wander's Walk, with both his companions and all of their talk,* London, 9 August 1806
Engraving, 4⁵⁄₁₆ × 3⁹⁄₁₆ in. (11 × 9 cm)
The Pierpont Morgan Library, New York.
PML 84077. Gift of Miss Elisabeth Ball, 1965
Figure 71

Section 8

George Morland, 1763–1804
The Comforts of Industry, 1790
Oil on canvas, 12¼ × 14½ in. (31.1 × 36.8 cm)
National Galleries of Scotland, Edinburgh
Plate 45

George Morland, 1763–1804
The Miseries of Idleness, 1790
Oil on canvas, 12¼ × 14½ in. (31.2 × 36.9 cm)
National Galleries of Scotland, Edinburgh
Plate 46

Francis Wheatley, 1747–1801
The Happy Fireside—Married Life, 1791
Oil on canvas, 31½ × 26½ in. (80 × 67.3 cm)
Private collection
Plate 47

John Opie, 1761–1807
Street Singer and Child, undated
Oil on canvas, 30 × 25¼ in. (76.5 × 64.3 cm)
The Cleveland Museum of Art. Gift of Mr. and
Mrs. J. H. Wade. 16.1030.
Figure 91

John Constable, 1776–1837
A Suffolk Child, 1835
Watercolor, 7¼ × 5⅜ in. (18.5 × 13.7 cm)
The Board of Trustees of the Victoria and
Albert Museum, London
Plate 48

John Flaxman, 1755–1826
Little Girl, ca. 1787–92
Graphite on pale gray paper, 11 × 6½ in.
(27.9 × 16.5 cm)
Museum of Fine Arts, Boston. Gift of Mr.
Rowland Burdon-Muller and the William A.
Sargent Fund. 1953.2648
Figure 92

William Ward, 1766–1826
At Home, undated
Colored mezzotint after George Morland,
14³⁄₁₆ × 18 in. (36 × 45.7 cm)
Grunwald Center for the Graphic Arts, UCLA.
Gift of Mrs. Katharine Siemon
Figure 86

Julius Caesar Ibbetson, 1759–1817
The Sailor's Return Home, 1795
Watercolor, 11¾ × 15¾ in. (29.8 × 40.1 cm)
The Board of Trustees of the Victoria and
Albert Museum, London
Figure 87

Isaac Cruikshank, 1757/58–1810/11
The Child Found, ca. 1790
Watercolor, 12½ × 9¹⁵⁄₁₆ in. (31.7 × 25.2 cm)
The Board of Trustees of the Victoria and
Albert Museum, London
Figure 88

Joseph Wright of Derby (Studio of), 1734–1797
Philosopher Giving a Lecture on the Orrery,
ca. 1768
Oil on canvas (grisaille), 17⅝ × 23½ in.
(44.8 × 59.7 cm)
Yale Center for British Art, Paul Mellon
Collection
Figure 90

Valentine Green, 1739–1813
Experiment with the Air Pump, 1769
Mezzotint engraving after Joseph Wright of
Derby, 18¹⁄₁₆ × 23³⁄₁₆ in. (45.9 × 58.9 cm)
Grunwald Center for the Graphic Arts, UCLA
Figure 89

Anonymous
"The Unlocking of the Good Child's Box,"
from Dorothy Kilner, *The Holyday Present,*
London, ca. 1788
Engraving, 4⅝ × 2¹⁵⁄₁₆ in. (11.8 × 7.5 cm)
Houghton Library, Harvard University, gift of
W. S. Poor
Figure 93

Anonymous
"Allegory of good behavior," from M. P.
[Dorothy Kilner], *The Life and Perambulations
of a Mouse,* London, ca. 1783
Engraving, 1⅞ × 2⅜ in. (4.7 × 6 cm)
The Pierpont Morgan Library, New York.
PML 85514. Gift of Miss Elisabeth Ball, 1965
Figure 94

Section 9

Sir Joshua Reynolds, 1723–1792
Master Crewe as Henry VIII, 1775–76
Oil on canvas, 55 × 43½ in. (139.7 × 110.5 cm)
The Rt. Hon. The Lord O'Neill TD DL
Plate 50

Philip Mercier, 1689–1760
Playing Soldier (The Dog's Education), ca. 1744
Oil on canvas, 50 × 39⅜ in. (127 × 100 cm)
The Detroit Institute of Arts. Gift of Mr. and
Mrs. Edgar B. Whitcomb
Plate 49

Sir Joshua Reynolds, 1723–1792
The Infant Academy, 1782
Oil on canvas, 44⅞ × 56 in. (114 × 142 cm)
The Iveagh Bequest, Kenwood–English
Heritage
[Berkeley only]
Figure 98

Sir Joshua Reynolds, 1723–1792
Child Baptist in the Wilderness, ca. 1776
Oil on canvas, 49½ × 39⅞ in. (125.7 × 101.3 cm)
The Minneapolis Institute of Arts, The Chris-
tina N. and Swan J. Turnblad Memorial Fund
Figure 99

Sir Joshua Reynolds, 1723–1792
Cupid as Link Boy, 1774
Oil on canvas, 30 × 25 in. (76.2 × 63.5 cm)
Albright-Knox Art Gallery, Buffalo, New York,
Seymour H. Knox Fund through special gifts
to the fund by Mrs. Marjorie Knox Campbell,
Mrs. Dorothy Knox Rogers and Mr. Seymour
H. Knox, Jr., 1945
Plate 8, figure 101

Sir Joshua Reynolds, 1723–1792
Mercury as Cut Purse, 1771
Oil on canvas, 30 × 25 in. (76.2 × 63.5 cm)
framed
The Faringdon Collection Trust
[Berkeley only]
Plate 51

John Dean, 1750?–1798
Mercury as Cut Purse, 15 August 1777
Engraving after Reynolds, 15½ × 10¹³⁄₁₆ in.
(39.5 × 27.5 cm)
Trustees of the British Museum
Figure 102

John Whessell, fl. 1760s
The Young Cottager, 1806
Engraving after Gainsborough's *Cottage Girl
with Dog and Pitcher,* 24¹³⁄₁₆ × 19¹¹⁄₁₆ in.
(63 × 50 cm)
Trustees of the British Museum
Figure 100

Illustrated Books

William Blake's *Songs of Innocence* and *Songs
of Innocence and of Experience* are lent by the
following institutions:

William Blake, 1757–1827
Songs of Innocence, London, 1789
Illustrated book
The Lessing J. Rosenwald Collection, Rare
Book and Special Collections Division, Library
of Congress

William Blake, 1757–1827
Songs of Innocence, London, 1789
Illustrated book
Harry Ransome Humanities Research Center,
The University of Texas at Austin
[Berkeley only]

William Blake, 1757–1827
Songs of Innocence, London, 1789
Plates from the illustrated book
Cincinnati Art Museum. Bequest of Herbert
Greer French. 1943.559

William Blake, 1757–1827
Songs of Innocence and of Experience, London,
1794
Illustrated book
Cincinnati Art Museum. Gift of Mr. and Mrs.
John J. Emery. 1969.509
[Berkeley only]

William Blake, 1757–1827
Songs of Innocence and of Experience, London,
1794 (watermarked ca. 1824)
Illustrated book
The Lessing J. Rosenwald Collection, Rare
Book and Special Collections Division, Library
of Congress

William Blake, 1757–1827
Songs of Innocence and of Experience, London,
1794
Illustrated book
Department of Rare Book and Special Collec-
tions, Princeton University Libraries. Gift of
Caroline Newton

Select Bibliography

Aiken, John. *Letters from a Father to his Son, on Various Topics, Relative to Literature and the Conduct of Life.* London: J. Johnson, 1793.

Alford, F., ed. *Life, Journals and Letters of Henry Alford, D. D.* London: Rivingtons, 1873.

Andrew, Donna T. *Philanthropy and Police: London Charity in the Eighteenth Century.* Princeton: Princeton University Press, 1989.

Andrews, C. Bruyn. *The Torrington Diaries.* 4 vols. London: Eyre and Spottiswoode, 1934–38.

Anon. *A Candid Review of the Exhibition.* London, 1780.

Anon. *A Collection of the Moral and Instructive Sentiments, Maxims, Cautions and Reflections Contained in the Histories of Pamela, Clarissa, and Sir Charles Grandison, Digested under Proper Heads.* London: S. Richardson, 1755.

Anon. *The Beauties of Fielding.* London: G. Kearsley, 1782.

Anon. *The Ear-Wig; Or an Old Woman's Remarks on the Present Exhibition of Pictures at the Royal Academy.* London: G. Kearsley, 1781.

Anon. *Miscellanies for Sentimentalists.* London, 1786.

Antal, Frederick. "Hogarth and His Borrowings." *Art Bulletin* 29 (March 1947): 36–48.

———. *Hogarth and His Place in European Art.* London: Routledge and Kegan Paul, 1962.

Archer, Richard Lawrence, ed. *Jean-Jacques Rousseau, His Educational Theories Selected from Emile, Julie and Other Writings.* Woodbury, N.Y.: Barron's Educational Series, 1964.

Ariès, Phillipe. *Centuries of Childhood: A Social History of Family Life.* London: Jonathan Cape, 1962.

Avery, Gillian. *Childhood's Pattern: A Study of the Heroes and Heroines of Children's Fiction, 1770–1950.* London: Hodder & Stoughton, 1975.

Avery, Gillian, and Julia Briggs, eds. *Children and Their Books: A Celebration of the Work of Iona and Peter Opie.* Oxford: Clarendon Press, 1989.

Axtell, J. L., ed. *The Educational Writings of John Locke.* Cambridge: Cambridge University Press, 1965.

Babenroth, A. Charles. *English Childhood: Wordsworth's Treatment of Childhood in the Light of English Poetry from Prior to Crabbe.* New York: Columbia University Press, 1922.

Badinter, Elisabeth. *The Myth of Motherhood: An Historical View of the Maternal Instinct.* London: Souvenir Press, 1981.

Balderston, K. C. *Thraliana: The Diary of Mrs Hester Lynch Thrale (Later Mrs Piozzi).* 2 vols. Oxford: Oxford University Press, 1951.

Barrell, John. *The Dark Side of the Landscape: The Rural Poor in English Painting 1730–1840.* Cambridge: Cambridge University Press, 1980.

Barry, James. *The Works of James Barry.* 2 vols. London: T. Cadell and W. Davies, 1809.

Bate, W. J., ed. *Samuel Johnson: The Idler and Adventurer.* New Haven: Yale University Press, 1963.

Bayne-Powell, Rosamond. *The English Child in the Eighteenth Century.* London: John Murray, 1939.

Beattie, James. *The Minstrel; or, The Progress of Genius.* London: E. C. Dilly, 1771.

Berens, E. *A Selection from the papers of Addison in the Spectator and Guardian, for the use of young persons.* London: C. & J. Rivington, 1827.

Bessborough, Earl of, ed. *Georgiana: Extracts from the Correspondence of Georgiana, Duchess of Devonshire.* London: John Murray, 1955.

Bindman, David. *Hogarth.* London: Thames and Hudson, 1981.

Blagdon, Francis William. *Authentic Memoirs of the Late George Morland.* London: Edward Orme, 1806.

Blunt, Anthony. "Blake's Pictorial Imagination." *Journal of the Warburg and Courtauld Institutes* 6 (1943): 190–212.

Boas, George. *The Cult of Childhood.* London: Warburg, 1966.

Boswell, James. *Life of Johnson.* Ed. G. Birkbeck Hill and L. F. Powell. 6 vols. London: Oxford University Press, 1934–50.

Brookner, Anita. *Greuze: The Rise and Fall of an Eighteenth-Century Phenomenon.* London: Elek, 1972.

Broughton, Mrs. Vernon Delves, ed. *Court and Private Life in the Time of Queen Charlotte: Being the Journals of Mrs Papendiek, Assistant Keeper of the Wardrobe and Reader to Her Majesty.* 2 vols. London: Richard Bentley & Son, 1887.

Brown, Iain Gordon. "Allan Ramsay's Rise and Reputation." *Walpole Society* 50 (1984): 209–47.

Bruand, Yves. "Hubert Gravelot et l'Angleterre." *Gazette des Beaux-Arts*, 6th per., 55 (January 1960): 35–44.

Buchan, William. *Domestic Medicine.* London: Strahan and Cadell, 1769.

Burney, Frances [Mme D'Arblay]. *Diary and Letters of Mme D'Arblay.* Ed. C. F. Barrett. 7 vols. London: Hurst and Blackett, 1854.

Burton, Anthony. "Looking Forward from Ariès: Pictorial and Material Evidence for the History of Childhood and Family Life." *Continuity and Change* 4 (1989): 203–29.

Cadogan, William. *An Essay upon nursing and the management of children from their birth to three years of age.* London: J. Roberts, 1748.

Calvert, Karin. *Children in the House: The Material Culture of Early Childhood, 1600–1900.* Boston: Northeastern University Press, 1992.

Carpenter, Humphrey. *The Oxford Companion to Children's Literature.* Oxford: Oxford University Press, 1984.

Carritt, David. "Mr. Fauquier's Chardins." *Burlington Magazine* 116 (September 1974): 502–509.

Caulfield, Ernest. *The Infant Welfare Movement in the Eighteenth Century.* New York: P. B. Hoeber, 1931.

Chartier, Roger, ed. *A History of Private Life: Passions of the Renaissance.* Cambridge, Mass.: Belknap Press, 1989.

Clark, J. C. D. *English Society 1688–1832.* Cambridge: Cambridge University Press, 1985.

Cormack, Malcolm. "The Ledgers of Sir Joshua Reynolds." *Walpole Society* 42 (1968–70): 105–169.

Cotton, William. *Sir Joshua Reynolds and his works. Gleanings from his diary, unpublished manuscripts, and from other sources.* London: Longman, Brown, 1856.

———. *Sir Joshua Reynolds's Notes and Observations on Pictures. . . .* London: J. R. Smith, 1859.

Coveney, Peter. *Poor Monkey: The Child in Literature.* London: Rockliff, 1957.

Crabbe, George. *Life and Poems.* London: John Murray, 1847.

Crown, Patricia. "Portraits and Fancy Pictures by Gainsborough and Reynolds: Contrasting Images of Childhood." *British Journal for Eighteenth-Century Studies* 7 (autumn 1984): 159–67.

Cunnington, C. Willet, and Phillis Cunnington. *Handbook of English Costume in the Eighteenth Century.* London: Faber & Faber, 1957.

Cunnington, Phillis, and Anne Buck. *Children's Costume in England from the Fourteenth to the End of the Nineteenth Century.* London: Adam & Charles Black, 1965.

Dabydeen, David. *Hogarth's Blacks: Images of Blacks in Eighteenth Century English Art.* Kingston-upon-Thames: Dangaroo Press, 1985.

Darton, F. J. Harvey. *Children's Books in England: Five Centuries of Social Life.* 3rd ed. Cambridge: Cambridge University Press, 1982.

Davidoff, Leonore, and Catherine Hall. *Family Fortunes: Men and Women of the English Middle Class 1780–1850.* London: Hutchinson, 1987.

Dawe, George. *The Life of George Morland, with Remarks on His Works.* London: Vernor, Hood, and Sharpe, 1807.

Day, Thomas. *The History of Sandford and Merton: A Work Intended for the Use of Children.* 3 vols. London: Stockdale, 1783.

De Mause, Lloyd. *The History of Childhood.* New York: Psychohistory Press, 1974.

Devonshire Letters. Chatsworth.

Dorment, Richard. *British Painting in the Philadelphia Museum of Art.* London: Weidenfeld and Nicolson, 1986.

D'Otrange-Mastai, M. L. "'Simplicity and Truth': Reynolds, Painter of Childhood." *Apollo* 65 (June 1957): 201–205.

Drotner, Kirsten. *English Children and Their Magazines, 1751–1945.* New Haven: Yale University Press, 1988.

Duncan, Carol. "Fallen Fathers: Images of Authority in Pre-Revolutionary French Art." *Art History* 4 (March 1981): 186–202.

Durantini, Mary Frances. *The Child in Seventeenth-Century Dutch Painting.* Ann Arbor: UMI, 1983.

Earland, Ada. *John Opie and His Circle.* London: Hutchinson, 1911.

Edwards, Edward. *Anecdotes of Painters who have resided or been born in England.* London: Leigh and Sotheby, 1808.

Edwards, Ralph. *Early Conversation Pictures.* London: Country Life, 1954.

Eland, G., ed. *The Purefoy Letters, 1735–53.* 2 vols. London: Sidgwick and Jackson, 1931.

Elgar, Alfred. "Morland's Children's Prints." *Antique Collector* 7 (July 1936): 171–74.

Erdman, David V. *The Illuminated Blake.* Garden City, N.Y.: Anchor Books, 1974.

Erffa, Helmut von, and Allen Staley. *The Paintings of Benjamin West.* New Haven and London: Yale University Press, 1986.

Erickson, Robert Allen. *Mother Midnight: Birth, Sex, and Fate in Eighteenth-Century Fiction.* New York: AMS Press, 1986.

Farington, Joseph. *Diaries.* Vols. 1–6, ed. K. Garlick and A. Macintyre; vols. 7–14, ed. K. Cave. London and New Haven: Yale University Press, 1978–84.

——. *Memoirs of the Life of Sir Joshua Reynolds with Some Observations on His Talents and Character.* London: T. Cadell and W. Davies, 1819.

Fenn, Eleanor. *Cobwebs to Catch Flies.* London, 1851.

Ferguson, Frances. "Reading Morals: Locke and Rousseau on Education and Inequality." *Representations* 6 (spring 1984): 66–84.

Fielding, Sir John. *An Account of the Origin and Effects of a Police.* London: A. Millar, 1758.

——. *Extracts from such of the penal laws as particularly relate to the peace and order of the Metropolis.* London: 1768.

Fildes, Valerie. *Breast, Bottles and Babies: A History of Infant Feeding.* Edinburgh: Edinburgh University Press, 1986.

Fitzgerald, Brian, ed. *Correspondence of Emily, Duchess of Leinster (1731–1814).* 3 vols. Dublin: Stationery Office, 1949–53.

Fletcher, Ernest, ed. *Conversations of James Northcote, R.A., with James Ward on Art and Artists.* London: Methuen, 1901.

——. *Conversations of James Northcote, R.A., with William Hazlitt.* London: Bentley & Son, 1894.

Fondazione Giorgio Gini. *William Hogarth: Dipinti, disegni, incisioni.* Ed. Alessandro Bettagno; catalogue by Mary Webster. Vicenza: Neri Pozza Editore, 1989.

Forrester, James. *Dialogues on the Passions, Habits, Appetites and Affections, etc., Peculiar to Children.* London: R. Griffiths, 1748.

Fremantle, Anne, ed. *The Wynne Diaries.* 3 vols. London: Oxford University Press, 1935–40.

Fuller, Peter. *The Naked Artist.* London: Writers and Readers, 1983.

Fuseli, Henry. *The Mind of Henry Fuseli: Selections from His Writings with an Introductory Study by Eudo C. Mason.* London: Routledge & Kegan Paul, 1951.

——. *Remarks on the Writings and Conduct of John James Rousseau.* London: T. Cadell, J. Johnson, B. Davenport, and J. Payne, 1767.

Garland, Madge. *The Changing Face of Childhood.* New York: October House, 1963.

Gardner, Stanley. *Blake's Innocence and Experience Retraced.* London: Athlone Press, 1986.

Garlick, Kenneth. *Sir Thomas Lawrence.* London: Routledge & Kegan Paul, 1954.

Gear, Josephine. *Masters or Servants?* New York and London: Garland, 1977.

George, M. Dorothy. *London Life in the Eighteenth Century.* London: Kegan Paul, 1925. Reprint, London: Penguin, 1987.

Gilchrist, Alexander. *Life of William Blake.* 2 vols. London: Macmillan and Co., 1863, 1880.

Gluck, Gustav. "Van Dyck, painter of children." *Gazette des Beaux-Arts* 6th ser., 24 (July 1943): 11–18.

Gombrich, E. H. "Reynolds Theory and Practice of Imitation." *The Burlington Magazine* 80 (February 1942): 40–45.

Gosse, Philip. *Dr. Viper: The Querulous Life of Philip Thicknesse.* London: Cassell, 1952.

Gowing, Lawrence. "Hogarth, Hayman and the Vauxhall Decorations." *The Burlington Magazine* 95 (January 1953): 4–19, 142.

Granville, Lady. *Lord Granville Leveson Gower.* 2 vols. New York: Dutton, 1916.

Graves, A., and W. V. Cronin. *History of the Works of Sir Joshua Reynolds.* 4 vols. London: H. Graves and Co., Ltd., 1899–1901.

Greig, James. *Sir Henry Raeburn, R.A.: His Life and Works with a Catalogue of His Pictures.* London: The Connoisseur, 1911.

Halsband, Robert, ed. *The Complete Letters of Mary Wortley Montagu.* 3 vols. Oxford: Clarendon Press, 1965–67.

——. *The Life of Lady Mary Wortley Montagu.* New York: Oxford University Press, 1960.

Hanway, Jonas. *An Earnest Appeal for Mercy to the Children of the Poor.* London, 1766.

Hardyment, Christina. *Dream Babies: Child Care from Locke to Spock.* London: Cape, 1983.

Harris Museum and Art Gallery. *Polite Society by Arthur Devis 1712–1787: Portraits of the English Country Gentleman and his Family.* Preston: Harris Museum and Art Gallery, 1983.

Hassell, J. *Memoirs of the Life of the Late George Morland,* London: J. Cundee, 1806.

Haydon, Benjamin Robert. *The Autobiography and Journals.* Ed. Malcolm Elwin. London: MacDonald, 1950.

——. *The Diary of Benjamin Robert Haydon.* Ed. Willard Bissell. Cambridge, Mass.: Harvard University Press, 1960–63.

Hayes, John. *The Drawings of Thomas Gainsborough.* 2 vols. New Haven and London: Yale University Press, 1971.

——. "English Painting and the Rococo." *Apollo* 90 (August 1969): 114–125.

——. *Gainsborough as Printmaker.* New Haven and London: Yale University Press, 1972.

Hayley, William. *The Life of George Romney, Esq.* Chichester: T. Payne, 1809.

Hazlitt, William. *Conversations of James Northcote, Esq., R.A.* London: H. Colburn and R. Bentley, 1830.

Heleniak, Kathryn Moore. *William Mulready.* New Haven and London: Yale University Press, 1980.

Hilles, F. W., ed. *Letters of Sir Joshua Reynolds*. Cambridge: Cambridge University Press, 1929. Reprint, New York: AMS Press, 1976.

———. *The Literary Career of Sir Joshua Reynolds*. Cambridge: Cambridge University Press, 1936.

Hilles, F. W., and P. B. Daghlian, eds. *Anecdotes of Painting in England . . . collected by Horace Walpole*. New Haven: Yale University Press, 1937.

Hogarth, William. *The Analysis of Beauty, with Rejected Passages from the Manuscript Drafts and Autobiographical Notes*. 1753. Reprint, Joseph Burke, ed. Oxford: Oxford University Press, 1955.

Houlbrooke, Ralph A. *The English Family 1450–1750*. London: Longmans, 1984.

Hoyles, Martin, ed. *Changing Childhood*. London: Writers and Readers, 1979.

Ilchester, Countess of, and Lord Stavordale. *The Life and Letters of Lady Sarah Lennox, 1745–1826*. London: John Murray, 1902.

Ilchester, Earl of, ed. *The Journal of Elizabeth Lady Holland (1791–1811)*. London: Longmans, Green & Co., 1909.

Ingamells, John, and Robert Raines. "A Catalogue of the Paintings, Drawings and Etchings of Philip Mercier." *Walpole Society* 46 (1978): 1–70.

Iveagh Bequest, Kenwood. *The Conversation Piece in Georgian England*. London: London County Council, 1965.

———. *Exhibition of Paintings by Angelica Kauffmann*. London: London County Council, 1955.

———. *John Hamilton Mortimer, 1740–1779: Paintings, Drawings and Prints*. Eastbourne: Towner Art Gallery, 1968.

———. *Paintings and Drawings by Allan Ramsay*. Catalogue by Alastair Smart. London: London County Council, 1958.

———. *Paintings by Joseph Highmore*. London: London County Council, 1963.

———. *Philip Mercier, 1689–1760*. Catalogue by Robert Raines and John Ingamells. London: Mellon Foundation, 1969.

Jackson, Mary V. *Engines of Instruction, Mischief, and Magic: Children's Literature in England from its Beginnings to 1839*. Lincoln: University of Nebraska Press, 1989.

Jackson, William. *The Four Ages, together with Essays on various Subjects*. London: Cadell and Davies, 1798.

Jarrett, Derek. *England in the Age of Hogarth*. New Haven: Yale University Press, 1986.

Johnson, E. D. H. *Paintings of the British Social Scene from Hogarth to Sickert*. New York: Rizzoli, 1986.

Johnson, Samuel. *The Idler*. London: J. Newbery, 1761.

Jones, Vivien, ed. *Women in the Eighteenth Century: Constructions of Femininity*. London: Routledge, 1990.

Kevill-Davies, Sally. *Yesterday's Children: The Antiques and History of Childcare*. Woodbridge, Suffolk: Antique Collectors' Club, 1991.

Kilner, Dorothy. *Anecdotes of a boarding school; or, an antidote to the vices of those Establishments*. 2 vols. London, 1790(?).

———. *The Life and Perambulations of a Mouse*. London: Baldwin, Craddock & Joy, 1819.

Kincaid, James R. *Child-Loving: The Erotic Child and Victorian Culture*. New York and London: Routledge, 1992.

Klingender, Francis. *Art and the Industrial Revolution*. London: N. Carrington, 1947.

Kunzle, David. "William Hogarth: The Ravaged Child in the Corrupt City." *Changing Images of the Family*. Ed. V. Tufte and B. Myerhoff. New Haven: Yale University Press, 1979.

Langford, Paul. *A Polite and Commercial People: England 1727–1783*. Oxford: Oxford University Press, 1989.

Lavater, Johann Caspar. *Essays on Physiognomy*. London, 1775–1778; reprint, London: John Murray, 1789–98.

Layard, George Somes. *Sir Thomas Lawrence's Letter-Bag*. London: George Allen, 1906.

Leader, Zachary. *Reading Blake's Songs*. London: Routledge & Kegan Paul, 1981.

Le Fanu, W., ed. *Betsy Sheridan's Journal*. Oxford and New York: Oxford University Press, 1986.

Leppert, Richard. *Music and Image: Domesticity, Ideology and Social-Cultural Formation in Eighteenth-Century England*. Cambridge: Cambridge University Press, 1988.

Leslie, Charles Robert, and Tom Taylor. *Life and Times of Sir Joshua Reynolds, with Notices of Some of His Contemporaries*. 2 vols. London: John Murray, 1865.

Levey, Michael. *Gainsborough: The Painter's Daughters Chasing a Butterfly*. Painting in Focus, no. 4. London: National Gallery, 1975.

Leveson-Gower, Sir George, and Iris Palmer, eds. *Hary-O: The Letters of Lady Harriet Cavendish, 1796–1809*. London: John Murray, 1940.

Levitine, George. "The Eighteenth-Century Rediscovery of Alexis Grimou and the Emergence of the Proto-Bohemian Image of the French Artist." *Eighteenth-Century Studies* 2 (fall 1968): 58–76.

Lewis, Judith Schneid. *In the Family Way: Childbearing in the British Aristocracy, 1760–1860*. New Brunswick: Rutgers University Press, 1986.

Liversidge, M. J. H. "An Elusive Minor Master: J. F. Nollekens and the Conversation Piece." *Apollo* 95 (January 1972): 34–41.

Llanover, Lady, ed. *Autobiography and Correspondence of Mary Granville, Mrs. Delany*. 2 vols. London: Richard Bentley, 1861.

Macfarlane, Alan. *Marriage and Love in England 1300–1840*. Oxford: Basil Blackwell, 1986.

MacMillan, Duncan. *Painting in Scotland: The Golden Age*. Oxford: Phaidon Press, 1986.

Malkin, Benjamin Heath. *A Father's Memoirs of His Child*. London: Longman, 1806.

Malone, Edward, ed. *The Works of Sir Joshua Reynolds . . . to which is prefixed an account of the life and writings of the author*. 2 vols. London: T. Cadell and W. Davies, 1798.

Manners, Lady V., and G. C. Williamson. *Angelica Kauffmann R.A.* London: John Lane, 1924.

Masters, Brian. *Georgiana: Duchess of Devonshire*. London: Hamish Hamilton, 1981.

McKendrick, Neil, et al. *The Birth of a Consumer Society: The Commercialization of Eighteenth-Century England*. London: Europa, 1982.

Millar, Oliver. *The Later Georgian Pictures in the Collection of Her Majesty the Queen*. 2 vols. London: Phaidon, 1969.

———. *Thomas Gainsborough*. London: Longman, Green & Co., 1949.

Morley Papers. British Museum, London.

Moore, R. E. "Reynolds and the Art of Characterization." *Studies in Criticism and Aesthetics, 1660–1800*. Ed. Howard Anderson and John S. Shea. Minneapolis: Minnesota University Press, 1967.

Museum of Fine Arts, Houston. *Images of Childhood*. Houston: Museum of Fine Arts, 1981.

National Gallery. *Thomas Gainsborough*. Catalogue by John Hayes. London: National Gallery, 1980.

National Gallery of Art. *The Treasure Houses of Britain: Five Hundred Years of Private Patronage and Art Collecting*. Catalogue by Gervase Jackson-Stops. New Haven: Yale University Press, 1985.

National Portrait Gallery. *Johann Zoffany*. Catalogue by Mary Webster. London: National Portrait Gallery, 1976.

———. *Sir Thomas Lawrence. 1769–1830*. Catalogue by Michael Levey. London: National Portrait Gallery, 1979.

Nicolson, Benedict. *Joseph Wright of Derby, Painter of Light.* 2 vols. London: Paul Mellon Foundation, 1968.

Nivelon, François. *The Rudiments of Genteel Behaviour.* London, 1737.

Northcote, James. *The Life of Sir Joshua Reynolds.* 2 vols. London: Henry Colburn, 1818.

Opie, Iona. *The Treasures of Childhood.* New York: Arcade, 1989.

Opie, Iona, and Peter Opie. *Children's Games in Street and Playground.* Oxford: Clarendon Press, 1969.

Paley, William. *Natural Theology; or Evidences of the existence and attributes of the deity. Collected from the appearances of nature.* London: Harvey and Darton, 1824.

Palmer, Iris. *The Face without a Frown: Georgiana, Duchess of Devonshire.* London: F. Muller, 1947.

Pasquin, Antony [John Williams]. *Memoirs of the Royal Academicians, Being an Attempt to Improve National Taste.* London: H.D. Symonds, P. McQueen, and T. Bellamy, 1796.

Paulson, Ronald. *Emblem and Expression: Meaning in English Art of the Eighteenth Century.* London: Thames & Hudson, 1975.

Paviere, Sydney H. *The Devis Family of Painters.* Leigh-on-Sea: F. Lewis, 1950.

Pickering, Samuel F., Jr. *John Locke and Children's Books in Eighteenth-Century England.* Knoxville: University of Tennessee Press, 1981.

Pinchbeck, Ivy, and Margaret Hewitt. *Children in English Society.* 2 vols. London: Routledge, 1969.

Plumb, J. H. *England in the Eighteenth Century.* London: Penguin Books, 1953.

——. "The New World of Children in Eighteenth-Century England." *Past and Present* 67 (May 1975): 64–95.

Pocock, John Thomas. *The Diary of a London Schoolboy, 1826–1830.* Ed. Marjorie Holder and Christina Gee. London: Camden Historical Society, 1980.

Pointon, Marcia. *Hanging the Head: Portraiture and Social Formation in Eighteenth-Century England.* New Haven and London: Yale University Press, 1993.

Pollock, Linda. *Forgotten Children: Parent-Child Relations from 1500 to 1900.* Cambridge: Cambridge University Press, 1983.

——. *A Lasting Relationship: Parents and Children over Three Centuries.* London: Fourth Estate, 1987.

Porter, Roy. *English Society in the Eighteenth Century.* Harmondsworth: Penguin, 1982.

Potterton, Homer. *Reynolds and Gainsborough.* London: National Gallery [1976].

Pottle, Frederick A. *Boswell's London Journal 1762–1763.* New York: McGraw-Hill, 1950.

Praz, Mario. *Conversation Pieces: A Survey of the Informal Group Portrait in Europe and America.* University Park: Pennsylvania State University Press, 1971.

Raines, Robert. *Philip Mercier, 1689–1760.* London: Paul Mellon Foundation, 1969.

——. "Philip Mercier, a little known eighteenth-century painter." *Proceedings of the Huguenot Society of London* 21 (1967): 124–37.

——. "Philip Mercier's Later Fancy Pictures." *Apollo* 80 (1964): 27–32.

Ramsay, Allan. *Dialogue on Taste.* London, 1755.

Rey, Robert. *Quelques satellites de Watteau.* Paris: Librarie de France, 1931.

Ribeiro, Aileen. *A Visual History of Costume: The Eighteenth Century.* London: B. T. Batsford, 1983.

Rogers, John Jope. *Opie and His Works.* London: Colnaghi, 1878.

Romney, John. *Memoirs of the Life and Works of George Romney, Including Various Letters, and Testimonies to His Genius.* London: Baldwin and Cradock, 1830.

Roscoe, S. *John Newbery and His Survivors.* Wormly, Herts: Five Owls Press, 1973.

Rosenblum, Robert. *The Romantic Child: From Runge to Sendak.* London: Thames & Hudson, 1988.

——. *Transformations in Late Eighteenth-Century Art.* Princeton: Princeton University Press, 1970.

Rousseau, Jean-Jacques. *Oeuvres complètes.* Dijon: Bibliothèque de la Pléiade, 1969.

Royal Academy. *Reynolds.* Catalogue by Nicholas Penny. London: Royal Academy, 1986.

Schama, Simon. *The Embarrassment of Riches.* London: William Collins Sons, 1987.

Schorsch, Anita. *Images of Childhood: An Illustrated Social History.* New York: Mayflower Books, 1979.

Shawe-Taylor, Desmond. *The Georgians: Eighteenth-Century Portraiture and Society.* London: Barrie & Jenkins, 1990.

Shorter, Edward Lazare. *The Making of the Modern Family.* New York: Basic Books, 1975.

Sidgwick, Frank, ed. *The Complete Marjory Fleming: Her Journals, Letters & Verses.* London: Sidgwick & Jackson, 1934.

Sitwell, Sacheverell. *Conversation Pieces: A survey of British domestic portraits and their painters.* London: Batsford, 1936.

Smart, Alastair. *The Life and Art of Allan Ramsay.* London: Routledge & Kegan Paul, 1952.

Smith, John Chaloner. *British Mezzotint Portraits.* 4 vols. London, 1878–83.

Smith, John Thomas. *Nollekens and His Times.* 2 vols. London: Henry Colburn, 1829; reprint, London: Century Hutchinson, 1986.

Sommerville, John. *The Discovery of Childhood in Puritan England.* Athens and London: University of Georgia Press, 1992.

——. *The Rise and Fall of Childhood.* Beverly Hills: Sage, 1982.

——. "Towards a History of Childhood and Youth." *Journal of Interdisciplinary History* 3 (1972): 438–47.

Spacks, Patricia Meyer and W. B. Carnochan. *A Distant Prospect: Eighteenth-Century Views of Childhood.* Los Angeles: W. A. Clark Memorial Library, 1982.

Stanhope, Eugenia, ed. *Letters written by the Late Right Honourable Philip Dormer Stanhope to his Son Philip Stanhope, Esq.* 2 vols. London: J. Dodsley, 1774.

Steegman, John. *The Rule of Taste from George I to George IV.* London: Macmillan, 1936.

Stephens, Frederic G. *English children as painted by Sir Joshua Reynolds: An Essay on Some of the Characteristics of Reynolds as a Designer. . . .* London: Seeley, Jackson & Halliday, 1867.

Stewart, W. A. C. and W. P. McCann. *The Educational Innovators: 1750–1880.* London: Macmillan, 1967.

Stone, Lawrence. *The Family, Sex and Marriage in England 1500–1800.* London: Weidenfeld & Nicolson, 1977.

Strickland, Irma, ed. *The Voices of Children: 1700–1914.* Oxford: Basil Blackwell, 1973.

Struve, Christian August. *A Familiar Treatise on the Physical Education of Children.* London: Murray & Highley, 1801.

——. *On the Rearing and Treatment of Children in Their First Years of Life: A Handbook for All Mothers Who Care in Their Hearts for Their Children's Health.* London, 1801–1803.

Summerfield, Geoffrey. *Fantasy and Reason: Children's Literature in the Eighteenth Century.* Athens: University of Georgia Press, 1985.

Sunderland, John. "John Hamilton Mortimer: His Life and Works." *Walpole Society* 52 (1988).

Tarcov, Nathan. *Locke's Education for Liberty.* Chicago: University of Chicago Press, 1984.

Tate Gallery. *Manners and Morals: Hogarth and British Painting 1700–1760.* Catalogue by Elizabeth Einberg. London: Tate Gallery, 1987.

——. *Thomas Gainsborough.* Catalogue by John Hayes. London: Tate Gallery, 1980.

Taylor, Jane, and Ann Taylor. *Hymns for Infant Minds.* 2nd ed. London: T. Conder, 1812.

Thicknesse, Philip. *A Sketch of the Life and Paintings of Thomas Gainsborough, Esq.* London: Philip Thicknesse, 1788.

Thompson, E. P. *The Making of the English Working Class.* London: Penguin, 1968.

Tinker, Chauncey. *Painter and Poet: Studies in the Literary Relations of English Painting.* Cambridge: Harvard University Press, 1938.

Trimmer, Sarah. "Reflections upon the Education of Children in Charity Schools." *English Historical Documents* 10 (1957): 571–75.

Troide, Lars E., ed. *The Early Journals and Letters of Fanny Burney.* 2 vols. Oxford: Clarendon Press, 1988, 1990.

————. *Horace Walpole's "Miscellany," 1786–1795.* New Haven and London: Yale University Press, 1978.

Trumbach, Randolph. *The Rise of the Egalitarian Family: Aristocratic Kinship and Domestic Relations in Eighteenth-Century England.* New York and London: Academic Press, 1978.

Trusler, Dr. J. *Proverbs Exemplified and Illustrated by Pictures from Real Life.* London: J. Trusler, 1790.

Tscherny, Nadia. "Beyond Likeness: Late Eighteenth-Century British Portraiture and Origins of Romanticism." Ph.D. diss., New York University, 1986.

Vertue, George. "The Notebooks." *Walpole Society* 1–30 (1930–52).

Vieth, David M., ed. *The Complete Poems of John Wilmot, Earl of Rochester.* New Haven and London: Yale University Press, 1968.

The Virginia Gazette. 1767.

Virginia Museum of Fine Arts. *Collection of Mr. and Mrs. Paul Mellon.* 2 vols. Richmond: Virginia Museum of Fine Arts, 1963.

Walpole, Horace. *Anecdotes of Painting in England.* 4 vols. London, 1765–71. Reprint [4 vols. in 3] London: Chatto & Windus, 1876.

————. "Notes by Horace Walpole, Fourth Earl of Orford, on the Exhibitions of the Society of Artists and the Free Society of Artists, 1760–1791." Ed. Hugh Gatty. *Walpole Society* 27 (1939).

Walvin, James. *A Child's World: A Social History of English Childhood 1800–1914.* Harmondsworth: Penguin, 1982.

Wark, Robert R., ed. *Discourses on Art.* New Haven and London: Yale University Press, 1975.

————. *Ten British Pictures.* San Marino: Huntington Library, 1971.

Waterhouse, Ellis K. "A Child Baptist by Sir Joshua Reynolds." *Minneapolis Institute of Arts Bulletin* (1968): 51–53.

————. *The Dictionary of British 18th Century Painters.* Woodbridge, Suffolk: Antique Collectors Club, 1981.

————. "English Painting and France in the Eighteenth Century." *Journal of the Warburg and Courtauld Institutes* 15 (1952): 122–35.

————. *Gainsborough.* London: Edward Hulton, 1958.

————. "Gainsborough's Fancy Pictures." *The Burlington Magazine* 86 (June 1946): 134–41.

————. *Painting in Britain: 1530 to 1790.* London: Penguin, 1953.

————. *Reynolds.* London: Kegan Paul, Trench Trubner, 1941.

————. *Three Decades of British Art.* Philadelphia: American Philosophical Society, 1965.

Watts, Isaac. *A Discourse on the Education of Children and Youth.* London, 1763.

————. *Divine Songs Attempted in Easy Language for the Use of Children.* London: Oxford University Press, 1951.

Webster, Mary. "An Eighteenth-Century Family: Hogarth's Portrait of the Graham Children." *Apollo* 130 (September 1989): 171–73.

————. *Francis Wheatley.* London: Routledge and Kegan Paul and the Paul Mellon Foundation for British Art, 1970.

Wendorf, Richard. *The Elements of Life: Biography and Portrait Painting in Stuart and Georgian England.* New York: Oxford University Press, 1990.

————. "Hogarth's Dilemma." *Art Journal* 46 (fall 1987): 200–208.

Wescher, Paul. "Philippe Mercier and the French Artists in London." *Art Quarterly* 14 (autumn 1951): 179–92.

Whalley, Joyce Irene. *Cobwebs to Catch Flies: Illustrated Books from the Nursery and Schoolroom 1700–1900.* Berkeley: University of California Press, 1975.

Whalley, Joyce Irene, and Tessa Rose Chester. *A History of Children's Book Illustration.* London: John Murray, 1988.

Wheaton, Robert. "Images of Kinship." *Journal of Family History* 12 (1987): 389–405.

Whinney, Margaret. *Sculpture in Britain 1530 to 1830.* 2nd ed. Revised by John Physick. Harmondsworth: Penguin, 1988.

Whitley, W. T. *Art in England 1800–1820.* Cambridge: Cambridge University Press, 1928.

————. *Artists and Their Friends in England 1700–1799.* 2 vols. London and Boston: Medici Society, 1928.

————. *Thomas Gainsborough.* London: Smith, Elder & Co., 1915.

Williams, David. *Lectures on Education.* 3 vols. London: John Bell, 1798.

————. *Treatise on Education.* London, 1774.

Williams, D. E. *The Life and Correspondence of Sir Thomas Lawrence, Kt.* 2 vols. London: Henry Colburn & Richard Bentley, 1831.

Williams, Raymond. *The Country and the City.* St. Albans: Paladin, 1975.

Williamson, George C. *George Morland.* London: George Bell & Sons, 1904.

Wind, Edgar. "'Borrowed Attitudes' in Reynolds and Hogarth." *Journal of the Warburg and Courtauld Institutes* 2 (1938–39): 182–85.

————. "Charity: The Case History of a Pattern." *Journal of the Warburg and Courtauld Institutes* 1 (1937–38): 322–30.

————. "Humanitatsidee und heroisiertes Porträt in der englischen Kultur des 18. Jahrhunderts." *Vortrage der Bibliothek Warburg* (1931): 156–229.

————. *Hume and the Heroic Portrait.* Oxford: Clarendon Press, 1986.

————. "Studies in Allegorical Portraiture, I." *Journal of the Warburg and Courtauld Institutes* 1 (1937–38): 138–62.

Wingfield-Stratford, Esme. *The Lords of Cobham Hall.* London: Cassell, 1959.

Winter, David. *George Morland (1763–1804).* Ann Arbor: UMI, 1980.

Wollstonecraft, Mary. *Original Stories from Real Life.* London: J. Johnson, 1791. Reprint, E. V. Lucas, ed., London: Dutton, 1922.

————. *Thoughts on the Education of Daughters.* London: J. Johnson, 1787.

Woodall, Mary, ed. *The Letters of Thomas Gainsborough.* London: Cupid Press, 1963.

————. *Thomas Gainsborough: His Life and Work.* London: Phoenix House, 1949.

Wordsworth, William, and Samuel Taylor Coleridge. *Lyrical Ballads, with a Few Other Poems.* London: J. and A. Arch, 1798.

Yale Center for British Art. *The Pursuit of Happiness: A View of Life in Georgian England.* Catalogue by J. H. Plumb. New Haven: Yale Center for British Art, 1977.

————. *Rembrandt in Eighteenth Century England.* Catalogue by C. White, D. Alexander, and E. D'Oench. New Haven: Yale Center for British Art, 1983.

Index

Photo Credits

Jörg Anders, figure 25

Richard Carafelli, plate 31

Curtis, Lane & Company, Sudbury, Suffolk, figure 51

Luiz Hossaka, plate 11

David A. Loggie, figures 16, 29, 36, 41, 42, 46, 59, 60, 63, 65, 70, 71, 94

Jeremy Marks, Woodmansterne Ltd., plate 20

John Mills (Photography) Ltd., figure 84

Newell and Sorrell Limited, plate 51

© R.M.N., plates 2, 29

Royal Academy of Arts, plate 50

Ed. Winters, B.Sc., figures 1, 2